[ART SCHOOLED]

Art
Schooled

*A Year among
Prodigies, Rebels,
and Visionaries
at a World-Class
Art College*

LARRY WITHAM

UNIVERSITY PRESS OF NEW ENGLAND

HANOVER AND LONDON

University Press of New England

www.upne.com

Text and illustrations © 2012 Larry Witham

Manufactured in the United States of America

Designed by Eric M. Brooks

Typeset in Fresco Plus Pro by Passumpsic Publishing

The illustrations in this book are representative of the events
described, and do not represent actual individuals.

University Press of New England is a member of the
Green Press Initiative. The paper used in this book meets their
minimum requirement for recycled paper.

Library of Congress Cataloging-in-Publication Data

Witham, Larry, 1952–

Art schooled: a year among prodigies, rebels, and visionaries
at a world-class art college / Larry Witham. — 1st.

ISBN 978-1-61168-007-2 (cloth: alk. paper) —

ISBN 978-1-61168-188-8 (ebook)

1. Maryland Institute, College of Art. 2. Art — Study and teaching
(Higher) — Maryland — Baltimore — History — 21st century. I. Title.

N330.B32M379 2012

707.1'17526 — dc23 2011037224

5 4 3 2 1

[CONTENTS]

PORTFOLIO DAY

O n a chilly December afternoon, an annual ritual shared by American art schools begins at the Maryland Institute College of Art, better known as MICA. It is Portfolio Day. Students arrive with artwork—drawings, paintings, and photographs—to impress faculty at an art school where they seek admission. On this Sunday in Baltimore, the morning fog, gusts of wind, and wispy snow offer a gray contrast to the brightness of the "art kids." Whether scruffy or groomed, all are armed to the teeth with proof of their skill and creativity. After morning campus tours of MICA, the parents and students head inside for the main attraction: portfolio reviews.

Portfolio "day" is not really a day, but a season, September to January, when art schools across the country transform themselves, each for a day, into shared recruiting stations. More than sixty other art schools have sent representatives to MICA today to set up tables around the campus, as MICA representatives will do at many of the other schools throughout the season.

To get reviewed by MICA, students form two long lines in the interior courtyard of the Main Building, a century-old edifice of Renaissance revivalism, a great marble landmark in this part of Baltimore, a neighborhood of brick row houses. Standing in the two lines, the students jostle folders and even big paintings. They inch across the inlaid floors, gazing up at classical statuary, replicas of works from Greece and Rome.

They are standing in two lines because of the way art schools are organized. This is the distinction between "fine art" and "applied art," the latter also called "design." Those who file into the first room (fine arts) are interested in drawing, painting, printmaking, photography, or sculpture. Faculty members crowd around the tables and gently move the students along, giving fifteen minutes of friendly advice to each. They tell students how to organize an effective portfolio. They also take notes: They are looking for top students, the *crème de la crème* (French is a preferred language

The Main Building from the campus green.

in the fine arts). The *crème* are likely to be recruited heavily, especially with merit scholarships.

In another room off the Main Building's courtyard, the wood-paneled President's Board Room, students meet faculty in the graphic design, illustration, animation, and architectural arts departments — the realm of applied arts, not the world of "art for art's sake," but rather art for clients. Some say, "Art for money's sake."

The students come at different levels of preparation, thanks to a feeder system for art colleges. The United States now has more than five hundred high schools for the arts (mostly magnet-type schools), an increase from twenty in the 1980s. In addition, most ordinary high schools offer AP (advanced placement) studio art.[1] Their teachers have gone to art college. They help art kids develop portfolios, as one exaggerated saying goes, "before they reach puberty." Whatever the preparation, MICA has an eye for students with "a good fit" for the school.

And so it is across Portfolio Day, a seasonal curtain-raising for each new year of art college. The nation's art schools — about fifty that are independent and hundreds more that exist as departments at colleges — are

friendly cooperators during Portfolio Day season. Their common cause: Fill the art schools, even as costs increase, high school graduation rates decline, and the racial and ethnic mix of the American student population is changing.[2] After a season of Portfolio Day cooperation, the schools invariably begin a behind-the-scenes contest, especially among the top independent schools, such as MICA. They compete over top students, negotiating benefits up to the eleventh hour. As private nonprofit colleges, the independent art schools also compete with the nation's public colleges and universities, many of which have large art departments, but charge less for tuition.[3]

The Portfolio Day season ends seven months before students begin their life at an art school. Students' Portfolio Day experiences are an omen. At every step of the way — to enter art school, graduate, win a competition, show at a gallery, get an art job — the portfolio, whatever diverse forms it can take, will be a key to their careers.[4] If they become artists, they typically also must decide whether to do it for art's sake, or for the money.

The emphasis on the portfolio suggests that the traditional goal of art schools remains intact — the goal of finding natural talent and teaching artistic skills. When MICA was founded in 1826, during an age of romantic landscape painting and monumental sculpture, the idea of *talent* in the art world reigned supreme. The "Maryland Institute," as it was originally called, was founded to promote the "useful arts," such as drafting, that would support America's booming industry, especially the railroads that were being born in Baltimore. As to skill, the art world most admired the *beaux arts*: classic drawing, painting, sculpture, and architecture. It was a world of talent honed by formal training.

In the twentieth century, many art school educators decided that a more democratic, less elite, approach was necessary. Suddenly, every person was a fountain of creativity, a spigot only to be turned on by art education. After the world wars, this was a fitting response to stifling conformity, and it was abetted by the new psychologies that said repression is bad, expression is good. With this, expressive art education joined skill-training. If skill got in the way of creative expression, the definition of skill was revised — or it fell by the wayside.

After the 1960s, something else entered the art world, going beyond mere skill or creativity. The art revolution of the 1960s announced that the

soul of art is an "attitude." Conceptual (and political) art had arrived. Its intellectual parallel was the rise of "critical theory," an amalgam of attitudes, Marxian and Freudian, geared to gender and race, often allied with anarchy, and now topped off by French "deconstruction" philosophies. Art students today invariably meet a mixture of these three expectations—skill, expression, attitude—and are challenged to decide; challenged to understand how different art schools serve them up in different proportions and intensities.[5]

For many parents and students, Portfolio Day is the first time they set eyes on a bona fide art school. As consumers of their children's education—one of the top two or three expenses a family will ever face—they are asking: What makes each school the same, but each school different? Today's art school curriculum is universal, if you seek an accredited bachelor's degree. Students must take two-thirds "studio" classes—that is, making art—and one third academic training, typically called the liberal arts.

One of MICA's administrators, Provost Ray Allen, has been considering the sameness and differences for years; part of his job has been to visit other art schools around the country, or sit on panels that review their curriculum. "The truth is, we're probably much more similar to each other than we'd like to admit," says Allen, who began his career as a studio art teacher. The schools share the same curriculum standards. Most of the teachers and administrators come from the same milieu. They studied at the same schools and, being of roughly the same age, witnessed the same artistic trends (although a younger generation—a computer generation—is just now beginning to take art school leadership). "The way art schools typically get differentiated is probably design schools and fine arts schools," Allen says.[6] Today, more schools try to be both. As illustrated by the two lines in the Main Building on Portfolio Day, MICA aims to offer these two worlds in full splendor.

For all the similarities of art schools, each school nevertheless has its own unique world. Each has its own city and history. As a campus, MICA is a jewel set on the rough edge of urban Baltimore. It is the second-oldest art school in America, founded in 1826. It has weathered that long history well enough. In the past three decades, the campus has grown. It has evolved into a mosaic of architectural styles—Renaissance marble, modernist cubist glass, and old factory brick. The campus meanders through a

cityscape of row houses, industrial plots, and highway bridges. The urban riots of 1968 set back Baltimore City's economic development for a few decades, and it has been MICA's fate to flourish on the borderline between a blighted urban section and Bolton Hill, an upscale historic neighborhood.

In the summer after the Portfolio Day season, the City of Baltimore shows what it thinks of the arts. In a blue-collar town like Baltimore, the kind of critical theory taught at MICA is definitely off-putting highbrow. Baltimore is more proud of its lowbrow art traditions.[7] One of them is mural painting, bright pictorials that cover old brick walls of factories, abandoned buildings, or highway concrete. An estimated 140 murals festoon Baltimore, and many more have washed away, fallen with buildings, or been painted over. Some date to the 1970s. New ones are added every season, painted by art students under the auspices of the city. The other great lowbrow art tradition in Baltimore is Artscape, the nation's "largest free art festival." For three days in late July, it comes like a tide, flowing up the central road of the MICA campus, Mount Royal Avenue, spilling into MICA's buildings, and inching its way to North Avenue, a city section once viewed as in irreversible urban decline. Now it has become the Station North Arts District. Artscape is the season for regional art exhibit prizes, and it is the source of the durable, often wacky, outdoor sculptures that populate Mount Royal and North avenues for the rest of the year, replaced by the next Artscape.

While Artscape keeps the distinct Baltimore character of a food-and-beer music festival, aiming for young adults and families, it does have artworks, kiosks with craftsmen and artists.[8] To a degree, Artscape also brings into the streets Baltimore's underground art scene, a summer showcase of more goofy art installations, crazy cars, and the risqué, since cabaret and striptease in Baltimore walk a fine line between voyeurism and "art," especially when they are called "performance art." For the real art underground, however, Baltimore must wait until spring for the annual Transmodern Art Festival, privately organized and touted as "four days of avant performance, installation, sound, film, mayhem, ecstasy, and radical culture!"[9] If Artscape is a mild taste of what students will find in Baltimore's alternative art world, the Transmodern will be a banquet, smaller but weirder.

Naturally, events such as Artscape and the Transmodern festival have a

complicated relationship to MICA. Like every top art school, MICA aspires to be a Harvard of art schools, elite, but with enough grassroots activity to be relevant. The school is active in community arts, murals, planting "urban gardens," holding forums for progressive social causes (feminism, racism, gay rights, antiwar), and doing projects with minority school children. As best it can, MICA assures its constituents that the school's grassroots activity is different from the wider collegetown party scene, which includes music clubs and alternative art spaces, and the mayhem of "radical culture."

In recent years, however, economists have begun to assert that any art scene in a city, lowbrow or highbrow, can contribute to its economic development, a force now being called the "creative economy." This has been the argument of one art economics guru, the urban economist Richard Florida. He coined the phrase "creative class" and has persuaded many city planners that they can assuage economic problems by supporting an "art scene," often funky, also boutique, but typically an urban salad of moneyed bohemians, gays, cafes, theaters, single professionals—and practicing artists.[10] This kind of art district hopes to draw a well-defined constituency back downtown, generating commerce and stability. The idea is taking off in many cities such as Chicago, Detroit, St. Louis, and San Diego. The quest for a robust art economy also has been launched in Baltimore, which in 2003 designated two urban neighborhoods as art districts, one of them near MICA, the Station North Arts District.

Art school educators also have been happy to hear the economic prognosis of Daniel Pink, a former speechwriter for Vice President Al Gore. Pink is predicting that the American economy will need more creative people, not more technocrats. To illustrate his point, he has revived the distinction between "right-brain" and "left-brain" skills, arguing that more right-brain creativity will create a more holistic, innovative (and even playful) workforce. In sum, says Pink, America needs more people with a master of fine arts, not a master's in business administration. "The MFA is the new MBA," he says in his best seller, *A Whole New Mind*.[11]

[]

By the end of summer, Portfolio Day and Artscape are just a flickering memory. Fall is approaching, and the school year begins. At the Main

Building one day, the president of MICA, Fred Lazarus IV, is ready for another school year.[12] He has been thinking about the art world for more than thirty years, since he was a staff member at the National Endowment for the Arts in Washington, D.C. Lazarus, a businessman with a Harvard MBA, likes the idea that the artist today is a "creative problem solver." There is a long list of things that art does to benefit the lives of individuals.[13] But Lazarus, whose youthful laugh belies his age and curly grey hair, prefers to offer a broad, singular vision of what an art school tries to achieve "We are creating citizen-artists, not just artists," he says of MICA. "Not only do students learn skills to get a job, but how to be responsible citizens engaged in the world. And that feeds back on who they are as artists."

From the private sector, Lazarus arrived at MICA to be its new president in 1978, the same year that the Portfolio Day tradition began among art schools. His predecessor had been the Yale trained artist Eugene "Bud" Leake, a gifted painter with an aristocratic leaning. Leake had led the school for sixteen years, reviving it from a slump and, through the 1960s, elevating it to the status of a college and making it a nationally known painting school.[14] Lazarus has an equally confident profile, being the descendent of the Cincinnati family that founded the great chain of retail stores known as Federated Department Stores, which later became Macy's. Now in the job for thirty years, he may hold the record for length of tenure as an art school president. Leake had made MICA into a fine arts school with a national profile. Under Lazarus, it has become a professional school as well, a corporate player in high-stakes higher education.

The MICA motto shows this confidence: "Leading the World of Visual Art." On such a diverse campus, with at least three generations of art teachers, and the demands of college marketing, the mottos for MICA are bound to differ. Naturally, some of its art instructors doubt that any single school can lead the art world. "We *follow* the art world and the art scene. We don't create it," says one veteran teacher. "We are just part of a giant network called art." Decade by decade, the larger art scene will infiltrate a campus, penetrating its bubble with new faculty, new students, new art publications, new market forces.

To stay current, art schools today must do the proverbial balancing act, taking in what is new without throwing out what is old. Some schools take

The blank canvas — where it starts.

sides. They are proudly avant-garde, and traditionalists need not apply. Others stay with an older academy model, the atelier, preserving tradition. MICA says it is trying to do both, even as the winds of change — or fads of the moment — are buffeting it. In art, there's always the siren call to be hip, relevant, eye-catching. "The challenge is to put one foot firmly in the future while maintaining one foot in the past," says Allen, the provost. Not easy footing.

The National Endowment for the Arts reports that two million Americans list their occupation, according to the Census, as "artist."[15] Just a quarter of them are engaged in the visual fine arts and applied arts. Today, about seventy thousand art students matriculate in the nation's art schools and college art departments. They are deciding which track to take, whether to ally with tradition or join the avant-garde. Will they invest themselves in community arts activism, or hunker down in front of a computer? They will ask, Do I have what it takes to be an artist? Do I *like* the "art world" and its people, now that I've seen it close up?

As Lazarus says on another occasion, "Some students will decide not to stay in art school, and I'm happy for them. Education is about finding out who you are, what you want to do. If they find themselves, that's terrific."

At the Maryland Institute College of Art, about two thousand students are asking these questions. To see how they are responding, this book will follow a small sampling of them through the school year. They are mostly freshmen, entering art school, but also students in the upper grades, such as seniors leaving art school and graduate students, who are pursuing the highest degree in the studio visual arts today, the MFA.

Each year at an art school is composed of a mixture of facts and metaphors, since art, like literature, is a creative endeavor. The facts are much like those of any college: A school year has two semesters, fifteen weeks each, and it moves across fall, winter, and spring. Each semester, students have a week off, and between semesters there is the winter holiday, a month away from college. The next semester starts up again in the new year, typically late in January. The year at an art college also may be taken metaphorically, a story of three stages (and thus three sections in this book). Art students begin by learning the basics, what art colleges call the "foundation." Then they learn about the art world around them, in fact about many art worlds, ones that they may one day join as members. Finally, whether as freshmen making it through a first year or as seniors who graduate, they will end their school year with a better sense of who they are as artists, recognizing their artistic soul, as it were.

Thirty-five years ago, I too was experiencing these facts and metaphors, earning a bachelor of fine arts (in painting) at a state university in northern California. It was the mid-1970s, a heady time in the visual arts, a watershed that divides today's "contemporary art" from mere "modern art." It was also a watershed, or revolution, that severed the art world's umbilical cord—some say safety anchor—with the past, the Western art tradition. The story that follows, tinted by the voice of a writer who is both an outsider and insider, and a probably a bit behind the times, hopes to find out where that so-called watershed has taken us today.

[Part I]

FOUNDATIONS

"VERY GIFTED PEOPLE"

o begin a school year, MICA holds Orientation Week, welcoming two groups that will be new to campus: graduate students and freshmen. They arrive in that order for good reason. The graduates are mature and focused, and only ninety in number, so they can get settled before the freshman tide rolls in. On a Monday afternoon in late August, Chris McCampbell is among these grads, who are sitting on the third-floor patio of the Gateway, a tall, glass structure on campus. They are enjoying a buffet lunch, a cool breeze, and the wafting outdoor music of their orientation day.

For a hot, muggy day in Baltimore, Chris is thinking, the weather is not bad. The art school atmosphere is enticing. Chris has just arrived from San Diego, California, pulling up roots to come east to pursue the highest studio degree in the visual arts, a master's of fine arts. Tall, with a trim, black beard, at age thirty he is not the typical art-school student. The vast majority are undergraduates, ages eighteen to twenty-three.

After working in the design field, Chris decided to earn an advanced degree in graphic design. He was not familiar with the Maryland Institute College of Art, or MICA, which everyone pronounces as "*Myka*," of course. But it looked good to him: *U.S. News and World Report* ranked it as the nation's fourth "best" graduate program in the visual arts (after Yale School of Art, the Rhode Island School of Design, and the Chicago Art Institute). Today is his first day to see the school (and in a semester, his wife will arrive as well).

The campus is turning out to be an interesting place, beginning with the Gateway, a ten-story building at the north edge of the campus. A modern structure of greenish glass, the Gateway is a kind of watchtower, a great round castle that someone said looks like it is made of hundreds of white, green, and black shower doors; a "postmodern" building, and MICA's most recent new structure.[1] On one side of the Gateway, the neon letters M I C A are stacked forty feet tall, facing the freeway below. The freeway traffic is relatively quiet today. Chris can hear its swish and

rumble from the Gateway patio, mixing with the cool jazz that is coming from speakers somewhere.

They say it takes new students a half year to comprehend the lay of the land at MICA, which has a fairly well-defined campus for an urban art school. However, if you go to the roof of the Gateway, the campus can be taken in quickly from two lines of view.

The main view goes south, down Mount Royal Avenue, which is lined with trees. At mid-campus, the eye catches a glass, cubist building and a Venetian-style palazzo in marble, and then farther south, a stone clock tower, the top of the old Mount Royal train station, an art-school property at its south edge. In late August, it's a view of leafy trees, bronze statues, outdoor steel sculptures, stone church steeples, and the red brick residences of Bolton Hill.

As students like Chris will learn from experience, the south end of the campus adjoins cultural Baltimore, with its symphony hall, quaint Charles Street, city university, and Amtrak's Penn Station, with a giant, aluminum, humanoid sculpture out front.

The second view, looking east, sees a different world. This panorama takes in Jones Falls Expressway (Interstate 83) and a landscape of cement-and-steel bridges that reach across Jones Falls Creek and the Amtrak, CSX, and city rail systems, bridges that carry art students to the Station North Arts District. It's a scruffy urban district of Victorian facades, gaudy billboards, scarred brick, and a good many boarded-up row houses, but it is hoping for an urban revival. One reason for that hope is a giant, five-story fabric factory—renamed the Studio Center—that MICA has turned into a honeycomb of painting studios.

By straddling these two kinds of neighborhoods, MICA has infused them both with life, measured especially by the increase of pedestrian traffic. Over the years, the school has also left its mark in dabs of bright color painted onto freeway embankments, bridge girders, and old brick walls. Chris likes the urban ambience. He knows, however, that his focus will be at the center of the campus. The Department of Graphic Design is in the Brown Center (the glass cube), the building where the graduate student orientation began that morning.

For that morning gathering, Chris and the others descended into Falvey Hall, down in the basement of the Brown Center. Falvey is the campus's

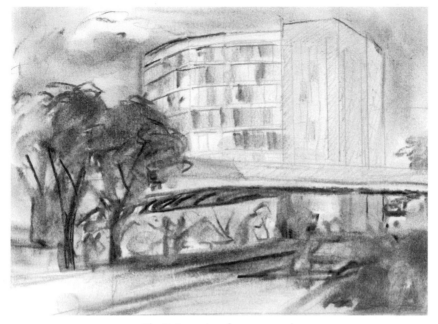

The Gateway by a freeway mural.

main auditorium. There they were welcomed by the provost and interim graduate dean of MICA, Raymond Allen, an abstract painter-turned art administrator. He greets them with warm candor. "No one says you have to go to graduate school to be a talented artist, designer, or teacher," Allen says. "But what you get is a totally dedicated environment."

Like any small college with an undergraduate and graduate program, MICA's structure is like a two-tier pyramid. The graduate program is smaller, sitting atop the bulk of the much-larger undergraduate realm. The two operate separately from each other. Of the ten graduate schools at MICA, four are especially well known nationally, including the graphic design school in which Chris has enrolled. Another is the Center for Art Education, which prepares artists to teach art in public schools or at the college level. The two others have namesakes: the Hoffberger School of Painting and the Rinehart School of Sculpture.

A master's degree from any of these four gives a graduate the best possible credentials to begin a career, carrying MICA's name into the field as well. Graduate recruitment has a big future at MICA, as it does at other art

colleges. "The undergrads pay the bills," says one MICA staffer. "The grad students make the reputation."

Back in Falvey Hall, Allen gets the grad students off to a good start. Slim in his tan summer suit, he has grey curly hair, round glasses, and a goatee. He's been out of the paint-spattered studio for a while now. He's just finished a term as president of the National Association of Schools of Art and Design. "The competition to be here was more fierce than ever," Allen tells them. One in ten applicants got in. After lunch, he says, the day will be spent seeing studio spaces and meeting directors.

They also should know one more thing before the fun begins. MICA has a new graduate requirement. It's an immersion course in contemporary art theory. Years earlier, when Chris did a bachelor's degree in art, he encountered the usual curriculum in art history, familiarizing himself with basic "artspeak," the constant invention of new terms to talk about new trends in art. At MICA, however, he'll go deeper than he'd ever imagined. He will learn countless neologisms, from "neo-geo" to "relational aesthetics," and try to understand what the French theorists mean when they distinguish between "modern" and "postmodern" art.

In time, Chris will question the relevance of artspeak for his career. Like many students, however, he'll appreciate what some MICA professors say about this: "You have to talk the talk to walk the walk." You have to know artspeak to succeed in art today.

As older students at an art school, those in the graduate program are already beginning to deal with how society views its artists. Art as an occupation is easily misunderstood, according to the National Endowment for the Arts (NEA). The previous year, the federal agency tried to buck up that image of the artist, commissioning an economic analysis, which found that artists helped fuel the American economy, especially artists in the entertainment industry. Artists in general, however, seem to have an image problem, according to the NEA report:

> America tends to see its artists as visionaries, rebels, outsiders, and eccentrics. These long-standing stereotypes have become mainstays of popular culture — perhaps because they are so entertaining. A troubled dreamer, a footloose bohemian, or a charming deadbeat can steal the scene from any workaday character. Presented from

whatever perspective—adoring, puzzled, bemused, or even hostile —these stereotypes almost always portray artists as outsiders, fascinating creatures who somehow manage to survive on the margins of society.[2]

As the graduate students mull their career prospects, knowing how the world may view them, the freshmen arrive at MICA with only a glimmer of what it means to be an adult artist. They are coming in record numbers this year, about 490. On Wednesday, they arrive by airplane and by car, most accompanied by parents, a few traipsing in all alone. The bright red hampers-on-wheels start filling the streets outside the freshmen residence halls. In a day-long flurry, parents and offspring manage, almost miraculously, to move hundreds upon hundreds of suitcases, bags, pillows, and art supplies out of cars, into hampers, and up elevators to the dorm rooms.

The freshmen are the big gamble for every art school. These eighteen-year-olds flung far from home are the object of the school's most "parental" care. Many art kids are introspective and sensitive souls, which probably correlates with the fact that artists must spend a lot of time alone to do their artwork.[3] At any college, a freshman class has the highest attrition rate of any grade. The same is true at an art school. However, at MICA, the first-year attrition is a mere 15 percent, very good for an art school and only half the freshman dropout rate at U.S. colleges in general.[4]

Before the freshmen arrived, all their first-year teachers—teachers in what is called the Foundation Year—gathered in the Main Building, scooping up some buffet lunch on a paper plate, then sitting around a ring of tables. They wanted to get on the same page, cover the freshman year details, focus their minds about what's ahead. Some are old hands at the Foundation Year, others relatively new. "You're dealing with prodigies, with very gifted people," said Patricia Farrell, head of MICA's Counseling Center and a psychotherapist. They are also dealing with many students who are not only creative, but who can now go to college thanks to medications. Farrell's center sees a quarter of all students (in all grades) each year. In the meantime, she counts on parents, doctors, and prescribed medications—mainly for Attention Deficit Disorder and depression—to help kids in their daily walk along the edge of life.[5]

After the meeting, Richard Barber, chief academic advisor for freshmen, headed over to his office on the same floor of the Main Building, the second floor, a kind of headquarters for the Foundation Year. He leaned back in his chair. Every new class has a collective personality, he said. For example, the current juniors (about 400 of them this year) came in calm and staid. The current sophomores (about 430) were the opposite. "A lot of big personalities, a lot of problems," Barber said. "This year there are more freshmen who normally wouldn't go to art school."[6]

In other words, there are more students with high grades (an average of 3.69, borderline B+ to A−), students who might have opted to study business, English, or law enforcement. Instead, they want to be artists. As an admissions report will state, the school has recruited a cadre of "more well-rounded artists" than in the past.[7]

On Wednesday, the freshman arrival is not willy-nilly. Nor is it quite social engineering. An entire MICA team has pored over student profiles, matching them as roommates, assigning them to the two locations for freshman housing, The Commons and Meyerhoff House.

As soon as he arrives, Adam Dirks looks over The Commons, a three-story brick structure with blue-painted steel girders. It looks to him like a vast apartment complex — a vast motor hotel — with a central lawn. Adam has arrived from the rural edges of Philadelphia. Athletic and sinewy, Adam wears dark, mutton-chop sideburns. Although he is very good at drawing, he wants to be a sculptor. He finds his room on the third floor in the back, and begins his life with 350 other freshmen at the complex. His first concern is where to put his bicycle, which will take him all over Baltimore in the next months. Adam knows the art system pretty well. He spent a pre-college summer in Tuscany, Italy, with a MICA drawing-and-painting program. In Italy, he met his girlfriend. She has just started at The Cooper Union, an art school in Manhattan. Already, she is on Adam's mind.

Down on the first floor of The Commons, two other freshmen are settling in, a painter and a filmmaker. From St. Louis, Jonathan Levy is a tall left-hander, a natural first baseman, who had the grades and background for medical school — his is a family of many doctors. Even so, he wants to be a painter. He has gotten the family blessing and, frankly, is amazed that he got into one of the best art schools. Jonathan's high school art teacher, who earned her master's degree at MICA, had helped him pave the way.

Across the hallway, Holden Brown decamps from New Orleans. Holden is winner of the top cinematic award in the Young Arts program, run by the U.S. Department of Education as the Cadillac of high school art contests. On arrival, he is happily dazed. He has never been showered with such attention. Like everyone, Holden brings his life and art experiences with him, some of them very hard experiences for a young man. Back in seventh grade, his best friend, a fellow artist, hanged himself, a memory that lingers. His family fled their home for five month during Hurricane Katrina. On the other hand, there are blessings, too. He nurtured his talents at a top art high school, located near the French Quarter, and now has a generous scholarship to MICA. Art college is not without its anxiety, however. He wonders how he'll live up to the expectations.

Two blocks from The Commons, about a hundred more freshmen are moving into the four-story Meyerhoff House, which has the feel of an old resort hotel with smaller rooms. The Meyerhoff used to be a women's hospital, and its first floor is now home to the main cafeteria and Student Activities office.

Jordan Pemberton, who just arrived from Michigan, is heading for the third floor of Meyerhoff, where she'll share an apartment with two other freshman women. Jordan's long, blond hair is tied up for action today. For the past two years, she had attended an art boarding school, Interlochen Arts Academy High School, where she excelled in oil painting. In that category, she was a recent Young Arts national finalist. As the Orientation Week commences, she sees a lot of those fellow travelers; Young Arts contestants are natural candidates for art college. For Jordan, college is also about intellectual nourishment, and she seems a shrewd judge of MICA's ability to deliver, since her high school friends are going to research universities. After she sets up house, she'll look for time to read a book.

At this point, Jordan thinks photography may be a better career choice. It seems more marketable than painting. So she has arrived as a photography major.

Career is also on the mind of William "Liam" Dunaway. He has arrived from the Florida panhandle, where his father is a lawyer in the Navy. Having moved into Meyerhoff quickly, Liam is already out on the town, with a good friend who is a MICA sophomore showing him how student life

really works. The official freshmen orientation will offer a "True Scoops" session, where anything can be asked anonymously (the most common question being, "Where do you get alcohol?" which MICA can't say in a state with a drinking age of twenty-one). Nothing can easily be swept under the rug in Baltimore, however; it's an urban college town with its drugs, alcohol, underground scenes, and red-light districts, a city that was the star of the expired HBO urban crime drama, *The Wire*.

Though young, Liam knows his limits and his values. He has worked at Boy Scout summer camps for the past four years. He is also a high school whiz at digital photography and computer design. He already does free-lance jobs producing calendars and yearbooks, including for his Methodist congregation back in Pensacola. He arrives as a graphic design major, but really can't decide. He is not even sure whether a full-fledged art school, versus a state university, is the way to go.

On Friday, Liam, Jordan, Holden, Jonathan, Adam, and all the other freshmen gather under a great white tent on the lawn of The Commons. They have divided into groups of about ten, each led by an Orientation Leader, or OL, volunteer MICA students who, wearing orange T-shirts, will serve as their tour guides, temporary best friends, and troubleshooters (the parents have been asked, warmly and discreetly, to say goodbye — and leave). Classes begin Monday, and the goal today is to continue break-ing the ice among the newcomers, a job now handed to the Reverend Dr. Jamie Washington, a motivational speaker.

Washington is clad in a bright red T-shirt. He has a big microphone. He is a former top Maryland college official. He is now a minister in the black gay church movement, a music leader, and a community builder. Sup-ported by the enthusiasm of the OL leaders, Washington is a maestro, or-chestrating cheers, spontaneous groupings, and fun things for students to talk about, such as birthdays, siblings, and their home states.

What he also evokes is the art students' memory of painfully "standing out" in their high schools (although perhaps less at art magnet schools and private art high schools).[8] The assumption is that art kids stand out because they do not go into sports or mathematics or the high school de-bating team or run for school president. Instead, they like the margins. They pierce their noses and lips, take on permanent tattoos. They cele-brate graffiti, Gothic-girl black, or spiked and bleached hair. When they

see art, they get it. If they felt a stigma in the past, says Washington, that is over at art college: "You come here, and, no, you ain't standing out" any more.

Now it's Friday evening. For many freshmen, it has become evident that a place like The Commons, by one student's account, is a small, enclosed city of "boys and girls with raging hormones." The topic of sex is brought to the fore, not just by students, but by the school. At all American colleges these days, more than eight out of ten students report having had sexual intercourse by this time in their life (the college years). One-third of women students report getting pregnant. Sexually transmitted diseases are on the rise. So it's time to address the issue. The Student Activities Department calls it the message of "healthy sexuality."

For the fourth year now, the bearer of this message is comedian "sexpert" Maria Falzone, who offers students her rollicking, naughty "Sex Rules!" They soon learn that the word "rules" is quite literal, a double entendre. After filing into Falvey Hall, the cheering begins. Throbbing music fills the air. A sultry Madonna belts out "Give it to me." Some OLs are immersed in personal dance expressions up front, orange T-shirt-shapes gyrating under spotlights. When the music fades, Falzone takes the stage.[9] She begins by saying that as a young woman, she became promiscuous, partly in rebellion against her mother's Roman Catholicism. Now she has an incurable sexual disease — a cautionary tale for her audience, but hardly an abstemious one.

With Falzone, MICA adopts the reverse-psychology approach. The adult talks openly with students about *everything*, saying it's okay if it makes you feel good. "You are art students," she says. "Play with your imagination around sex." In full color, and blue language, she talks about sex positions, cellophane, lubricants, condoms, body parts, orifices, fluids, autoeroticism, hot wax, and toys, all of it adumbrated with audience cheers and whoops. Once entrusted, however, Falzone can also warn about the serious lifelong health risks, and why mixing drugs, alcohol, and sex usually turns out badly. Still, she says, if you follow the sex rules, "You can do anything you want with a consenting adult."

The next morning, Saturday, the freshmen look at their schedules with relief: There are no more assigned events, but lots of fun optional activities. For the more serious-minded, the big one comes on Sunday afternoon, a

forum called "The Art of the Critique." After the issue of sex, perhaps nothing else is more central to art college than The Critique, the time when teachers and fellow art students comment on your artwork.[10] When Sunday arrives, about sixty freshmen will head over to the Main Building for the critique workshop, and there they will meet one of MICA's senior students, Jennifer "Jen" Mussari, who has volunteered to help walk them through the critique experience.

This is the start of Jen's last year in art school. As the freshmen are arriving, she and the other seniors are planning their departure. Jen is a General Fine Arts major. The week has been exhausting, since Jen has been an OL, leading her own group of ten or so. Like many of her peers, Jen was the art star at her high school in the Philadelphia suburb of Newtown Square. She painted the backdrops for school plays and took the maximum number of art class electives. Her love of nature turned her into a defender of animal rights and a lifelong (so far) vegetarian. She came to MICA as the art girl who drew animals well, and, of course, her art has grown in breadth and sophistication along with her own confidence as a person and as an artist.

Part of that senior-year confidence is supposed to come from what the school calls its "professional development" program. Professional development means a good portfolio, resumé, comfort with job interviews, and a modicum of zeal and business savvy. Less formally, it means having a personal identity as an art maker.

As a senior, Jen is well on her way in forming that identity, and it's more than just her fetching looks, her big eyes, and long dark hair. In economic jargon, Jen must also become an artist with a "brand," a recognizable product or style. A tattoo on the back of her upper left arm is one small piece in that puzzle. It is a "hex sign" of her own design. The design soon will appear on her business cards. This kind of circular image, originally seen on barns in the Pennsylvania "Dutch" (actually, German) farmlands near her hometown, are folk religious symbols. They connote blessings. However, urban legend-makers redefined them as hexes, or curses. Either way, they are vintage decorations from a folksy past. This aesthetic — "not folksy, but influenced by Americana and vintage styles" — appeals to Jen. She designed her own hex symbol — with tulips, hearts, and birds — and wears the tattoo.

During Orientation Week, Jen has plenty of senior-year worries: completing final credits, pulling off a senior thesis, graduation, and, most chilling of all, entering the real world—as an artist. She has gotten a taste of that from her boyfriend, Jonnie Hallman, a MICA graduate who that summer landed a job with Adobe, a premier graphic design and software company. Jen and Jonnie are turning out to be an art-school success story, though the day is still young (and art critics say thirty years is the best measure of success). When Jen graduates, they are moving to San Francisco, hopefully to the artsy SoMa district (South of Market), the neighborhood of dot com companies, cafés, and artist lofts. She's only got nine months of art school to go.

On this mild Sunday afternoon at the very end of August, she has one more thing to teach the freshmen. She's had countless critiques. "By the time you're a senior, you've been subjected to this for a while," she says.[11] Dressed in an off-white blouse and skirt, Jen walks across Mount Royal to the Main Building, ready to climb, gripping her two portfolios firmly. From the street, nearly thirty steps lead up through the main double doors, and then up to the interior courtyard.

The courtyard looks like a small art museum. Twenty or so plaster statues, like Greek and Roman sentinels, ring the atrium and second-floor mezzanine. High above is a vast art nouveau skylight, tinted green. Around the mezzanine, the names of the great Renaissance artists are presented in inlaid stone, eleven of them in all, bracketed on each end by the names Michelangelo and Raphael. Indeed, these are the eleven "white males"—painters, sculptors, and architects—who gave the world the Western Art Tradition.

For today's demonstration, Jen is teaming up with veteran professor Nancy Roeder, once chair of MICA's Foundation Department. As people gather in the large studio room off the courtyard, Jen pins up about twenty pieces. They are drawings, paintings, and prints. This is the classic art-school wall, found everywhere in every building, made of hard, spongy Homasote wallboard painted white, walls you can pin things on, work on, and renew every year with coats of fresh, white paint. By now, about sixty students have arrived, taking their seats on four-legged stools. They look around furtively. They wait for Roeder and Jen to begin the show.

Cameron Bailey, a young man with ruddy cheeks, is just beginning to

feel at home, his third day in Baltimore. He is from the rural precincts outside Seattle. Today he has come to learn about the critique in the real art world. "In high school, my teacher complimented my work, even when it was BS," he says. "I need someone to say, 'This is wrong, that is wrong.'"[12]

Back home, Cameron had won a few local art awards. Attending an East Coast college is his dream-come-true. He arrived at Baltimore-Washington airport with a suitcase and backpack, took a bus into Baltimore, the biggest city he's seen, and made his way up to Bolton Hill. Actually, he's hanging on for dear life. "It's all very intimidating," he says. Walking around the Main Building, Cameron saw all the classical art, read the names of the Renaissance figures, who are often dismissed as too old-fashioned for the contemporary art scene. However, tradition is beginning to lure him (even though he *thinks* he wants to study video and animation).

A ways over from Cameron sits Nora Truskey of Durham, North Carolina, and elsewhere Calvin Blue of New Orleans. They are old hands at art studies. They've done pre-college art summers, Nora at Rhode Island School of Art and Design and Calvin at MICA. They are part of MICA's "minority" enrollment, which is about a third of freshmen this year, with Asians (mostly Koreans) the largest segment. Nora is biracial, with a Chinese mother, and Calvin is black. As the year begins, they will grapple with the normal set of first-year challenges, settling in with a group of friends, keeping up with the homework, watching how art supplies eat up their money. Nora has come to MICA to study illustration. Calvin wants to be a painter. Their first year at MICA will also be about racial identity, both in life and in the culture of the visual arts. As they will see, "identity" is almost as common an art-school word as "critique."

Also in the gathering is Corynne "Cory" Ostermann, who waits quietly for the session to begin. Her father, a musician, drove her to Baltimore from Batavia, west of Chicago. Her mother was a public school art teacher. In rebellion now, Cory was reared in their upper Midwest, evangelical Christian, Dutch subculture. She, too, is beginning at MICA with profound questions of identity. She's certain she was a feminist by age seven, confirmed in high school when she began her series of sarcastic drawings of housewives. She secretly has rejected her religious upbringing and be-

lieves that art can fill that void. Feminism aside, Cory's sense of good art is traditional, a matter of expert drawing and painting. Skill and feminism — these are her identity issues, and her youthful ambition.

Now the demonstration begins. It is called a critique, but everyone refers to it as "the crit." Roeder begins with some historical perspective. She was trained at the University of Cincinnati and Western Michigan University, and back in the 1970s, some art professors felt free to tear a student's work from the wall, crumple it, and throw it on the floor, with a harsh word or two. That was the boot camp critique. Conversely, if a critique is "too nice," nothing is learned. "When you start taking things personally, that's when you get in trouble," Roeder says. She also says it's better to feel the heat in art school, and grow used to it, because the outside world can be merciless, especially if you create "difficult art," as the euphemism goes.

The students leave their stools and head for Jen Mussari's artwork, moving from piece to piece, looking closely.

"Okay, who would like to comment first?" Roeder asks.

As in most critiques, quiet descends, and it stays. Eventually, at Roeder's prompting, someone speaks, and then others. They offer compliments, vague half-sentences, perhaps a meek criticism. Roeder turns to Jen, asking her for the artist's perspective.

Jen explains that an artist, when appearing in public, certainly can explain her work, but it's not an obligation. "You can also not say anything," she says.

For her part, Jen prefers a written explanation over a verbal one, and that is the role of various kinds of "artist statements." The statement can be a manifesto of the artist's overall work, or just a few sentences, a few facts about the work posted on the wall. At any rate, every senior, like Jen, is required to have produced a manifesto-type statement as part of the senior thesis. This is a ways off for the freshmen. From the first day, however, they are asked to join the boisterous debate over whether artists must "explain" their work.

More than ever, contemporary art has made art an *explanation*, not just something to look at. Some artists resist this contemporary mandate, leaning on the legendary riposte: "If you can talk about it, why paint it?"[13] This is the art world debate over *form* and *intention*. Form is what you see.

The graded crit — a way of life.

The question it raises is: How does an artwork operate visually? This is what art experts look at when they engage in "formal analysis," a term that sounds, at first blush, like talking about three-piece suits and top hats. However, in a strict formalist view, art must work visually. If it is visually confusing, boring, amateur, obtuse, or ugly, no amount of explanation, or good intentions, will save the day.

However, other artists believe that form is not enough. What makes art real is its "truth," not its beauty. The truth is in the artist's intention. In this view, artwork that is ugly, boring, or naive, can be the handmaiden of a powerful idea. This is the argument of conceptual art, which since the 1970s has been the most sweeping trend in the art world.[14] The debate between form and intent remains vigorous, almost sectarian, and art school is unlikely to clear it up for the students. Invariably, teachers themselves disagree. Nevertheless, for the next four years, students will be asked to explain their ideas and analyze their intent.

[]

As the brief afternoon session on "The Art of the Critique" wraps up, Roeder alerts students to another freshman challenge they must brace themselves for: the obligation during the second semester to pick a major. This is another identity question. What kind of art will I do in life? Each

year, when choosing-a-major time comes, says Roeder, "It's nervous breakdown time."

Encouraging this decision is the job of Richard Barber, the freshman academic advisor. Later in the semester, he'll go around to each class, asking student to sign on the dotted line. The signing is done in fairly high drama, almost Faustian, but humorously as well. Choosing a major can be hard, so a ritual of commitment seems to help.

Besides choosing a major, freshmen undergo other psycho-dynamics as well, Barber explains. One is the big fish–little fish syndrome. In high school, a student may have been the big art fish, the acknowledged art star. Now the pond is an ocean with many big fish, some obviously bigger. Even the Young Arts students, trained for competition, can feel like part of the food chain in the Chesapeake Bay. Eventually, they will learn the hard numbers of the art world: so many artists, so few jobs. So much art-school talent, but so few galleries and so few art magazines with monthly cover stories on the latest hot young artist.

Second, says Barber, at art school, art becomes work. It used to be for fun and escape, but now it equals grades, six-hour classes, and homework. Barber, altering his voice, impersonates a familiar freshman complaint: "Now art, this thing I love, is what I'm being forced to do!"

This school year, the Admissions Office will make one more poignant observation about the new class. In colleges in general today, women outnumber men, and at art schools it's not uncommon to find 60 percent women, and often higher. This freshman class, however, is 72 percent women. When presented with this finding, one freshman, a blue-eyed fellow from Detroit, smiles, "That doesn't bother me. I like it." The administration has a different message for the trustees: "Men are considered an underrepresented population at MICA."[15]

Art schools today are a catching-up place for women in Western art. For centuries, art was a man's exclusive domain. Not any more, of course. Feminism has claimed a special place in the visual arts because art involves "looking" at "objects." According to feminist theory, men have been looking at women as objects for millennia, and it must stop. It is called the "gaze," oppressive by its very act, thus making the entire history of Western art guilty of oppression. The fires of art feminism don't burn as hotly as they did in the art world of the 1970s perhaps, but that's because art is

always looking for something new, putting behind the old-hat. Each new generation of female art students is asking how to move on.

Theories abound about why art schools attract so few men. The statistics at MICA give some hints. Male applicants to art school on average have lower GPAS (especially in language scores) than those of the female applicants. In general, college recruiters are faced with the fact that girls, physiologically and in language skills, develop a bit faster than boys by this age. To compensate, "Some schools have lowered admission standards for boys," says MICA's head of admissions, Theresa Bedoya. "I'm not ready to do that yet. But I do wonder about our assessment tools for boys." Another theory holds that, with the rise of feminist ideology in kindergarten to twelfth-grade education, boys receive less attention. Later in the school year at MICA, a feminist leader in art education contests this "boys crisis" theory. Speaking at a session of the National Art Education Association meeting in Baltimore, she says: "There is no crisis in boy's education."[16]

Either way, the trend is being noticed. The topic of men and women, male- or female-style art, is sensitive at art schools. In their cultural bubbles, art schools typically are pledged to diversity, multiculturalism, and multi-gender experimentation, probably more than general colleges and universities.

Only in the art world bubble, for example, is the modern-day gender war played out in visual images (rather than, say, marriages or workplace law suits). In one view, the intensity can be traced most recently to the 1950s era of abstract expressionism, or the New York School, where a manly regime of hard-drinking, hard-painting males defined modern art. It was against this school that feminist and homosexual artists in latter-day New York (or Los Angeles) rebelled. By some estimates, the rebellion has turned art into a world of gender ambiguity, at times swinging to another extreme, that of homoeroticism and androgyny.[17]

Historically at MICA, the "macho" department had been sculpture, which once had focused on the heavy-duty casting or welding of big objects. Today, the male recruits tend toward the applied arts, those that are computer- or object-design based or that aim for a defined industry. "I really don't understand what masculine art is," Jen says. "I don't really see much of it at school." Her boyfriend, Jonnie, says that in high school, boys

are not encouraged into the arts if they can do well in sports or mathematics. In his case, however, his whole family was in the visual arts, so the choice was natural. "I didn't exactly grow up thinking I was going to be a business major," he says.[18]

When Jonnie and Jen arrived at MICA as freshmen (in 2005 and 2006 respectively), construction dust was still settling on parts of the fast-expanding campus. For the newcomers this year, the campus looks as if it always has been this way, pristine, suspended in time. It is a landscape of buildings that, as the year goes on, will symbolize art-school life, its power structure, and the trajectories of students.

As a graduate student in graphic design, Chris McCampbell will spend his time at the Brown Center. Freshman such as Holden Brown and Liam Dunaway also will be attracted to the glass cube, since they are interested in digital arts. Jen is a senior in the fine arts divisions, so she is given studio space across the bridge at the Studio Center, the former factory building. For freshman Adam Dirks, Mount Royal Station, with its sculpture studios, will be a haven. Jordan Pemberton, who looks forward to the academic courses, will find them in the nondescript Bunting Building, home to the library as well.

At the Main Building, the administration has its eyes on a busy year ahead. Despite the recession, MICA has recruited record numbers, students from thirty-nine states and twelve foreign countries, more than eight in ten from beyond Maryland, a "testament to MICA's national reputation," says a report to the trustees.[19]

This year the school also is looking at expansion. It wants to open more buildings, add one hundred new slots to the graduate programs, and inaugurate new majors. It is completing its once-a-decade accreditation review by Middle States Association of Colleges and Schools, the quasi-government agency. This is also the year the administration must settle a long-simmering salary dispute with the campus faculty, whose number is now reaching 350, the vast majority of them part time. The National Art Education Association also comes to Baltimore this year, and MICA is playing host to many of its events.

Fred Lazarus, the president, is the image of calm. When the parents brought their freshmen to campus, Lazarus was introduced to them by the head of the Parent's Council as "Fred" — "the guy with the bow tie."

No one stands on ceremony at the average art school. Informality is the norm on campus. Into the school year, many students will not know the last names of their professors. This worries the staff in the campus Center for Career Development, which helps art students prepare for the workplace (where bosses still prefer Mr. or Ms.).

By Monday, however, there's no turning back. Classes begin. At noon, Lazarus opens the first campus-wide event, a talk by this year's visiting artist-in-residence. This is "art in the dark," a mainstay of art schools, with students as an audience watching art projected on a screen. However, the presentation today is also a story of a lifelong artist's life in art, says Lazarus. "It's a wonderful way to start a new year."

VISITING ARTIST

I n his red T-shirt and paint-spotted blue jeans, Sean Donovan sets out across the great trestle bridge. The summer sun beats down. The bridge, its steel girders painted several colors, is an elevated highway as well. It is the connector between the main campus and the Studio Center, the former factory building across the railroad tracks. Sean is one of about fifty painting seniors at MICA. Like Jen Mussari (and other fine arts seniors), he'll be walking back and forth on this bridge a lot today.

This is a Monday, the first day of the school year, but every Monday will be a very ambulatory one for people like Sean. Each week, it is the day when many seniors gather at the Studio Building for crits. Then, at lunchtime, they boomerang back to the main campus. They head for Falvey Hall, the high-tech auditorium.

On Mondays, Falvey is host to the Artist at Noon Lecture Series. At the lectures, the seniors gain exposure to a wide variety of career artists. They are artists outside the campus, and that means "visiting artists." Every department has off-campus artists dropping by throughout the school year, but Artist at Noon — with its central location, budget, and ability to draw bigger names — has pride of place. Plus, seniors are required to go.

The talk by the first visiting artist is a special event. She is the painter Lani Irwin, who will hold the female-artist-in-residence chair this year. She has arrived at MICA with her painter husband, Alan Feltus, who will also teach. As a couple, they live and paint in Italy, and while modern, they extol what painters did in the Renaissance. Italy is a destination for many MICA students as well, who participate in various art studies abroad, and the "Italian connection" is particularly strong. That summer, Sean had been painting in Italy, attending the International School of Art at Montecastello di Vibio, Umbria, a school where faculty at MICA and other American art schools travel to teach now and again.

The Italian summer has changed Sean's life, he claims. The pressures of senior year are also surely at work. "After I came back from Italy, I knew

I wanted to be an artist the rest of my life," says Sean, who is tall with cropped black hair, blue eyes, and a toothy smile. Sean paints in a "figurative" style, his version of human forms, interiors, and recognizable objects (as opposed to pure abstraction). So a painter and speaker such as Irwin interests him. After Italy, moreover, he wants to become productive like never before. "I have to start taking this pretty seriously," he says. "Put in the time and energy."[1]

At the front of Falvey Hall, Irwin is being introduced by painting chairman Barry Nemett. Nemett is a Yale-trained artist who often takes students to study painting in Italy during the summers. (He takes them to Montecastello di Vibio, near where he met Irwin and Feltus, while MICA has two "official" summer programs in Florence and Sorrento, near Naples.) Nemett is a minor legend at MICA, an impresario of art, an outgoing personality, and a family man. By way of introduction, he says Irwin is most of all a good friend, a traveler from Italy, member of a wife-husband painting team with "one foot in tradition, one foot in the contemporary world."[2]

What Irwin offers today is widely known as the "artist's talk." Artists speak of their lives and works while images of their art project on a screen in the darkened room. The screen in Falvey is massive. Irwin and her husband paint human figures in interior environments. Indeed, she and her husband met at American University in Washington, D.C., which then had a "good, strong, figurative painting department," says Irwin, a woman with short, white hair and a colorful dress to her ankles. Since moving to Italy in 1984, they managed to live and rear a family of two sons on the sale of paintings and artists' grants, with a little teaching thrown in.

In their oil paintings, Irwin and her husband both evoke a kind of Renaissance realism. They use clear, if muted colors and create modern-day moods, but in times and places that are hard to locate. Figures, male and female, lounge at tables. They hold letters, pass tea cups, comb hair, let clothing hang with painterly exactitude from their forms. They often look you in the eye. Irwin puts her figures in carnival environments, with circus balls, costumes, and suggestions of old-fashioned acrobats. Irwin ends her talk by projecting an image of her favorite painting in art history. It is the highly composed deposition of Christ from the cross by Rogier Van der Weyden, an intense psychological study of faces, gestures, and atmo-

sphere. The appeal is not necessarily the religious imagery. It's the painterly magic.

On this first Monday, the campus has come to life. This being noontime, the two main eating establishments — Cafe Doris by Falvey, or the Meyerhoff student residence — are small Grand Central stations. The school day passes in three stages, since class times are blocked as morning, afternoon, and evening. At the Main Building alone, on a Monday, some three hundred students will navigate its steps, attending about twenty different kinds of courses, ranging from photography (in the basement) to sophomore painting, life drawing, community arts, and African literature upstairs. Before the first semester is over, the art students at MICA will circulate through more than 650 course offerings.

Nevertheless, for all the circulation, a student might still lack a sense of intimate artist-community. That is one reason that Irwin has been given the annual chair, to create an art "salon" on campus, a regular setting for students to gather with an artist couple, to talk the trade, to talk about life. The couple will live at the campus's Kramer House, with its spacious public area, where Irwin and Feltus will paint. Here also they will hold regular soirees, times of shared food and conversation. The art salon is a storied tradition. It's one way of being bohemian, evoking images of Hemingway and other "lost generation" artists hanging out at Gertrude Stein's apartment (salon) in Paris.

"Most of us are solitary," Irwin says in her talk on the artist's life. "We spend a lot of time by ourselves." Hence, "the community of artists is very important." In particular, Sean Donovan is taking note. He lives on Bolton Hill, just three blocks from Falvey Hall and the bridge, and just five blocks from Kramer House. He knows he has to find a painters' community as well as going solo in the studio.

[]

Before Irwin and Feltus arrived in the States, a tour of their paintings, a show titled "Personal Interiors," already had been organized, and it is now beginning in Tulsa, Oklahoma, later to arrive on the East Coast. Before they head back to Italy in the late spring, works by Feltus will open at a New York gallery.

Organizing exhibits is no easy task, as Gerald Ross knows intimately

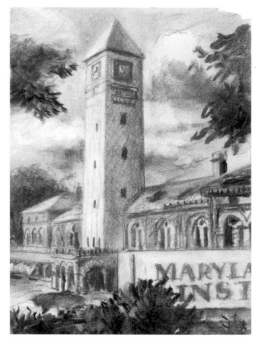

Mount Royal Station turns art school.

well. A tall native of Wyoming, Ross is director of the Department of Exhibitions at MICA. At MICA, he does this every day. In fact, there are times when Ross feels that his department, logically, is the most important on campus. Without exhibits, there would be no art to see at an art school. "When people come here," he says, "they want to see art that is being made."[3] The public can't see it in classrooms, studios, or student dorms—they only see it on the walls in exhibits. No wonder that Ross's department—five staff assisted by subcontractors and work-study students—helps to set up and tear down one hundred exhibits during a school year.

As the Monday talk unfolds, Ross is in his basement office next door, down in the Fox Building, location of the two most prestigious galleries on the MICA campus, the focal point of a campus with twelve galleries and plenty of nooks where various departments exhibit seasonal work. Each school year begins with four exhibits, the least of them the Summer Abroad, in which Sean has a series of small Italian landscapes.

"I hate landscapes," Sean says, accentuating his preference for interiors and human forms.

The most touted campus shows of this season are two by the faculty—the Sabbatical and Faculty exhibitions—and then a third, a display of student art that "provides a glimpse into the future of the art world."[4] This is the Foundation Year Exhibition. It includes work done by the previous freshmen, which MICA advertises as glowing evidence of the great work that even a first-year class can do.

Like each freshman class, each Foundation Exhibition has its own character. This year's exhibit is getting mixed reviews. For his part, Ross (trained as a painter at the Kansas City Art Institute) naturally likes outlandish art. He enjoys seeing it each year in the Foundation Exhibit, but this time, something seems edgier. "The darkest year I've ever seen," Ross says. To the casual observer, it might look like today's art kids are being shaped darkly by their culture, which, at the touch of a computer button, serves up slasher movies, vulgarity, and pornography. The faculty members are less concerned about that (it's visiting parents who notice).

Whatever the cultural influences, the first-year kids come out of high school these days "fully loaded, so talented," Ross says. "Way different than when I went to art school." Trained at an art school, Ross never imagined he would be working at one. It is actually not uncommon. At MICA, many of the campus staffers are long-ago graduates. Also, 30 percent of the 270 listed studio-art faculty members have MICA degrees. No wonder the administration speaks of the campus "family."[5]

Having been in Baltimore for twenty years, Ross worked at various museums before coming to MICA eight years ago. Just about everywhere, exhibition work is made up of tight schedules, complex logistics, and careful handling, but it also can include a dilemma that the art world calls "censorship," even at MICA. The school's *Installation Handbook and Policy Guide* states that the Exhibitions Department will never "remove any artworks—and would never attempt to censor any work displayed in campus galleries." But there are limits: Exhibition art cannot disturb people with loud sounds, strong odors, or dangerous materials, such as animal tissues or human fluids.

Since MICA galleries are also exhibit spaces open to the public, an occasional sign will be put up.

THIS EXHIBITION CONTAINS SUBJECT MATTER THAT
MAY NOT BE SUITABLE FOR SOME VIEWERS

"It's only because we have a lot of people coming on the campus," Ross says. For artists, of course, the debate is never-ending. Each art institution tends to sort out its own policy. Some art venues want to shock and titillate adults. Others, like MICA, beckon children and families. While MICA's policy tends to screen out truly egregious (or dangerous) art, there's always something to offend somebody, either parents or passersby. "This is an adult campus with an adult dialogue, an adult intellect," Ross explains. Furthermore, some students play the censorship card to their advantage, Ross explains, creating "a censorship issue to highlight their exhibition."

For this art school at least, the policy is to strike a balance between the artist's vision and the community's values. To keep that, the exhibition system tries to stay in discussion with each artist, treat them equally, and be mindful of the public. "It gets really tricky," Ross says. "I'm not a lawyer or anything."

Historically, the art exhibit is where art meets the world and sees how it will respond. When the National Endowment for the Arts lamented stereotypes of artists, it did not use the descriptive terms "naughty" or "subversive." But this is one enduring side of the art world, and no one should be surprised.

Nudity and vulgarity have been age-old topics in the arts. About 250 years ago, when the Salon in Paris dominated Western art, the painter Jean Baptiste-Siméon Chardin (d. 1779), took the floor and addressed the temptations and fates of young artist, who become voyeurs of nudity. If the voyeurism does not lead to skill, Chardin said, the young artist has lost both morals and livelihood.

> The student is nineteen or twenty when, the palette having fallen from his hand, he finds himself without profession, without resources, and without moral character: for to be young and have unadorned nature [i.e. naked models] ceaselessly before one's eyes, and yet exercise restraint, is impossible. What to do? What to make of oneself? One must take up the subsidiary crafts that lead to financial misery or die of hunger.[6]

The artist who starves to death *because* he does art is virtually a roman-
tic myth. But Chardin's musings remain relevant. What the painter Irwin
calls "community" can, in many cases, be a type of amoral subculture.
Art schools, like the art world, do not pass judgment on whatever subcul-
ture, or "scene," an artist will call her own. The naughty and subversive
subcultures are fairly common, and for very good reason — some of the
most famous artists of the twentieth century created those subcultures.
Those subcultures are now marketed by leading art magazines, forums,
and galleries.

In the first two generations of modernism, these subversive subcul-
tures offered a variety of themes. At first it was the decadent art move-
ment, when artists sought to shock the middle class with ribald tales of
libertine lives, spiced with sexual freedom, opium, and hashish. Art his-
torians next speak of the *fin-de-siècle* period, or end of the nineteenth
century in Europe, a time when erotic, morbid, and despairing themes
characterized innovations in Western art.

The final subversion, however, did not come until the period surround-
ing the First World War, when the French painter and provocateur, Marcel
Duchamp, emerged on the American scene. Backed by wealthy Ameri-
can modernists, Duchamp set out to confuse the very definition of art.
As a Frenchman, he enchanted the American avant-garde, first with his
somewhat cubist painting *Nude Descending a Staircase* (1913), then with
his suave life as a chess player and subverter of art. After announcing that
mere "retinal art" is passé, he invented the idea that any "found object"
or "ready made" thing (bought in a store) can simply be declared to be a
work of art. To dramatize his point, he anonymously submitted a ceramic
urinal, signed R. Mutt, to the 1917 inaugural exhibition of the Society of
Independent Artists in New York City. When the urinal was effectively re-
jected, Duchamp's allies cried censorship.[7] Today the urinal is one of the
most famous "artworks" in the canon.

The other Duchampian legacy, rather more indirect, is the idea that
context alone determines art. As soon as a urinal is put in an art exhibit,
in other words, it takes on the mantel of art. This subversive idea was
furthered by Andy Warhol who, while actually constructing and painting
his Brillo boxes (rather than simply finding them), turned these simula-
tions of mundane commercial objects into fine art by displaying them in

a gallery. After this, the Duchampian subculture rapidly expanded, giving rise to such artists as Robert Rauschenberg, who glued urban street refuse to canvases.

Naturally, the legacy of naughty and subversive art circulates in modern-day art schools. The previous year at the MICA commencement ceremony, a graduating senior opened her academic robe to reveal herself naked underneath. This school year, students will also delight in crossing boundaries. One student brings in a giant red phallus for her color theory project, and in another assignment, a young man draws a picture of a woman with her hand up her rectum. The new Eros class — erotic drawing — will soon display what, in the world of graphic novels, is called "good pornography." At MICA's venerable Photography Department, a hot project of the season will be digital photos of sex toys. Even the publicists for porn star Annie Sprinkle have plastered MICA's campus events boards with a poster on her "artist talk" in Baltimore.

It will take time for incoming students to learn the full weight of the Duchampian revolution. Many of the new students have not yet heard of Jeff Koons, MICA's most famous living alumnus. Early in his artistic career, Koons revived the Duchampian readymade. He displayed an off-the-shelf vacuum cleaner in a Plexiglas case, titling it *New Hoover, Deluxe Shampoo Polisher* (it eventually sold at Sotheby's contemporary art auction for $2.16 million).

In later years, Koons risked all by making art of explicit sex acts, a "Made in Heaven" series (1989) of giant photo prints, movie, and titillating glass sculptures. With his boyish good looks and virile chest, Koons poses with his European porn-star wife, hiring skilled craftsmen to make the actual artworks. On arriving at MICA for a visiting artist talk one year, Koons explains that "Made in Heaven" is actually anti-pornography. "It's not anti-sexual, but it's not pornography," says Koons, a master of careful art verbiage. Sex is sublime, even religious, he explains. "Spiritually, the way to enter the eternal is through the biological."[8]

In his own life, Koons has had children by three women, and it has changed the work he creates. Now he is world famous for gigantic children's toys in colorful chrome, so famous that they were juxtaposed with classic art at the Palace of Versailles outside Paris (not far from where Chardin had given his ancient advice). Chardin would not be surprised

at Koons's moral fate, but he was wrong on the finances. By his daring, Koons has become an immensely wealthy, multi-millionaire artist with a factory-like studio in New York City. He tells interviewers that the quest of the artist is to be free—free of guilty feelings.[9]

The previous year at MICA, Koons returned for the graduation commencement, accepting the school's Alumni Award.

[]

By the second week of the new school year, the MICA campus has become a different kind of human landscape. The students, like busy ants, are moving about campus with their hands full. They have bought their first supplies for the year. They carry large portfolios, paint boxes, canvases, and variously shaped boards and household objects.

They are generally in a hurry, especially for the 8:30 a.m. classes that freshmen take at the Main Building. By now, the freshmen are beginning to see their new world as limited, like an island, with familiar faces everywhere. They all have Elements of Visual Thinking, a kind of freshman "homeroom" class where they learn the most basic aspects of artistic thought and creativity.

The Drawing class is also illustrative of their world closing in. For the next thirty weeks, Jonathan Levy, Cory Ostermann, and Liam Dunaway will be in Drawing I and II, meeting in the same room with the same teacher. Others have jumped ahead. Nora Truskey and Adam Dirks start in the same Drawing II class, a jump also made by Cameron Bailey and Jordan Pemberton. Some of them, due to their financial arrangement, will also have work-study jobs. Calvin Blue works for the Department of Exhibitions, sitting as a monitor in a gallery, or carrying ladders across campus. Jonathan works at the campus post office, and is good humored about it. "My grandmother said if I can't make it in art, I can at least join the postal service," he says.

Back on Bolton Hill, in her row-house apartment, graphic design junior Meghann Harris knows campus life very well.[10] She is a student leader on campus. Today she is typing away on her Mac laptop, standard gear for art students. She is blogging and sending e-mails to make sure the first meeting of the Academic Affairs Council, one of two wings of the Student Voice Association (SVA), is a success. For a second year, Meghann is president of the council, the place where student delegates from each of

the fourteen undergraduate departments and from the Foundation Year bring their "academic" concerns.

When Meghann became secretary of the Academic Affairs Council as a freshman, only ten or so students showed up for the monthly meeting. This year she hopes to push it to a group of thirty or forty. It's still a hard draw. About as many students show up for the campus-wide student government meetings as show up for many of the forty or so student clubs, such as the Black Student Union, the Haunted House Club, or the Maryland Institute Queer Alliance.

The student government meetings gather in the dark wood-paneled President's Board Room in the Main Building, one of the most distinguished rooms on the campus. It has a bronze bust at the entrance, a vast Persian rug inside, and a large central table as dark as the paneled walls. Those walls, punctuated by tall windows, bear a century-old trustee portrait, but they also serve as a gallery of bright student artwork, large canvases of rainbow paint. Season by season, new student paintings play off the antique ambiance.

As SVA president, this is where Meghann hold courts, often with administration figures and Department of Student Activities staff also attending to hear student concerns. Meghann was an art kid in high school with a knack for computers and for making Web sites. She arrived at MICA seeking more than just the bachelor's degree: She is also seeking, for a fifth year of study, a Master of Arts in Teaching (MAT), needed to teach art in public schools. If the journey to her final goal — to be a graphic designer and art teacher — has been circuitous (changing majors twice) she has the self-described "A-type" personality to pull it off. She is tall and lithe, her long red hair either in a ponytail or tied up. Mondays she works at a tea house downtown. On her Web site, she is "Meghann Victoria," a persona, even a brand, as she lets the world see her design work.

Right now, she is finishing up the SVA blog. After that, she turns to the next thing: her first assignment in Typography I. By next week, she must paint a giant serif letter. Meghann has chosen a giant K, white on blue. Like any big piece of artwork, she'll carry it across Bolton Hill. Then she will climb the cement stairs of the Brown Center, the glass cube, home to graphic design, the heart of what MICA calls its program for "design culture."

On the second Monday, Meghann enters the class with the great K in her arms. The Brown Center classrooms are stark and white "smart" classrooms, ringed with computers and electronic functions, warmed by the arrival of human life. Each week, the start of Typography I is predictable enough. Students are given a topic to attack with a "20-minute solution." On their computer screens, using art software—Photoshop or Illustrator, for example—they use various fonts (type faces) to illustrate the given topic in an 8x8-inch frame, then post it on Flickr (an Internet image-sharing site) for fellow students to see their "solutions."

Meghann's Typography I teacher is Brockett Horne, chair of graphic design. As the day's exercises continue, Horne sets a tone that characterizes the applied arts. "You have to learn to be competitive," she says at one point. In other words, her students must learn to be quick in finding solutions to design problems. In the marketplace, they will serve clients. Those clients often have deadlines. So quick is good. Quickness is also important because the graphic artists must generate lots of ideas on the spot. As Horne says, "The way to get the best idea is to have lots of ideas."[11]

By the end of the semester in Typography I, students such as Meghann will rack up fifteen quick solutions. This learning by practice has a range of intensities. Another graphic design teacher was famous for heaping on the assignments. He required students to pick 35 words, and then find 30 associated words. That totals 1,050 words—and the assignment was 1,050 thumbnail sketches based on each. Later he pushed for 1,700 sketches. For Meghann's tastes, the intensity of Typography I is just right.

The work never seems to end, however. A few days later, on Thursday, Meghann chairs the first SVA meeting of the year. It's September 10, and naturally, the turnout is modest—but it's a start. A staffer from student affairs arrives to help oversee the event, as do fresh box lunches. Their aroma fills the room and titillates the appetites of the arriving students. A noontime sun cuts through the tall windows and gauzy curtains of the dark-wood boardroom. Some of the paintings on the wall pick up the light. Everyone's arrival is surprisingly prompt. Meghann is visibly pleased.

"Well, it's good to see everyone," Meghann begins. "Thanks for coming."

At the start of the year, the best the council can do today is get an overview and get up to speed. Meghann passes out an agenda sheet, which

keeps the topics simple. Invariably, however, the perennial concerns of students begin to dominate the opening session.

"The buildings close too early," a young man offers, touching the nerve of a popular student complaint (even though school surveys find underuse of some studio buildings). Other familiar concerns begin to surface: Many courses are hard to get into. Course descriptions are vague, or often don't match the actual course. And already in the freshman year, the Foundation Year, students are worried about the cost of supplies.

"It's a lot more than expected," a freshman reports.

The school officially estimates that students will need $700 per semester for class supplies. However, students in photography, or those buying the best paints, paper, or large canvases, or a brand new art history textbook, are quickly busting their budgets. Sooner than expected, today's time has run out. Student government has gotten rolling. Thanks to Meghann's good management, the meeting wraps up soon enough for everyone to grab their free lunch, even linger a while. Classes begin again at one o'clock. The student reps finally head out, the bronze bust outside the door looking on, as it has for nearly a century.

Afterward, Meghann is at her computer, sending out more SVA smoke signals. She sends them into the blogosphere, namely the Internet, where art students live half of their waking lives. In many classes, students will open their Macs as soon as they sit down. In some cases, teachers must forbid them from doing computer "work" during instruction time. That work, of course, will often include surfing the Internet or watching YouTube videos, a student delight in multi-tasking that soon tunes out the teacher.

Meghann is all for being attentive in class, but at this moment at home, she is flying through cyberspace, typing away, telling readers of the SVA blog what she will do next. "This is the poster I've made in order to give SVA a bit more attention this year." She has uploaded the image so it appears on the Internet. It is the image of a sky blue brain-shaped thought balloon, suitable for an academic wing of student affairs. She will also print it as a poster. She can do this on color printers at the high-tech Brown Center or the technology building on Mount Royal Avenue. Then she'll spread the posters around, hoping that the blue brain stands out among the myriad advertisements, garish handouts, and urgent appeals

that fill the cork message boards and easel displays inside every campus building and hallway.

"Every semester, I'll make a new poster with our meeting dates, URLS for our blog and Twitter account, and information about what SVA is," she types on the blog. "Don't be surprised if you see this around campus soon."

Now she is off to some other art assignment, grabbing her large brown sketchbook. She takes it wherever she goes, using it for notes or to draw visual ideas. For graphic design students, however, the computer is the ultimate canvas. That is under Meghann's arm as well. With her computer, she takes a studio with her.

Other students have a much large studio space to manage, and the fine arts seniors are a case in point. They are finishing off a final year, so storage space and elbow room for final projects is a must. As a senior in General Fine Art, Jen Mussari has her space in the Studio Center across the bridge, an easy stroll by day, but a reluctant walk by night. As this year begins, she is formulating a senior project: her thesis. The final product will appear in the greatest exhibit of the year, the Commencement Exhibition of all the graduating artists.

For better or worse, after several years at MICA, Jen Mussari still likes to work in many media. She has at hand a favorite art book, Faythe Levine's *Handmade Nation: The Rise of DIY, Art, Craft, and Design*, which tells the story of how artists who do crafts in all kinds of materials are making an impact, developing a market. This year, Jen is particularly interested in hand-made lettering. Also, she soon will begin stitching, in green thread on raw white canvas, a tree-lined landscape, expressing her love for nature. More than the art of computer networks, she is attracted to the crafts movement, which seems to be creating a new commercial niche, not only at craft fairs (and yes, on Internet marketplaces), but among publishers who like imagery that does not look like it was made by a computer. Whatever Jen's thesis project will be — and matters can look ambiguous at this early stage — she has been allotted space at the Studio Center, that long walk across the bridge.

Whether by foot, bike, or car, the students make it over there on Monday, a day of the week when the building is buzzing. When MICA bought the old factory building in 2000, and then Baltimore named its blighted

neighborhood the Station North Arts District in 2003, it was days like this that everyone had in mind. The building is full, the sidewalks bustling, the cafes doing a brisk business. On Mondays, all fine arts students in the upper grades must report to the Studio Building, which is why the ambiance is different from other days: busier, full of commotion. The seniors in fine arts, for example, all meet with their supervising senior thesis teachers in their studio spaces, making Monday a day of regular group crits as well, a day when students must have work to show. All of this dictates one other fact of the Studio Center: It is also buzzing on Sunday night, since the average art student, like anyone else, will often wait until the last minute, employing the stress of a deadline to achieve optimum productivity.

Once past the two security gates, the main stairway inside the Studio Center zigzags up four floors. At each level, the floor opens out like a small city, a maze of cubicles. The streets of this studio city are made of heavy wooden planks, creaking with warehouse-loft romance, the skies a skein of pipes and vents, generally whitewashed like all the walls. Here and there a bright yellow line shows the way (a fire code requirement). The studio cubicles are rooms of white-painted walls that stop short of the ceiling. A partial wall leaves an opening, the doorway.

On Mondays, the second floor, where seniors have their studios, is humming with activity. Seniors such as Jen and Sean are starting a year of weekly meetings with a faculty mentor, head of their "core group" of about eight or ten students. Today is September 14, the second week, and Sean's core group has gathered around painting instructor Christine Neill, who is taking them from studio to studio to hear each student's plan for the year ahead. "You need to be focused and open at the same time," says Neill, who has a calming, mellifluous voice. Calming is good. "It can be frightening to walk into a studio and say, 'I've got to produce a body of work this year,'" she says.[12] The students nod, grin.

Neill is a leader of the professional development movement at MICA. She helps formulate MICA's plan for how young artists can develop over four years, four stages, each with personal and professional goals. The senior-year stage is probably the most practical; it includes building a "substantial body of work," knowing about jobs (teaching or non-art jobs also), tying in with professional networks, understanding copyright laws

and contracts, and planning to establish "a professional physical environment: studio or study" to keep doing art after leaving school.[13]

Neill and her group walk down the main atrium of the second floor, and turn left toward Studio 242, which is Sean's work space. They are seeing how each student creates a working environment, clean or messy, the art space of a pack-rat or a monk. Nothing will match the mystique of Sean's. The group crowds in. The entire cubicle is painted black. His oil paint palette, a table-sized piece of glass, is also mostly gobs of black. Blue paper towels (like mechanics use) are scattered on the floor, stained with black paint. At this time in his career, black is Sean's favorite "color." His latest painting is an interior with a human figure, a grotesque. The black is heavy. The figure is hard to discern.

A native of Chicago, Sean works in the expressionist tradition. Thick paint, bold strokes, distorted imagery—but with recognizable humans in their compact environments. As the school year unfolds, he will go to the library, check out books on famous expressionist painters, and bring them into his dark studio, looking them over as he thinks about his own work. Foremost, he is studying a group of expressionists who do grotesques, exaggerated human figures. They include the Englishman Francis Bacon or, going further back, Mathis Grünewald of the northern Renaissance. They also include twentieth-century expressionists: James Ensor, Chaim Soutine, and Jean Dubuffet. The contorted human figure, shaped by emotion, is a long tradition. Over time, these grotesques have become more expressive, with paint used more freely, colorfully.

Sean is trying to do the same. For now, though, he's mired in his black paint, trying to bring the figures out, using a minimum of color, yet hoping to create a visible narrative that expresses his own emotions.

When Sean was young, his mother was killed in a car accident by a negligent driver. She gave him his crystal blue eyes. She is often a theme behind his work, which is not the case with his younger brother, who is also attending MICA, a year behind him. Both were reared by a caring father, and in Sean's case, schooling was not easy, for he worked best with his hands, not with books or computers. His interest in art was confirmed when he attended a summer course at the Chicago Art Institute, and then he aimed for an art college.

He first chose Ringling College of Art and Design in Florida. He went

to study graphic design, but soon realized that it's all digital work now-adays. Computers were not hands-on, so he switched to sculpture, a weak department at Ringling (which is strong in animation and illustration). At Ringling, students flocked to the nearby beach, too sunny a clime for Sean. "I think you need to be true to yourself in a little bit more depress-ing atmosphere," Sean says. Art is an internal, psychological pursuit. He transferred to MICA to do sculpture, but finally moved over to painting, where he finally feels at home. Over the past summer, when Sean traveled to Italy, Renaissance paintings made a powerful impression, at least in terms of composition or drama, especially the works of Caravaggio, whose dramatic figures emerge in bright light from utter darkness.

In his studio today, surrounded by his peers, Sean is fairly reticent. He's not in the mood to explain the sources of his inspiration, though visitors can see the kind of art books that are scattered around. Someone says his studio looks like that of the late English painter Francis Bacon, a figurative expressionist, a painter of the grotesque, who said he needed "chaos" to paint. (Today, Bacon's studio, in which trash slants down from the walls, creating a mere aisle of foot space, is preserved as a museum exhibit in London.) Bacon also used the wall as his palette. Sean does too. After Sean explains some of his goals for the year, it's time to move on, but not before Neill, apologetically, suggest that he might want to clean up the solvent-tinged rags on the floor. There was a fire in the Studio Cen-ter the previous year.

Noontime has arrived, so the seniors head for Falvey Hall.

As with the Irwin lecture, this second Artist at Noon presentation also will be different from the norm. Today's visiting artist will not just fly in for the talk, but will be around for the semester, traveling in each week to teach. He is Warren Seelig, a fiber and mixed media artist, based in Rock-land, Maine.

Like many college art-school teachers, Seelig commutes to teach. Dur-ing spring semesters, he travels to Philadelphia, spending three days a week at the University of the Arts downtown. This year he's on the road for the fall semester as well, flying from Maine to Baltimore, an artist far from his New England studio, traveling a circuit. (A school like MICA would like to have all its teachers live in Baltimore, but a sizeable fraction still commute from out of state).

Visiting artist, art in the dark.

This is a big year for Seelig at MICA, where his former students, now faculty, run the Fiber Department (with ninety-seven majors). The school will hold a massive retrospective of Seelig's work, the largest single exhibit of the school year. Titled, "Textiles per se," it will decorate the main buildings of the campus for fourteen weeks. The works will include gigantic metal mobiles—Seelig's "axle and spoke" pieces—hanging from high ceilings, colorful fabrics folded origami-like and hung on walls, and steel-rod sculpture tipped with hundreds of pebbles and rocks, his "shadow-land" pieces. For Ross, head of exhibitions, it will be a major installation project, but with a very nice payoff: Such a long exhibit gives his staff time for doing inventory, taking vacations, or preparing for the spring events.

Today Seelig's topic is "the intelligence that is expressed through making things by hand."[14] As he explains, the work-a-day world has grown very cerebral these days, characterized by white-collar jobs, computers, and all the rest, and that's why there is a counter-movement toward working with one's hands. The arts, too, have become overly cerebral, and Seelig places the blame on the legacy of Duchamp, after whom philosophers and conceptual artists intellectualized art objects out of existence. Such is the case with the art philosopher Arthur Danto, who has declared that Warhol's Brillo boxes were a turning point in art history, the actual "end of art," so that now art must exist primarily as philosophy.

Seelig, however, speaks today of a movement that is proving Duchamp

and Danto wrong, a trend in the arts and in society that asserts "the value of work, and working with materials, and making things by hand." He calls this "materiality." While that materiality may still make useless art objects, and may use discarded raw materials, its goal is nevertheless to
. create material forms of beauty and fascination. After the long reign of Duchampian ideas, Seelig declares that there has been a reversal, a "full-scale redemption of the idea of art as practice." The growing number of textile artists is a case in point. So are artists who do environmental installations and crafts, all illustrated by his slide show. In the past, Duchamp and Danto had prophesied that art-making would end, but that is not the case, Seelig tells his audience: "None of this has happened."

Artist at Noon is off to a good start, and it will grow as students, whether required to go — the case for many seniors and juniors — or not, will hunker down for their lunch hour. A freshman like Jonathan Levy took his Monday lunch hour to see Seelig, since he has work-study in the post office that day. In his first season at MICA, Jonathan already has seen evidence of conceptual art around campus, and he certainly has seen it at the avant-garde museums around Baltimore, such as the nearby Contemporary Museum and, down by the Inner Harbor, the Visionary Art Museum, dedicated to "outsider" art. On campus, though, he is finding plenty of traditional skill and craft. Seelig's talk is one more piece of encouragement. "I've always been impressed, drawn toward, more skillfully done artworks," says Jonathan, who knows he'll learn more about conceptual art in his art history courses, and perhaps some studio classes. "I've always struggled with that sort of [Duchampian] interpretation of what's art."[15]

This early in the year, many of the new arrivals to MICA are busy, feeling overwhelmed already. On Monday, freshman Nora Truskey has plenty of projects on her plate. One other newcomer who does not have time to attend Seelig's talk is Amelia Beiderwell, a transfer student from Oregon. Monday is her day to catch up. Nora and Amelia have something in common at this moment. Both are preparing homework for a Tuesday class called Elements of Visual Thinking, a required course for anyone who wants a degree from MICA. Known by students simply as Elements, it is an immersion course for everyone, a back-to-the-basics of visual arts. The course is also a legacy of the Bauhaus, the German art school that has defined art education in the twentieth century.

TATTOOS AND
THE FOUNDATION YEAR

When autumn arrives, making its debut in late September, students have fallen into the art-school groove: long classes by day, up half the night, crashing-out on the weekend, but back to life on Sunday night to binge on homework. Nora Truskey and Amelia Beiderwell begin their weekly classes on Tuesday, and Tuesday means the studio course called Elements of Visual Thinking.

Having climbed the great stair in the Main Building, Nora makes her way to instructor Dennis Farber's Elements class, which meets in a large white room with tall windows on the second floor. All the students are at the wall, pinning up their homework—tattoos they have designed for their parents. As Nora pushes in tacks, a few others students put down iMac laptops, or objects (such as three oranges), on which they'll display tattoo designs. Before long, about twenty tattoos festoon the front of the classroom, and they are about to tell the story of the students' parents.

Although some art students wear tattoos, the black inky inscriptions are not Nora's cup of tea. However, she has designed one for her mother. It's a stylized portrait of an Asian female (her mother is of Chinese ancestry). A red flower decorates her hair. Nora's drawing style is delicate, using fine lines and avoiding bold contrasts. Her drafting skill is obvious.

Many of the students show artistic skill, in fact, and this provides Farber with a teaching moment. A veteran artist himself, Farber is in his sixties, tall and trim with short, gray hair. For the rest of the year, he will remind his students that the Elements course is not in search of the most skillful art, but rather the most creative and analytic thinking behind an art project.

"Don't get me wrong," Farber tells his class. "Skills are good. But they take you only so far. Some things demand a high level of craft, others don't."

Farber likes the young people. He has worked with enough of them to know how to be close, and how to keep a distance, how to take them by the hand and defend them when needed, but how to challenge them as

well. As he says later that day, "In my classes, unless their skill is necessary for the project, it looks like showing off. I'm more interested in them developing as people. I want them to come to consciousness as an artist and as a human being. That's what I'm after."[1]

As the morning crit of the tattoos proceeds, the class arrives at Nora's tattoo drawing, a finely wrought piece. The relationship to her mother is the obvious connection. It's a pleasant tattoo if there ever was one.

"Where would it go?" Farber asks.

Someone says, "The upper arm."

"Maybe the back?" offers another.

Farber is always looking for points of departure, teaching moments. "Tattoos are a big commitment," he says. They are permanent. They send signals. Yet in culture and art, people have always put designs on their bodies, temporary or permanent. Up on the wall, some of the students' tattoos are humorous, others blatant. One is despairing: "My son goes to art school." Another is of a man on a Himalayan peak. He is a baby boomer dad who went there in search of enlightenment. Next, there's an angel/devil combination tattoo (for mom and dad?). In another, a pinup rides a bomb amid a fiery mushroom cloud; the student's father is in the Air Force.

Evidently, everyone feels most comfortable making tattoos for fathers. Nora's dad is Caucasian American, a research scientist and professor in North Carolina. That makes her biracial. "I'll never look fully Chinese or white, and even though it has made me question my identity I have grown to love and embrace being biracial," Nora will write in a paper for another class.[2] She's in limbo, proud of her mix, and a little confused by it as well. This is Nora's particular spin on identity, a natural topic for her Foundation Year. Every freshman, at every turn, is urged to think about identity. They are urged to explore it in their art. Some students will indeed get a tattoo as part of that identity building. Nora will pursue it in writing, and as evident in Elements, in some of her art as well.

"Don't we all struggle with our identity?" Nora writes.

For his part, Farber decided to identify as a painter at a young age. As time went on, he had his own studios in Los Angeles and then Manhattan, doing mixed media, using photos and painting. Eventually, Farber turned to full-time college art teaching: University of New Mexico, then to

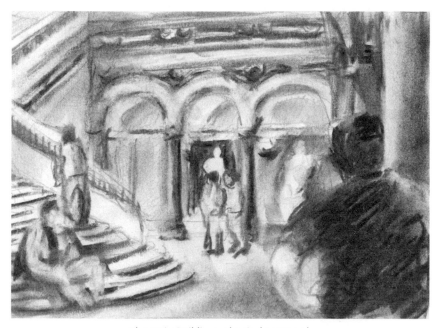

The Main Building's classical courtyard.

Baltimore. He has been at MICA for more than a decade, pacing in front of freshmen Elements classes for nearly as long.

On an average day, the Main Building is humming with Elements classes, all in large, white rooms. Over two semesters, each of these classes aims to teach freshmen the basic principles of two-dimensional (2D) and three-dimensional (3D) art, and also the theory and use of color. Farber's class syllabus, for example, presents Elements as a course on the mechanics of making images, using the basics: line, shape, composition, space, texture, value, and color—all of this adding up to the essential "form" of a work of art. Then, students will look at how form creates meaning as well.

As it turns out, today—tattoo day—will also include a brief search for meaning in the learning styles of the students. For this, Farber takes a break to let a school counselor conduct a half-hour workshop in his Elements class. This is the "Learning Workshop" (one of three kinds of workshops held during the freshman year). Now Farber's students are filling out a personality questionnaire. It is a watered-down Myers-Briggs personality

survey, geared for art students. The core question is this: Are you a "think-ing," "doing," "feeling," or "innovative" learner? Each student adds up the numbers to find out. Nora ends up a thinking-type learner. Once you learn your learning style, the counselor says, you can find a strategy to work with various teachers, even "when your instructor doesn't teach to your preferred style." The survey lists several of these strategies.

The workshop is not all questionnaires, however. Now the counselor asks the students to make a public statement. She tells those who are happy at college to stand over on one side, and those who are feeling qualms to walk to the other side, which is where Nora will go. The few students on her side mainly miss home. A few concede that art school was a late choice. Even college was questionable. In freshman year, a lot of feelings are being resolved, so the counselor says that honesty is good. Identity is also being formed. Some students quickly embrace the artist mystique; they get tattoos (or a body piercing), entering the artist tribe. According to Nora, other freshmen are reluctant to take such leaps. They are waiting to see what it means to be an artist, to live and dress that way. Meanwhile, she likes self-deprecating humor. "Everybody going to art school is a little crazy, in their own way," Nora says. "We're all a little off, somehow." [3]

Nora and her classmates will stick together for the entire year. This is the backbone of the Foundation Year: two semesters of Elements are "linked" to two liberal arts courses, Critical Inquiry and Art Matters, one about art theory and literature, the other a kind of combination of art his-tory and sociology. All together they create an art-making and art-thinking experience for every freshman.

What comes across in Elements, a studio class, is a long series of weird projects (depending on the teacher). In this, Farber is a master. In the next weeks, Nora and the others will consider the imagery of monsters—"Cyclops to cyborgs"—and then draw one (metaphorical or real) and be ready to discuss it. They will create large images of themselves, then break them into small elements (to learn about subjective art). To learn non-subjective art (following exact instructions), they will use a ruler and French curve to fill four sections on a sheet of paper with designs. They will make "mail art" and send it to the teacher, alter the "feel" of the class-room space (installation art), and work on a piece for exactly three hours (conceptual art).

One day, Farber asks them to come to class with a piece of kitsch art they have made. The term means "trash" in German, but more popularly it applies to objects that lack taste, such as Elvis paintings on velvet, silly refrigerator magnets, or garish tourist items. In the 1970s, some artists decided that kitsch, treated in an ironic or humorous way, could be turned into fine art.[4] Farber has asked his students to read up on this history, and today they've brought in their own interpretations of kitsch. Using glitter, Nora has made a picture of a yellow rubber ducky. It is surrounded by rays of purple and black and silver trim.

"I thought *kitsch* was used originally to put down another's work," Nora says. Her fellow students tend to agree: When people say something is kitschy, it usually means cheap, corny, or in bad taste.

In classes for upper-level students at MICA, Farber gives a lecture on three of modern art's most successful kitsch artists. They are the American Jeff Koons, the Englishman Damien Hirst, and the Japanese Takashi Murakami, each a multimillionaire. All three take everyday objects (toys, cartoons, butterflies) and enlarge them into giant sculptures or paintings. This use of mundane objects began with 1960s pop art, when comic strips and Campbell Soup cans were enlarged. But the new kitsch is bigger, brighter, and bolder.

"I think kitsch is a smart business move," says one student, perceptively enough.

"True," says another. Kitsch can make money. "But kitsch is still mostly used pejoratively."

"Isn't kitsch really anything that's been mass-produced?" asks a third student.

"Is it the art of the lower classes?" another says.

"Okay," replies Farber. "So kitsch is about social class?" He sees this as another teaching moment.

The students talk about highbrow art and lowbrow art, fancy tastes and vulgar tastes. One student recalls that grandparents, or "old ladies," are typically the people who like to collect kitsch.

"What about that?" Farber asks. What's wrong with collecting kitsch? Keepsakes or bric-a-brac might make some people very happy.

Everyone agrees, of course. There's nothing wrong with collecting kitsch, but the thought of grandmothers and kitsch has generated some smiles.

Learning kitsch by making it.

Then Farber turns to Nora's duck, the one made in yellow, silver, black, and purple glitter. "What if you made that six feet tall?" he asks, spurring laughter.

As anyone who flips though a contemporary art catalog knows, Farber's suggestion is not at all absurd: If Koons, Hirst, or Murakami made a six-foot glittery duck, an art collector or museum would buy it for an amount that could easily pay for Nora's college education.

The kitsch project was definitely fun, and some of the assignments in Farber's class are more enjoyable than others. In other assignments, students will send a political message in an artwork, produce a video, and make a piece of art that defies good behavior at an art school. For that bad-behavior project, Nora puts a blob of white paint on the wall and frames it. Naturally, students like the projects that tap their personal lives most, such as Farber's assignments on "identity" and "memory."

Art can also be a serious business, he explains, especially when the messages of art run contrary to the messages of society.[5]

There's a word for this battle of messages, Farber says. "It's called rhetoric."

It's the rhetoric of art against the rhetoric of the powers that be. That is why politicians don't like art, Farber explains. "Art is persuasive and that makes it dangerous. The music you listen to, the images you like,

the clothes you wear." Now Farber is smiling, of course. With all that art, music, and the rest, he says, "You are a threat to homeland security."

[]

By now it is apparent that in the Foundation Year, projects and exercises make up the bulk of all class work. The goal is to teach creative problem solving. Each exercise tries to convey a different approach. Naturally, art educators are full of ideas about exercises. They share them. They also publish them in art journals. However, the best way to present the Foundation Year to freshmen is still a matter of considerable debate in American art schools.

One art educator, Randall Lavender at Otis College of Art and Design in Los Angeles, writes that many teachers, practicing artists themselves, expect their eighteen-year-old students to be artists like them. Consequently, some of these Foundation teachers don't like to slog through the basics: point, line, and plane, or making a box, for example.[6] They prefer to just let the students be creative; the less structure the better. Whenever this kind of Foundation Year debate arises, one solution is to try to rediscover the roots of the idea of a "foundation" experience for young artists.

For some art theorists, those roots can be found in the work of Rudolf Arnheim, Harvard's Professor of the Psychology of Art in the early 1970s. Arnheim persuaded a generation of artists that there is a specific kind of human thinking that is visual. He referred to this visual thinking by the German term *gestalt* (a term also used by a psychology school, but in an entirely different way, aimed at therapeutic techniques).[7] For Arnheim, the *gestalt* of the mind is the ability to take in a chaotic field of vision, organize it, and gain insight into its quality or meaning. Some say the title of MICA's course, "Elements of Visual Thinking," comes straight out of Arnheim.

However, when it comes to the idea of a Foundation Year—of teaching 2D, 3D, and color to new students—the ultimate roots for most art instructors is the Bauhaus, the German art school that lasted from 1919 to 1933. In its short life, the Bauhaus laid the groundwork for modern art education. Its Preliminary Course was the forebear of the Foundation Year. The founder of the Bauhaus in 1919 was Walter Gropius, a German architect, and indeed Bauhaus means "Building House." Gropius was

convinced that art had its future in a marriage to industry. In this sense, the Bauhaus offers a legacy of industrial design, the emphasis on line, plane, color, construction, and application. Even so, its origins are not exactly that simple.

When Gropius formed the Bauhaus, he merged two older schools in Weimar, Germany: the Arts and Crafts School and the Institute of Fine Arts. He was also amalgamating two contrary forces in the European art world, one being architecture and industry, the other being "expressionism," a wild, new, turn-of the century appeal to abstraction, color, and emotions. At the Bauhaus, the wild side came in the person of Johannes Itten, a Swiss painter and artistic polymath. Gropius hired him to design and teach the mandatory six-month Preliminary Course, the mother of all foundation years today.

Itten used the elements he saw around him. In the expressionist painters, he found an interest in the subconscious and the psychology of color. He used textbooks on the point, line, plane, circle, and spiral, analyzed the composition of old masters, and adopted a color wheel. Finally, Itten modeled his approach on the German educational movement called "kindergarten," which emphasized play. It was learning through experiments with basic objects and materials.

Itten's personality did not work out with Gropius's vision, however. Gropius was embracing industry, science, and rationality. Itten was a mystic. He shaved his head and wore robes. He was fired in 1923, and the Bauhaus focused itself more exclusively on design and architecture. (Others who took Itten's place in teaching the Preliminary Course were Laszlo Moholy-Nagy, a leader in design and photography, and Josef Albers, a leading color theorist).

The Bauhaus moved its location to the flat plains of Dessau, where Gropius put his vision into concrete and steel, building the famous utilitarian Bauhaus school building. The clash between utility and mysticism did not end so easily. Expressionist painters that Gropius hired, such as the Russian Vassily Kandinsky, chaffed inside the boxy housing units Gropius provided. They filled them with color and draped them with messy fabrics. The Nazis closed down the Bauhaus in 1933, but before that nightmare descended, the school had succeeded in becoming a Grand Central Station for a generation of influential art educators.

Both Moholy-Nagy and Albers migrated to England, then the United States, spreading the Bauhaus idea on fertile soil. Moholy-Nagy especially influencing American industrial design schools. Albers ended up directing the Design Department at Yale. And all of them—Itten, Albers, Moholy-Nagy, Kandinsky (and Paul Klee)—wrote books about the foundations of art education. After 1960, the idea of a Foundation course for art schools prevailed everywhere in the West.

The Bauhaus revived one other kind of idea in art education. It was the belief in the "total work of art," known in German as *Gesamtkunstwerk*. In the past, total art was the baroque cathedral or the Weberian opera, and indeed Gropius saw theater as the second greatest art after architecture.[8] Even at MICA, an Elements class can approach something like "total art," and it typically comes through the process of changing 2D art into something that is three-dimensional. This is the process that Amelia Beiderwell is about to experience.

[]

On Tuesday mornings, Amelia arrives at the Main Building for her Elements class with Catherine Behrent, who is co-chair of the Foundation Department.[9] Somewhat courageously, Behrent has taken on this particular Tuesday morning class. It is a special group of newcomers to MICA, a group mostly of transfer students. They don't live in freshman housing. As older students, they have a bit more attitude, gained at a previous school or just by experience.

Having arrived from the great Northwest, Amelia is among sixty-four transfer students at MICA this year. She is a reserved young woman with tied-up auburn hair, blue eyes, and a fancy for dressing differently, wearing sashes and pins in her hair, or small hats. She stands out for other reasons. Amelia is an accomplished artist already, around thirty years old with previous roles in art studios. Earlier, she studied marine biology, but returned to her other love, art making. To come to Baltimore, she has pulled up a lifetime of roots around Portland, Oregon. Her goal is not so much finding an identity as obtaining a professional degree in sculpture and fiber. To do that, however, she too must matriculate through Elements of Visual Thinking, as every transfer student must do.

From the first day, Behrent has been sizing up her class of generally

older students. Her task is to compress the Elements into one semester, which means 2D, 3D, and color theory squeezed into fifteen weeks. Behrent herself began in art school, earning her bachelor's at the University of Texas, teaching some public school, and, when her two sons came along, she returned to oil painting. Happily, for several years her paintings sold well at a Texas gallery. It might sound like the artist's dream come true (to actually survive on painting), but it was a modest living. When she became a single mother, Behrent wanted to expand her horizons. She went to MICA to earn a master's degree (class of 1992), and now she teaches, while still doing gallery paintings on the side.

To start the 2D and 3D project, Behrent's students have brought in a simple object. "Pick something that calls you to it," Behrent told them. "Don't think about it too much. Trust your intuition."[10]

Now the objects are put out on the table and the students are explaining them. Amelia brings in an antique pincushion, small and square. Other objects jumble about: an orange pill bottle, a black binder clip, toy mouse, pair of glasses, Fonz doll, dice, crab shell, woman's shoe, umbrella, herbs, dead cicada, pendant, elephant toy, keys, video game control, and a chrome Zippo lighter.

As part of the same homework, Behrent asked the students to sketch the object, think about it, look up its dictionary definition, produce a few odd photocopies of it. All of this is the material for a 2D composition, which means on a flat surface. For that surface, Behrent has provided her students with large sheets of 3 x 3-foot reddish paper, which they must work on with their own art media: charcoal sticks, pencils, paints, brushes, and scissors and glue if they try collage. They can pick their object and their media, but there is also a catch, Behrent explains. For this entire project, she will "direct" them on what they have to do, week by week.

Their first assignment is simple enough. They must fill every inch of the red paper with images of their object. Think of a jungle, she says, a surface filled with the object using as many lines, shapes, values, textures, and colors as can fit. As expected, however, most students miss the big picture. Instead, they spend the morning drawing their object in one corner, laboring over it. This is Behrent's teaching moment. She hurries them up, urges them to stay lose, move quickly, cover everything, don't worry about having to change it later.

"Don't get too precious too early," she says. "That's the lesson here."

One day, Behrent drops a thick volume of artwork by Robert Rauschenberg on the main work table for the classroom. It's here for students to look for ideas about filling up visual space.

"He's done everything," Behrent says, flipping through the book.

Rauschenberg famously went from 2D to 3D, from paintings to collages to 3D "combines" that threw all kinds of things together. In the 1950s, Rauschenberg was the bad boy of modern art, leader of what some call neo-dada. Rauschenberg began conventionally enough, studying at the Kansas City Art Institute. Then he went to the experimentalist Black Mountain College (where the Bauhaus's Albers taught before heading to Yale). If Gropius and Itten clashed at the Bauhaus, Albers and Rauschenberg also became contrarian symbols (the former methodical, the latter untamed). You might say Albers kept the textbook side of the Bauhaus, Rauschenberg the kindergarten side.

Try as they might, Behrent's students haven't yet excelled at being antiprecious, but she must move to the next stage. Once they fill up the paper (at home), they must now turn it into a formal composition. She gives them a handout on "the Principles of Organization." To create a composition from their dense drawing, they must edit: adding, subtracting, covering over. The editing has two goals. One is to create visual harmony (patterns and rhythms). The other is to create visual variety (differentiated elements). Both of these share qualities that Behrent puts on her instructions. A good 2D composition has:

> balance
> proportion
> a dominant element
> visual movement
> economy (just the right amount)

A week later, when the students come back, most of their compositions are jam-packed with drawing, collage, and paint—as per the assignment. A few are still very precious, however. The day starts with an open-ended viewing, a quick crit. Now that everyone's work is pinned on the walls, one right next to another, Behrent moves to a next phase, a surprise. Today, each student will step to the right, she announces, and

change the artwork to the right. Like a dance step, everyone shifts over. They are told to add their object somewhere in the neighbor's artwork. It seems like vandalism, but Behrent says everyone has to take what comes. "You have no control as to what they are going to do to your piece," she says. "This usually enhances it."

The vandalism is typically mild, such as putting a small image here or there, nothing like altering the entire picture. Keys end up by candles, game controls with crabs, umbrellas with Zippos. The rhythm of the project has caught on, and after students finish, Behrent moves to the final 2D phase. Students must take the over-wrought 3 x 3 pieces of heavy reddish paper home and change them radically. Cut them up, turn them around — just so some history of the original object remains.

"Create some kind of unity by editing," Behrent says. "You can re-organize by grids, color, dominance, or editing out things."

The next week, some of the works offer powerful new compositions. Others have hardly changed. They are up on the wall again for a final crit, but this time it will move beyond mere "formal analysis" — looking at shapes, lines, and colors. "What value do you find in these works?" Behrent asks, opening the door to talk about meaning in the art.

From a formal point of view, Amelia has produced one of the more polished works, a drawing and collage. The composition is filled with pincushions, which seem to be flying in circles. There is value, too: Amelia explains that the pincushion is a sentimental object.

For a debate on value, however, the young man who did the next painting on the wall is about to steal the show. By all appearances, he is the most experienced painter, a graffiti artist whose object is a cicada. The work is a large horizontal painting, surrealist and colorful, with the large insect and a large red mushroom (with white polka dots), but now "edited" with profanity. No one can miss the scribbling of the word "fuck" here and there, and the awkward sex cartooning. The young artist sits cross-legged on the art table, clad in skinny jeans, black tennis shoes, a few piercing and tattoos, rings, and wrist bracelets. The class takes it in.

One student says he likes the profanity. In saying this, he adds his verbal expletives for emphasis.

A young woman disagrees. "It looks like an adolescent tantrum," she says.

"The graffiti is gratuitous," says another.

"Isn't all art graffiti?" comes one more comment.

The artist himself, a precocious smile on his face, remains silent. Behrent goes with the flow. Foundation Year is not a time to squelch student creativity, no matter how trashy. An occasional teacher will warn a student to be careful if they expect to go public with such works. The bigger offense, however, is to do something "that's been done before." On occasion, students themselves will do the scolding. On a very rare occasion, a class might rebel against a teacher's agenda. (After today, Behrent's class begins to come a bit unhinged, some of the young men, at a later date, roughhousing each other).

Behrent has seen it all. "So, breaking the rules," Behrent says today, summarizing the F-word mushroom painting. "Pay attention to art that riles you up." Her role is to be enthusiastic. Affirm each student.

So the 2D project is done. But 3D awaits: How do you turn this flat artwork into a three-dimensional experience? For this, the students will need time. They gather in small brainstorming groups, research their objects further, talk with friends about their ideas. This will be a major project, this 3D finale. Each student will present the work in class and attach a formal artist statement. Here, perhaps, the students approach the realm of total art, *Gesamtkunstwerk*.

On 3D day, two classrooms become a white-walled gallery. The red papers have mostly disappeared and large objects, hangings, videos, and installations have taken their place (with something of the object still there): a crab suitcase, giant dice, videos of animated shoes, and a death ritual for the cicada. The largest piece hangs from the ceiling, an apparent shroud-covered corpse floating above a table, its purple sheet and several strips of lumber floating with it (all done by wires).

By comparison, what Amelia offers is fairly reserved, elegant in its execution.

On a back wall, Amelia hangs a long stretch of maroon-colored cloth about two feet wide and fifteen feet long; at the top the cloth is folded in elaborate draping, but on the floor, it extends like a carpet, upon which a small stool holds a glass baking tray full of grain. It's a memorial for a deceased friend, says Amelia (the friend who owned the pincushion).

"She was a master chef," Amelia says.

Though contemporary, Amelia often puts a Victorian flair into her work. Amelia's artist statement says that the work is "in the vein of Victorian Hair Wreaths," a memorial decoration that includes locks of hair from the departed. In this case, Amelia uses grain. She also has stitched into the cloth the words, "Et in Arcadio ego," a Latin lament (it is believed) that death visits even paradise. Amelia's friend, who died at age forty-four, tattooed those words on her arm.

But the best is yet to come.

The young man who had the elephant object now sets up a sound system. He strips to his dark boxer shorts and puts on a purple elephant mask, a paper vest (his 2D project tailored, as it were), holding a book in one hand, a microphone in the other. What comes next is pure neo-dada, a Rauschenberg. As elephant man reads rap gibberish (some profanity, too), his computer distorts the voice. It also sends out musical rhythms. After two minutes he's done, and 2D has became three dimensional. (In fact, art experts say performance takes you into 4D art).

Amelia rocks back on her stool, claps her hands, and laughs. "It's the best thing I've seen so far [at MICA]," she says. Behrent asks the class whether it can take the elephant piece seriously. Not really, they say, though it was humorous. "It raises questions about art," Behrent says.

In recent weeks, one other thing has attracted Amelia's attention in particular. During Elements class, Behrent announces that in November there will be auditions for the school's stage play, only its second, this year being *A Midsummer Night's Dream*. This is the kind of total art that intrigues Amelia, who has done costuming and stage design for college plays in the past. In fact, Behrent announces, there is credit for the theater project, a course called The Play's the Thing. Actually, Amelia can't wait to audition. Before that, however, Behrent will take her class on the final Elements adventure, into the land of color theory, the world of the "Albers color exercises" — Albers of the Bauhaus, of course.

SEEING RED

very Elements teacher teaches color. As a consequence, they all take their class on a pilgrimage, a walk across campus, to the art-school library, downstairs to the very back. On this fall afternoon, the painter Michelle La Perrière leads her class of freshmen on that journey. Among its ranks is Calvin Blue, who loves bright colors in his artwork, but is a little dubious about having to learn "color theory."

On a table inside the library, the object of their journey sits in a cardboard box delivered by appointment. The box comes with white gloves to avoid soiling what is inside, a copy of Josef Albers's *Interaction of Color*, published in 1963. It's the Bible of color theory. Rather than a conventional book, it is a boxed package, a booklet with twenty-six sections, and 150 plates of color. Each plate is an experiment or exercise in color. Each was printed by Albers's own hand, using silk-screen. A limited number of original books exist, and that's why MICA guards its two copies with vigilance (though one has been cannibalized over the years).

As the students settle, La Perrière puts on the white gloves and begins to show the plates, sampling here and there.[1] Much of what Albers illustrates is the basic science of color and optics. La Perrière holds up an Albers plate that shows how a single color can look like two different ones. The students stare at an Albers plate of yellow dots, then see an afterimage of white dots. Another plate with bars of color seems to make the surface curve. La Perrière moves through the plates, holding them up, pointing out these visual effects.

The students will soon buy a pack of Color Aid paper and start doing their own color experiments. Once they do some experiments, approaching color methodically, they will use color more successfully in their artwork—at least that is the hope. They will also begin to notice that the commercial world has been using color mindfully for decades, from the "optical art" (op art) in posters to vibrating prints in fabric design and fashion.

At MICA, color theory used to be its own separate Foundation course. It

was called Phenomena of Color. Over time, however, teachers fit the color segment into the year-long Elements as they liked. La Perrière stretches her color lessons over several weeks, employing her favorite exercises, projects, readings, and examples. The bedrock in most classes, however, is Albers and his *Interaction of Color*, and what Albers famously says about the color red. "If one says 'Red' (the name of a color) and there are 50 people listening, it can be expected that there will be 50 reds in their minds," Albers writes. "And one can be sure that all these reds will be very different." [2]

For Albers, there is indeed something solid in color. There is something solid based on the physics of photons in the light spectrum, electrons on objects, and the rods and cones in the human eye, which separate the color spectrum for processing by a certain part of the brain. However, after all of that solidity, color is relative when it comes to what people see. Albers calls this the "personal preferences and prejudices" of how we see color. "He who claims to see colors independent of their illusionary changes fools only himself," Albers declares. The skill of the artist is to know how these illusions work, and how to manipulate them for various effects, what Albers calls "psychological engineering."

In principle, a student like Calvin Blue is interested. He is more inclined to agree with what some art teachers say of color theory in moments of candor, that "It's all theory," because in the studio artists work by the seats of their pants. They will paint and print by intuition, as Calvin is inclined to do already. At art school, he's also going to learn that there is more to color than just paint, for color is also about politics, race, art history, and the way society operates—even about the animal spirits of the physical body.

La Perrière is co-chair of the Foundation Year along with Behrent. After earning fine arts degrees at the Chicago Art Institute and MICA, she knows the challenge of teaching color theory. Some students find it highly intellectual. So she comes at it gradually. They look at cool videos related to color. She assigns short readings. Then come the color experiments, the painstaking part, as illustrated by the patient and tedious work of Albers himself. He spent his last decades painting a series called *Homage to the Square*, producing the first in 1949. Each is a colored background with other colored squares floating inside. After Albers became head of the De-

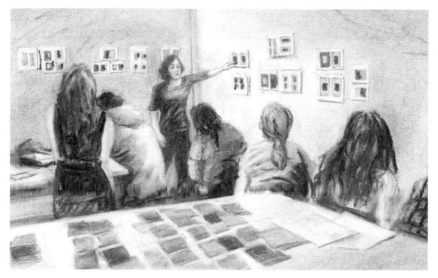

Putting up their Albers.

sign Department at Yale, these homages—and his 150-plate book—became his legacy.

Back in La Perrière's classroom, the color assignments begin. Grudgingly, students have plunked down $100 to get a package of Color Aid paper (they typical share it and the cost), which contains 314 postcard-sized sheets. "Every color that there is," one teacher says. Broadly speaking, La Perrière wants to explain that there is an objective side to color, a kind of mechanics, and a subjective side, which has to do with personal feelings. Two classic examples of the mechanics are "making one color look like two," and more difficult, finding a "middle mixture" color between two very different colors. Neither is easy. With diligent study, Albers says, anyone can develop a "sensitive eye for color," learning how color change works.

Albers recommended that students get these kinds of assignment as homework. This way they wrestle with color on their own. After that, they should bring their color solutions to class for everyone to discuss. Today is that day in Calvin's Elements class.

"Okay, put your Albers up," says La Perrière, a whirlwind of energy. "Another way to put it, Put your color-change panels up." Calvin takes to the wall, pinning up his squares. Three walls are covered, bristling with

tiny fields of color with other colored squares on them. Over here is a suc-cessful "one color becomes two": it is a yellow and purple field side by side, each with a middle square of the same brown color. But the brown looks very different in each. "Color is completely dependent on its con-text," La Perrière says.

The middle mixture exercise is more difficult. There are fewer successes on the wall. "Why are these colors not working?" La Perrière asks.

At this stage, students are often perplexed. Color theory can be confus-ing, since even Albers spoke of its trial-and-error nature. When students are stressed, La Perriere knows how to help them relax. She is a yoga en-thusiast. On arriving today, the students sit calmly, close their eyes, do neck stretches. Even in this she can bring in some color theory. Their eyes closed, she asks them to envision a color. "Do you have it?" she says. Now, try to change that by a mental power alone. Afterward, student testimo-nies are mixed. One could see purple and change it to yellow. Others could not produce a color at all.

Perhaps the easiest, and most satisfying exercise, is for students to make one color look like two different colors. It's a trick that painters use all the time, especially because of how pigment works. Using pigment, you can make colors lighter or darker only by adding white (a tint) or another color (a shade). However, the more colors you mix, the muddier — the more gray or "neutral" — a color becomes. To avoid muddiness, painters make colors lighter and darker by the trick of "subtraction." They subtract light or dark from a color by strategically putting it next to another color, which alters it. Albers calls it getting "rid of too much" dark or light, and artists today go around talking about their "subtractive" use of color.

In the classroom, the color theory sessions often lead to art history. Many famous paintings can be illustrations of how color creates various effects. These range from the illusion of depth in Renaissance paintings, to the surface flux of Paul Cézanne's works and the flattening effect of Paul Gauguin's colorful paintings. Elements instructors frequently use segments of a PBS series called *Art 21: Art in the Twenty-first Century* to illustrate lessons, and today La Perrière shows one on Mary Heilmann, a California ceramicist turned color painter.

Heilmann has fallen in love with bold, simple color. She produces paintings that reflect her latter-day interest in icons, a part of her Roman

Catholic background. In her wilder youth, Heilmann says, she did art to get attention, even to antagonize. "I wanted to cause trouble," she says. It is this, more than Heilmann's color work, which comes up in the student discussion afterward.

"She's unashamed to have an artist's egotism," says one student. "It's refreshing to see someone honest about that impulse."[3]

[]

For La Perrière, a better term for ego is identity, which she puts at the center of her Elements course. This brings the class to the subjective side of color: What does color mean to their own identities?

Today La Perrière is at the blackboard. She draws a diagram: a square divided into nine equal parts. This will be a color "palette," a grid of nine colored squares packed together, cut from Color Aid and pasted with the greatest care.

"The craftsmanship is important," La Perrière says.

As Albers argued, only perfect squares, rectangles, bars, and edges allow the eye to study color theory with no distractions. For Calvin Blue, who is a painter with visions of giant canvases, cutting out and pasting little squares is not his idea of a great day in art class. He does it, though, and does it well.

By making these palettes, La Perrière begins to explain, the students can probe their personal lives, an idea that perks student interest. The first two palettes will express their feelings (in colors) from their childhood and from their present identity as young adults. The second set of palettes will express in color the feelings they have for their mother and their father.

"Okay, get started," La Perrière says. "Your presentation is absolutely critical for these."

The large art tables become a sea of Color Aid paper. Soft jazz music fills the air. Some students work with Color Aid like a deck of cards, picking through. Others line it up in piles, neatly dealt. Then there are piles like so much laundry. The music shifts, the tiny colored squares are going down everywhere, and the day peters to a pleasant end.

Next class, the palettes are up on the wall, and the first order of business is trying to guess, between the first two, which is childhood and which is

the present. Each palette is a mixture of primary colors, secondary colors, and blended colors (the so-called neutrals). Each palette is dazzling in its own right. La Perrière gestures here, then there. "It's a gorgeous palette, because you have all these neutrals," she says. "You can do many different paintings with these colors."

Student by student, they keep track of the guesses — childhood or the present? — and go back for the answers. The guesses are only half right. Apparently, in class today, there is no compelling color pattern for childhood and young adulthood. If the students read further, however, they will find out that scientists study this question, looking for patterns, and that people have always believed that certain colors stood for certain things, or evoked certain human emotions. As to childhood, one student now speculates that childhood may evoke soft and pretty colors. Young adulthood is sharp and full of contrast. Or could it be the opposite?

"A lot of it is memory," says a student.

"Yeah, the colors in a room, or toys," another replies.

A lot of teachers assign color palettes, often with different lessons in mind. In Dennis Farber's Elements, he asks students to make three color palettes, one that is beautiful, one that is ugly, and one that is eccentric. Again, it starts as a guessing game when they are put up on the wall. Farber asks the class, Which is the most interesting of the three? The students are in for a surprise. "Without fail, it's the 'ugly' ones," Farber says. "They take more chances."[4] They make more interesting combinations. Albers called it the changing of color prejudices, the way people can shifting from repugnance toward some color combinations to liking them.

In their continuing study of the subjective side of color, La Perrière's student have also made a second set of palettes, one to represent the mother and one for the father. To review this work, the students all sit around a ring of tables. La Perrière, limber from yoga, sits on the floor in the middle. She puts out each of the students' mother-father palettes for discussion. As evidenced by this color exercise, these students like their parents. They are eager to talk about them, quirks and all. Unlike color in childhoods, the colors for parents show a distinct pattern. In every case but one, earthen colors are reserved for fathers. Mothers are in reds, pinks, soft and delicate colors.

Calvin has portrayed his mother in a beautiful array of roses, soft or-

anges, and the like. For his dad, however, the pallet is black. He never knew his father. With two sisters, a mother and aunt, Calvin grew up being the man of the house. His dad was absent. "Black is the absence of color," he says.[5]

Calvin's opportunities to experiment with color, however, seem endless, including in his Sculptural Forms course, another freshman requirement. There he has taken his favorite color—blue—and created a light box on which he uses tin foil to enhance the glow on a blue Power Ranger he has cast in resin. Later, in La Perrière's class, he'll experiment with setting a lamp by a cup of water with blue ice cubes, beaming its light as the cubes melt. "I'm trying to epitomize a color," Calvin says. "I'm trying to do that using only light and water." He'll move on to a memory box assignment—make a box that contains memories—in blue.

The interest in blue has something to do with Calvin's art learning, the need for identity, even branding. For as long as he remembers, however, his favorite coloration has been the three primaries all together: red, yellow, and blue. When he began to look through art books to see paintings by the old masters, he also found the primaries, the red and blue of robes, the yellow of halos. "I try to use the old masters' approach in painting," he now says. "I just love those colors. It just enlightens me." This semester, Calvin has one of his paintings displayed in the Black Student Union exhibit at the Maryland statehouse in Annapolis. Here, too, the primaries dominate. It is a realistic painting in which Calvin himself, like a toy character, is on a desk top filled with sundry objects, all in red, blue, and yellow.

However, in Sculptural Forms, Calvin is going full-out with more than twenty colors. In the campus wood shop, he has made a miniature room (a floor and two walls, 1 foot by 1 foot), and more than forty tiny wooden blocks, cutting and sanding them into squares and rectangles of various shapes. He has taken them back to his dorm room at the Meyerhoff House, and on the appointed day, he starts to apply the color. Calvin uses water-based paint, easy to mix and quick to dry (plus, oil paint and its toxic solvents are forbidden in student housing—officially, at least).

First, Calvin paints the two walls yellow and red, the floor blue. Then he starts mixing his paints in small amounts, taking the primary *and* secondary colors (red, yellow, blue *and* orange, green, purple) and tinting

them with white, then applying his brush to each block, producing about twenty color variations. In his imagination, Calvin is seeing this room and its little blocks at full size, as if it is a gallery in New York City with giant colored blocks stacked and laying about the room, being walked around by art critics and gallery-goers. At any rate, there's nothing wrong with imagining. For now, he has produced a tiny model, or *maquette* (in French), which he will put to some use. "The blocks are between childhood colors and colors in the great paintings," he says. This fulfills one class assignment, a sculpture about childhood and memory. In future days, Calvin will take his colored "room" over to the Bunting Building, the academic classrooms, and put it in the lounge on the fourth floor. There, students can play with the blocks, stack and move them about, try a little color theory as they wait for a class to begin.

[]

Across the street from the Elements classrooms, over at the Brown Center, graphic design student Chris McCampbell is thinking about color in "additive," not subtractive, terms. On the computer, McCampbell works with color as light, where the colors of the prism add up to white light, or various hues in between. In computer work, color is delivered in pixels, tiny squares that line up shoulder to shoulder to produce complex imagery. Albers says this color in pure light is color for the physicist, not the painter. In the studio, however, it is the color world of the photographer or designer with digital software.

As Chris knows, artists must work with two different technologies of color. One is about mixing light while the other is about the mixing of pigments or inks. The two technologies are called "RGB" (for red, green, blue) and "CMYK" (for cyan, magenta, yellow, and "key" black), two different systems of mixing colors. The art of translating the color seen on the computer screen to an accurate representation on a color printing press is not easy. The translation of color takes mastery, even years of practice.

Digital color on computers also has its translation problems, Chris explains, giving a demonstration one day on his portable iMac, which is fully loaded with design software. He types, points with a mouse, drags, pushes color buttons. From his chair, Chris can see down into Baltimore, with the shifting colors of the sky above. His studio is on the top floor of

the glass-enclosed Brown Center. The computer can be almost like the sky, where color *is* pure light. "Color shifts often from computer screen to computer screen," Chris says. "It shifts from computer screen to printer." Different software alters color, too. "It's always tricky. The color you see on Illustrator or Photoshop changes when you put it up on the Web."[6]

These problems of digital color have cropped up after Albers, but it's still a problem for the physicist, and it's a technical challenge for the graphic designer. However, Albers's idea that color is relative stays alive in the computer age. Mastery of additive color by light, like subtractive color in paint pigment, takes a trained eye and experience.

Color is also political — an idea that goes beyond Albers, but which is taught at art schools today.

Back in his Elements classes, Calvin Blue is learning how color "privileges" one group over another. La Perrière takes her students down this path in a few different ways. One reading assignment is from Richard Dyer's book, *White*, which criticizes the way "whiteness" has become a norm in Western art and media, asserting "that whites are people whereas other colours are something else."[7] Six of the students in La Perriere's class are not white, including all four of the young men. In many Elements classes, color lessons look at the human flesh tone, typically finding that its actual coloration is elusive. While superb techniques to paint flesh are available — from the Flemish and Venetian to modern acrylics — flesh is a nebulous mix of cells, blood, and tissue, all catching light in different ways. Then, of course, Matisse, Picasso, and others have painted flesh orange, blue, green, or red.

Be that as it may, the color of race does matter in much art-school instruction. La Perrière's students are assigned to attend a session of "Transformations: New Directions in Black Art," a major three-day academic conference on MICA's campus. The focus is on artists whose skin happens to be dark, in this case not a relative matter at all. Calvin is quite happy about this assignment. He skips the black artist panel, however. Instead, he makes a beeline to the keynote address, a mixed-media rap performance by D.J. Spooky, a rising star.

If colors have privileged people down through history, colors also have been exploited to express feelings. This was a huge debate between Albers and Johannes Itten, the two Bauhaus figures. Albers insisted that

color is relative, and that even in people's tastes for various colors, "Preference won't be constant, but will change." In contrast, Itten searched for what is universal in color. Itten's classic text, *The Art of Color* (1961), sees coloration as having a permanent status in the universe, much like Platonic forms. The Itten trajectory, quite naturally, has been used by astrology, cosmetics, and fashion to argue that personalities have essential colors.[8]

By the time students are in their painting classes, most of this theoretical debate is bypassed to focus on mixing pigments. They will study the mechanics of color. For example, in instructor Paul Jeanes's Painting I, the first assignment covers gray scales. Students paint ten squares, going from black to white, with grays in between. Then they match that up with color scales, as if the colors were in a black-and-white photograph. They are learning that colors have values, dark to light, which is one of the hardest qualities to judge in a color.

In a more advanced painting class, Jeanes reveals something else about color. He is reading his class passages from the book *Chromophobia*, which argues that prudish Western society has viewed color as dangerous. That is why society prefers black, white, and gray, lines and text over wild colors, which have scared politicians, Puritans, and the bourgeoisie. Thus "color has been systematically marginalized, reviled, diminished and degraded," says *Chromophobia*.[9] Color creates anxiety because it is "the other."

In La Perrière's class, students explore similar ideas in the "Vision" chapter of *A Natural History of the Senses*, a meditation by the poet-science writer Diane Ackerman. Ackerman celebrates the senses. She explains how color stimulates the nervous system. After one hard day at work, she says, "The visual opium of the sunset was what I craved."[10] Ackerman also probes the medical phenomenon of visual synesthesia, cases of people seeing colors when they read certain words or hear sounds. It happens because the brain's visual cortex shares nerve strands with other parts of the brain. Culturally, plenty of poets have linked color to human passions.

Not that MICA students are having euphoric outbursts because of color theory class. Color theory enjoys an art-school reputation as intellectually dense, hard to grasp. After all, Albers says that color is relative, learned

only by constant trial and error. It takes work. It's not something that can be mastered in the five weeks given to the topic in Elements of Visual Thinking.

Albers calls the study of color "exciting" and "courageous." The poet Ackerman speaks of intoxication. When Farber teaches his color section in Elements, his aim is far more modest. He would like to plant a seed. He hopes student interest in color grows. He hopes they read the Albers book, a cheap paperback now. "I can only introduce this and hope it helps them in painting class," Farber says. But he knows the old story too well. "When kids go to their second year, the professor says, 'Did you learn anything in the Elements year about color,' and they'll say, 'No, we didn't learn anything.'"

LINES AND MARKS

Upstairs at Room 215 of the Fox Building, Cameron Bailey cracks open the heavy door. He wanders into the dim classroom, flipping the switch. The florescent lights above flicker on unevenly. Cameron has arrived at the Fox, a brick edifice, earlier than anybody in his Drawing II class, which begins at 8:30 every Wednesday morning. It may be his only time to get there first. Sometimes, he thinks, it's good to be prompt, indeed, to be first.

Whoever arrives earliest at the L-shaped Room 215 has the same scene to behold each week: easels, tables, stools, and platforms scattered every which way. Room 215 is used by painting and drawing classes. It is in constant flux. When the rest of Cameron's class arrives, followed by the teacher, they begin to impose order. They claim easels, or sit at tables, or move a partition for crits, or even drag over a platform for a model. Each week, who knows what will come? That is for the teacher, Barry Nemett, to announce when he arrives.

Drawing II is an advanced class. Being here, Cameron is beginning to feel that he wants to be a serious student of drawing—not video or animation. That's certainly Nemett's encouragement for all his students. "This is my favorite class," Nemett tells them.[1] Nemett, a bundle of energy, compact with swept-back grey hair and trim beard, is among the leaders of the "sketchbook" movement on campus. This is a call for students to carry sketchbooks everywhere. "Drawing is not just something I teach; it's something I do all the time," he says to his attentive class. Nemett sketches people when he waits at airports, at a train station. He sketches statues and architecture in Italy. As he talks in class, students have their sketchbooks out, drawing him.

In the Drawing II classes at MICA, a certain self-conscious tension fills the air, a tension that seems unique to drawing. The drawing skill can be more comparative, even competitive. In Drawing, everyone can see immediately if you've got it—or don't have it. On one hand, most of the students realize that "drawing" is defined vaguely in contemporary art;

it can be almost anything (from a collage to a drip painting). Drawing is simply called "mark making." On the other hand, students also know that some kinds of marks immediately impress other people: namely, marks that show the ability to observe something and accurately reproduce it, the classic idea of drawing.

Experienced teachers like Nemett know that this tension over students comparing their "skill" abounds in drawing class. So the drawing instructors find ways to help students adapt. While Nemett definitely wants his students to learn to draw (in the classic sense), he is more impressed by how they interpret, invent, and compose. As he explains, it is the "passion, feeling, risk-taking, personal decision making, and intensity that make a drawing strong." Nevertheless, Drawing II is an elite class, only five of which are run amid the twenty-one freshmen drawing courses. These students should be able to draw.

Over in the Illustration Department, instructor Warren Linn also regulates the balance between realistic observational drawing and creative drawing. At the least, he hopes students can produce a "substantial equivalency" to what they observe. When a student just cannot do it, but others can, tears will fall. Linn see this most years in teaching his classes. "The disparity of abilities can be difficult," he says.[2] Like other benign art instructors, Linn can only preach the virtue of practice. Keep working in that sketchbook. The organizers of Artist at Noon will set aside a Monday in late November for a sketchbook at noon event. At this, Nemett and Linn will speak on the sketching lifestyle. As usual, a full house of students will bring their sketchbooks to display on long tables in the black box theater in the Gateway building.

In his Wednesday classroom, Fox 215, Nemett speaks loudly and clearly. All day, the trains trundle by. You can see the tracks and train stations out the back windows. They shake the windows and transport Drawing II to an urban state of mind. Nemett is a veteran at MICA. He arrived in 1971 with a master's degree in painting from Yale School of Art. He has worked in both abstract and traditional approaches, though he often is noted on campus for the latter, and for his colorful gouache paintings of landscapes and objects. He's also a story teller, often apologizing for telling the same story twice.

What is advanced drawing about? Nemett asks. "It's about relation-

ships," he says. Relationships of dark and light, far and near, rough and smooth, clear and ambiguous. He also emphasizes "figure-ground," the relationship between objects and their visual environment, which can also be viewed as an arrangement of positive spaces (the objects) and negative space (space around objects). Then he tells a story about his daughter, Laini, a talented painter living in Brooklyn. She is in the room. Cheerful and well-spoken, she's the teaching assistant, the "TA," this term (not to be confused with a "TI," or teaching intern, which graduate students do). Soon, Nemett is telling another story from his own art-student life. He knows how this looks, this storytelling. "I may jump around a lot," he forewarns his students. "That's just who I am."

When the weather is good—and it is today—Nemett takes the class outdoors. They head out to a nearby park to draw. The theme for today's session is "left and right." This is "a way of establishing some visual logic on the canvas," Nemett explains. Back in class, he has shown them some slides, examples of a how some famous paintings or drawings show an awareness of the two sides. The park is on an alley by the Kramer House, a short walk from campus toward the Meyerhoff House, the student residence. The park has a brick gazebo, tall leafy trees, black iron fencing, and vistas on the rickety back porches of the three-story row houses. It's a common place to sketch, and the back porches and the gazebo, show up in countless student assignments.

Before dismissing them for the day, Nemett has also given his class homework, an extension of their lesson, a more serious piece of art. "Anything you want, as long as it deals with left and right," he clarifies. Also, as long as they spend six hours on it. Six hours is the normal requirement for drawing homework, and it's a high standard. Each week, during crits, everyone is thinking—including the teacher—how long did it take to do that drawing?

On an average day in Drawing II, students never know when Nemett will ask them to start drawing. It typically comes in the second half of class. They can focus on a still life, a model, or go someplace. At times, however, Nemett kills two birds with one stone. He sits on a chair on the model platform, giving a monologue, and asks students to draw him. They do quick sketches, sometimes longer studies. Students must be agile. It's drawing in a very fluid situation.

That kind of drawing makes sense to Cameron, though the quickness is a challenge. He understands figure-ground. He understands positive and negative space. What confounds him is an assignment like "left to right." Cameron has a deeply conventional idea of drawing. "In high school, I copied what I saw, and if I did it fairly accurately, somebody praised me," he says."[3] Now he is told that drawing is more than that. When he is asked to draw right and left, he comes up blank.

Another morning has arrived. By now, the students know they shouldn't just come in at 8:30 and plop down. They should have their homework up on the walls, ready for critique, drawing materials at hand, ready for in class exercises. The left and right drawings have gone up. Some are large, others small. Everyone is thinking, hmm — six hours? The students with the most literal drawing skills have put in the time, and some of their work is definitely showing off. They post highly rendered drawings: a figure in an interior, an outdoor scene with a house, cars, and a line of people. Other students, with a different definition of drawing, put up collages, a mix of things they've pasted on paper.

Sheepishly, in tousled hair, white undershirt and blue jeans, Cameron pins up his work. It's a partial drawing of head, a shoulder, an arm. It's embarrassingly unfinished. Clearly not six hours. He'd done it the night before, his first human figure. The drawing paper hangs limp on the wall, mostly empty space. As Nemett goes piece to piece, he takes them on their merits, noting that some addressed the left-right problem, others did not. Next is Cameron.

"Who's is this?"

Cameron raises his hand.

"If you want to stay in this class, you have to do much more than that," Nemett says. "Otherwise, you are insulting me and the students."

The teacher is all business. This is Drawing II. In another case, another student has used a piece of cheap paper, thin, a tattered edge. To clarify the standard, Nemett describes the paper as "crap," unworthy of a serious art student. He moves on quickly. Soon he is evoking the joys of a good drawing.

Cameron's stomach is in a knot. His ears ring. He wonders whether art school is for him. The next homework assignment is equally puzzling. This is to draw on the theme of "inside and outside." This time, one side

of the drawing must be at least four feet long. On this one, he'll spend six hours. But inside and outside? "The conceptual stuff is way over my head," he admits. Even so, it's time to be ambitious, to "spend a lot of time to show, well, hey, I can draw." On his computer Internet connection, Cameron pulls up one of the old masters, the *Venus of Urbino* by Titian, and he gets to work. By class time, he has drawn the Renaissance nude across four feet, done in meticulously shaded graphite pencil.

Though not finished, it is pretty good. Nemett's reaction is not negative; he acknowledges the obvious hours of effort. "I was happy to get any reaction," Cameron says. At this juncture, he sees the writing on the art-school wall. He's got to wrap his head around the "conceptual stuff," and he's got to draw every day. That will be easiest by drawing people, always at hand, and the natural place to focus, he decides, is the face, not always easiest to draw, but certainly the most interesting. "I had to figure this drawing thing out or I would be totally left behind." For this, his black sketchbook will move him forward

[]

While the sketchbook is omnipresent at MICA, the old-fashioned how-to drawing book is rarely seen. For much of American history, and still today, the drawing manual is stock in trade for publishing houses. New ones seem to come out all the time. But at art school, why require such books when you have actual drawing teachers? When drawing teachers get together, however, as they have on one particular day at MICA, they like to show their knowledge of the best and worst drawing books.

At the start of the year, instructors who teach first-year drawing pull their chairs together in a room at the Main Building.[4] One of them oversees the Foundation drawing year, informally, and they all have their list of classes. The conversation quickly turns to drawing books, even though few are assigned to students.

At the MICA bookstore, they've got *All about Techniques in Drawing*, required for animation class. There's also *Observation Drawing with Children* and *The New Drawing on the Right Side of the Brain*, both for an art-education course. The only classic in stock is *The Natural Way to Draw*, by Kimon Nicolaides, requested by Linn. In Illustration class, Linn recom-

Sketching classmates.

mends that students buy their own lifetime copy of a classic in anatomical drawing, such as *Constructive Anatomy* (1920) by George Bridgman.

Like any group of specialists, the drawing teachers love to talk their trade. Now one of them recommends Brian Curtis's *Drawing from Obser-vation*. Curtis is an outspoken opponent of how conceptual art has un-dermined drawing skills. Soon, a female drawing instructor adds her two cents. She says older Bridgman books are very good, even if they are "sex-ist" (since Bridgman, who famously taught at the Art Students League in New York City, was of an old-fashioned era). Whatever the book, however, the drawing teachers all agree: Drawing is indeed an "old-fashioned skill set," a manifestly Western skill set, and students cannot get enough of it if they want to be artists.

Lamentably, says one instructor, to get into MICA, students do not have to show any drawings in their portfolios. This means some students in Drawing I will be drawing for the first time. Two semesters of drawing is required of students, but if you can get into Drawing II, then you're done

for the rest of a college career. Old-timers rue the day that drawing was cut back to make room for courses on computers, professional development, and art theory. In memory, MICA used to require five semesters of drawing for every student.[5]

Every art class has a budget, but for drawing, it can be fairly expensive, since models must be paid by the hour. In Nemett's Drawing II, for example, he has budgeted to have a model twice in the semester. Linn will teach a class, Drawing as Illustration, that is budgeted for a model nearly every session for an hour or so of quick sketching. Drawing I typically has a model for a single class session, usually at the end of the semester. Some teachers have the model in the first few weeks, giving students a jolt of grownup solemnity, a nude model, since "life drawing" bespeaks serious art studies.

For students who love to draw the human figure, MICA begins the year with a venerable tradition. On Friday nights, it holds an open life-drawing session in the top floor studio of the Main Building. If some students prefer the night life, a party, or sleeping in on Friday night, Jordan Pemberton looks forward to the mystique of serious life drawing. Week after week, her sketchbook is filling with her finely wrought, cross-hatched, black pen drawings of human forms. "Some people look at these and ask if I'm an architect," she says. Baltimore's alternative art world also offers its opportunities. Over in the Station North Arts District, the Windup Space, an art venue, hosts "Dr. Sketchy's Anti Art School," serving beer along with "life drawing . . . with a twist," the drawing of "burlesque beauties" — a business that serves art-school neighborhoods nationwide.

But if you don't have a model, you can use a book, following a great American tradition that MICA has been wrapped up in as much as any art school.

During America's national growth before the Civil War, scores of drawing books were published. They emanated especially from the Northeast, where industrial and public education grew in fertile soil. The idea, parallel to the common school, was that every citizen could learn to draw. Rembrandt Peale, the founder of a dynasty of early American painters, was one of many who designed a drawing curriculum that latter-day American artists, such as Winslow Homer and Thomas Eakins, learned from.

The classic story of the American drawing movement arose in Mas-

sachusetts. In 1859, the state legislature was the first to require drawing in public schools. Eventually, the captains of industry petitioned government to provide drawing instruction in all the larger towns, free to every citizen, more fuel for the "industrial drawing movement." Massachusetts next hired a drawing master from England. Walter Smith crossed the Atlantic in 1871. He soon took on an impressive list of responsibilities, including Director of Drawing for the Public Schools of Boston and head of the state's Normal Art School. "Everyone who can learn to write can learn to draw," he reported on arrival.[6]

The dramatic rise of Smith did not end well. By 1882, he was dismissed from all his positions. Historians puzzle over the exact reasons, but it seems that he became embroiled in a dispute over the considerable profits from sale of his *American Textbooks for Art Education*, required in the public schools. The commercial publisher and Smith, despite the lucrative monopoly, turned on each other, an unseemly event that sank Smith's reputation and sent him back to England.

To replace him, Massachusetts tapped Otto Fuchs, a German immigrant who had led mechanical drawing at The Cooper Union in New York City and designed ships in the Civil War. By 1881, Fuchs was head of the Normal Art School, a foretaste of his next career. In two years, he would move to Baltimore to become director of the Maryland Institute. In the pompous prose of the era, the U.S. government officer for drawing duly reported, "Professor Fuchs brought to the schools of the Institute the methods which had been thoroughly proved by Walter Smith and himself." For his part, Fuchs clarified that this meant not drawing "pretty pictures" from flat copies, but drawing real things, doing creative construction, grappling with industrial design (his examples: an antique head, a brick building, a steam engine).[7] Naturally, Fuchs also produced drawing books, including a *Handbook on Linear Perspective, Shadows, and Reflections* (1903), followed by one on mechanical drawing.

When MICA students entering the Main Building today glance over their shoulders, they will see a bronze plaque, a low-relief portrait of Fuchs working with a compass, T-square, and right angle. As principal, Fuchs led the school for twenty-two years. His final act was to persuade Andrew Carnegie to put up money to build the Main Building after the school burned to the ground in the great Baltimore fire of 1904. The great

marble building remains, but the legacy of required courses in technical drawing vanished at MICA in the 1960s.

Classical drawing survived, however, thanks to a covey of instructors who ran the school through the 1950s. Their leader was Hans Schuler Sr., a classic bronze sculptor (nearby Greenmont Cemetery is full of his Victorian imagery). Schuler, too, believed in drawing, working from classical plaster casts as a start (not until the 1960s were MICA freshmen allowed to draw from nude models). Today, students going to Drawing class on the first floor of the Main Building pass by a bronze medallion portrait of Schuler, hard to notice, poised as it is above a plaster cast of a classical Greek statue of two men wrestling.

It was not only a dislike of classical drawing that began to push it out of art-school curriculums. Some say it was pushed out by the need for more kinds of courses, especially courses using computers. However, rejection of the classic approach did play a role at MICA, according to what happened in 1957, the year that the school hired a new "progressive" director after the retirement of Schuler. One of that new director's first acts was to "throw the institute's Elgin marble casts into the alley behind the school's Main Building."[8] The janitors refused to lug out the heaviest ones, so some of them survived to be displayed in the Main Building today.

[]

The cold embrace of mid-October has arrived. On Wednesday, Nemett's class bundles up and departs the Fox Building. The sky is overcast, and while the trees still hold their green, they are turning, soon to be bursts of yellow, red, and orange. The students walk south, down the hill, and as they leave arboreal Bolton Hill, they enter a world of cement and asphalt, a part of town where the expressway, the eateries, the city university, and the train depots overlap. Eventually they bear left, arriving at Pennsylvania Station, home to Amtrak, the transportation hub of Baltimore.

Only four blocks apart, Penn Station and the old Mount Royal Station (owned by the art school since 1964) recall an epic battle of East Coast railroads. When the New York rail system defeated the Baltimore-Ohio line, Penn Station was ascendant (and Mount Royal closed and was put on the auction block in 1959). Out in front of Penn Station, the students pass the giant humanoid statue by Jonathan Borofsky, commissioned by the

Going to draw at Penn Station.

city in 2004 and a favorite topic of disagreement. Borofsky connects minimalism with pop art, and in Baltimore either you like or hate his 51-foot-tall *Male/Female* made of brushed aluminum. Like two cut-out dolls, a male and a female figure intersect, a spherical heart in their common chest. The silvery thing, critics say, looks either contemporary or kitsch, depending on your tastes.

Nemett's drawing class passes by and enters the double doors of Penn Station. They spread out in the large T-shaped lobby, take a bench, and start drawing people who are waiting for trains. This is not the first art-school invasion of the Penn Station, and not the last. In another season, a group of women from the Performance Garment class gather in the lobby for a silent dance ritual in purple robes, leaving travelers gawking. Amtrak, who owns the station, has mixed relations with the art school. They mostly get along. Community art has a lot to do with transportation. Posters by art students — public service announcements — are hung in buses or the local light-rail trains. In the spring, after delays, an art-school mural will dominate the Amtrak lobby.

Nemett's students draw in pencil, ink pen, and hard charcoal. Police in dark blue size them up. Many of MICA's drawing classes pursue this primordial exercises: drawing real life as it moves. (Linn takes his class downtown, to the municipal buildings). At these locations, people are moving. So you have to draw them quickly, get the gist. Capture a key

gesture. Mark in the essential dark and light. In Nemett's classroom, the students viewed slides of Honoré Daumier, who drew passengers in crowded French depots in a previous century. As an alternative, the Drawing from the Masters class walks farther into Baltimore, down to the Walters Museum, where they copy old European paintings and *real* marble sculptures, too.

Nemett strolls around the Penn Station lobby, visiting students as they work. Presently, he arrives in mid-lobby, where Aviva Paley, sitting on a long, empty, passenger bench, is sketching in bold, circular gestures with her charcoal stick. Aviva graduated from a top art magnet high school nearby.

"You should draw that couple across the way," Nemett says, trying not to point.

Aviva soon has the couple in her cross-hairs, her hands sketching quickly. The couple begins to notice. When their train arrives, they dart over to Aviva.

"How much would you sell that for?" the man asks.

"Whatever you like," Aviva says. They give her a few dollars, rush for the train. Aviva lights up with smiles. "This is the first time it's happened to me."

Nearby, Cameron Bailey is in gear. His *Venus of Urbino* copy won him some points in class. He has become devoted to his large, black sketchbook. His challenge is to sort out the process of drawing, for it is a process, a choice of several ways to begin and end. Nemett and Laini, his daughter, are hanging out with Cameron for a while, talking art, looking at his sketchbook. They are please at the amount of outside-of-class work he has done. Nemett comments that he definitely is going after portraits. The faces have character as well.

"I get obsessed with details," Cameron says. "So I get all the parts in, but in the end they're not matching up."

Nemett begins to speak, but this being Penn Station, an announcement of an arriving train drowns out the conversation. In a moment, all is quiet, and Nemett continues to advise Cameron to draw in the big composition first, the shapes, the shadow and light. Cameron finishes the thought: "Then go back in with details."

"You're really coming along," says Nemett. He likes surprises. Which

student, a sleeper at first, will surprisingly blossom? Some start off stupendous but fizzle; others quite the opposite, says Nemett. "You never know."

[]

Today also, at the Fox Building, the head of the Art Education Department, Karen Carroll, is considering the buzz on the Internet. It's a buzz among art educators about the topic of drawing. The day before, the *Washington Post* on-line ran an opinion essay by a prominent art-school director, David C. Levy, a big name.

Though a musician, Levy founded the Delaware College of Art and Design. He also had been director of the Corcoran College of Art and Design in Washington, D.C., and Parsons School of Design in New York. Levy said the reason public education is not giving money to art teachers these days is that, simply, they cannot draw. They cannot prove they have a particular skill. "While English teachers may not be able to write the Great American Novel, the chances are pretty good that they can compose a competent essay," Levy wrote. "But many art teachers can barely draw!" A teacher who can't draw, will be unable to see mistakes in drawing, and "worse," won't be able to guide students to see them either. He blamed the system, but is "gloomy" about the system changing.[9]

After teaching art education for decades — and now overseeing sixty-five MICA students pursuing graduate art-teaching degrees — Carroll is a bit outraged by the "can't draw" headline. "He made a sensational hit," she says, worried that it will be one more strike against the morale of public school art teachers — though she knows that Levy has a point.[10] On Carroll's computer is an academic article she's writing that says the same thing. "We like our teachers to have breadth, but they don't have the opportunity, in their undergraduate programs, to gain depth," she summarizes, poised in her small office, train tracks and brick buildings out the window. Art teachers may indeed end up leading K-12 classes without having mastery of a single discipline. "Most of our teachers out there are ill prepared compared to their potential to feel like real artists." And real artists, presumably, can draw.

Levy's *Washington Post* missive is about the past, art education that is water under the bridge, but nevertheless is shaping how it takes place

today. Over that period, art education dropped studio disciplines to include more theory, psychology, curriculum studies—and a whole lot of "visual culture." This is the study of how media images work in a capitalist society. In Carroll's opinion, studio training is losing out. "Visual culture is hot," she says. Drawing is not.

[]

On the same Wednesdays as Nemett's class, instructor Phil Koch is in Room 200 of the Main Building with his band of freshmen, embarking on a year of Drawing I and II. Koch can show you how he'll teach his thirty weeks (two semesters) of drawing on a chart. When he began teaching at MICA in 1973, he thought he could develop the ideal drawing scheme, and then ride it along for a career. But no, he says, something creative has to happen each new class, for times change and so do students. Like Nemett, he's sure of one thing: practice makes perfect. "You're not an artist until you have a stack of drawings as tall as yourself," he says.[11]

This is the numbers game in art. Koch endorses it heartily. "If people do a lot of drawings, they get better," he says. "It's almost impossible to not grow if you are keeping busy." One of his favorite forms of pedagogy in a year of drawing is to begin classes by showing students works by old and new masters: sketches, etchings, ink drawings, things done in charcoal. He'll point out that some of our great artists, when it came to details, could not draw that well (human hands, for instance). However, they could always pull off a satisfying effect overall. They also did lots of drawings.

For the year, Jonathan Levy, Cory Ostermann, and Liam Dunaway, all have drawing with "Phil." Though Koch is a modernist, when it comes to drawing he can be as classical as a Fuchs and Schuler. That's what Jonathan likes, and it is what will challenge Liam, who never took drawing in high school.

"I hate perspective," Cory says.[12] But she'll learn it in Drawing I. For several hours one day, she sits outside her dorm room in The Commons, drawing the perspective in the outdoor hallway. "Ugh," she says. Rulers. Lines. Filling in large areas, like cement walls, to make them interesting. Actually, it turns out to be her favorite work of the semester. She nailed it, got the effect—both linear and atmospheric perspective. People can see the space Cory made, walk into it with their minds. On the mezzanine of

the Main Building, Jonathan is spilling black charcoal dust on the stone floors. His style is to be tenacious: attack a drawing and be done. (On reflection, he'll eventually learn to take time, go back to something on another day). His large newsprint pad is on an easel, and as his charcoal moves furiously, it reveals an architectural scene, the archways, columns, statues, and stairway of the Main Building's classical courtyard.

Liam is a different story.[13] He is drawing only what he has to. It's a new world for his eye and hand, trained for years on computers, not with charcoal. Another Koch pedagogy is to speak to young artists of having "surrogate parents" in art, namely, a great artist they might emulate to get started on their own journey. In time, Liam will emulate the minimalists, the modern artists who built simple squares, put a single neon light bulb on a wall, or covered a canvas with two colors. Obviously, Liam is headed for studies in graphics, design, and architecture, so minimalism is a logical choice. It is also a way to avoid too much angst over being able to draw perspective, human figures, landscapes, or a still life. For students such as Liam, Koch will say, "The heart of drawing is noticing more than the next person with your eyes. Drawing is not a technique. It's a state of 'seeing.'"

If Koch himself has a surrogate parent, it might be Edward Hopper, known for his austere landscapes with one or two figures, all of which evoke lonely moods. For many summers, Koch went to New England to paint in the threadbare cottage where Hopper had painted. Now, Koch does bold, colored landscapes. They are bought, shown in galleries. They travel to shows, especially in college art galleries. Even in Drawing class, he advises his students about their future prospects: how to choose frames, what to charge for their art, how to present themselves to ordinary people who like pretty pictures. In his more advanced classes, he'll tell students to find mates who support, or accept, their mercurial lives as artists, key to a happy marriage.

In Koch's Drawing I, they begin drawing sliced bananas in class. Teachers try to avoid the term *still life*, however, since it evokes images of old ladies or amateur Sunday painters. Koch says bananas are crystalline, like a Bauhaus modernist design. Next they draw green bell peppers. They are like the wrinkled witch in Hansel and Gretel. Class work extends to homework, the weekly "home studio" assignment. First students must build a

geometric object, like a tiny house. Then they bring it to class and draw it in perspective, illustrating the way its lines reach a common point on the horizon. Even this house has one-, two-, and three-point perspective. Round things also operate under the rules of perspective, creating ellipses on flat surfaces and foreshortening on objects such as human limbs.

The list of drawing tasks grows, but for the entire year the class mostly sticks with two simple media, charcoal (or Conté) sticks and later ink and brush (and a little color pastel). Rather than emphasize fancy drawing tools, the idea is to master the simplest. "You can put a mark down, and put a better mark on top of it," Koch says of that basic process. The students draw drapery, objects mingled together. They add and subtract from the same picture, use a spotlight, create a dominant shadow. The assignments cascade: do an abstraction, a toned drawing paper, a pet, a three-panel narrative. In his Drawing I and II, Koch says, "What I don't allow is a conceptual solution." The students must produce a visual effect.

Nearly all the Drawing courses take place in the Main Building, as do the Elements of Visual Thinking classes. Like many other faculty, Koch sees these two kinds of courses as the two sides of art school. Elements is a class where students can be outrageous, whereas in Drawing they need control. Some students don't like Drawing class, he concedes. "Some respond better to the Elements class. Other students find Elements enraging." They prefer drawing class. Art schools will always have these two sides, Koch says, the traditional and the avant-garde. From his second-floor classroom, he gestures out the window at those two symbols on campus, the Main Building, a marble edifice built by Otto Fuchs, and the Brown Center, a glass cube erected in the twenty-first century.

Modern innovations have always affected drawing (as well as architecture), as Nora Truskey and Adam Dirks are learning as freshmen in Drawing II. Both have the skill, but if Nora is seeking to hone it (she's an Illustration major), Adam will shed it happily (as he slowly converts to sculpture and performance art). Either way, they learn soon enough that many famous artists "draw" by projecting an image on a surface and tracing the outlines. More disheartening, perhaps, they'll learn that old masters "cheated" when it came to drawing. In Nora's Elements class, they watch the BBC documentary on the so-called cheating thesis proposed by British artist David Hockney.[14] A pop artist, Hockney has argued that the

best draftsmen of the past used prisms and cameras to trace outlines. All of this raises the modern-day art question, Why not use a projector, or scan photos into a computer and, using software, turn them into "drawings?" Why sweat the messy free-hand work?

It can seem that the idea of using technology to make realistic drawing easier is a very Western conceit, at least if the Asian students at MICA are considered. The Asian kids—especially Koreans, from the United States and abroad—seem to prefer the traditional approach to Western drawing, the classical approach of observation, proportion, illusion, and detail. The American kids seem far more prone to make collages or videos and call that "drawing." The irony is not lost on some faculty. Historically, Asian "drawing" has used flat, collage-like, abstracted shapes (think of Japanese block prints or Chinese scroll landscapes). Asian students, however, tend to draw like members of the Paris academy, like students of Otto Fuchs a century earlier. MICA teachers have a tough decision. Should they drum the Paris academy out of the Asians, or let them set an example for slacker Westerners?

[]

This is a fine season for Nemett. He has three shows of his work coming, and then a half-year paid sabbatical. One day, Nemett packs his class into three cars to take the expressway around the corner and head to east Baltimore's shoreline neighborhood to the Creative Alliance, a gallery and art hub in the old Patterson Theater, with its neon marquee. This is a neighborhood of narrow streets and prefab grey row houses. It's part of Baltimore kitsch, along with pink flamingos and beehive hairdos—and it's Baltimore's second art district (Station North near MICA being the first).

Inside the Creative Alliance, Nemett's drawings and paintings are on display, as is the poetry text often that is incorporated into his imagery. He has drawn and painted landscapes in Umbria, Italy, done series with exotic animals, and composed bright pastel still lifes of books piled on a table. As ever, Nemett speaks at length. Students sit on the floor. Students end up being late for their next class or for work-study jobs.

Drawing is going through a transition at MICA. Everyone knows it's a superb skill. Some acknowledge that the classically trained draftsman is beginning to disappear. New blood is harder to find (or is not hired).

As Linn says, students should buy their own human anatomy book, because that course has disappeared from most art schools. In the past few years, in fact, the fastest-growing department at MICA is Illustration (with 321 majors), while the major in Drawing proper is shrinking (with 38 majors). The shift in student interest is hard to control. It's a market force or, as one staff member says, "The cattle have started grazing in a different field."

Students in fine arts drawing, if not beleaguered, are self-conscious of the difference. One Drawing major says that her discipline is art for art's sake. Illustration is doing what clients pay for. "They are two different worlds," she says, hinting that illustration is not really art, or at least not fine art. A senior student like Jen Mussari, now in General Fine Arts, is wondering what is going to be best for her future — to stand on fine arts principle, or to have clients? Through this first semester, she's comparing the choice. She's not sure which way to go, since she sees drawing as central to her own training and practice. The question comes down to this: Will she do it for art's sake, or for the marketplace?

It's an age-old debate. For some MICA faculty, fine art drawing and illustration are like oil and water. For others, they are simply two sides of a coin. Before the year is out, that distinction between fine art drawing and illustration may begin to blur at MICA. For instance, the school will inaugurate a new course, Drawing from the Tablet, also called "digital drawing," in which students use a stylus on a computer screen to limn shapes and fill in colors. They draw from live models. Then they print out the drawing on a four-color printer. Illustration students will flock to this new course. This is not the end of drawing as we know it, according to one of the instructors. "It's a re-emphasis on drawing as observation," only using computers.[15]

As the school year ends, MICA will begin mingling the departments of Illustration and Fine Arts, presumably so that one department — like Illustration — doesn't take over the school, but also so that more students are directed into classes that teach traditional drawing skills — more than simply making marks.

DEAD AUTHORS
CAN'T DEFINE ART

he giant blackboard in Critical Inquiry class is rarely used, but it's there when Amy Eisner needs it. Eisner is a poet and English professor. She turns to the blackboard to start her twenty students on an adventure in "critical thinking," what she will also call "the young artist as an intellectual." With a smooth and deft hand, Eisner moves the stick of white chalk on its way, her writing crisp and clear.

"Samuel Johnson is indignant."[1]

How many questions, Eisner asks her students, can arise out of a simple sentence like this?

"Why is he indignant?" comes one quick reply.

With this, the students begin to list the ways. Who says he's indignant? Indeed, who the heck is Samuel Johnson? A half hour later, Eisner's students realize that this is the nature of their course, required of every freshman. They will spend a semester of "close reading" of both literature and art.

Close reading is all the rage in modern literature, also akin to such approaches as "critical thinking," postmodern analysis, or "deconstruction" of literature. What they share is the desire to analyze something deeply. At an art school, that something will be both literature and visual art, making Critical Inquiry an integral part of the Foundation Year.

Harvard trained, and now with two young children, Eisner is a lively teacher, engaging her students with an easy smile and expressive eyes. "If, by the end of the year, they accept that literature is art, that's great," she says. Eisner is the kind of teacher who hands out poetry journals to the students as a gift. "What Critical Inquiry tries to do is to make sure the students have the entire world of culture available to them for their art."[2]

At MICA, making culture available to art students is the mission of the liberal arts wing of the school.[3] That wing has been led by poetry and English professors for the past thirty years, and for good reason. Literature is the world of imagination and fantasy, unimpeded by physics, politics, law,

economics—or conventional morals. As students will learn, in the post-modern milieu that dominates college humanities everywhere, art is not just an object. Now art is treated as a "text," which is a distinctly literary approach to reality.

Like the Elements course, Critical Inquiry with Eisner will be a kind of home room for the twenty students. For all the freshmen at MICA, their Elements and Critical Inquiry courses are thus "linked," part of the uni-fied Foundation Year experience. Critical Inquiry is fairly rigorous. It re-quires a good deal of reading and writing. The students must also produce artwork for class; granted, rather quickly done artwork, very often last-minute-late-at-night artwork, and it will show. Eisner knows the rhythms of such a class as this. Her goal is to get the students speaking, engaging each other, espousing opinions, all of which means that she stands back. ·However, if the students are dead in the water—and this is a 9:00 a.m. class—she has to put a fire to their feet.

To ignite that fire each week, Eisner has some help. At MICA, Critical Inquiry has a standard textbook, *Critical Theory Today*, a dense but edgy textbook, to be sure. It's basically about literature. However, the class ap-plies its lessons to artwork as much as possible. For example, one day the students come upon a literary idea present in the textbook, the idea of "the death of the author," coined by the French cultural critic Roland Barthes in 1967.

Soon they will find out that this morbid death watch not only has to do with the "author," but perhaps with the "artist" as well. According to *Crit-ical Theory Today*, in the past, students of literature studied the author's life and motives to understand a novel or other kinds of artwork. Not any more, says the textbook: "We focus, instead, on the reader; on the ideo-logical, rhetorical, or aesthetic structure of the text; or on the culture in which the text was produced, usually without reference to the author. So, for all intents and purposes, the author is 'dead.'"[4]

The goal of the textbook, *Critical Theory Today*, is the same at any con-temporary college humanities department. Teachers use it to introduce students to how eleven different "critical theories" are employed to inter-pret literature. The eleven begin with Freudian and Marxist "readings" of literature, and then come feminist, deconstructionist, queer, race-based,

and post-colonial approaches. There is also a "reader-response" approach to literature, which focuses on the act and experience of reading a work, finding out what the reader makes of it.

With these as a backdrop, Eisner's goal is to mingle art and literature, showing her students their rich interactions. "It's hard to put a finger on why you respond the way you respond to a work of art or literature," Eisner says one day. So each week, the students try to pin down those responses. On one particular day in early fall, Eisner and her twenty students try to do that with a poem and five works of art.

[]

The Baltimore mornings have turned cool. In Eisner's classroom, you can look out a wall of windows and down on Mount Royal Avenue, where the trees are showing a crimson edge. Today, her students arrive having read the reader response chapter in *Critical Theory Today*, and also a poem-story by the modern poet, Galway Kinnell. The poem is titled "The Deconstruction of Emily Dickinson." [5]

It's a little before nine when Eisner arrives, and her students are also trickling in. Five of them have been assigned to bring artwork, and those students put down their books and packs, and go over to pin their art on the wall. The artwork has been done in response to Kinnell's poem. As everyone settles down, nobody really notices who is putting up which art. After attendance is taken, everyone gathers in chairs by the wall, which exhibits the five smallish artworks.

As with every week, a group of five students are responsible for leading the crit. Since the artwork is approached anonymously, it may not be until the end of the session that everyone knows who did which work. However, they all know what was read that week, and in this case it is Kinnell's poem, assigned by Eisner. In the poem, Kinnell creates the imaginary scene of a lecture hall where a "Professor" has just finished deconstructing the works of Emily Dickinson. Then the poem's protagonist, who has just arrived, challenges the Professor by offering to recite Dickinson's poetry directly. As the Professor starts to theorize again, some in the room shout,

"Let's hear the poem! The poem!"

But the Professor does not yield for a short while, insisting that even in this poem Dickinson is unaware of her unconscious mind. Her words are potentially subversive and ironic. Or as the Professor explains,

"While our author says 'no,' the unreified text says
'yes,' yes?"

As the Professor finally stops speaking, the protagonist begins imagining ways that he can unmask the Professor's folly. He imagines that:

Without rising to my feet, I said,
"Professor, to understand Dickinson
it may not always be necessary to uproot her words.
Why not, first, try *listening* to her?"

This does not seem cutting enough, so the protagonist, still in his imagination, considers a more sarcastic comeback:

So I said, "Professor, I thought you
would welcome the words of your author.
I see you prefer to hear yourself speak."

As it happens, Kinnell's protagonist decides to say none of this. He instead stands up, smiles derisively, and simply recites the poem. Eisner's students seem to get the point: Kinnell's story of the imaginary lecture hall is a parody of how postmodern theorists can go overboard with close reading. By contrast, there's nothing imaginary about what happens next in Eisner's classroom. As her students look at the five works of art done in response to Kinnell's poetry, the conversation turns toward how some art is literal. For example, in one of the five artworks, the student has drawn a picture of Emily Dickinson, a very literal reply to the American poetess. Literalness is not for everybody, of course.

"I like images that are not literal to the text," one student comments along the way.

Three other artworks on the wall seem to be more abstract, or symbolic, and these will also bear comment. However, the fifth artwork is the most enigmatic—and it will dominate today's discussions. There it floats, pinned to the wall, hanging slightly away from the other four artworks. It is a small black-and-white pen drawing. Typically, when an artwork

is confusing, students are taught to begin (in crits at least) by simply describing the work.

"It looks like a telephone, one that hangs on the wall," a talkative student offers.

The drawing's image is soon identified to everyone's satisfaction: It is a wall phone, off the hook, with its cord on the floor, twisted, and there's also a person sitting on a chair at some distance from the phone.

"The cord looks like an upside-down question mark," another says.

"It's pretty well drawn," comes the next comment. That brings a few laughs.

After this, however, the perplexity grows. What does a literal telephone have to do with Emily Dickinson? As the students fall quiet, Eisner says, "What do you think the artist has in mind?" She is prodding.

"Is it something about calling Emily Dickinson? Or . . ."

"I don't see how it relates," comes a student rejoinder.

With that comment in the air, a student named Grant Lindahl, who comes from Maryland, suddenly grows suspicious. Something is wrong. This work of art does not belong here. Logically, he thinks, it might be left over from another class. Maybe there are exactly five pieces on the wall because someone did not come to class today, or failed to finish their artwork for today. Grant counts again: There are five works on the wall. So it's risky to speak up. He might offend someone. However, his skeptical feelings overflow.

"There's something strange," Grant says. "I don't think it's from this class."

Now the debate shifts. To understand this work, should they ask the artist to reveal himself or herself? The students are divided. Some say that if you let the artist explain the work, that ruins the viewer response. The artist (that is, author) is irrelevant. Eisner is thrilled by this self-generated debate. Her class comes to life. Strangely, too, it sounds like the world of Kinnell's poem. Finally, student curiosity wins out. Everyone seems willing to break the sacred rule and ask, point blank: Where is the artist? What are you up to?

"Okay, who did this one?" Eisner asks.

No one comes forward. The ink drawing was left over from another class.

"I knew it," Grant exults. "Somehow I knew it." He is feeling a rush. His gut feeling was correct. For him at least, it's a breakthrough. As a young artist, he has to make many decisions by gut feelings, like which major he will commit himself to. "This was probably one of the definitive moments in my life," he writes later.

Eisner could not have designed a better class experience if she had conspired to put up the orphaned drawing herself. The students debated a piece of art that they could not understand, or suspected as fraudulent. In the grown-up art world, this happens all the time. There is a rich tradition of pranks in art, for a start. Moreover, there's seemingly no limit to what can be found in a work of art using critical theory, as illustrated by the *Critical Inquiry Today* textbook, which shows how eleven different critical "readings" can divergently interpret a single 1924 work of fiction, *The Great Gatsby*. Under this eleven-pronged assault, *The Great Gatsby* is more than just a great yarn. It's a kind of monster, the textbook explains, "a classist, sexist, homophobic, racist, colonialist novel that romanticizes the evils of capitalism."[6]

The "critical" search for hidden meaning in the visual arts has become just as ambitious as in literature. Some art students will learn more about this in upper-level art history and theory courses. They may learn about the case of a painting done by a donkey's tail, a canvas accepted as a human artwork at the 1912 Salon des Indépendants in Paris, a prank seriously reviewed by Parisian art critics.[7]

More certainly, they will learn about the case of the porcelain urinal, titled *Fountain*, which was entered in a 1917 New York City art show, the largest ever art exhibition in the United States. This prank was carried off by the art trickster Marcel Duchamp. Critical thinking, however, has no favorites, so even Duchamp has been subjected to its subversive analysis. The Freudian art theorist Arturo Schwarz argued that Duchamp's youthful painting *Young Man and Girl in Spring* (1911) revealed his dark desire for incest with his sister. Schwarz knows this, even though Duchamp does not, because Duchamp operated under "influences and drives of which he was ignorant."[8] For many, the Schwarz theory is ludicrous. However, this is critical theory at work.

Critical theory in the visual arts has become a cottage industry, now applying itself to myriad historical works of art. For example, it has been ap-

plied to Winslow Homer's *The Gulf Stream* (1899), a painting that seems the epitome of a literal picture, the delightful painting of a black boy in a windswept boat. However, one critical theorist has written that the painting reveals Homer's unconscious racism (even if Homer himself is "ignorant" of such motivations). "I regret very much that I have painted a picture that requires any description," Homer said in his own day, puzzled that the meaning of the picture was not completely obvious.[9] With critical theory, however, nothing is obvious.

In the upper grades at MICA, the debate on critical theory can be lively. Students will wrestle over the validity of such "subjective" interpretations of the objective world. They will debate whether you can find "whatever you like" in a work of art. The MICA professor John Peacock, who teaches the theory seminar in MICA's graduate schools, is candid about the slippery nature of critical theory. "The theory game is like a big poker game, and everybody keeps their cards close to the chest, because nobody really knows what the hell any of this is about," he says, half in humor. "But they know that somehow it's in the air."[10]

The great debate in college humanities today is whether art should be treated in this critical, even political, way. Some educators worry that the "death of the author" idea has reinforced plagiarism among students (since, after all, there is no author).[11]

No such great policy debates swirl about a freshman classroom such as Eisner's. For MICA's freshmen, the *Critical Theory Today* textbook is there to show them that this debate exists. Eisner is not asking them to choose any of these eleven approaches. "They are tools," she says. "All of them should be available, and there will be more." The value of critical theory is that it provides tools for students to "decode" modern ideologies and other kinds of authoritative claims. Some students may decide to adopt one of the eleven viewpoints. "But after taking my class," she goes on, "they should not do so without understanding that each approach is a pair of glasses, that no ideology is truly comprehensive, that always when some things are brought into focus, others become harder to see."

For all this intellectual engagement, a student in a Critical Inquiry class doesn't change much in a mere semester, though Eisner hopes that each one will have moments of self-discovery. The students tend to show their strengths early on — and stay that way. Nora Truskey, for example, is one

of the best writers, but she is quiet, and will be for the duration. Four young men, including Grant, tend to comment the most in class (at least until a discussion of feminism shifts that classroom debate), but it's a fairly quiet class.

"It's a morning class," Nora says.

Quiet can also mean deep. In fact, the ultimate goal of Critical Inquiry is for student to learn about *themselves* as young artists; the final essay will be titled, "Portrait of the Artist as an Intellectual."

"This is not a theory class," Eisner says early in the semester. Nor is it simply an English class. "This is about values and consequences."

As the instructors of Critical Inquiry at MICA will tell you, the course was meticulously invented to put values and consequences at the heart of the freshman's art school education. This is to be achieved by linking Critical Inquiry with Elements of Visual Thinking, a decade-old innovation. It was designed by English and theater professor Christopher Shipley, a self-described postmodernist, who believes that in an age of relativism, artists must chose their values, and live with the consequences.

The other premise of the linkage program is that art students learn differently: They learn visually and communicate visually. "I wanted to honor that," Shipley says. "When you read a story, you may not be the best kid in the class to talk about it or write about it. But you can damn well respond to it visually." The goal is to inspire students to articulate the ideas in their art (and hopefully, improve their ability to write and speak about them, too). "Whatever mark they make, whatever color they use, has content, carries intellectual content," Shipley says.[12]

For this kind of class to work, Shipley designed a system, and it is playing out across every Critical Inquiry class. Over the semester, every student writes three essays on their class experience, but the nub of the system comes each week. The weekly nub is the "artifact," as seen in the case of Eisner choosing "The Deconstruction of Emily Dickinson" that week (she'll also assign other poems, essays, *New York Times* articles, and a film as artifacts). Each week, her students write a long paragraph responding to the artifact. Each week also, her students fall into four work groups. One group makes an artwork in response to the artifact, a second leads the classroom crit of the five artworks, and a third offer questions from the textbook chapter. (The fourth group is off the hook that week).

This is the Critical Inquiry system, a kind of pedagogical machine with four moving parts. For a literature expert like Shipley, who has spent three decades teaching, a semester of Critical Inquiry is too short. He would like to see the course go for thirty weeks, the entire school year.

[]

Elsewhere on the fourth floor of the Bunting Building, another part of the freshman link-up is taking an interesting turn among the students of Kerr Houston, a Yale-trained art historian. He is teaching the other liberal arts requirement for all freshmen, Art Matters, a kind of thematic art history.

At this moment, his students are moving their heavy blue chairs into groups. They begin animated discussions on the topic of the day. Adam Dirks is in one group, Cory Ostermann another.[13]

"I don't think anyone can define art," Adam says.

Over in Cory's group, someone exclaims, "None of these can work!"

This is no ordinary art history class, and for a decade, the art history teachers at MICA have planned it that way. Art Matters does not "survey" art history—the typical format in college—but rather introduces young art students to three hubs of arts: the artist, the art institution, and the art object. This is as much sociology and critical theory (feminist and Marxist, for example) as art history. Before students enter these depths, however, Houston begins at the beginning. "Before we go further," he says, "it might pay to think about what we mean by the term 'art'?" Most of the students think this will be simple enough, but they'll soon think again.

Houston is a popular teacher, a carefully spoken scholar, but otherwise just part of the campus proletariat, sporting a goatee and favoring blue jeans. For the lesson today, he starts by giving his class a definition of art by the Renaissance biographer, Giorgio Vasari, who insists that true art reflects "the glories of nature."

Cory is sitting up front. A young revolutionary, she still likes to take teachers at their word. "I love Kerr's class," she says. So Vasari's definition sounds *so* right.

"Well, actually, no . . .," says Houston.

Cory is bit confused, but not for long. Houston explains that Vasari is hardly the final word on defining art. "What's a class on art to do?"

The exercise has begun. Houston goes over a list of definitions. The

Victorian Englishman John Ruskin said that the "most beautiful things in the world are the most useless"; this is art for art's sake. Leo Tolstoy says art transmits a feeling so "others may experience the same feeling." In modern philosophy, Ludwig Wittgenstein suggests that naming art is a language game only. Finally, there is the sociological definition: Art is politics. Art has no intrinsic value, says art historian Mary Ann Staniszewski, until it "circulates within the system of Art," with its power structures of galleries, art historians, critics, and collectors.

Houston gives his students ten minutes to thrash this out. Each group tries to come up with an ideal definition of art. Hence the cry, "None of these can work!" Cory has grown perplexed. She has gradually realized that there may not be a clear definition for art. Disheartened for the moment, she'll trust the teacher's assertion that they have not bumped up against failure, but variety.

"One of the goals of this entire semester is a flexible openness to new ideas," Houston says.

This is one of Adam Dirks's favorite classes, especially on days when Houston combines academic learning with hands-on activities. Eventually, the class has moved into the topic of the ways that artists have practiced their craft. For this, Houston takes them back in time, back to 1916 Zurich, the birthplace of an art form called dada. The students will try to stand in the shoes of the dadaists and their heirs, seeing what it was like when the modern idea of "chaos and the liberation of the artist" was being born.

For the exercise, the students pull their chairs into a large circle. They all have colored paper and glue sticks for what comes next. Houston begins by speaking about the early dada artist Jean Arp, who made collages. He made them, however, by letting torn pieces of paper fall where they may: He used chance as a tool of creativity. So the students start making their own collages, using chance if they like. The room fills with the sound of ripping paper. Cory tears out egg shapes in red, orange, yellow, and off-white colors and glues them to a grey background. She's leaving little to chance.

As the collages evolve, Houston keeps his student's minds on the deeper lessons. This is more than play, he suggests. "I hope you see how these exercises might be artistically useful, or how they might spark new

creative possibilities." Keeping his students serious may be a challenge in what comes next.

They now turn to the dada poetry, or "sound poetry," started by the dada writer Tristan Tzara in 1916 Zurich. In general, every dada innovation was a way to cope with, and protest again, the violence of the First World War. The dada use of chance and spontaneity was continued by the surrealists who, drawing on Freud, added the unconscious as an artistic force. For now, however, dada poetry is the Art Matters exercise and Houston is going around with a container in his hand, each student taking out five slips of paper. Each slip is a word cut from a newspaper (as Tzara had done in Zurich). Adam and Cory take their words and, like the others, glue them onto a sheet of paper, making a five-word poem.

"Oh my gawd," Adam says, gluing down his creation: "grow sales battle floor law." It's his dada poem, a sound poem if you like, since the words themselves lack a meaning.

Cory ponders her picks for a moment. Then she glues down, "house taken officials around work."

Now Houston gathers up the sheets and, in a professorial tone of voice, part dada and part poetry reading, he recites what his students have created. When the lines create natural jokes or puns, or when words collide, the classroom fills with giggles and guffaws.

"This is so ridiculous," Adam says. "I love it."

Today's experience is drawing out the difference in temperament between young artists like Adam and Cory. Adam is thrilled by the performance side; Cory by the graphic arts side alone.

"I like the collage more than the words," she murmurs.

Finally, the class moves to an activity innovated by the surrealists, a parlor game called "The Exquisite Corpse," a title that popped up at random among the surrealists. The game involved each artist adding something new to a drawing, not seeing what the previous artists had done.

To achieve this, Houston has devised a way to fold a sheet of paper by three. The first student draws an image, folds it to the next facet to hide that work, and then the second student draws in the blank area, folding again, and handing it to the third student. When the entire sheet is displayed, they have a drawing produced by chance associations. Looking at hers, Cory describes it as "an octopus creature with hobbit feet."

Of the three exercises, she likes this one the best, and she'll keep the picture.

Art Matters is an academic course with lots of names and dates to learn. However, Houston knows there's nothing like hands-on activity to keep students engaged. These can include dada exercises, field trips to Washington, D.C., and to the nearby Walters Museum (to see art museum systems), or asking students to stand in the shoes of art critics, commenting on current events.

With the lively dada session today, however, Adam has definitely confirmed his interest in participatory art. He is an art maker with good skills in craft and drawing, a person who is sociable and likes to speak in class. Being hard-wired for art also seems to undercut his prose writing (though he says he wrote poetry in high school), and before the term is over, Adam fails to write his main Art Matters paper.

"When it comes to writing a paper, it's torture," he says.

Adam is a common kind of art student. He prefers *doing* to writing. Tonight, he has ridden his bike to the Honey Comb Hideout Boxing Gym, a warehouse on East Preston, seven blocks east of the campus. He is sketching boxers in action. His pages fill with gesture lines, action ghosts. Adam knows something of their experience because he's done some martial arts and some rounds in a boxing ring. Now the boxers, dripping sweat, come over and look at his drawings.

"What the hell is that," one boxer says. "Come on, that isn't art. Do I look like that, with all those lines?"

"You're moving," says Adam. "I can't draw you realistic. I can't draw you like a photograph."

For Adam, this is a lesson in defining art. The public has a very different idea from the artist, the boxers from him. Besides, Adam says, "It's almost an artist's duty to break the definition of art, to break the boundaries." He can't think of a single art teacher in high school or at MICA who's been able to pin that topic down for him: what is art?

[]

Like Critical Inquiry, Art Matters is another Foundation Year innovation. Whereas MICA used to require three semesters of survey art history for all students, Art Matters has broken that survey tradition, which had hinged

on following art history textbooks. For a century, the textbook approach was a timeline tour of masterpieces and monuments, A to Z from ancient Egypt to modern France. The timeline, in turn, "privileged" certain groups, such as sculptors and narrative painters, white males and the rich and powerful.

But the old approach couldn't last, says Joseph J. Basile, the art historian at MICA who helped shepherd through its curriculum change in 2001. "Art historians asked, 'Why do it this way, and not that way?'" he says.[14] In Art Matters, for example, they still cover the old European methods of "formal" analysis (the form and materials of a work) and "iconography" (its meaning for a given society). However, they also touch on what the Marxist and feminist art historians say about the timeline, the privileged groups, and the powerful people who commissioned great artworks. They further avoid the chronology by using themes, projects, and field trips. No single art history is the truth anymore. "There are multiple art histories," says Basile. Nor is every art student a painter or sculptor. "We weren't serving graphic design majors, for example, or those interested in performance art."

For his part, Basile is an expert in Roman art, just as Houston specializes in medieval art. In teaching Art Matters, they often use examples they know best. Each year, however, new art is riveting freshmen, so teachers such as Houston and Basile try to keep up with other examples: graffiti art, graphic novels, or Internet video art. It keeps them on their toes and makes Art Matters one of the more challenging courses to teach. "I'll be frank," Basile says. "The survey approach is easier. It's the canonical list that we all know by heart." So to break from that list, and engage his students, Basile throws in a few novel exercises, one of which he calls "one hour, one object."

That exercise comes one Thursday morning in the Art Matters class. Calvin Blue, shaking off his sleepiness, arrives with his peers, all of them about to taste the rigors of art historical research. Before they show up, Basile has put ten art objects on a table at the head of the class. Now he tells them to break into groups of three, each group choosing from among the objects. For his group, Calvin Blue selects a small coin. In this one-hour exercise, Basile challenges them to discover all the facts they can about an unknown item of art.

In search of the historical coin.

The members of Calvin's group begin their investigation on the Internet. They Google "coin" and "ancient." Someone says "Roman." Another student says "Greek." Scads of ancient coins start showing up, but too many to handle. They know it's from Roman or Hellenistic times, but there are countless species, all with heads of rulers. So they head downstairs to the library in search of a book on ancient coins, returning with a few volumes that narrow down its Greek origins. As they flip through page after page, however, they find nothing that matches the head on this particular coin.. The hour runs out. When they deliver their report in next week's class, they still don't have it exactly: it's Alexander III (the Great) minted c. 320 BCE.

This kind of research-oriented art history is not something every art student enjoys; perhaps most art students don't. One has the impression that students still prefer that their teacher do the research and tell them the outcomes. This year, Houston gives his class a questionnaire on whether they prefer a freshman survey course, like the textbooks. He chuckles at the results. As if indifferent, the students generally say, "Sure, why not."

Meanwhile, at least, Art Matters tries to jostle some of their preconceptions, Basile says. "They are art makers and they come here invested in the idea of art. And then I challenge them."

The problem of defining art goes beyond the classroom, of course, and is taken up by art-school administrators, who deal with government attempts to measure outcomes in art, and by art intellectuals, the academics who hold hairsplitting debates on the nature of art history itself. As fall turns to winter, two of MICA's best and brightest—Provost Ray Allen and historian Houston—will fly into these debates, literally, on airplanes heading out of Baltimore.

The first trip is taken by Allen, who lands in Pittsburgh for the annual meeting of the National Association of Schools of Art and Design (NASAD). As the rain pelts Pittsburgh, the art educators assemble inside a conference hotel, and the main business session begins. The president and the executive director of NASAD both sound a similar theme: Art schools are under assault by Washington bureaucrats who want to "measure" outcomes in art. Among both political parties in Washington (and in the states), this is the push for "standards-based" assessments, and schools that meet the standards are rewarded with government money.

Sam Hope, NASAD's executive director, minces no words on this rising tide of bureaucrats. These government overseers occupy "centralized systems focused almost solely on assessment techniques and accounting." After him, NASAD President Robert Milnes is equally blunt about "the oppressive regime of accountability." Unfortunately for higher education (and public schools), government does seem to want to define art, just like it wants to define good reading and writing and good science learning.[15]

When lawmakers ask for proof of "achievement" in art, however, groups like NASAD are in a quandary. At the Pittsburgh meeting, it's duly noted that some lawmakers on Capitol Hill would like to require even art colleges to report how many of their graduates obtain art jobs six months after receiving the bachelor of fine arts.[16] This is not only like defining art, but defining art employment, a chilling prospect, says Sam Hope.

When the annual NASAD meets, the cause of "institutional autonomy" for art centers is the paramount policy theme, since the group's headquarters is just outside Washington, D.C. Autonomy is hardly the only theme this year.[17] On a more celebratory note, NASAD honors MICA's Ray Allen with its top award, merited by his years of service, including as past president, but also helping with the onerous task of being on review teams to assess and accredit art departments and colleges around the country.

They all want to improve their standards, and in one of his presidential addresses, Allen had famously emphasized the concept of "achievement and quality," two words that have become notorious in the art world, raising hackles among fine art educators especially. To the mind of many art educators, who has the gall to define quality? On another occasion, Allen confirms that the "quality" topic is a hard one for art colleges to talk about, even as they assert autonomy in defining that standard. "We avoid it like the plague," he says. "It is one of those things that everybody says, 'I recognize it when I see it, but don't ask me to talk about it.'"[18]

Nonetheless, everyone agrees that the government should not be defining art (or its quality).

Later in the school year, MICA art history professor Kerr Houston is also taking an out-of-town trip, going to another national forum of debate on defining and teaching art. He has landed in Chicago, scene of the annual College Art Association, where on Friday night he presents his paper on a topic his Art Matters freshmen are learning about: Can art be described in words? The session is titled, "Can Description Help Images Speak," and before the evening is through, it will be obvious that many art critics and historians, by their descriptive writing, have indeed tried to help. The final answer to that question, however, seems to be yes *and* no. For if critics often say "words cannot express" the power of art—they just as quickly start putting down words.[19]

In his presentation, Houston tells his fellow academics that this was a rich debate of the 1950s in American art criticism, a time that shaped the modern art journals. The debate began between the poet critics at *Artnews*, who used poetic phrases to speak of art, and the writers at *Arts Magazine* and *Artforum*, who shunned poetic fog and used empirical description. In either case, Houston says, everyone believed they could and should describe art—that was their task. However, something seemed to change by the 1960s, as his paper "The Limits of Words" argued. It may have been the influence of the English philosopher Ludwig Wittgenstein, whose writings (1953) showed that words are not fixed, but in flux, like pieces in a game.

So Houston suggests that the art critics may have come under Wittgenstein's persuasion, for by the 1960s they are conceding "the possibility that description may be impossible." Wittgenstein may be over the heads

of his freshmen back at MICA (though for student consumption, Houston has just written a textbook on art criticism for Prentice Hall), but Houston is not suggesting that their assignments to describe art are futile. In the real world (as compared to the philosophical debates about describing art), it is still being done everyday.

For Amy Eisner's Critical Inquiry class, the goal is definitely to write clearly. The philosophical debate usually swirls around eighteen-year-olds questioning what they learned at home, in high school, and in the media. The course asks them to consider whether any new "theories" (in the textbook or elsewhere) work better for them than others. As Eisner reminds her students, the *Critical Inquiry Today* textbook does not exhaust the options. In their studies at MICA, the young artists can take courses in classical philosophy or ecology, and even religion (the school has just hired a full-time religious studies professor). So Eisner invites her freshmen to search for their own approaches.

According to student surveys, MICA freshmen find the Critical Inquiry course to be one of their favorites, and some would like it to run for an entire year. Judging by the participation level and comments from Eisner's students, they love her class as well. They will miss it when it's over—even if it is a 9:00 a.m. class. Eisner seems to be a bright light in their morning fog. "Mega amped-up in the morning. She could make Eeyore happy," comments one student. Another says, "Always intrigued by what we were thinking/saying/making." [20]

But on this particular Tuesday morning, Eisner is unusually stern in beginning the class, her hair still damp (as is much student hair) from the mad dash to school through morning traffic. She's about to talk to her students about their latest writing project, which has not been their best.

By this time in the semester, all of her twenty students have turned in the second of their three essays. This latest one is on how, during a particular day in class, the students responded to someone's artwork. [21] One of Eisner's goals is to teach her freshmen to write well. Even if they are writing on art topics, she expects them to be able to handle it in plain English. Yet everyone's paper shows the same problem. She calls is "creeping abstraction." The students are falling victim to nebulous jargon. They are using a lot of words bandied about in art crits, words like unity, boundary, contradict, juxtapose, interrogate, resolve, and perceive.

"Your second essays are really, really hard to read," she says.

In short, the papers are not describing the real-world things the students were looking at on those particular days in class. The things they looked at had shapes, lines, and colors. Someone made these things, and they were made of certain materials and discussed in specific words. These are the concrete aspects of good writing, Eisner suggests, even art writing.

"You cannot analyze what you cannot describe," she says.

ART WORLDS

URBAN LEGENDS

Wandering west through Bolton Hill, an art student will reach Eutaw Place, a famous old street in Baltimore. In Victorian times, it was a promenade of wealthy homes and bronze fountains. It's now a transition into poor neighborhoods. For MICA students who get this far, and turn right, a spectacular old building comes into view. This is the Marlborough Apartments, a towering edifice of pink and white stone, now a bit shabby, but still haunted by one of the great urban tales about art in the city.

On this Tuesday morning, it is sunny but chilly when a group of MICA students passes the old Marlborough. They are taking a two-mile walk through the poor neighborhoods to reach Druid Hill Park. As freshmen, Cory Ostermann and Adam Dirks have enrolled in this class, called Finding Baltimore. It promises to get them out on the streets, where students can learn about hard neighborhoods, mural painting, and the social impact of art and artists. Nobody in the group has yet heard the Marlborough story, so nobody stops. Bundled against the cold, they walk briskly past, headed north.

The heart of the Marlborough story is its top-floor apartments, where Claribel and Etta Cone lived in the early twentieth century. The Cone sisters were independent, well-educated spinsters, wealthy by inheritance. So they traveled every year to Europe, smoking cigarettes in Italy and looking at cubist paintings in Paris. In time, the Cones amassed one of the first great collections of modern art in the United States. They hung it in every square inch of their living space.[1] Typically, MICA students do not learn this until their first visits to the Baltimore Museum of Art (BMA), whose "Cone Collection" and Cone exhibits have given the museum a national reputation.

Beyond the Marlborough, the students pass by blocks of row houses, some boarded up, with graffiti here and there. They finally reach the broad lawns and leafy trees of Druid Hill Park, where they gather under a red-roofed gazebo with picnic tables. A strong breeze ripples the surface of

nearby Druid Lake, which is a cold, dark blue. Today they will start a new project. There are sixteen of them, and they begin to unpack their art supplies. Guided by their teacher, Paula Phillips, a seasoned, black, community artist from Texas, the class's goal in the next two hours is to choose the basic design elements for a public work of art, a mural for a Police Athletic League center in a neighborhood concerned about its young people.

For MICA students, there's plenty of chance for adventures into urban art. Not a few classes try to paint murals in derelict neighborhoods. In the classroom and the museums, they can also learn some of the most colorful art-in-the-city stories as well. Some of the early ones go back to Victorian times, before World War I, as with the Cone saga, while others begin in more recent decades.

The Cone sisters traveled to Europe at a time when Paris was not only the center of the art market, but the hub of new experiments in art, now called "the birth of modern art." The Cones' connection to Europe came through a friendship with Gertrude Stein, whose home in Paris had become a Saturday salon for many writers and artists. (With their inherited wealth, Stein and her brother Leo bought the Parisian artists' paintings). In her Paris exploits, Stein had actually learned a thing or two from the Cone sisters, since Stein had previously lived in Baltimore for a few years. In Baltimore, the Cone sisters held Saturday evening gatherings at their apartment, and Gertrude and Leo frequently attended. They were both Jewish families, cultured and wealthy.

When Gertrude and Leo moved to Paris in 1903, their house became a crossroads for the bohemians and the avant-garde, including Matisse, Picasso, and many others. As it turned out, the Cone sisters' second visit to Paris came in 1905, and in that year they witnessed the first exhibit of the painters led by Matisse, a group that the critics called fauves, or "wild beasts," for their wild use of color. Each trip to Europe thereafter was a shopping excursion to bring back works by Matisse, Picasso, Cézanne, Manet, Degas, Gauguin, van Gogh, and Renoir. After Claribel Cone moved to Europe to practice medicine, Etta continued collecting from Baltimore, and in the 1920s, MICA held a public exhibit in the Main Building of the Matisse paintings she owned. On December 7, 1930, Matisse himself arrived in town, paying homage to Etta for buying so many of his paint-

ings and bronze sculptures. By staying at Etta's apartment, he also raised some eyebrows in Baltimore's polite society.

Today, as if following in Matisse's footsteps, anyone can wander into the Cone apartment, because one of its rooms is an exhibit at the Baltimore Museum of Art. The museum is a place where senior MICA students such as Jen Mussari have been plenty of times by now. If Cory and Adam don't yet know this history, Jen is applying it to some of her favorite liberal arts courses in her last year of art school.

The first of these is the History of Illustration, in which the class took a field trip to the BMA. During this trip, Jen found out that the museum holds one of the largest U.S. collections of European prints. They, too, had sprung from Paris, and it happened around the time that the Cone sisters began their collecting. Once she knows about the collection, Jen dovetails it into a project for her other favorite course, called The Lost Generation, which studies the arts and letters of the period before and after the First World War, especially in Paris. It was Stein who famously said to these expatriot artists and writers, people like Ernest Hemingway, that "you are a lost generation."

Naturally, Jen's course reads Hemingway's 1924 novel *The Sun Also Rises*, and it also reads some of Stein's experiments with words, which she called her "cubist" writings. The most extensive of these word experiments is Stein's *Tender Buttons* (1914), a poem of nearly a thousand sentences, each of them nonsensical. As Jen reads, she comes across this oft-quoted one:

Out of kindness comes redness and out of rudeness comes rapid same question, out of an eye comes research, out of selection comes painful cattle.

Then soon after:

A single image is not splendor. Dirty is yellow. A sign of more in not mentioned. A piece of coffee is not a detainer. The resemblance to yellow is dirtier and distincter. The clean mixture is whiter and not coal color, never more coal color than altogether.

"It's a very long poem that doesn't make any sense," says Jen, summing up the reading experience.

Nonetheless, the style of Stein is a favorite among artists, even today. Poetry was always a preferred idiom for artists (over discursive prose, for example), and Stein only added to its rejection of conventional grammar to focus on sounds and, indeed, to subvert "linear thinking," as artists will say today. (Later, Jen will produce a series of art posters, one of them titled "Lost Gen," a reference to her own age group, and its contemporary grasping for purpose in the world).

Be that as it may, Jen's discovery of the massive collection of European prints at the BMA is providing perfect subject matter for her Lost Generation class presentation. Since the cache of prints is called the "Lucas Collection," she must first identify the mystery man Lucas. What is more, the prints made their way to Baltimore around the turn of the century, when bohemian Paris was boiling over, so that must be part of the story as well. In fact, just recently, when the BMA held its largest ever exhibit of the Lucas Collection, the title was "A View Toward Paris."

Standing before her class, using slides, Jen begins with biography, the story of George A. Lucas. A native of Baltimore, Lucas was yet another American in Paris at the turn of the century. He was the seventh son of Baltimore's leading printer, and in time became a connoisseur of fine arts. Lucas had attended West Point, tried civil engineering, but on leaving for Europe (soon after the Civil War), he spent the rest of his life there as an art agent and consultant for American collectors. In 1859, Lucas offered his consulting services to one of Baltimore's wealthiest men, William Walters. Walters traveled to Europe and they became close friends. (In time, Walters's private collection became the city's Walters Museum.)

Lucas himself had also built up quite a repository of valuable artworks. In his final years, when Baltimore was being rebuilt after the Great Fire of 1904, Walters urged him to bequeath these personal holdings to his hometown, specifically to the newly built and opened (1908) Maryland Institute, now housed in a building of marble, both fireproof and collapse proof. Lucas's collection contained twenty thousand prints, many sculptures, and paintings by a celebrated cast of characters: Edouard Manet, James McNeill Whistler, Mary Cassatt, Eugène Delacroix, Jean Baptiste Camille Corot, Théodore Rousseau, and Gustave Courbet; Lucas in fact was a personal patron of Whistler and Cassatt.

The aging Lucas was persuaded by the idea of giving his art to Balti-

more, and when he died in 1909, his executor, Walters, conveyed it to the Maryland Institute, "dedicated to sincere art education in his native city."[2] Eventually, ship loads of crated art began to arrive in the port of Baltimore.

By now, Jen was wrapping up her presentation, ending with how the collection, in the end, slipped through MICA's fingers. "Rumors say that at MICA the collection could be found in every available storage space and prints were even used to block light from the windows," Jen explains. "The students weren't using it properly. So the BMA ended up being able to buy it from the art school."[3]

In general terms, this is a fair overview. But there came the day when the MICA trustees looked more closely at how the school lost the collection. Or had it? This was a question that, in the 1990s, even a Baltimore circuit court had difficulty sorting out. Measured by art auction prices, the Lucas Collection was now worth $11 million, prompting MICA to review exactly how it reached its current status at the BMA. Back in 1929, on the eve of the Great Depression, the BMA had just opened its new building next to Johns Hopkins University, and was looking to fill it with art. Four years later, the struggling Maryland Institute, financially strapped, "loaned" the BMA the massive Lucas collection. A few years later, the BMA loaned some of those paintings to the Walters Museum as well.

Since 1989, the MICA trustees had been talking to the BMA about the school's intention of selling the collection. In 1995, the BMA filed suit to block the action, making its own claim on the art as its caretaker for six decades. The museums wanted the art, MICA wanted it auctioned for cash, and Maryland politicians wanted the art to stay in the state—and in the end, that's what happened. Under a settlement brokered by the court in 1996, the collection was sold to the two museums for $8.5 million, half of it paid by Maryland taxpayers. The money went to MICA. As the *Baltimore Sun* editorialized, "All three institutions are strengthened."[4]

At Druid Hill Park, the freshmen in the Finding Baltimore class are no more aware of how the settlement has bolstered MICA than they are of how Matisse set foot on Bolton Hill. Some of that income is underwriting scholarships, such as those for Adam and Cory, who did not know the strange fact that the escalating value of art from Paris a century earlier was helping them go to art school today.

What they do know is that the police are waiting to see the first draft of their art project. It's an urban tale of a different kind.

[]

On a Wednesday, police sergeant Terry DeBoise bounds up the steps of the Main Building. He is picking up a small-scale drawing of the proposed mural the students are working on. Paula Phillips, the teacher, unrolls it for a peek.

"Wow," DeBoise says.

His cruiser is soon headed for police headquarters in Towson, the seat of Baltimore County.

"Yeah, we like this," his captain says. "Let's do this."[5]

Unlike anything DeBoise has seen at the head office, this project got clearance by the next day. He is a former beat cop working in the "soft" department, the Community Resources Section. This includes Baltimore County's nine Police Athletic League (PAL) Centers for youth, and one of them in Randallstown could use a mural in its long central hallway. The center aims to teach kids that books and computers, not the streets, are the way to achieve their dreams. Before Sgt. DeBoise got through the bureaucratic process, the sixteen students in Phillips's class went through a creative one, and it had begun the day of the two-mile hike (and two back) to Druid Hill Park, past the Marlborough Apartments, to rendezvous under a picnic gazebo.

It's a Tuesday, October 13, and Phillips is calling for attention under the gazebo. She is a consummate teacher, able to instruct in the classroom or out on the street. Her long, black hair is accented with silvery grey. For her Finding Baltimore class this year, the budget is too tight, meaning they don't have vans to travel to outlying urban quadrants of the city. So the class is taking the long walks through nearby neighborhoods. Today at the gazebo, time is running out. They have a deadline, which is in the nature of painting murals and working with other people in the community.

Having the cops clear your art is travesty for many artists. Some kinds of public art are designed to create outrage, to offend as many people as possible. There's plenty of that in Baltimore, but not necessarily in a MICA class. In this case, it's a class on community art. Phillips makes clear that community art is about working with clients, collaborating with and

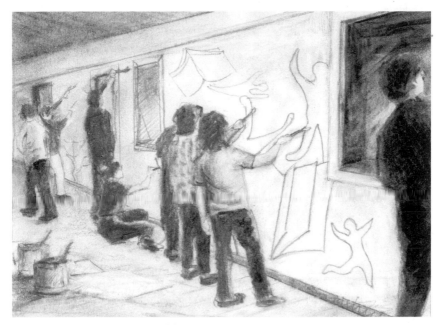

A mural for the Police Athletic League.

pleasing constituents. "We cannot eliminate the idea of the partner," she tells the students. In community art, artists are producers. The clients and the community are consumers. It's not hard to understand.

"We need to distinguish art for myself and art for other people," one student offers. "You can't impose your art on a community."

Adam had done some community arts with needy kids before. He also knows something about murals. So he shares his conviction that once at a mural is up, as at the PAL Center, it's permanent. "They're going to have to see this mural every day," he says.

Whatever design they come up with, it must be approved and painted on the walls in a few weeks time. Fortunately, the students have already narrowed their many mural ideas down to two general themes, which they're now sketching on pads with color markers. Human figures are one theme, an obvious element for a mural, and Cory proposes a generic shape for the human, a kind of wispy body with pointy arms and legs. Others catch on. Such a figure can twist, turn, and bend, plus it can be every race and gender.

"That would make them inclusive," one student says.

A morning breeze rustles the tall trees next to the gazebo, fluttering sketch pads, where the second theme is taking shape. The students are looking for central decorative elements for the mural, cheerful objects such as flowers. Books are also a relevant object for what the youth center is after.

"What about books as flowers?" says Adam.

For an instant, the entire class seems to gasp. Then comes a ripple of voices: "Ahhhhh. Ah, yes. Heyyyy. That's it!"

Phillips stands back, letting her students lead themselves. What she needs is a final decision. Under the gazebo, the mural components are chosen. It will be generic figures and books that blossom like flowers. Next week, back in the classroom, they've got to put it in a composition, decide colors, draw a precise, small-scale version (the version Sergeant DeBoise will be picking up the day after). They've nearly gotten it done, but there's no time to slack off. They have another mural project to complete, one they've already designed, but it's waiting for approval by Amtrak authorities to put up at nearby Penn Station.

[]

After fifty years of mural painting in American cities, buoyed by the modern urban renewal movement, the public has grown accustomed to public sculptures and bright, happy murals on brick walls. At MICA, the school is encouraging students down the community art track. Adam and Cory opted for the Finding Baltimore class for freshmen, but they could have chosen one in human development of children through art, a course that Liam Dunaway tried out, working with youth at the Mount Royal Elementary/Middle School.

The work of community arts gets even more serious in the advanced courses and graduate degrees MICA offers in this field, a program in which students are taught a social justice agenda. "Community art supports the fundamental tenet that a community defines its own creative prerogatives," not "the ideas of the elite or ruling class," writes one MICA teacher, a leader in this department.[6] For training students, MICA cooperates with AmeriCorp, a federal program that funds "volunteer" work in needy urban and rural settings. At the National Endowment for the Arts, in fact, the

feds are taking seriously the new research that suggests that neighbor-
hood art programs curtail delinquency, generate civic activity (such as vot-
ing and neighborhood watch), and generate business and jobs.

The community arts movement, however, is being buffeted by two
competing forces. The clash can be summed up in the term "the So-Ho
effect." The So-Ho is the name of a fashionable art district of London. In
the 1970s, it was adopted in Manhattan's "south of Houston Street" area,
where contemporary artists were renting, or squatting in, old warehouses.
From New York's So-Ho emerged the modern art scene, rising art stars,
galleries and, most essential of all, the influx of money. Eventually the
grimy warehouses became boutiques, cafes, high-end apartments. Soon
it was no longer possible for artists to afford setting up in So-Ho. The pro-
cess is called gentrification, or the "So-Ho effect."

In Baltimore, the city finally spoke the So-Ho word in 1994. Relying on
federal urban development grants, the nonprofit Baltimore Development
Corporation announced that it would develop an "Avenue of the Arts"
along a hard-hit commercial street just south of the MICA campus. Just as
quickly, the project petered out, due in good measure to skepticism and
resistance. The failure was also due to two interest groups with very dif-
ferent visions for an Avenue of the Arts. One wanted inexpensive studios
for artists and help for the local poor, while the other wanted real estate
profits, the very reason to put money into a bad part of town. Accord-
ing to the So-Ho effect, in a project like this the real estate people usu-
ally win in the end, while the artists and poor are priced out of the new
neighborhood.

From a purely economic view, the So-Ho effect is exactly what many cit-
ies ache for, since it does boost the economy. Around 2000, that was the
message the urban economist Richard Florida was taking to the Maryland
statehouse and other local governments. One urban tale told in Baltimore
is that by coincidence Florida met Martin O'Malley, Mayor of Baltimore,
when they had adjacent seats on an airplane trip. Soon to be governor of
Maryland, O'Malley, a musician who collects art, liked Florida's big idea.

In *The Rise of the Creative Class* (2002), Florida argued that an "art
scene," typically composed of single professionals, gays, bohemians,
cafes, and local rock bands and theater troupes, can be the economic pow-
erhouse of future cities. "[H]igh concentrations of gays and bohemians

tend to have higher rates of innovation and economic growth," observed Florida, then a professor of economics at Carnegie Mellon University.[7] Florida believed he was giving empirical evidence to a vague sociological idea that had been around for a few years, the idea that America had produced a wealthy class of cosmopolitan social liberals—variously called "bobos" (bourgeois bohemians, heirs to the yuppies) or neo-bohemians, a group known to settle in urban clusters, bringing their money, buying art and entertainment. Florida forecasts that without this art scene, cities cannot draw a talented work force or the companies that hire it.

Not that Baltimore ever lacked a kind of bohemian scene. As a long-time sailor town, its shoreline Fells Point continues to be a playground for the lowbrow party, street art, and the world of adults and their entertainments. When the 1960s came, the sailors and the beatniks were eclipsed by the hippies, at least up near MICA in the Mount Vernon section, which became Baltimore's hub for the counterculture, before and after the 1968 riots reversed the fortunes in that end of town. As the account of a former MICA student goes:

> It was the late '60s and we were cocky and looking for action. The Maryland Institute, College of Art was affordable then, so even though most of us came from working-class families, we went. Everyone was doing "black paintings" and nude performance art. . . . I immediately attached to my fellow risk-takers. God knows the variety of intoxicating substances we ingested, . . . though we favored hallucinogenics, which were quite abundant. It was the year of the riots. We skulked around the alleys during curfew. It was fun. Artists, gay boy-men, and fag hags like myself made up my elite circle of friends. The times were quite ripe for a sociocultural review. Sexuality was one of our favorite topics. Men were flying out of closets and straight men said they were queer to avoid the [Vietnam] war. Subversives were speaking out.[8]

Whether the more recent airplane story about O'Malley and Florida is true or not, Baltimore still likes the idea of having popular urban districts—and having the arts. Long ago, Baltimore lost its battle with New York City for the dominance of commerce (New York City got the Erie Canal; Baltimore just inland railroads). Yet the port town has always had

captains of industry to build art institutions. The old Protestant money of Johns Hopkins, Walters, George Peabody, and Carnegie, among others, got the ball rolling. In this era, Baltimore Jewish families—Meyerhoffs and Hoffbergers—have replaced railroads with real estate and breweries to quench Baltimore's taste for art.

Back in the late 1920s, when Baltimore began building its first museum (the BMA), the federal government in Washington, D.C., had already launched its first modern funding system for public art, allotting 2 percent of every federal building budget—typically beaux-arts and art deco buildings—to some decorative art, such as statues, murals, or designs. During the Depression, this funding stream expanded under the Works Progress Administration's Federal Art Project (1935–1943), which employed thousands of artists, many of whom not only survived on the largess, but made up the postwar generation of rising art stars, typified by Jackson Pollock and other abstract expressionists.

The idea of a percentage of the government budget going to art was revived in the 1960s, and by cities as well. The federal agencies called it decoration with a clear purpose, such as "a mural painting which immortalizes a portion of the history of the community in which the building stands, or work of sculpture which delights the eye and does not interfere with the general architectural scheme."[9] Cities tended to see public art funding as a form of urban renewal. In 1959, for example, Philadelphia's Redevelopment Authority made it the first city to mandate that 1 percent of rehabilitation construction must go to public artwork. To be sure, this was due to the successful lobbying by the main artist union, Artists Equity, which had been gaining strength since the days of the New Deal, and it flexed its muscle equally well in Baltimore.

In 1964, Baltimore became the second U.S. city to declare the 1 percent rule. Fortunately for public art, this legislation was sponsored by an ambitious young councilman, William Donald Schaefer, who was just beginning his fifty-year career in Maryland politics, including decades as mayor of Baltimore and governor of Maryland. During Schaefer's tenure, the street artists say, they gained freedom to experiment with art around the city, and received some funding, too. However, the two factions that invariably make up community arts competed for each dollar, one side wanting to help the poor and improve the declining neighborhood, and

Station North Arts District.

the other side wanting to have an arts-and-entertainment scene, a commercially successful enterprise. Ideally, the solution was to generate a scene in a downtrodden area, improving life for the poor, and bringing in business. This was the idea of the "art district," and Maryland was among the first states to pass legislation on the policy.

When cities began competing for the honor of having a state-designated art district, which included tax incentives and a tourist designation, one criterion was that the urban neighborhood had to have some cultural tradition to build upon.[10] In this opening salvo, no neighborhood fared better than the environs of MICA. In 2002, a hundred acres of decaying neighborhood on the east edge of the campus was declared Station North Arts District. The next February 15, Mayor O'Malley and local artists held a "Gotta Have Art" street festival to make the district official. Artists are the Marines of economic development, O'Malley said. "They go where others won't."[11]

During the festival, local artists, especially MICA students and alumni, hung colored chairs in trees and collected trash, putting it in colorful bags that then were stuffed into abandoned-house windows, "re-presenting," as artists say, the trash as art. Computer printouts of animal faces decorated other blank windows and, in all, the festival's "Door & Window Project" festooned vacant houses with works by more than forty artists. The mayor also showed up for the grand opening of Area 405, an old brewery

turned into an art gallery and studio loft by a collective of artists (toward whom zoning and inspection officials have been lenient).

As a neighborhood with two centuries of architectural history, the Station North Arts District is a crazy quilt, much of it streets of abandoned row houses. On the other hand, some of its stretches go back to Victorian times, featuring Queen Anne and Edwardian style building fronts that are on the National Register of Historic Places. The main artery for the district is North Avenue, a promenade of abandoned theaters, closed restaurants, and a derelict bank. At the edge of the district sits the Studio Center, a former warehouse purchased by MICA in 2000 and now its primary private studio space, hosting several hundred studios for upper-level fine arts students, especially the painters.

The city often puts the number of artists living in the art district at four hundred, perhaps more. It's always unclear how many of the "artists" are students enrolled at MICA, since most of the four hundred live in two revamped factory buildings, the old Cork Factory and the Copy Cat Building, two popular housing options for MICA students.

The Copy Cat is famous for student art parties and, under the sponsorship of the Copy Cat Theater (a "DIY experimental theater"), variety shows and performance art events, such as the largest of this school year, *The Rooms Play*, which recruited fifty artists (namely students) to create twenty rooms, each an environmental experience, much like a haunted house tour at an amusement park.[12] In keeping with the Copy Cat Theater's manifesto — to "alter traditional conventions of space, movement, tension, language, and sound" — *The Rooms Play* used the idea of a "hero's journey," an Odyssey of sorts, but in this case through a human digestive tract. Truth be told, walking (and crawling) through the twenty rooms is anything but anatomical — each is a goofy yet clever cameo, people in costumes acting little scenes, different uses of lights and color, rooms done up with sundry found materials.

Like much performance art, and like much that makes up any student art scene in America, the Station North Arts District struggles to gain a toehold financially. A *Washington Post* writer came into the Station North art scene about this time, heralding its expansion of cheap artist spaces, but concluding on a sour note. "So far, no art stars have emerged from the Baltimore scene," reports the *Post*. "A good number of the city's artists seem in

it for the bohemian cred, rather than for the chance to make serious, challenging art." One local artist, an experimental filmmaker, describes the art scene esprit a bit more precisely: "Half the time, it's like a party."[13]

Nevertheless, many believe that Station North has the makings of an art-led urban renewal. One group that thinks this way is the urban developers. For some years already, they have had plans on the drawing board, what city officials call a "Vision Plan," replete with beautiful architectural drawings of sleek buildings, blue skies, well-dress consumers and workers prancing along clean sidewalks. The plan includes turning Penn Station into a gala mall (as at Washington, D.C.'s Union Station), making North Avenue into an open market and bustling Asia Town, and opening a Design Center over by MICA. The ideas can be inspiring. City planners talk about them nearly every year. But so far, Baltimore cannot find the money and incentives to make them happen.

The teachers at MICA, however, are not going to wait forever. They have designed a new course, Art, Artists, and the City, in hopes of stimulating new ideas to upgrade the Station North neighborhoods. While some MICA classes are always out on Station North streets, working in broken-down alleys, hanging art on derelict buildings, or painting over ugly brick walls, Art, Artists, and the City is trying to engineer a formal agenda. With two artist-architects as instructors, the class is mapping Station North, probing its features, evaluating it resources and pitfalls. By talking to residents, the students are learning about its worst areas, its upswings, and what might be possible with art. Each student is also designing an art-related community project. These will be documented in a book for the neighborhood association.

As one student soon experiences, changing society with art can be tough in a tough part of town. She organizes an astronomy night in an abandoned lot at Lanvale and Barclay, once an open drug market. The art event is called the "Sky Space Project" and it commences, between nine and midnight, with a telescope for children to view the stars, refreshments, and an art-like ambiance. Soon enough, two police cars arrive, lights and sirens blaring. It's like a scene out of the HBO series, *The Wire*, which did so much to persuade TV watchers worldwide that Baltimore is crime city No. 1. The police, wielding a megaphone, made themselves plain. The crowd must disperse immediately.

When a MICA student protests, one of the policemen is blunt about the risk of being robbed or mugged in the neighborhood late at night.

"You are like minnows around sharks," he says. "You've got to leave."[14]

[]

It's the first week of November, and the trees around the PAL Center have turned red, orange, and yellow. Inside, the MICA students have finished the mural with a two-day assault. Using their scale drawing with a grid of squares, they put up the outlines, then painted in the light blue background all down the hallway, the largest area of color. Then came the basic colors of the plants and books, green and purple. At a later stage, more colors are added, black lines defining the book pages, extra touches of orange and red, and letters of the alphabet filling each of the happy human figures, which twist, turn, and fly across the mural.

On the final day, a few police from the soft side, the Community Resource Section, sit in a circle with the MICA freshmen, a few local kids, and members of the black sorority service group, Delta Sigma Theta, that linked the art school and police center. They all share what they learned in completing a mural project, and describe how the thirty-five foot mural has gotten the neighborhood children excited. The police saw professionalism in the students. The students, in turn, realized art can take you into the community. "We get out of the studio and work with others," one student says. Art is not about a perfect end product, but about the process as well. "You learn to work with people you don't know."

Paula Phillips, the MICA instructor, will shepherd through ten or more mural projects in the school year. She has a comment for her students. "When you make these choices, when you design a project like this, you have to see it through," she says.

EXHIBITMANIA

In a few more days, the clocks will be turned back, and night-fall will envelop the campus soon after students reach their 4:00 p.m. classes. They'll emerge to see a full moon over the Brown Center, which glows from within at night, revealing its steel skeleton and glass skin. Halloween is around the corner.

Everyone is back from fall break, and for MICA's freshmen, it has been their first chance to evaluate where they stand. This has been the time of mid-term evaluations for all students, a time when warning slips go out if anyone is slipping behind in a class. For freshmen, however, the first mid-term is designed to be merciful (they'll have other opportunities to get warning slips the rest of their years at MICA).

Tonight is Thursday, a time to relax and make the art scene. Even at an art school, that means schmoozing at an opening reception for an art gallery show.

At the centrally located Fox Building, the sound of jazz and R&B standards wafts from the lobby. At both ends of the lobby are the campus's main galleries, the Decker and the Meyerhoff. (In addition to having the galleries, the Fox Building is the most multi-use on campus — painting, drawing, illustration, general fine arts, art education, community arts, and environmental design). Tonight the Decker and Meyerhoff galleries are host to a reception for the largest competitive student art show of the year. It's called the Undergraduate Juried Exhibition, and it's the opportunity for a select few to feel like the chosen few.

Of 1,700 undergraduates, just 234 submitted works to the jury, some encouraged by teachers, but most responding to posters around campus or to an e-mail alert. Finally, 118 students are featured in the show, what the school calls "the best of the best." Not every student saw it coming, too busy to read the signs or hear the announcements. As usual, there is a bit of regret or jealousy. Not for Nora Truskey, of course. She has joined the Haunted House Club, which is racing to finish its haunted walk-through at the Gateway's BBox Theater, two fun-filled sessions of "the

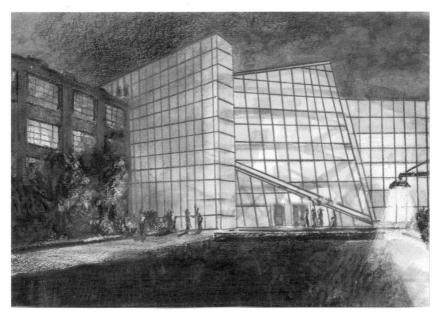

The Brown Center aglow in fall.

coolest most frightening things to experience in the universe." (That is, it "will scare every part of your disgusting peasant self and then feed you to the worms. HAUNTED HOUSE will offend you. It will make you cry and vomit at the same time.")

Plus, Halloween night comes in a few days. There's nothing at an art school—in terms of bizarre costumes and publicity posters—like Halloween. The pageant of costumes will come down the grand stairway at the Main Building.

The Undergraduate Juried Exhibition has a different aesthetic from Halloween, naturally enough. The reception draws a large crowd, which knots around two cloth-draped reception tables. The students pick at fruit, crackers, and cheese. The Geoff Rohrbach Trio of piano, bass, and drums heads into its two-hour set.

The gallery scene at Fox tonight is not that different from the art world in general, whether it's an opening at a prestigious New York gallery or a beer-and-chips gathering at an "alternative space" around Baltimore. Mostly, there are white walls hung with art and people holding refreshments. In Baltimore, like any art city, the gallery spaces have names that

are hard to keep track of. If the spaces last over time, the names become mainstays. (Only the art historians know all the details, such as that surrealism had its first American outlet at the Julien Levy Gallery in 1932, "happenings" got started at the Reuben Gallery in 1959, or "neo-geo" began at the Sonnabend Gallery in 1986). In the city of Baltimore, gallery spaces have names like Area 405, Load of Fun, Windup Space, the H&H Building galleries, the Creative Alliance galleries at the old Patterson Theater, Maryland Art Place, or the city-funded School 33 Art Center. At art schools, galleries usually bear the names of donors, and that is everywhere the case at MICA.

At the Fox galleries tonight, the music rises and the food supplies diminish. For the undergraduates, it's an early taste of the competitive art world. They are also learning how art history is made. If general history is defined by political regimes, wars, scientific inventions, or the founding of nations, art history is defined largely by art exhibits, with their names, dates, and locations. However, art schools rarely have a prominent role in making this history.

At MICA, the school will show a hundred exhibits a year in its twelve galleries (and many more nook exhibits). None will make a mark on history, although some gain local attention. A city like New York, Paris, London, or Los Angeles can hold an art show exhibit that gains wide attention, but a city like Baltimore is hard pressed, naturally. What all the cites have in common, however, is that art exhibits today hinge a lot on the people who design and present them, a person called the "curator." Whether on a global or local stage, the exhibition curator decides what is new and good. Increasingly, curators are writing art history, or at least becoming the gatekeepers in modern art. At MICA, they've naturally begun to teach curation as a profession.

[]

At this time in her life, Jordan Pemberton is too much of an art-making artist to think about curating other people's work, though she knows that it is something many successful artists will do later in life, especially when asked by a museum or gallery. When it comes to Jordan showing her work at MICA, she is her own first curator, picking and choosing. She did not submit work for the Undergraduate Jury Show. Today, however,

she is on the second floor of the Fox Building putting up her own exhibit. The space is called "Fox 2," a long, open hallway with a gallery alcove. A few weeks earlier, Jordan's instructor in Drawing II, Cornell Rubino, assigned the class to draw the same object forty times, each a different interpretation. Jordan chose an orange, limning it in paint.

Rubino is among the instructors who believe in series. Art should explore a theme exhaustively, he says. His own exhibits tend toward several pieces, not just one. "Forty I think is demanding enough," Rubino says of his class assignment. "How to walk around an idea. How to take an idea and exhaust it. I know it overwhelms some students."[1]

Not Jordan in this case.

Exhibits rotate weekly at MICA and the busiest place of all is Fox 2. For this week of November 10, Jordan's class and another, Painting II, have the space, and faculty have selected the best from these freshmen students. Jordan's forty oranges are lined up on one wall.

They are displayed under gallery spotlights, so this is a good time for Jordan to "document" them. She goes picture to picture with her digital camera, clicking off each one. Then comes a friendly interruption.[2]

"These are really cool. Did you do these?" It is Barry Nemett, chair of painting and evangelist for the department as well.

Jordan turns and smiles, suppressing a nervous laugh. "Yep," she says.

Nemett says he is impressed. "What major are you choosing?

"I'm thinking of photography."

"Oh, that's a great program."

When Jordan finds out that Nemett is chair of painting, the conversation quickens, she full of questions, he full of helpful and enthusiastic answers.

The encounter will prompt Jordan to calculate her options more seriously, which means more precisely. At MICA, which has majors — some art schools do not — the major you chose determines what classes you can take for the next four years. If Jordan majors in photography, that limits her choice in painting courses. The reverse would not necessarily be true. If she majored in painting, for example, she could still take some photo courses. At this point, Jordan is interested in analog photography, the old-fashioned kind with film and darkrooms. Fortunately, MICA is still big on learning analog, while many schools are shutting down their

Landscape painting in autumn light.

expensive, chemical-fumed darkrooms and moving to digital photography entirely.[3]

"I've had a lot of people tell me how impractical analog is," Jordan says. It is expensive for one thing. "It's easy to mess up and there's nothing you can do about it, 'So why don't you just take a picture with a digital camera and in Photoshop you can do anything you want with it?'"

At MICA, photography comes under fine arts. Though its darkrooms are still active, digital seems to be the way of the future. For Jordan, however, analog photography retains a central role in fine art. On her recent field trip to New York City, she went to see "Proud Flesh," a gallery show of photographs by Sally Mann, who still uses large film plates. "I haven't done a digital work," says Jordan, who is not good with computers. Besides, she adds, like analog photography, "A lot of art isn't new and modern and practical." Take oil painting for example—Jordan's forte.

Meeting Nemett in Fox 2 will make a difference. "He was just really interested and helpful, and had a lot of advice," Jordan recalls. At this time, the school also holds Major Cafe, a day when each of the fourteen undergraduate departments pitches its major to freshmen. The Fox 2 oranges, though, seem behind Jordan's decision (to major in painting).

[]

Back on Bolton Hill, Meghann Harris is in her apartment typing away at her SVA blog. It's not easy to lure students to student government meet-

ings, at least compared to art gallery receptions. She knows that one event will grab their attention—the Christmastime art market on campus. So she's putting that high in her blog. At the art market, you can sell art to Baltimoreans looking for holiday gifts.

Later in the week, the next Academic Affairs Council of students arrives. It's around noon when the department representatives gather in the dark-wood boardroom at the Main Building, eyeing the buffet lunch. The day is overcast, but the chandeliers brighten the antique room. One or two new paintings hang on the wall. This will be a solid hour of hearing department reports. Students have canvassed their peers and will elaborate on their concerns.

"We have a big agenda today," Meghann begins. "I hope everyone can be brief, as best we can."

The premise of student government is that students are paying customers. They know the world is not ideal, but they do expect the services paid for, and probably a bit more. The administration welcomes the advice (also known as complaints). As the year goes on, student representatives will also attend exhibition meetings and budget meetings. Each semester also features a town hall meeting. This allows face-to-face exchanges. For today's meeting, the concerns are a broad but familiar list, given in some verbal detail by students from fourteen undergraduate departments.[4]

"We're kicked out of the studios at 1:30 a.m." an Animation Department student says. "And if the power is shut off, our projects can't get done overnight."

What is more, animation students can't use the specialized computers they need during the day since other classes occupy the rooms. (A similar issue will be noted for the Fiber Department: You can't always get to the work table because a class is in the room). For animation, meanwhile, students would like more cutting-edge software.

"The teacher has to show things from YouTube," a young man goes on. "Is it possible for the department to get its own copies of these animated films?"

Indeed, its video library is chockfull, but it seems hard to keep up with all the new (or old) releases. Much of what follows is student concerns about time and space—having studios open overnight, and having more space to work in.

"More metal shop space, fabrication space, would be good," says someone from Environmental Design.

For art schools in particular, space is always a challenge. Also, art students are night owls. They have assignments due in the morning. Over in Interdisciplinary Sculpture, students say it can take half the night to install a sculpture for class the next day; their petition has 122 signatures requesting all-night access to the Station Building. (Everywhere on campus, buildings are closed to trim electricity and security guard budgets).

Before meeting today, Meghann talked to the head of security about the official 2:00 a.m. closing times at all buildings. "Students are not supposed to be kicked out before that," she reports. "Please, politely tell the guard that you're allowed to stay 'til two, but please, leave promptly at two." And don't be rude. "The guard has to lock up and get home."

Then from the Painting Department comes this: "We really would like the sinks unblocked. And we also need more paper towels in the classrooms." Naturally, the janitorial staff has its own view of how students maintain the classrooms. Students pour paint down the drain when they are not supposed to. They leave mounds of detritus behind, including food wrappers and abandoned canvases. The school seeks a balance, of course. The SVA meeting is one place to work on that.

Before today's SVA meeting is over, the department representatives also voice their concerns about a more intangible reality on campus: department status. Each department wants to show the flag. Even Meghann feels that her department, the Master of Arts in Teaching (MAT) program, is almost invisible. "We'd like more publicity on campus," she says, speaking as representative for the MAT.

For many departments, showing the flag means having more exhibit space. The Drawing Department feels doubly inconspicuous. They do not have their own chairman, but share one with General Fine Arts. "We feel this does not give us the presence we deserve," a Drawing major says. "We'd also like a bigger show at the end of the year for sophomores and juniors." (At the Department of Exhibitions, however, they point to an eleven-page schedule, printed on goldenrod paper: Every space on campus is booked every single day of the year). Even at a campus like MICA, with large facilities and more coming, exhibition space is finite and runs out pretty quickly.

A student from the liberal arts department speaks for many when she says that students want "more accurate course descriptions." There's no clear data on whether this applies to studio classes or the liberal arts courses. The upshot, one representative says, is that students often choose a course by the catalogue, but then drop out the first week, when the syllabus and course are different than expected.

This is a topic that Meghann will take to a Faculty Assembly meeting in the future, not her favorite job, but her duty. She is part of the student-faculty feedback system, just as Gerald Ross is part of a staff-faculty feedback. In both cases, someone has to do it. This fall, Ross will go before the Faculty Assembly to remark on the low response rate to the annual Faculty Exhibition. "I'm not looking forward to it," says Ross, dutiful as well.[5] In doing this, both Meghann and Ross are public servants, helping communication flow, a sometimes thankless job, but a necessary one even in the art world.

After the Academic Affairs Council meeting, Meghann is back at her computer, sending out happier news on her next SVA blog. It's another reminder about the Christmas Art Market, now in its third year. "Art Market is a glorious event that became even more *amazing* last fall semester," Meghann reports. "It is where students can sell their artwork/crafts/various handmade items through MICA and make an awesome profit. It is a professional event, complete with business cards, artist statements, resumés, and packaging." The school takes 15 percent of the profits and uses that for three scholarships for three students. That's about $2,500 each.

"Awesome, no?" Meghann writes.

[]

For the past few decades, the byword at MICA has been expansion. Thus, gallery space has become a game of musical chairs. It's been fairly stable for a few years now, says Ross, head of Exhibitions, but it was not always so. At one time, the Main Building was the only art museum in Baltimore. After the school bought and renovated the old Mount Royal Station in the late 1960s, its ornate lobby became a campus art gallery. Back then, the Station was the hub of campus life. It centralized the social life of the entire art school, including exhibits and their boisterous opening receptions.

Then in 1980, the school opened the Fox Building. It used to be the four-story Cannon Shoe factory, but after three years of renovation, it became a spacious art-school facility. After a successful capital campaign in 2000, the school embarked on building the high-tech Brown Center, which along with the Fox building and a campus green, became the heart of MICA. With each new building, of course, new names are added across to the campus, a rolling history of donors and their visions to improve the art school.[6]

It also re-jiggers the gallery experience, with trade-offs of all kinds, says Ross. "It's totally complicated." The public used to flock to the main gallery down at the Station Building. "Everybody knew where to go," he says. But now, it's hard to find the main galleries. Not only are they tucked inside the Fox Building, they are surrounded by a fast-food cafe, with all of its fast-food clutter.

[]

Around this time, as the calendar year is ending, the local newspapers and magazines—*Baltimore Sun*, *City Paper*, *The Urbanite*, and various Web sites—are taking stock of the best art events of the year. In its coverage of "The Year in Visual Arts," the scrappy *City Paper* prefaced its top-ten picks with this economic analysis of a year hit by the Recession, an economic downturn not yet over:

> The past 12 months really delivered a blow to the arts—you know, the stuff and ideas that comes from that creative part of the mammalian brain that, in part, is what makes us human . . . [E]ven when American art world times were ostensibly flush, Baltimore—from the Baltimore Museum of Art to the MICA undergrads improvising an exhibition space in an inexpensive studio—was lean. Local artists have been doing more with less since before the BFA graduating class of 2009 was born. No money, no problem—they'll find a way.[7]

The paper commences to announce that a MICA exhibit, curated by Ross and students in the Exhibition Development Seminar, is best of the year in the entire region. The MICA campus exhibit was of Laure Drogoul, a native of Baltimore and graduate of the Rinehart School of Sculpture.

It was "rollicking, flamboyant, and sprawling," says the *City Paper*. It included twenty-five years of Drogoul's work. It was so large and delicate to install that it filled the Fox Building's two main galleries corner to corner. If the exhibit title — "Follies, Predicaments and Other Conundrums" — was not avant-garde enough, the names of her individual works were sure to bemuse, including titles such as, "She Pod of Rotten Enchantment" or "Workshop of Filthy Creation."

The *City Paper*'s top-ten list is a fair survey of the art museums, galleries, and art "spaces" in Baltimore, many of the spaces "alternative," the scene of the most avant-garde artworks. Over at Park School, the "If I Didn't Care" exhibit showed works by about thirty female artists of different races and ethnicities, ranging from ages thirty to ninety, an intergenerational exploration of "stereotypes, customs, and unique cultural phenomena . . . part of a larger dialogue about using art to express one's heritage, gender, and identity." That is No. 2.

To follow in rank is the Current Gallery, which put up the "Abandon Ship" exhibit of artworks, which were rapidly destroyed as city wrecking crews demolished the Calvert Street gallery building itself. Then comes Gallery Four, with space in the artist-loft H&H Building; the four artists on display, says *City Paper*, "make shit that looks cool." After that are shows at Area 405's oily warehouse (a former brewery), Towson University's immaculate galleries, a traveling show that came through the University of Maryland Baltimore Campus's Center for Art and Visual Culture, works at the Creative Alliance at the Patterson Theater, art on the second floor of Load of Fun (a scene of cabaret), and finally a retrospective of MICA faculty member Johlyne Smail at the commercial gallery Goya Contemporary.

What links this diverse selection is obviously not the kind of gallery, or whether works are for sale. They are united by being "curated," a topic, as it happens, that art history professor Kerr Houston is taking up right now in his class across campus.

Gathered in the Bunting Building, the class is Introduction to Art Criticism, and Houston has just put up an image on the projection screen. It's a picture of seven smiling people, men and women, of a few different races. They are all curators, a rising fixture of the art world. Each of them was a curator at Documenta 11, the international contemporary art exhibit, an exhibition that sets trends, which runs for one hundred days

every five years in Kassel, Germany. Curators are the new "culture brokers," the artistic director of that Documenta says.

With this slide, Houston makes the same point. "Curators, to a certain extent, are replacing the art critics."[8] Some in the art world will say that the changing of the guard has already taken place. In this popular course, Houston's upper-level students have seen how critics over the centuries, from Denis Diderot at the eighteenth century Paris Salon exhibits down to the present, have labeled art and its movements.

Critics writing in art magazines and journals used to label entire art movements with names they coined—terms such as surrealism, orphism, cubism, fauvism, abstract expressionism, action painting, pop art, kitsch, post-painterly abstraction, hard-edged painting—and just about every other name in today's art history books. However, that power of the art writer—to name trends, or make or break artists—has declined. In their place has arisen a new gatekeeper: the curator. For example, the "catalogue essay" written by curators is now shaping art interpretation, taking the role away from the art critics (in their magazine or journal reviews).[9]

No wonder, then, that when MICA hired a "Curator-in-Residence" in the 1990s, his essential task was to create a curatorial program to train students and help MICA have an impact on the Baltimore art scene. He was George Ciscle, founder of the Contemporary Museum in Baltimore. Ciscle, in cooperation with the Department of Exhibitions and various faculty, has run the Exhibition Development Seminar, a student course, since 1997 (and next year it will offer a master's degree in Curatorial Practice and Social Design).

At MICA, curation projects have swung between activist social issues and mind-boggling aesthetics. In 2007, it hosted the "Black Panther Rank and File" art exhibit and symposium (provoking some faculty dissent), and indeed the Contemporary Museum, with which MICA has often worked, was founded in recognition of the 1989 "Day Without Art," a movement publicizing the death of gay artists from AIDS. In 1999, Ciscle's students challenged the staid ethos of the Baltimore Museum of Art (BMA), helping organize an exhibit, "Kickin' It with the Old Masters," that featured mixed-media by black artist Joyce J. Scott (a 1970 MICA graduate). The exhibit reportedly drew a hundred thousand visitors to the museum and, for a blue-collar city that is mostly black, reportedly altered the image of the

BMA, changing it from an uptown monument to Matisse collections into a pop venue for public school field trips and kids.

In recent years at MICA, the Exhibition Development Seminar's curation projects generally have been about problems of racism. For those who say "all art is political," curation and exhibits have always contained that element. For contemporary art curation, however, the seminal event is probably the Whitney Biennial of 1993. Its four curators dramatically inserted the theme of "multiculturalism" into the elite art world. About a decade earlier, in 1985, the Guerilla Girls were outside a New York City museum protesting its curatorial practices; they protested that the Museum of Modern Art's exhibit, "International Survey of Painting and Sculpture," included just thirteen women among the 169 artists. Their protest banner read, "Do women have to be naked to get into the Met. Museum?" (referring to paintings of nudes). At the 1993 Whitney, the protest was from the inside, from the curatorial management itself. Visitors to the event were given an admission lapel pin that bore, in a cryptic way, part of the phrase, "I can't imagine ever wanting to be white."

These two iconic events (among so many) illustrate, of course, the power of curators to make social statements (as well as design art shows). Beyond MICA's borders, the big curation event of the school year will be yet another Whitney Biennial of contemporary art, to which many of the students will travel.

The curator of this year's Whitney Biennial has already been drawn into a social controversy, an international debate over curation. For the Whitney exhibit, Italian art curator Francesco Bonami has promised to present the most cutting-edge work, fifty-five artists whose work reflects "the cultural, political, and social moment." However, over in Italy, there is a major distraction for Italian art experts like Bonami. The government has just chosen Vittorio Sgarbi, a traditionalist, to curate the Italian Pavilion at next year's Venice Biennale (a bigger curation event than even the Whitney).

To mock the avant-garde, the traditionalist Sgarbi says he might stock the Italian Pavilion with Renaissance paintings. Naturally, Bonami is incensed, likening Sgarbi to an art terrorist. "Contemporary art is to Sgarbi what America is to Bin Laden," Bonami, the Whitney curator, says. He adds that the traditionalist throwback in Italy will be suicide for its art

scene. In Italy, Sgarbi seems to enjoy the hue and cry of the avant-garde.
He says he might leave the Italy Pavilion empty, with only an address book
of Italian artists: "I may also just include a single artist such as Saturnino
Gatti, a 15th-century master who has been erased from art history, making
him really contemporary."[10]

Thus is the prominence of curators today to define the art scene, raise
an international debate, and make art history.

On the MICA campus, students such as Calvin Blue are keeping their
minds on a more practical side of curation. For his work-study job, he's
one of twenty students on duty for the Department of Exhibitions, patch-
ing walls, carrying ladders, peeling off the black plastic lettering that
creates the signage for each campus show. Not a few of Gerald Ross's
work-study force take an interest in studying curation, he says.

Another outlet for curation training is the three student-run galleries,
spaces overseen by Student Activities. These are small rooms with rotating
shows that are "student run, student juried." Each semester a jury panel
of students, with faculty advisors, review student requests to present a
show. In the Piano Gallery (which has a piano) by the Meyerhoff Dining
Hall, Michelle Gomez, a Miami native, curates a show on erotic art, "Aph-
rodisiac." She is also editor of the campus circular MICArotica. Michelle
says that erotic art at MICA is not necessarily preparing students to work
at adult magazines or produce the "good pornography" seen in a booming
graphic novel industry. She says it's purely artistic "self-indulgence."[11]
Part of that indulgence is to curate a show.

When Cameron Bailey thinks of curation, he is not exactly keen on
modern art, or what is showing on campus in terms of the award-winning
"follies" and "conundrums." He has chosen curatorial studies as a "con-
centration" (the term for a minor in a liberal art topic). At this point, he
likes old-fashioned old masters art. He has not yet made the scene at the
avant-garde Area 405, for example. He loved his field trips to the Walters
and the National Museum of Art in Washington, D.C., where an older
breed of curators have laid out a feast of traditional artworks.

[]

As November passes by, leaving naked branches and brown leaves on
the campus landscape, a crucial meeting takes place. It includes Ross's

staff and a group of faculty overseeing the seniors in each of the fourteen departments. Already on November 18, they are talking about the Commencement Exhibition. This is like the Venice Biennale of this art school, the three days next spring when the signature artwork of some 357 graduates will line every wall of every building on the main campus. They say it's anywhere from two to five miles of art, and takes three days to view. "It's like nothing else I've ever seen," says Ross.

The show is also a day of reckoning for seniors. Like the light at the end of the tunnel, it is a day that seniors, from Fine Arts generalist Jen Mussari to painters such as Sean Donovan, are working toward. It's already Thanksgiving time. The night falls early, as if there's less time in a day. None of these seniors necessarily have a "major body of work"—the core of their senior thesis—ready to display before the viewing public. At least Sean and his senior-painter friends know that when their work is done, they will be angling to get the main studio room on the first floor of the Main Building. It's a big room with a storied history. Most important, it's a room where they can hang large paintings in natural light, paintings seven feet on a side.

The variety of objects that must be displayed at the Commencement Exhibition is mind-boggling, even if paintings on canvas are pretty common. Nowadays, however, a new kind of canvas is nipping at the heels of the old cotton fabric kind, and is becoming a specialty of the new breed of curators as well. The new canvas is the computer screen.

DIGITAL TSUNAMI

On the second floor of the Brown Center, back in the corner, a row of Mac computer screens flicker. They sit on white pedestals like works of art, which in fact they are, a small exhibit titled "ss14: Sight Sound Interaction 4." Outside, the November winds and rain pelt the barren trees. Each day students bustle past the flickering screens. On a campus with six hundred white Mac computers sitting around, however, it's hard for a display like this to stand out, until you stop and really look.

In each of the nine computer artworks, the artists have tried to solve particular problems of software, images, and sound. They often ask viewers to roll up their sleeves and work as well, for the interaction might involve spending some time, reading a complex explanation, or pushing some buttons. The exhibit is put on by MICA's Interaction Design and Art Department, and the name is apt—*interaction* is the new buzz word in art and technology, and the heart of what the art world has now heralded as the age of "new media."

As the latest frontier in art, new media essentially means electronic, digital, and computer art. At MICA, while upper-level students can matriculate through Interaction Design and Art as a major, every freshman is also sent through an introductory new media course: Electronic Media and Culture, or EMAC. The course explores "the computer as the main creative vehicle" in art, and it prepares students for a world beyond the art studio, a world of rapid technological change.

"We have kids coming into EMAC now, and they don't remember life when there wasn't a computer screen," says Jason Sloan, organizer of "ss14" and a leading instructor in digital art on campus.[1]

On a Monday morning, about fifteen students in Sloan's EMAC class file in, put down their coats and bags, and start organizing their day around a computer screen. Each student has a Mac laptop, but Mac desktop computers also line the tables. When Liam Dunaway arrives, he takes his regular seat down a middle aisle, and Holden Brown settles in up front. They

are both in Sloan's advanced EMAC class for good reason: Liam is experienced in digital design; Holden in making videos. Out the back of the room, a wall of windows offers a view on urban Baltimore, a sea of brick buildings, the sky a pall of gray. The visual focus of EMAC, however, is the small computer screen and, at the front of class, a giant projection screen, which will be Sloan's tableau for teaching.

Throughout the semester, Sloan will do things on his computer that will show up on the giant screen. Students will watch as he zips through software uses, Web site construction, graphic effects, and scrolling through the Internet worlds of social networking, video, and the mental guts of the computer, which aficionados call "coding space." Then the students might try this on their own computers. When students begin projects, however, Sloan advises them to retain an age-old art practice, which is to put down ideas in little sketches first.

"The possibilities of what the computer can do are endless," Sloan says. "But sometimes without a direction, all these options can become overwhelming and in turn counterproductive."

Sloan organizes his semester around a morning-time historical tour of art and technology, with hands-on work coming later in the morning or afternoon. The hands-on projects are fine with Liam and Holden, but it's the morning lectures that have turned out to be the most fascinating.

A couple months into EMAC, Sloan is telling his students that they live in a special time in the art world. For the first time in forty years, the art world is experiencing a truly new genre, says Sloan, a trim athletic man in his thirties, dressed all in black—T-shirt, pants, sensible glasses, and spiked hair.

"It is happening right now," he says, the room dark for his slide projection. "We are living through a genre. Very seldom are we allowed to live through developing art history."

As he explains, the last great turning point in modern art was pop art. That was a time when commercial objects—such as Warhol's Brillo boxes or Roy Lichtenstein's comic strips—challenged abstract expressionism. Since then, there have been a few minor innovations. Artists have used videos or installations to produce art. However, these were not really revolutions.

"These were not really defining moments," Sloan says.

The computer as the new canvas.

In other words, installations and movies have been around for a century and more. What *is* entirely new, Sloan goes on, is the power of the Internet to bring a "network" to computer screens, connecting people in real time. In this turning point, "The work of art could not exist in any other way without the network."

The intellectual core of EMAC will be this tour of art history. At the turn of the twentieth century, futurists in Europe began to use experimental sound, and eventually film. At the Bauhaus (1919–1933), some of its staff experimented with little machines and flickering light. By eschewing traditional media, these experiments often allied themselves with the dada movement, which enjoyed combining photography and sound with absurdist and anarchic art forms. A later dada revival was called "Fluxus," after the word flux, which suited this approach to art and technology.

"I had no idea of how far back the history of digital art extended," Liam says, enjoying the survey. "The history of weird people doing weird things." [2]

Under the rubric of new media, today's contemporary art glossaries include "network art," "media art," "computer art," "sound art," "online art," and "video art." New media also includes "body art," in which artists use their bodies as the proverbial canvas, but need video to "document" what takes place, the body-theater, the acts of self-mutilation, or the use of electronic devices on the body to create a sci-fi drama.

The furthest along that Liam will go in body art is to pierce his lower

lip with a small ring. It's not for the girls, he says. "Just something different."

Eventually, Sloan gives his morning lectures on Internet security, surveillance, and networks, with a related assignment to follow. For this hands-on project, Liam turns to his Facebook page as the raw material. He extracts the faces from every photo in his iPhoto library, using face identification software. The result is thirty-five thousand images of faces, which he loads into Adobe flash, the basic animation software. Then he posts it on a Web site where the faces can run in succession, dozens at a second, forty-five minutes in all, then starting again.

"It's an overflow of images, a vibrating head structure," Liam says. For the patient observer, something solid appears. "If you focus on the eyes, everything around them changes. It had some interesting effects if you stare at it long enough." As a conceptual piece of art, it has also achieved a kind of digital "surveillance," having collected the faces of thirty-five thousand people without them knowing or consenting.

Even though Liam is considering a major in environmental design, he's definitely drawn to new media. He is even tempted to go into Interdisciplinary Sculpture, a world of electronics, video, environments, and performances. In time, he will be projecting a three-piece video image from his computer onto three pieces of framed glass that will be hanging from the ceiling. The video is heavily edited, erasing a human form pixel by pixel while leaving the clothing and actions intact—a video of a ghost. In his Drawing class, Liam, who already has acquired a strong taste for minimalist art, will fulfill a "light and dark" drawing assignment not with charcoal on paper, but by video shots of colorful neon tubes.

While Liam is still weighing his options for a major, Holden is certain as can be. He can barely wait to begin taking courses in his field of interest, filmmaking. Until that day comes (which is the next semester), the projects in EMAC are not capturing Holden's imagination as much as another freshman course, Sculptural Forms, where he also can use digital art. His teacher is Ben Luzzatto. Young and energetic, Luzzatto is a new media advocate, a conceptual artist who graduated from the art program at the Massachusetts Institute of Technology. This time around, Luzzatto has assigned his sculpture class to create an artwork about something *impossible*.

"Like jump across the ocean," Holden explains.³

For a few years already, Holden has been immersed in work with video. His prize-winning short movie, *Starmaker*, done in high school, was a feat of digital manipulation, what Holden calls his strong suit in video. "I can rely completely on the computer to make the visual effects to advance my story," he says.

Naturally, as Holden comes up with a concept for his "sculptural" work, he's wondering how to incorporate video as well. Soon enough, his idea springs from autobiography: During Hurricane Katrina, Holden and his family were evacuated from their New Orleans home. He was displaced by the ocean. "So I was thinking about the impossibility of becoming one with water," he says. "If I became part of the water I wouldn't be displaced." His impossibility is to become like water, rendering the hurricane harmless.

Holden soon gets to work in his dormroom at The Commons, his workshop. He inflates a six-foot-long pool, fills it with water, and lays back in it. His hair floats out like a halo. To record this work of art, the video camera is on, capturing what looks like Holden floating in the ocean, showing the impossibility of his becoming one with the water. (Soon after, much of the water has accidentally spilled on the floor). To add more detail to this first image, Holden overlays another, the foreground image of three water-filled mason jars. Each jar holds an insoluble element — bone, skin, and lard. His art piece is a sculpture, but recorded on video, edited and arranged by digital manipulation. He'll call the artwork *The Subtraction of Parts*. As he explains, "The idea was to subtract the parts of me that are not water, and try to dissolve them." Dissolving them, of course, is impossible, and hence his artistic solution to the class assignment.

By using a computer and video camera, Liam and Holden, each in their own way, have created what the new media regime calls "time-based" art. Curiously, neither of them have ever heard the term. For all the term's popularity in art journals, or among art faculty, its definition is by no means clear. Nonetheless, the use of "time-based" strongly suggests that new media is far more than mere electronics. It's also something philosophical, a new kind of art-world interpretation of "time" itself.

The simplest way to explain time-based art is to say that *time* is what makes something "four-dimensional art," that is 4D, not just 2D (a flat

painting) or 3D (a voluminous sculpture). At first blush, 4D can seem a pretty ordinary concept to require a new term. Nearly all art incorporates time. Cathedrals are built over centuries, paintings are done in weeks. Even the casual visitor to a museum pauses a few seconds to look at a picture.

So what is this *new* "time-based" art? Movies and theater are the closest approximation. Time-based art is video, Internet, and live performance, often with viewer participation. This time-involved interaction is what is *new* to the new media. None of this art has altered time, like a time machine or worm hole into another universe. More like experiencing "time fly," it simply plays on the slippery perceptions of time passing. That passage is also influenced by participation, the "now" experience of the interaction; the now experience of being in a "network." Finally, *time-based* art is part of the perpetual name-inventing that is the soul of contemporary art.

[]

As many art schools wrestle with how to shoehorn new media into the jammed Foundation Year requirements, or find the money for massive computer upgrades, MICA bit the bullet ten years ago. The EMAC course was designed and implemented when the Brown Center opened in 2003. It became a showcase of new technologies. The journey of MICA from pigments to pixels, and then to courses like EMAC and film and theatrical arts, is one that faculty and staff recall with pride, and a little pain as well.

In 1981, if you walked into the MICA bookstore, a brick storefront down by the Station Building, you would have found former graduate art student Tom Hyatt keeping inventory on IBM's first PC, just out. It was MICA's very first "desktop" computer. As manager of an art-school bookstore, Hyatt was far from the computer departments at research universities, but he soon learned of their innovations. It was those computer wonks who first toyed with weird "art" effects on computer screens.[4] Some of the wonks then cobbled together software and hardware to do graphic design. The Apple IIe computer was born in 1983, and immediately snapped up by MICA's graphic design section. The mouse-controlled computer was out the next year, and soon enough the mainstay software for serious

computer art—Illustrator (1988) and Photoshop (1990)—were flying off the store racks, if artists could afford them.

Affordability perpetuated the great chasm between art schools and industry. In Hollywood, for example, the idea of having scores of people hand-draw frames for animated cartoons was being retired by giant animation computers, powerful work stations that could produce 3D modeling, the beginning of 3D animation. The art schools were way behind, not only because of funds, but for fear of buying equipment and software that would soon be outmoded, so rapid was the digital revolution in the 1980s and 1990s.

At MICA, a few people had their fingers in the digital wind—people like Hyatt, graphic designer instructor Lew Fifield, and sculptor Richard Lipscher—so the art school was relatively far ahead for its size.

"Almost as soon as they came out, we went for them," Hyatt says of the school's attempt to buy at least one of each new upgraded computer. "On the fine arts side, nobody thought this technology would have a role in art; it was simply graphic design."[5]

In the campus studios, as Fifield moved ahead with the 2D graphic design work, Lipscher, who arrived in 1986, began to explore the 3D powers of the computer. He bought a computer to write a paper, and then said, "What kind of art can I do on this?"[6] An acquaintance of his, a Westinghouse scientist, showed Lipscher what he could do: He gave Lipscher his first copy of Design CAD-3D, which modeled three-dimensional shapes on a computer. The software was also the first hint on MICA's campus of 3D animation (In 2D animation, students still made hand drawings and photographed them one by one, though the video software Flash soon made the process easier).

One day, in the mid-1990s, twenty computer work stations arrived at MICA. Under the Department of Education's Title III program, the school had received a grant to use computers to teach writing, which the school did. However, Lipscher also loaded the computers with his newest modeling software, 3D Studio Max. "This was the first computer, fine-art oriented lab on campus," says Hyatt, who had the next thing to figure out, and that was the Internet.

As the "computer guy," Hyatt doubled as Internet guru, learning at nearby universities, tying the school phone cabling system into servers.

The technology was going faster than the traditional art faculty could adapt, and one of the obvious challenges was to persuade them, one by one, to own and use a computer. The revolution became official at a "big meeting" in 1997, held by Hyatt (now director of computer technology), and academic dean Ray Allen (recently returned to MICA after being dean at a Maine art college). In short, the school, known for its fine arts curriculum, decided that it was time to invest in the digital revolution.[7] From that year, MICA offered a master's degree in digital art. In 2000 it launched its EMAC course and electives in animation and video.

Compared to the commercial industry, from New York to Hollywood, MICA was a late arriver, but it was early on the scene among art schools. Today, every art college and art department is being forced to decide about the kind of digital art requirement to put in a Foundation Year, a year already chockfull of basic courses. They are also being forced to consider how much software and technological know-how to squeeze into the minds of art students, from Web site software to video cameras.

At MICA, an average EMAC class is awash in such tools. Not every student enjoys the feast of technology, however, and that may be one reason EMAC is the least liked class among freshman, according to one campus survey.[8] Year by year, the technology will separate the students as sheep and goats (or goats and sheep, depending on your point of view). One group will attach to computers, another will eschew them.

Either way, the campus is equipped to introduce students to as many tools as possible, including the more specialized, such as laser cutters, giant fabric printers, and 3D printers.[9] Nonetheless, there are limits to what an art school can offer in comparison to the wider world of the digital revolution. MICA has eighty "smart" classrooms—equipped with sound, projection, and wireless connections. However, the cyber world beyond is far more vast—and it is competing daily for student attention (as when students surf the Internet in class rather than listen to their teacher). This allure beyond the classroom is the world of search engines and social networks: Google, Facebook, YouTube, and Twitter. MICA tries to stay ahead of the curve, but there is really no keeping up, since digital innovation is so rapid.

"Students expect the best technology, as if things have always been this way," say Hyatt, recalling the "old days" fifteen years earlier. Students can easily be critical of not having the *latest* of everything.

Over in animation, Lipscher knows the student grievance about software intimately. He knew that MICA was a fine arts school, not a Disney Studio. So when 3D animation was offered, it was under the rubric "experimental animation," with an emphasis on experimental, not commercial or professional. "An artist is always going to struggle with not enough materials," Lipscher says. "So you've got to be more creative." At MICA, they've always done more with less. In a digital age, it is almost impossible to tell that to students and their parents. The students, who see the latest work on YouTube, not to mention the latest Pixar or Disney movie, come to class and ask for software to do what Disney is doing.

"Can we do this?" a student asks, pointing to the newest industry visual effects.

"No," says Lipscher, pointing to his department's standard software. "You can learn everything on 3D Studio Max."

On reflection, Lipscher adds further, "If students have drawing skills, painting skills, understand 3D and are not afraid of a computer, able to move on to the next program, and show all this in a portfolio, they will get a job just like everybody else will."

The digital world of art, like the dot-com world, is also prone to bubbles. In the early 2000s, Hunt Valley, a rural town turned industrial park north of Baltimore, became one of the fastest-growing centers for designing computer games. At the ground floor, in fact, was a group of talented illustrators who graduated from MICA. It seemed like a boom. As the interest in a gaming major grew at MICA, so did classroom exchanges with Hunt Valley companies, such as Big Huge Games. Then the bubble burst, nationally and then locally. Big Huge Games nearly went out of business. Today, MICA does not have a gaming major, though as Lipscher argues, it teaches the necessary skills, those of drawing and software use. The school *might* have invested heavily in gaming, suffering the burst bubble along with the industry.

[]

The turbulence of computer industry bubbles should not deter MICA from moving in that direction, according to the digital visionaries on campus, which includes Sloan. He and others don't see how students can keep up with the digital revolution in art if they don't learn to do computer

coding itself, entering what is called "coding space." Up until now, Sloan says, artists could rely on software to do all the work. Using software is like driving a car: Push the accelerator, and it goes. "Now you have to go under the hood," Sloan says. "You have to go under the hood and teach the code, the underlying architecture." He has another favorite analogy: The old software was like buying a pre-stretched canvas; the future of digital art is like stretching your own.

In the more advanced classes at MICA, some of this "going under the hood" is taking place. In some graphic design courses, for example, students are learning how tweaking the computer code can produce visual effects in computer graphics.

This afternoon, graphic design major Meghann Harris, her Mac computer under her arm, is headed for the third floor of the glass cube, the world of the Brown Center, with its glass, cement, steel pipes, and white Mac computer screens everywhere. Today, her Flexible Design Studio I class is in the process of re-designing one of the most popular games on Facebook, the world's most popular social network site on the Internet.

The game is FarmVille and Meghann's teacher, Dan Halka, is art director at Zynga, the company that owns and markets the game (among many others). FarmVille is a pleasurable pastime, a game of growing crops, exchanging supplies, and going to market.

As the class begins, Halka says, "FarmVille is a kind of kooky, cartoony world."

Yet happily for a company such as Zynga, Farmville is also an Internet phenomenon, since tens of millions of people of all ages are playing the game online. Still, Halka has assigned his students to enter the "coding" world of Farmville. By toying with the code — computer language that determines the imagery on the computer screen — his students must make Farmville's graphics look better, enhancing what he calls the "polish-level stuff."

Now it is Meghann's turn to show what she's done in the coding world. Her analysis, well spoken, flows quickly, precisely, as her improved version is flashing on the projection screen in a darkened classroom. As Halka intends, these kinds of class presentations are also training. They are good practice for the day you go into the job market.

"Legibility was an issue for me because of the cartoony typeface,"

Meghann says of FarmVille.[10] "The typeface should be playful, but at times it gets blurry."

By tinkering with the graphic codes, she's produced an alternative typeface, new icons, and more convenient menu (the panel that provides the buttons for doing things). She also adds a "zoom in" and "zoom out" feature so the space on the computer screen can be used profitably. She is also thinking of the audience, a wide range of age groups. "I changed the icons to silhouettes to speak to an adult, but also the childish crowd," Meghann says, and of course she has picked a typeface that is "playful, but also easy to read with a decent line weight."

Other young artists who trained at MICA are probing "coding space" more deeply. Nearly a year ago, Jonnie Hallman (boyfriend of Jen Mussari) was sitting in a MICA classroom, earning his degree in graphic design. Now he is a former student, an art-and-computer designer for Adobe, the art software company.[11] Never interested in games, Jonnie nevertheless was interested in how computer code makes visual things happen on the computer screen — mostly on his own time. His job at Adobe is working in its "experience design" section, the "X-D Team."

Until he and Jen move to San Francisco, where he'll work in one of Adobe's home offices, Jonnie is sitting in front of his laptop at a home office, every day going "under the hood" of the digital world. He lives on Charles Streets, jut a few blocks from MICA. Though trained in the fine arts, Jonnie has a Web site and blog in which he talks with hundreds of other art-and-computer entrepreneurs on how to improve "apps," or applications, the little visual icons or boxes on computer screens where users enter online services such as e-mail, Twitter, Flickr, social networks, magazines, or games. As Jonnie reports one day, in both prose and computer code:

> I'm always looking for ways to improve performance in my apps. One aspect that has always been in the back of my mind, but never implemented, is an improved scrolling technique.
>
> ```
> // bounds:Rectangle = new Rectangle (0, 0, _Area.width, _Area.height);
> bounds.y = (_Content.height - _Area.height) * _Scroller.value;
> _Content.scrollRect = bounds;
> $itemHeight = 50;
> ```

```
$visibleItems = Math.round (_Area.height / $itemHeight);
$invisibleItems = _data.length - $visibleItems;
$A = _items.length;
for ($a = 0; $a < $A; $a++) {
```

As a MICA student, Jonnie had to learn about going under the hood mostly for himself. The time and patience required is what prompts many art students to lose interest. "MICA is not a programming school, it's not a computer school at all," Jonnie says. Luckily for him, his instructors saw his ken for digital work, especially after he won the annual Adobe "Designer Developer Collaboration" award at the start of his senior year. So MICA let him design his own major, called "digital design," and he worked mostly off campus, at his local design-firm job, mastering coding space.

On his blog, Jonnie is reporting that in design and coding, there is always a tradeoff between making a computer image "pretty" and making it fast; to make it prettier, the computer might work slower, and visa versa. In fact, this has become Jonnie's specialty, and why Adobe values him: as a designer, he is good at "optimization." That means the best look at the best speed, and it is this combination that is driving competition among the popular mobile devices of the age, gizmos such as smart phones, tablet computers, and laptops. All of these have much deeper coding systems than the mere apps, systems *way* under the hood, which are trade secrets, controlled by the big industries themselves, Titans like Apple, Microsoft, Adobe, and many others. However, designers like Jonnie can at least work at the app level, just under the hood.

Using this approach, Jonnie redesigned apps for Flickr and Twitter. His design "look" is the dark-gray screen (not glaring white), and attractive ways to drag and organize images or incoming information (such as message "tweets" or e-mails). In fact, his designs quickly earned him an Internet reputation (and landed him the Adobe job). His Internet presence also has been enhanced by his own artist-programmer identity: He calls his Web site "DestroyToday," an ironic version of the Latin phrase *carpe diem*, or "seize the day."

"To destroy today is to make the most of the day—destruction as a form of creation," Jonnie explains to his growing number of Web site visitors.

Until the day he flies to San Francisco, he's typing out line after line of

code, sharing the insights with a community of computer code lovers not limited by geography. One fall day, his wrists slightly aching, he types out:

> Programming is exhausting, especially if you type more than you have to. I'm always looking for ways to improve performance. . . . Sure, you can program a function that cuts a few milliseconds off your previous method, but if it's not as legible, it might not be worth it.

When it comes to artists entering coding space, there is no more ardent a visionary at MICA than Jamy Sheridan, who, like Sloan, teaches both EMAC and advanced digital art classes at MICA. According to these two digital guys, coding space is deeper than most art schools can imagine. Young artists must take gradual steps, of course, but they must be steered in the right direction, toward the world of computer language, which is the future, according to Sheridan, who uses computer algorithms to produce 3D shapes in animation courses.

"Computers are places where language lives, and that is more than a metaphor," he says. "Computers act independently of human consciousness."[12]

Sheridan is not proposing that computer software, and the global electronic networks it creates, is actually *alive* (but, on the other hand, maybe so). He is saying that the language of code is going to shape all of life one day. So the artist's mission — as compared to the scientist's — is to imagine, creatively, how the "coding space" will be felt, perceived, and applied. "Art-think is the engagement with the world before the concepts are truly formulated," says Sheridan, who sits on a national commission for arts multimedia in higher education.[13] "As the social structure changes, the role of art changes. . . . The changes are largely code-based."

Sheridan and Sloan, as advocates of new media and coding space, have no doubt that art schools should throw their resources in that direction, given the rapid pace of technological change. For MICA to upgrade its computer-and-art field, it will have to invest time and money. The money will have to go to new staff, equipment, and departments. The time would go to the teachers, who say it takes "free time" to do serious new research. In the great Bauhaus tradition, Sloan and Sheridan call this "play." In any field, including computers and art, the artists need time to

experiment, to see what happens. That's how children learn, Sheridan says. "What if I told you we'd have no more sand boxes. No swings and no slides; no pools, no weekends?" Play is not a luxury, he insists, but part of grownup learning. Politicians, the military, and economists have think tanks where smart people play all day long, seeing what can happen. Why not art schools? "If you don't invest in it, you get what you are paying for" — and he forecasts the unfortunate result that art teachers will be way behind their students. Art schools will lag behind entrepreneurs in producing creative uses of the computer.

When described by computer visionaries, digital art can sound like more than just science fiction. It can sound almost apocalyptic. Sheridan asks in closing: "Who will educate the next generation of designers when that wall over there is a transparent video screen, which is already happening?"

[]

It's a breezy November afternoon and Amelia Beiderwell, happily free of such futuristic questions, is walking up Mount Royal Avenue, enjoying what's left of the fall colors. She is heading into another kind of high-tech world, the "black box" theater at the Gateway, which sits at the north end of campus. The BBox is the cutting edge in all-purpose modern theaters, a giant space (painted black) with the potential to be anything from a Shakespearean stage to the scene of a disco concert (or a Haunted House Club thrill ride).

As a sculptor, Amelia began her artwork before the digital revolution. She's a maven of older technology, which includes the soft technology of fabrics. Walking to the BBox, Amelia is planning to offer her services as a costume designer for the annual theater production this year, *A Midsummer Night's Dream*, the classic Shakespeare romantic comedy. Those who want to act or play instruments in the production will audition. Those who will make the art, such as sets or costumes, will present their resumés in an interview, and Amelia is preparing for this.

As a transfer student, Amelia has also been required to take an EMAC class. She brings a unique perspective to that world of digital art and performance. For some students, the history of "new media" raises questions about the distinction between performance art and traditional theatrical

presentations. This blurring takes place because of the emergence of "happenings," a spontaneous kind of performance that was designated a new art form in the 1960s. A happening is "unlike a stage play," explains the movement's first leader, Allan Kaprow. "The Happening is performed according to plan but without rehearsal, audience, or repetition. It is art but seems closer to life."[14]

For Amelia, the differences between various kinds of performance are pretty clear. For one thing, she has been a costume director at community college plays; these are stage plays. If anything is a stage play, it's Shakespeare's *A Midsummer Night's Dream*, typically the number one choice of American high school theater departments. However, in the rarified art world, the lines are always shifting. The idea of *performance* is now a leading definition of art in the avant-garde. Amelia is learning this as well, and perhaps for the first time. In her Performance Garment class, for example, she is making garments for entirely experimental art, something akin to happenings, not something she had done during her theater work at a community college.

As MICA prepares to put on the second theater production in the school's history—the first came the previous year with the rock musical *Hair*—it is presenting it as a kind of "total art," which is another historical genre that seems to overlap with new media. To put on the play, MICA's liberal arts department offers a course, The Play's the Thing, which gives credits and thus generates the student manpower. In putting on a play, the course combines every skill in art, "from costume design to painting, environmental design to performance, sculpture to the study of literature, illustration to graphic design"—a pretty good definition of total art.[15]

Amelia has an impressive resumé when it comes to college theater productions. As the actors are having their auditions videotaped, she sits down for her interview with one of the production leaders.

"I've had experience as a lead costume designer," Amelia says. That was at a community college that actually had a theater department with full costume racks, work space, and years of the campus tradition. At MICA, however, it's all new. For this reason, Amelia didn't present herself as wanting to lead the costuming, and it was just as well that another young woman, a senior in fabrics, could put that role on her graduating resumé.

"This is basically the first show," Amelia says later, reflecting on how it's just fine to be assistant costumer this time around. "They are still figuring out how everything is going to work."[16] The next term, in fact, she will be improving on her costuming skills when she takes a course in Garment Production and Design, which includes a strong element of professional tailoring.

A few weeks later, the actors and staff for the play are chosen. They arrive at the BBox, a giant black space with bleachers, and the building-up of camaraderie in this new theater troupe begins. About fifty students will put their shoulders to the task, earning two semesters of credit, and a select group of them have been chosen to play the twenty-one stage characters. The mechanics of the production are becoming clearer. At the end of March, the play will begin its performances at the BBox, sell tickets, and operate on a budget of about $50,000.

As winter break approaches, the twenty-one actors are informed that they'll have some work to do during their holiday.

"Everyone go home and learn your parts," the producer says.

The memorization could almost be imagined as code that will be loaded into the minds of the cast; each knowing his or her part, spoken lines and well-timed gestures. The play also includes a good deal of visual artwork. These staff members must publicize the play, decorate the theater, and create the stage's atmosphere. That means posters, Web sites, stage scenery, lighting, and props.

It also means creating forty-one costumes. "All from scratch," says Amelia.

ART MARKET MONSTER

Down at the Station Building, where the great clock tower is keeping time, the thoughts of a group of graduate-level sculpture students are far from Shakespeare. Their minds are on Miami. During this first week of December, Miami is the scene of the largest art fair in North America, Art Basel Miami Beach, which also draws fourteen other "satellite" fairs. All together, they bring fifty thousand potential art buyers to Miami, millionaire collectors to the VIP lounges and ordinary art lovers to the sun-baked streets and white-tent pavilions.

On Tuesday, without ceremony, Calder Brannock steers his old maroon-and-white GMC pickup across the cobblestone parking lot of the Station Building. He bumps through Baltimore and catches the freeway south. Behind him, his truck is towing a 1967 Yellowstone Camper, dull silver. Inside, however, it sparkles. Calder has turned it into a white cube mini-gallery on wheels, calling it "Camper Contemporary."

Calder and a fellow student at MICA's Rinehart School of Sculpture, Ben Kelly, are co-driving the truck. The rest of their co-conspirators (nine more Rinehart students) will meet them in Miami's art district. Although Art Basel Miami Beach is across the waterway at the Miami Beach Convention Center, the city's So-Ho-type start-up is the Miami Design District, a strip of palm tree lots and warehouses running south through the Wynwood neighborhood. "This is the only time the nice people are around," a cab driver says of the one-week art season.[1] Thousands of Miami Beach visitors shuttle over to Wynwood to sample the less-expensive satellite fairs, held in white-tent pavilions, arenas, and warehouses.

The second largest of these satellites is Red Dot, a well-attended fair named for the sticker put on works when they are sold. By Thursday, Camper Contemporary is parked in front of Red Dot, getting attention, especially since the MICA students all wear blue jump suits. They put up a sandwich-board sign and a flag, which snaps in the wind with the words "Too Big to Fail." Inside is a selection of mostly student artwork, ceramics, photos, art books, an oil painting, conceptual-type thingamajigs. Soon

enough, the Miami police move them on. Fortunately, they have met organizers of the Aqua exhibit, several blocks down on a warehouse street. "Everyone going to Aqua has to pass by our camper," says Calder. "So it really works out." [2] Aqua will be Camper Contemporary's home for the next three days, and besides steady foot traffic, four hundred people inquire at the Camper Contemporary Web site.

This is Art Basel Miami Beach's eighth year, and it is drawing collectors from around the world. In recent years, art fairs have been eclipsing the gallery world as a venue for annual sales of "contemporary" art, which may include modernist art from the twentieth century, but typically is art produced after 1970. For collectors, the art fair is one-stop shopping, an easier and more festive arrangement than visiting dozens of galleries separately.

Although many galleries report "fair fatigue," since the number of fairs is increasing, they continue to be the best venues for contacts and sales. In many cases, fairs produce the bulk of annual sales at a gallery. Despite the hassle, the art fair — like the shopping mall or Internet — has a big future. They now account for a third of the $20 billion that circulates in contemporary art sales worldwide each year (with the other two-thirds split between auction houses and some 17,000 walk-in art galleries). [3]

As a new graduate student, Calder saw how difficult it can be for a walk-in gallery to succeed. He worked at the Fraser Gallery outside Washington, D.C., and the previous year he manned a Fraser exhibit at one of the Miami satellites, the Bridge fair. In Miami, the scales fell from his eyes: He saw as much traffic in three days as the entire year at a storefront gallery, where rents are high and good addresses hard to find. One summer, Calder joked to a fellow art student about how the only way to kill the overhead is to sell your art out of an old camper. When he checked craigslist, and found a road-worthy Yellowstone Camper for $200, the temptation was too great. Driving around selling art from campers, or holding art-and-book events in trailer road shows, is not new. However, at Calder's scale — housing a white cube gallery in a Yellowstone at Art Basel Miami Beach — the mobility is novel.

The previous year, Calder and others from Rinehart went to the big Armory art fair in New York City, where they walked around in blue jump suits, sparking conversations and gathering invitations to insider

Camper Contemporary in Miami — too big to fail.

art parties. This year, for Miami, Calder is thinking more seriously about commerce and curation. One day he hopes to run a gallery, even revolutionize the art market. "I think the camper is a critique of the fair system," he says. "You're paying for all this booth space, and we're coming down with an alternative space. But I wouldn't say it is a negative critique. I'm a huge fan of commerce in art. This is just sort of a different way, a humorous way."

[]

Tycoons and heiresses have always bought art. Near the end of the Gilded Age in America, the English art dealer Joseph Henry Duveen put it this way: "Europe has plenty of art, while America has plenty of money and large empty mansions, and I bring them together."[4] Now there is an entire system that brings them together. At the pinnacle of this system is a handful of the most famous and powerful art gatekeepers, individuals who, all at once, own galleries, deal art, and collect art — names such as Marlborough, Saatchi, Boone, Gargosian, Castelli. From the pinnacle on down, the system is a sociological and economic creature, a chain of gatekeepers, all of whom determine which art is "good," and thus worth buying.[5]

In the 1970s, the auction houses, which formerly had sold only antiques, diamonds, and old masters, tapped into contemporary art — works

done by living artists—and learned that they could create a market every bit as speculative as real estate or stocks. The classic story is the 1973 "Robert C. Scull auction," an event following a messy divorce that required a wealthy "hippy" collector in Manhattan to put his 1960s works—neo-dada and pop art mostly—on the auction block. The market buzz was engineered just so, attracting collectors looking for good investments, since museums generally are conceded to have bought up all valuable old art. On the day of competitive bidding, the prices for the Scull art soared, rising into the tens of thousands of dollars, and Scull made a killing.[6]

Analysts today speak of the "Warhol economy," referring to the speculative rise of prices for pop art, fashion, and other art collectibles beginning in the 1970s.[7] In Miami, one Warhol is on show, the silkscreen *Mao*, tagged at $2.5 million (and later sold, perhaps to one of the new riche collectors in China, where ironic Mao art is big). Other works from the neo-dada and pop art era are in circulation as well. At the Galerie Thomas booth, a gallerist points to a Jim Dine pop art painting of a big red heart.

"This one is $3 million," he says. "It's from the sixties."[8]

Elsewhere, the Neo Rauch painting *Mars* (2002) goes for $1.25 million and a maquette by the sculptor Alexander Calder (*Plumeau Sioux*, 1969) for $1.4 million. An arrangement of neon (*Untitled [to Paddy]*), done by the minimalist artist Dan Flavin (admired by MICA freshman Liam Dunaway) sells for $350,000. Color prints by the English artist David Hockney are going for around $25,000 a piece. A drawing by the Russian-born sculptor Naum Gabo, *Linear Construction in Space No. 2*, fetches nearly $1 million. These works are called "blue chip," a term used in the stock market for stock that could always be sold for a little more. As the venerable British-run *Art Newspaper* headlines on the first day of Art Basel Miami Beach, "Brighter mood as blue-chip art finds buyers at Art Miami."[9]

A *Miami Herald* survey finds that most works are selling for under $150,000, and a few come in at $2,000.[10] These are the small ones, of course, or the ones by entirely new artists. In the main, however, Miami traffics in large pieces, the kind that only museums and collectors with warehouses can handle. According to one New York City agent, here to buy for her collector, when you have a warehouse and lots of money, the "addiction" to collecting is unstoppable. At this moment, she takes a digital photo of a piece she likes. It's a train schedule board painted black,

flipping randomly. Shortly after, she sends the digital image to her collector back in New York.

"He likes this sort of thing," she says. She'll recommend a buy.[11]

Throughout the Convention Center, well-dressed figures, debonair and pre-middle-aged, walk with older people, who typically are the collectors. This is the agent-collector team, and the agent is there to give advice on the best purchases, either by the artist's name or by the resale value of the investment.

As collectors look for a deal, the gallerists keep on eye on each other as well. They have been wheeling and dealing for years. On Wednesday morning, for example, as VIP collectors are being shown around before the public opening, a team of federal marshals makes its way through the main entrance. Showing badges, they breeze past security, glance into the Art Collectors Lounge, and head up Aisle B, entering the booth of Gmurzynska, an up-scale Swiss gallery. With a court order, they confiscate paintings worth $6 million—works by Edgar Degas, Yves Klein, Fernand Léger, and Joan Miró. "I selected four pictures and told the marshals what they were worth," says the owner of another galley, Edelman Arts Inc. in New York. Edelman had just won a court ruling in a dispute with Gmurzynska over damaged goods.[12] (A day later, the four paintings are returned after a settlement is reached).

For this year at Art Basel Miami Beach, the seizure and the celebrities are about as dramatic as the art party is going to get. It is also at Gmurzynska that the artist-actor Sylvester Stallone is showing his "smeary neo-Expressionist" paintings, as the *Miami Herald* reports, with a colorful front-page picture. Compared to past boom years, when the Miami fair was characterized as "all singing, all dancing," a scene of "froth and partying" of the super-rich, this year is somber by comparison.[13]

In the days before the previous Art Basel Miami Beach, the U.S. government declared the economy in recession. A good number of art collectors were caught up in the Bernard Madoff ponzi scheme, and another segment would have their art auctioned or confiscated to settle debts. Much of the high-end market—made up of buyers and sellers—did not know its worth anymore, though by some estimates, the value of contemporary art dropped 40 percent. "When markets contract, art fairs shrink—but only to a point," the *New York Times* summarized.[14]

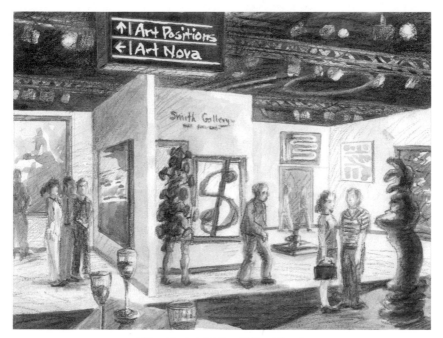

Miles of art at Art Basel Miami Beach.

This year in Miami, fears are assuaged by the sense that the recession floor has been hit. The daily buzz about sales—and the names that walk the floor—also infuse hope. As the event advertises, the fair always attracts "two thousand Very High Net Worth individuals."[15] There is Steve Wynn, the Las Vegas developer and collector, "who quickly bagged" the bright red James Rosenquist painting, *Zone*, for just under a million. There also is Elle McPherson, the model, John McEnroe, the tennis player, and Calvin Klein, the designer, but more significantly Eli Broad, the Detroit-to-Los Angeles billionaire, who owns twenty-seven of the works done by MICA alumnus Jeff Koons. Nearly every contemporary art museum of note shows up.[16]

Eventually, some of the nine Rinehart sculptors, wearing their bright blue overalls, also appear at the Miami Beach Convention Center. Although security stops them for their suspicious blue outfits, the MICA sortie is admitted on a promise to behave. Inside, they are subjected to a veritable maze, 265 booths representing galleries—180 of the galleries considered mainstays—showing works by 2,000 artists. It's a world of

soft rugs, bright art, hallway after hallway of booths, and plenty of well-dressed gallery experts standing around.

To unify this vast landscape of art, the curators hired by Art Basel have organized the floor plan by themes. At the center of the Convention Center is Art Salon. Here is a room where featured artists speak, a lounge, and display area for eighty-three art magazines and journals. Around this hub is a corridor called Art Positions, which features twenty-three galleries with special projects by young artists and galleries. Much of this art takes on the contemporary task of "questioning" the world, that is, its consumerism, capitalism, patriarchy, war, and the rest.

Another theme is Art Nova, which includes sixty "emerging" galleries, which have the cheaper real estate in the floor plan. These galleries typically are trying to sell untested new artists who are living. The sale of their work is called the "primary" market, the riskiest market, unless you have a big name artist. In the primary market, galleries have extra overhead costs; they must also deal with living artists, an ancillary hassle, to be sure. That is why most dealers prefer the "secondary" market, resale work that is already branded (and the artist dead or at a distance). Investors think strategically in both markets. But it is the secondary market where blue chip art makes the scene.

Naturally, it is the secondary market that dominates the best corridors at Art Basel Miami Beach, the prime real estate along corridors A, B, and C. Along these hallways stand the brand name galleries, a good number of which have booths this year under the theme Art Kabinett, which bespeaks collections of vintage art. The Art Kabinett booths feature mementos from Marcel Duchamp's chess-playing career, for example. There is also a booth with items from the "Fluxus" movement, a display on "Ninety Years of Bauhaus," and paintings in the "Aspects of Pop Art" booth, all of them selling the historical keepsakes to collectors.

Several blocks away at the beach, the art fair is also unfolding at Oceanfront Park, which is made to look like a colorful city by Los Angeles installation artists; and it has a stage for films and artist discussions. Outdoors, the Convention Center is surrounded by thirteen commissioned artworks. They range from a swordfish with its bill stuck in the side of a building to a giant "NO" sculpture on a truck. A thatched hut also floats in the ocean, a piece of conceptual art designed to sink. Mishaps arise, unavoidably. Art

movers cut off the swordfish bill to fit in a crate, so emergency welders are called in. French artist Claire Fontaine's outdoor neon sign, "Capitalism Kills (Love)," is refused by the building owner, once he sees what it says.

The fair organizers are focused on curating a particular mood, a mood of feeling good about buying art, which encourages others to buy. The red dot stuck on sold works fires this excitement. Critics of the art fair speak of a better time, a day when galleries ruled (with their meditative environments). The art fair is more like a shopping mall, with its features of convenience and sensory overload. At Miami this year, the mood is up, but people are mostly buying reliable art. Fingers are crossed as the days tick by, "You don't really know until Sunday at six o'clock," one gallerist says.[17]

[]

Back at MICA, the future of the art market can be studied with relative ease. There is not yet an art economics course, but the course on Professional Practice for the Visual Artist looks at the tools of marketing and the way that galleries operate. There is a cottage industry of how-to books on the art business, and other kinds of overviews, such as *The $12 Million Stuffed Shark*, suitably subtitled "The Curious Economics of Contemporary Art." Its author, the Canadian economist Don Thompson, a collector himself, says, "Money itself has little meaning in the upper echelons of the art world — everyone has it. What impresses is ownership of a rare and treasured work." By owning a rare piece of contemporary art, a collector is "above the art crowd, untouchable."[18]

Art students at MICA also learn early on about "branding," a word that evokes soap and corn flakes, but that essentially explains why Warhol and Koons have made millions. Creating your own brand as an artist, in fact, is a specific lesson being taught in the Illustration Department, with a senior seminar to prepare young artists for the marketplace.

What even Warhol did not have, however, was the Internet. He died in 1987. Young artists everywhere now have this advantage, and some analysts predict that the Internet will permanently change the shape of the art market. The Internet has transformed every retail industry, from books to diamonds to used Yellowstone campers. In the case of art, the usual rebuttal is that art must be seen, even touched, to move the buyer, and hence galleries will continue to flock to art fairs, not falling back on Web

sites or Internet marketing. Nonetheless, the Internet and mobile devices already have invaded the fairs, as agents snap pictures and send recommended buys to collectors, who might be sunning on the Riviera.

For the foreseeable future, much about the art market will be business as usual. The auction houses will continue their exclusive grip, for example. To buy the really coveted art, or to become an artist-millionaire, you will still need access to a very small club of the top dealers. It's a rare occasion when an artist, or buyer, can go around the system. Some underground art has attacked the system, but when it becomes popular, the system has enough money to simply buy it, too, in a process called co-optation. That is what happened, it is said, with rebel graffiti and street artists such as Jean-Michel Basquiat and Shepherd Fairey; in a bit of masterful art marketing, Fairey also offered the "Obama for President" campaign a free poster (based on an *Associated Press* photo he cribbed), ensuring that his own brand name rose with political events.

In recent years, some dealers have also tried the "American Idol" approach, buying up a young artist's works, then giving the artist a massive publicity buzz. When the artist gets hot, the works are sold to collectors. The classic example here is that of London dealer Charles Saatchi, who publicized a group that became known as the Young British Artists, one of whom—Damien Hirst—put the stuffed shark in a tank, funded by Saatchi (and then sold by Saatchi for a reported $12 million).

The art fairs are making the art market a bit more democratic, with perhaps more buyers, if not more lifelong collectors. For the artists who feel shunned by the market, the government offers some hope. Taxpayers do support artists, but typically at the start and end of their careers, not as a way of life. In the start-up phase, federal student loans and grants underwrite art schools. There follows an economic limbo, but later in life an accomplished artist may receive federal grants for projects. In between, the artist must scramble. The scramble is often for art prizes, which are multiplying in number. Worldwide, that number is estimated at 4,500 prizes totaling $100 million a year.[19]

In the Baltimore area, the local artists—including students and staff at MICA—keep their eye on those prize opportunities, which for some is an act of round-the-year vigilance, keeping a list of shows, fairs, grants, and awards on offer.

In December, at the end of the first semester at MICA, there's always something like a season of art shows, all with a frigid ambiance. Over in the Station North Arts District, you can see your vaporous breath in the lighting outside the alterative Baltimore gallery space, Area 405. Here, sixteen undergraduates in Interdisciplinary Sculpture set up a show, "Installations," a one-night event, but valued for its sociability.

Another show is underway at Maryland Art Place, down in the entertainment district by the Inner Harbor. These exhibits tend to be more long-lived and, by their location, are able to draw urban traffic and even tourists. As a private venture with some public funding, Maryland Art Place was founded by a group of activists (including MICA's Fred Lazarus) who believed that artists must be given some stable venue—studio or gallery space—or they will leave Maryland. The plan has worked to some degree, and it has also given an important outlet to MICA artists, as is the case on one particularly cold December night.

Inside Maryland Art Place on this festive evening, fourteen graduate students in the Graphic Design Department are beginning to give a walk-around explanation of their exhibit, fourteen different works, organized under the title "Instant Messages," and showing for five weeks. The works illustrate that "design" easily overlaps with what others might call fine art, even conceptual art. The works run the gamut from prints and handmade objects to conceptual pieces, painted imagery, and video projections. Chris McCampbell and two others have something extra on display tonight: They have also created a permanent design for the long hallway of Maryland Art Place, a commission that involved paying a small fee to the budding graphic designers.

Finding an idea for how to decorate a long, dull hallway was only the start, as Chris tells the tale, and the concept had to work across the entire 60-foot wall. After a few fits and starts, a logical idea occurred to the three grad students, coming, as these things do, first gradually, then all of a sudden. It was the idea of *transformation*. Transform what? Things, of course; and why not transform things from past to present?

They began making a list of objects both natural and artificial: a bird, a human hand, a computer, a radio, and so on. "As we listed them, we decided that focusing on the forms was more important," Chris says. "We had to decide how the shapes were going to transform."[20] So they began

to sketch. The sketches evolved into solid icons, fifty of them, each different. They had to be perfect, though, and this meant scanning them into the computer, making them precise, and finally cutting each icon into black vinyl with a laser cutter, each a perfect black silhouette.

"Yeah, a lot of work," Chris confirms.

On opening night, however, there it is—a line of icons telling a visual story of transformation all down the hallway—from the primitive human hand print to the jet airplane and radio—and at the very end, a final icon sticking out from the wall, a computer board.

"Smooth all the way down, and then, 'Boom,'" Chris says.

On his return to wintry Baltimore, Calder is philosophical when he compares its art scene to what he has just experienced in Miami. "To be honest, the most traffic for a Baltimore show comes from the opening night," Calder says. This is the beer and crackers world, fun but hardly lucrative. Nevertheless, Calder plans to hold a homecoming gallery reception for Camper Contemporary, in the Station Building parking lot, before the semester ends in several days.

For gaining practical knowledge, his trips to New York and Miami to see art fairs have been valuable research. "It's hard to get a handle on the art world unless you see how the art world is played now," Calder says. "The new future of the art world is art fairs." With Camper Contemporary, his goal is to expose as much saleable art as possible with the least overhead cost. In addition, Calder is mulling "new curatorial techniques," ways to commission specific kinds of art that give each camper display a theme. Meanwhile, he muses about the day that Camper Contemporary gets invited inside Art Basel Miami Beach: "My truck will pull the camper right through the door."[21]

[]

In a few weeks, the semester ends and students head home for a month. They return for the spring semester in late January. The break can be a time of relief or a time of reckoning. Each year, a freshman or two doesn't come back—art school is not for them. For most, such as freshman Adam Dirks and senior Jen Mussari, the winter break is a time to make major decisions in their art-school careers. Jen is thinking about her major, whether it's her best choice, and whether it's too late to make changes,

with only four months left at art school. Adam has two aches, one in his heart and the other in his wallet; he misses his girlfriend in New York City, and art school is turning out to be more expensive then he, a nineteen-year-old, had expected.

Today, Jen wanders around the Third Annual Art Market, which for the past week has taken over the atrium and hallways of the Brown Center. It is a cheerful, boisterous scene of tables, crafts, paintings, and lots of buying and selling. The public swirls about, looking for Christmas and Hanukkah gifts. As a fan of the craft movement, Jen enjoys seeing what the students have made, all of it generally small, decorative, and saleable. Jen drifts by the table where her own item is displayed, a white cotton tote bag that is silk-screened with a quirky and humorous original design of her own titled *Parade*—with a *Star Wars* robot and animal characters. A pang of nostalgia comes over her; this will be her last Art Market before she leaves Baltimore for good.

At this moment, Jen is a General Fine Arts major, but she is wondering seriously whether fine arts has prepared her for making a living in the world beyond MICA. Fine arts is feeling a bit nebulous to her, whereas when she meets illustration majors, they are cranked up for the hard-core marketplace (as is her boyfriend, Jonnie, who's working for the software company, Adobe). Jen says to herself, "But it's too late to switch departments, to switch around my entire senior year. Isn't it?"[22]

Now she is standing by the Illustration Department table, where she meets Whitney Sherman, the woman who has been chair of the department for thirteen years. Sherman is Jen's instructor in a liberal arts class, the History of Illustration.

They chat and then Sherman says, "Jen, what you do is illustration."

"But isn't it too late to change majors?" Jen asks.

"Possibly not," says Sherman. "We'll have to look at your credits. Otherwise, there's no problem on my end." Fortunately, they have the next month, the winter break, to look at this more closely. Sherman must review the courses that Jen has completed so far, and determine whether Jen can complete the requirements for a bachelor of fine arts in illustration in the spring term. The requirements for each department are exacting, but flexible.

Sherman says, "Send me an e-mail over winter break."

Jen has some thinking to do over the next month or so, while she shuttles between her Baltimore apartment and her parents' home in Pennsylvania for Christmas and visits.

As the Art Market comes and goes, another big December event on the MICA campus is Portfolio Day. On this day, hundreds of parents and art students arrive on a Sunday, a nice weather day for December, it turns out. As the day approaches, Adam Dirks is in his dorm at The Commons, thinking obsessively about New York City—and how to get there. Although he has been going to art school on generous scholarships—both in high school and now college—the fees and expenses in Baltimore are astounding him. He eats only macrobiotic food, which adds to the expense. His thoughts fly to New York, however, because that is where his girlfriend lives. She is attending The Cooper Union art school, going for *free*, fending only for her room and board.

"If only I could get into Cooper Union," Adam is thinking. "And I'd be with her."[23]

Even the staff at MICA call The Cooper Union the "Harvard of art schools," since it inducts a freshman class of only about fifty. Thanks to its $600 million endowment, they get a free ride at a state-of-the-art school of art. The school is located in the East Village, a prestigious art scene, though an expensive place for a student to live. Even so, Adam makes his way over to Portfolio Day, feeling a little guilty, since he likes Baltimore, too. He arrives at The Cooper Union table, which is set up in the first-floor art education classroom of the Fox Building.

The woman who is the information officer is not busy, and she is more than helpful. She is also quite honest with Adam. She tells him that New York City is expensive. The downtown art scene is moribund, with the vibrancy moving away from Manhattan, first to Williamsburg, the first stop out on the L subway, but then out farther as Williamsburg rents skyrocket.

"For a student, there's more happening in the Baltimore art scene," she tells Adam.

Still, his heart and wallet ache. As he inquires, she confirms that to get into The Cooper Union you must submit a rigorous "home study," or student response to a list of artistic and conceptual problems presented by The Cooper Union. Nowadays, you can send that portfolio by e-mail.

Over Christmas break, Adam is going to give it a try. He has a month at home in Pennsylvania, a time also to visit his girlfriend in New York City and get the inside dope on The Cooper Union. It is a long shot, but he'll have to decide soon. December is almost over, and the first weeks of January will fly by, as usual. Then, the second semester begins, another fifteen-weeks-of-art-school rollercoaster, starting off on a Tuesday, January 19, to be exact.

THE END OF SCULPTURE
(AS WE KNOW IT)

On the first Wednesday morning of the second semester, January 20, the frost is melting away, letting the sun in through the skylights of the campus sculpture studio. Inside, the white walls grow brighter. The room also fills with the faint sound of two students smacking clay on armatures. They are ready to sculpt the head of a model, who is late to arrive. It's a low turnout this term for Intermediate and Advance Figure Sculpture, but that is what the instructor, Tylden Streett, expected. This term, students have a schedule conflict with another required course.

Today, Streett paces the studio, high in the stone, fortress-like walls of the Mount Royal Station building. Normally, he'd have a full class of ten. "And they have to learn everything in fourteen days," he says, referring to the one-day-a-week schedule. "They say doing sculpture is best for the hand-eye skill."[1] At the last faculty show, Streett put up a bronze-cast low relief, showing himself, with stylus, working on a clay sculpture of a female figure. The title was, *Figurative Sculpture Is Alive and Well in a Far Corner of [MICA]*. Some students told him they didn't know such a course existed. He understands. At art school today, students must learn one of everything, jacks of all trades but masters of none. Also, the market for classical sculptors—those who work in clay, marble, or bronze—has fallen on very hard times.

Not that sculpture is unpopular at MICA, however. It's an expanding world now for the modern art student. In 2005, the department was renamed Interdisciplinary Sculpture to indicate how many media the discipline may include. "Sculpture," the catalogue says, "is contemporary art's meta-medium." With sculpture, "artists cross boundaries, invent hybrid processes, and explore innovative content in areas of object-making, installation, performance, site-work, time based art, and digital forms."[2]

Streett has taught sculpture at MICA for a half century, watching the art form evolve to what it is today—from cemetery statuary to cubist and

expressionist forms, giant outdoor mobiles, and finally rooms filled with light shows and dancing performers. Sculpture means "anything three-dimensional," he says. He can still talk the same language with the newest generation of sculptors.

"They tolerate me, and I tolerate them," he says. "And we're friendly. We're all in the same racket."

The sculpture racket today has much in common with "new media." That is because traditional three-dimensional objects are now combined with conceptual art, performance, video, and sound technologies. At MICA, and at other art schools, sculpture has gone through the *interdisciplinary* revolution, a kind of rejection of specialization, but also a broader meaning for each art discipline.

Down two flights of stairs from Streett's studio, the seeds of sculpture's popularity are being planted in MICA's Foundation Year course, Sculptural Forms. A semester long, it introduces every art student to materials and tools. Depending on the teacher, you can get very conceptual assignments, or ones that have the feel of an engineering or materials problem. Either way, freshman like Liam Dunaway and Holden Brown are finding sculpture to be more satisfying than anything two-dimensional they've done, indeed "the only meaningful place to do art," Liam will argue.[3]

This being the second semester, Holden will take his first course in filmmaking, his major, but he has been surprised by sculpture as well. If once it seemed to be mere objects on pedestals, now it can seem cinematic, he says. "I discovered that same kind of satisfaction in sculpture that I've found in film; seeing a vision fully realized."[4] In his Sculptural Forms class, he was given an assignment to "fill the greatest amount of space with the least amount of material." For this, he had a vision, perhaps like a film. He would create a human figure, built of chicken wire, put his own plaster-cast face on top, then cover it with flowers and, in a dark classroom, project on it a video image of bees, with a buzzing sound piped in. With this sculpture, he has densely filled a space with mostly air, light, and sound.

Like Holden, Amelia Beiderwell also is drawn to the world of creating spatial experiences. When Amelia arrived at MICA to be a sculpture major, the breadth of its modern definition was no mystery to her. "My work is more conceptual," she says. "I like mixed media work. I will always be a

sculptor, but I will always work with fiber as well."[5] At her previous college, she ran the sculpture studio as its technician. That exposed her to welding, carving, and all the rest.

At MICA, however, she is extending her ideas of sculpture to theater and the use of fabrics to make costumes. About now, the pressure is on for her four-member team to design and produce the forty-one costumes for *A Midsummer Night's Dream*. The producer of the play, literature professor Christopher Shipley, is hoping for MICA to develop a full-scale theater department. Until then, the costumers are using available space at the Station Building, where the Fiber Department operates cheek by jowl with the sculptors. The space is tight, given the many classes using the fabric tables, so Amelia and her colleagues shuttle between there and their apartments, using manikins when they can, dropping by thrift shops for materials, and sewing at home. It's the start of the semester, and they have nine weeks until the curtain rises on *A Midsummer Night's Dream*.

The costuming, of course, must follow the plot of the Elizabethan comedy, in which Shakespeare adapts the ancient tale of the marriage of Theseus, the duke of Athens, and Hippolyte, queen of the Amazons. He turns it into a fanciful comedy of rival love interests, forest creatures, mistaken identities — and mischievous magic, all of which takes place one midsummer evening in the moonlit woods.

In effect, the play has three plots. The first is about the four lovers resolving their differences. The second is about Oberon, king of the fairies, settling a score with his wife, the queen. The third is that of a six-member amateur acting troop — the "rude mechanicals" — that is practicing in the woods the night of the events (the play within a play). And given the complexity, you keep track of the characters to some extent by their costumes; especially since the set is usually dark and misty. Over the centuries, *A Midsummer Night's Dream* has been adapted to every kind of set and costume, typically with royalty in Greek togas, but distorted into every kind of fabulous look by the avant-garde as well.

To proceed, MICA's production team has created scale models of the set, which will feature the spooky forest, a Greek porch and gateway, and paintings of large male and female figures. The directors are also seeking a cinematic look, as in a movie theater, with a long stage and piped-in music that surrounds the audience. The look of the costumes, however,

Costuming Shakespeare's Peaseblossom.

is still in flux. "At the beginning, there was almost a punk kind of feel, with pyramid and spikes," Amelia says. Then it moved back to more traditional Elizabethan styles, but then settled on "a modern take on the Athenian garb."

Similarly, the costume ideas for the forest creatures—the king and queen fairies and their five fairy assistants, including the chief mischief-maker, Puck—began a bit surrealist. "At one time we were talking about much darker, foresty insect-like creatures," Amelia says. In the end, however, convention tended to rule, and while the fairy outfits were certainly hard to make, they ended up with a customary fluffy look, like fairies. The garb for the "rude mechanicals" turns out rustic enough, Amelia says, to match their "working-class, threadbare characters."

[]

For all the possibilities of costuming Shakespeare, it rarely will spill into some of the outlandish performance art that also takes place at art schools

(although the MICA students did do the whole-cast-goes-naked scene when they staged *Hair*, the rock musical). When Amelia saw the "elephant man" performance in her Elements class—when a student stripped to his boxer shorts and recited gibberish—the neo-dada boldness and anarchy delighted her. However, it was a minor eruption of performance art compared to what has emerged since the 1960s.[6]

Performance art today can seemingly have no limits. According to the encyclopedic book *The Artist's Body*, artists have nailed their hands to Volkswagens, disemboweled sheep, torn their faces and torsos with rusty nails and razor blades, put meat hooks into muscle, and rolled naked on shards of glass. They also have held public cervical inspections and "surgical performances," self-drowned, laid down with the dead, and sliced their genitals. "Has the art world gone crazy?" asks a *New York Times* survey of such performances, a forty-year phenomenon. "Some people discover meaning in these displays. Most simply avert their eyes."[7]

At MICA one day, a student will sit in a vat of ice water until unconsciousness descends (hypothermia). Soon after, another student will begin his sculpture project, a performance, by masturbating in front of the class (by the way, this *is* a famous form of contemporary art invented by a revered founder, Vitto Acconci, who appears in art textbooks). In these two MICA cases, the risk and the offense will have gone too far. The classes do not end happily. The first student is revived, the second stopped in the act. The female instructor, an art veteran, will promptly resign from teaching the class, distressed by the student actions.

After this, a new policy is warranted. As the posted memo says, the Interdisciplinary Sculpture Department (IS)—where "performance and experimental work are encouraged"—not only abides by the normal Student Handbook policy, which forbids works that are dangerous, hateful, or use human fluids, but will now require that:

> [A]ny works that involve physical/emotional stress (potential or real) to the artist and or audience *must* be outlined in proposal form and submitted to the course instructor before the performance takes place or the work is exhibited for critique. *Students must discuss these projects with the course instructor beforehand* . . . to protect the physical and emotional safety of both faculty and students.[8]

At art schools today, it is hard to put the three-dimensional body-art genie back in the bottle. From the highest authorities in modern art, it's certainly okay, even praiseworthy, to indulge in exhibitionist performance art. As one sculpture instructor points out, the Museum of Modern Art (MOMA) in New York is sending that message at this moment. For a retrospective of pioneer performance artist Marina Abramović, the museum for the first time in its history is allowing scores of live naked bodies to reenact her famous works (plus, films of her many naked performances and her art films, including one of several men, seen from the backside, copulating with a green lawn).

"Well, look at MOMA," the MICA instructor says.

How performance art came to art schools has both an old and new story in the twentieth century.[9] The old goes back to dada's variety shows and absurd poetry readings and to the Bauhaus advocacy of modern theater as the new total art. Today's performance art, however, has a 1960s vintage. A representative figure is John Cage, the musician, who abandoned formal study to attend the experimental Black Mountain College in North Carolina, where many early performance and visual artists passed through. In time, Cage became an advocate of art anarchy, admiring the plays of the surrealist director Antoine Artaud and also the absurdist theater. Cage also justified his belief in anarchy by adopting the ideas of the I Ching (Book of Changes) and Zen Buddhism, both of which view reality as in flux, guided only by chance.

Not surprisingly, Cage became a protégé of the aging Marcel Duchamp, a confluence of old and new dada anti-art traditions. They became firmly anchored in New York City, where the neo-dada "Fluxus" movement, just arrived from Europe, also set up shop under the leadership of the anti-art provocateur George Maciunas. Cage taught his views at the New School for Social Research in New York City. His audience quickly expanded beyond the art subculture to the nation's university audience, where Cage held virtually all of his "musical" performances. This was hardly an underground audience, in other words. When such events were held to entertain wealthy art patrons of New York City, it was called "black-tie dada." And when a Maciunas manifesto explained the short-lived Fluxus activity as "a fusion of Spike Jones, gags, games, Vaudeville, Cage and Duchamp," it spoke for the nature of most performance art in the 1960s.[10]

If the Black Mountain–New York intersection was one source of the new total art, it was not absent from painting either. Jackson Pollock's expressionist drip painting had been called "action painting," suggesting that the physical exertion is more important than the resulting art object. A student in Cage's university course, the painter Alan Kaprow, decided that, in merging Pollock and Cage, art is the "action" part alone. Along with others, Kaprow was a founding father of modern "happenings," a twin to performance art. Today, the graduate sculptors at MICA's Rinehart school read Kaprow's collected works, perfectly titled, *Essays on Blurring Art and Life.*

Part of that blurring continues in the overlap of performance, theater, and dance. Modern dance was introduced into performance art by Merce Cunningham, another student at Black Mountain, and eventually Cage's lover. The line was happily blurred by the trend-setting Judson Dance Theater, which adopted the ideas of Cage and Cunningham, choreographing dances that mirrored simple Zen-like actions for everyday objects: bouncing, throwing, and catching a red ball, for example. The props were simple ropes, poles, or planks (and some argue that these props gave the idea to minimalist art, in which a row of bricks, a box, or a florescent light bulb is presented in a gallery).

Most of this happened in alternative spaces, or off-Broadway, but it would storm the theater district one day as well. Such was the case of the Public Theater's 1967 production of *Hair*. In parallel, "guerrilla theater" took to the streets, first protesting war, but also becoming an art form. At MICA, as with other art schools, these art trends inevitably have become institutionalized. Not only have the students produced *Hair* (perhaps forgetting what its anarchic message was all about), but a lot of their performance art, especially off campus, is delightful guerilla theater.

[]

What used to define sculpture at MICA were its large personalities. These began with Hans Schuler Sr., director of the Maryland Institute for the first half of the twentieth century, and a famous sculptor of bronze monuments. The next of these outsized sculptors was Norman Carlberg, a Yale-trained artist who was head of the Rinehart School of Sculpture for thirty-five years, ending in 1996. Carlberg specialized in minimalist

works—called modular constructivism. As the number of undergraduate students grew, the school hired Lila Katzen, a New York painter who turned to sculpture in the 1960s. She began in the minimalist vein, but eventually wanted to engage people with a sense of shapes and environment. Today, Katzen's works—tall aluminum or stainless steel abstract shapes, curved, perforated, and textured so light glints off the silvery surfaces—grace the streets around MICA.

Two other personalities arrived in the 1970s, giving the department its macho reputation for heavy metal. One was the mustachioed Roger Majorowicz, a South Dakotan who wore boots and a cowboy hat. The dominant sculptor in the undergraduate department, Majorowicz was dedicated to abstraction in bronze and steel. He was joined by Art Benson, also a welder. Still, the department was no more unified than the two men—who did not get along. So when Majorowicz returned to his Maine studio in 1983, Benson led the way through the new century. Benson, however, was never a convert to the "new media" or the newfangled interdisciplinary sculpture.

Personalities aside, MICA eventually had to make a philosophical decision about how it would teach three-dimensional art, especially as conceptual, performance, and digital art swept the field. As with most art schools, MICA was struggling to determine the difference between teaching the traditional 3D study prescribed by the Bauhaus for a Foundation Year and teaching sculpture itself, especially with the many new definitions of "sculpture."[11] Over two decades, MICA arrived at this solution: It taught 3D in the Elements course, but also required Foundation Year students to take a semester of Sculptural Forms, the basic introduction to materials, tools, and sculpture.

In the late 1990s, MICA began to refocus its graduate and undergraduate programs in sculpture. In 1997, it hired Maren Hassinger, a black conceptual artist working in Los Angeles, to head Rinehart. As head of this graduate school, Hassinger selects the new students each year, six in all, and tries to include a range, from conceptual to traditional. "Sculpture is about anything that happens three-dimensionally, or in time," she says. Among Rinehart students, "There are people who are carvers and casters, and who weld," she says. "It's not all conceptual artists or all videographers, or all this or that. I look for people who manipulate materials as

well as make video installations." She picks a mix of entrants. She wants students exposed to different approaches. "You don't want your students to think that everybody 'out there,' in the grown-up art world, is thinking your way. There's a huge amount of diversity out there."[12] This year at Rinehart, of the eleven students, two are strictly conceptual artists. Three others work in large wood or metal display objects.

Around 1997 also, the undergraduate sculpture instructors, whose program was entirely separate from Rinehart, for the first time created their own Sculpture Department (previously it was more a concatenation of classes) and hired its first chairman. It soon went through changes, being renamed Interdisciplinary Sculpture in 2005, and now with its third director, the current chair, Ledelle Moe, a South African sculptor. She has taught regularly at MICA since 2002, instructing in all the basic sculptural disciplines, but working herself in carved cement sculptures.

On any given day, the walls of Moe's office at the Station Building rumble as the csx freight train goes by. In the late 1960s, when MICA acquired the old Mount Royal train station, it gained a rare working space. Besides having a foundry yard and mold-making rooms, the building offers a vast floor space. This is now divided into eleven studios for Rinehart students, leaving an equally large area for a well-equipped metal shop. For students who want to get physical with sculpture, the space and materials are there, as are the giant saws, metal choppers, and welding tools.

One evening, Amelia Beiderwell has all the appearance of Rosy the Riveter, a young woman artist doing heavy metal art. She wears protective green overalls and the dark-glass eye-shield that protects welders from damaging their eyes. She's armed with a welding torch that is spitting a hot blue, white, and orange tongue of flame.

"Pshshsh," crackles the torch.

She moves it across an area of the steel, small sparks flying occasionally. In time, the steel turns from burnt black to a dirty red and then a bright orange. That's the signal for Amelia to act quickly. She puts down the torch, grabs her heavy rubber mallet and begins to pound.

"Whomp! Whomp! Whomp!"

The steel reluctantly bends, Amelia's angular blows making it curl. It's soon changing back to dirty red, hardening, and then she'll have to subject it to the torch again.

Pouring molten bronze.

This will take hours, but Amelia has a vision that keeps her motivated. She is in Moe's Metal Fabrication and Foundry class and she is working on a "conceptual" piece—pillows of steel. Already, she has taken two smaller sheets of thin steel and bent and rumpled them. Then she pinched their edges together, creating a convincing "soft" pillow shape. Now she is pounding on a larger sheet of steel to make the bed cover, bending its sides and finally its four corners, which will act like four bed legs. She stands up and stretches, flipping back her face mask. "The biggest thing I've done all semester," she says. Then she turns on the torch again, sparks it to life, and is back massaging the steel with fire.

In sculpture, bending steel offers definite satisfactions, but when it comes to working with metals, casting of bronze is probably the epitome. On a cool Tuesday morning, Moe's Introduction to Sculpture class is out near the tracks, gathered around the large sand pit where the casting is done. For a few weeks, they have been carving small objects in wax with a "monument" theme: a gesturing hand, a baby's head, two breasts, a dead bird. They covered the wax models with a plaster-like casing. Now, in the foundry area, the "lost wax" process has begun. Three of the students have suited up in leather coverings, gloves, and heavy helmets with face shields to assist the foundry technician as others look on.

"It gets hot enough to burn off your facial hair from a foot away," says the technician, a big, bearded man, a sculptor himself.

Once the fifteen or so molds are piled on a rack, a giant furnace hood is lowered over them, melting the wax out or burning what is left.

While the molds are cooling, the foundry team begins to plant then in the sand box, the openings facing upward. In another furnace, a giant pot of bronze has been melted, and the pot itself is glowing red. At the signal, the team guides a sliding gurney of iron bars and chains over to grab the red pot and, in high suspense, swings it into position over the sand pit. Like pouring batter into muffin pans, they go mold to mold, filling each with a thin waterfall of molten bronze.

Adam Dirks is in the foundry class, casting bronze, and as a freshman he has been thoroughly converted to sculpture. "I think sculpture is the *only* category for art today," he says. "Everyone is a sculpture major at heart."[13] By expanding the definition of sculpture, Adam has also entered the realm of performance art. Slowly but surely, art objects have take on a new meaning for him. "This past year, I discovered a love for performative art," he tells his class during one crit. "It was probably always in me, the interest in objects that can be a part of a performance."

As part of the bronze-pouring team, Adam has now stripped away his protective gear. He's cleaning up his bronze bird, which is beginning to show the beautiful copper color of bronze. He is also quieter than usual, for Adam is harboring a terrible secret. It has a lot to do with both sculpture and performance art, but probably most of all it has to do with money and his girlfriend. He's working up the gumption to tell his teachers what happened.

During winter break, Adam went home to Pennsylvania, and then headed to New York City to be with his girlfriend, on her winter break from The Cooper Union. One frigid morning, they left her apartment for the New York subway. She was carrying a video camera, but Adam was far less encumbered: He was naked except for his beige briefs and plenty of body paint. He was painted like an Indian, or at least how he imagined a Native American looked before the white man came to Manhattan; red and black dots and stripes on his face and body. Down in the subway, his girlfriend shot video as Adam walked through the crowds, sat on a subway ride, and did the final act of his art: He "planted" a small paper tree on the subway sidewalk.

Two female subway police checked him out, but he made it safely home,

and Adam's piece of performance art on the New York Subway would soon have its intended effect. The video is part of the portfolio "home study" he plans to submit to The Cooper Union. The performance solved one of the art problems The Cooper Union presented, that of a "feral creature" relating to the earth. Hence Adam, the feral Indian, puts a tree as close to the Manhattan soil as possible.

In early February, his mother calls him at MICA.

"You better sit down, Adam," she says.

The Cooper Union has accepted him. He'll have a full scholarship (except room and board).

Before he leaves MICA, Adam has one more object he wants to make and use in a performance. For this, he rises early and walks over to the large asphalt parking lot that adjoins Penn Station, a lot that fills with train commuters' cars every day. So he chooses Saturday, when the space is more open. In the sculpture shop, he has made a small replica of an eighteenth-century field plow. He laminated red oak and cut a piece of steel. He lugs it the few blocks over, and begins his performance, with a friend wielding a video camera to document the work of art. For the next seven hours, Adam pushes the plow over the parking lot, "plowing" the equivalent of an acre. Cars drive by slowly, perplexed. The low, abrasive sound is relentless. The asphalt fills with scratchy white lines.

Days later, the plow sits on a white pedestal in the sculpture classroom. On another pedestal, the video plays on a small television. Adam's work is not the only piece gaining attention during the day-long crit in Introduction to Sculpture, but his exploits—and the sheer physicality of his effort—stand out. The plowing performance, he explains, is an artistic statement about the simple people of the earth who struggle in an urban age against capitalist greed.

Some students think his bronze bird is the better piece. None of them doubt Adam's strenuous work ethic, or the pretentiousness of modern performance art.

"It seems really sweet to me," says one female student, as Adam's plowing video plays. "Attempting something you don't have to do—and is kind of foolish."

This is a compliment, for sure. It is also a comment on the transience of much performance art (typically preserved only in video). Another student

is sympathetic. She recognizes that Adam has tried to say something big. His plow and video are castigating the rich and powerful, the urbanization of life. He is standing up for the poor farmer with his plow, a romantic and bygone figure. However, she is also not shy to add, "To be in art school, and to be bad-ass, is self-indulgent in a way."

By now the secret is out. Adam has told his teachers he is leaving MICA for New York City. "Baltimore has a lot to offer, and I think I'm going to miss that," he says. "But I made my choice."

[]

In art schools today, the world of sculpture is obviously alive and well, even if, as one MICA administrator says, "Nobody knows what sculpture is anymore." The MICA catalogue casts a wide net, calling it the art of "meta-mediums" and "hybrid processes" that "cross boundaries." Arguably, sculpture is only leading the way in something that is happening to all art disciplines, and it goes by the new buzz word of "interdisciplinary."

The idea of interdisciplinary art is both welcomed and feared. It frees the artist from constraints. At the same time, however, it undermines all the traditional categories on which art schools organizes their faculty and classes: film, photo, drawing, painting, sculpture, and so on. Many art schools have looked for new names, short pithy ones, but behind such cosmetic attempts, an empirical reality endures. Even in an interdisciplinary age, most art faculty still have one foot, or both feet, in well-defined disciplines and teaching roles. They know their department structures, feel comfortable with their specialties. They also rely on contracts with specific pay scales, usually attached to their distinct field (painting, film, sculpture, or the like).

All of this leads to the question of how an art school allots its resources. At one time or another, the administration and faculty of an art school will fight over the use of money—for salaries and other benefits—and this is *that* year at MICA. The blurring of clear roles and duties of teachers plays some part in the dispute, heightened this year by the arrival of a five-year review of faculty salary scales. This year also, MICA delivered its once-a-decade report to the Middle States Association of Colleges and Schools, which accredits colleges. In the process, a small group of faculty members met with the Middle States visitors and complained about their treatment,

an issue now being called "shared governance," and it is a dispute mostly over who decides how to use the money. As the salary discussion unfolds on campus, the administration calls it a "review," while the activists on the faculty, which is not unionized, call it a "negotiation," as if they were unionized.

At the more bitter moments, some faculty float the idea of a walkout, not showing up at spring Parents Weekend, for instance, or boycotting the graduation commencement. This is hard to do, however, since no one wants to hurt the experience of the students. At times like this, the leaders on campus grow philosophical, dissecting what, and who, is important at a college. Christopher Shipley has been thinking about this for more than just this salary-review year.

"The faculty are the most important constituency in the college," he says, tapping his desk top for emphasis. "It is what a college is; that's what a collegium was; it wasn't a group of administrators. It was a group of professional thinkers, academics. We are the continuing core of the college."[14]

On the other hand, school president Fred Lazarus emphasizes how a college is an entire system, and it is in this system that faculty members have the privilege to serve. No one will deny the observation that MICA, by its unique history, is a "strong president" school. Lazarus has built the school over thirty years, a unique tenure in higher education, and he continues to be integral to the board of trustees, which makes all the financial decisions for the institution.

Thanks to both Lazarus and his faculty, MICA shares the rank with three other top art schools in the country, something recognized by *U.S. News and World Report*. MICA is happy to publicize this "top four" status, but the comparison has also stirred contention. At the three other top schools — Yale School of Art, Rhode Island School of Design, and the Chicago Art Institute — the faculty are paid better than at MICA. In the salary debate, faculty say they should be paid the same, but the administration draws a different comparison. An official MICA-commissioned study determined that its faculty was doing very well compared to salaries at comparable small colleges. Nancy Roeder, chair of the Faculty Executive Committee, summarizes the stalemate: "There is no agreement on who our peers are at this time."[15]

Everywhere in higher education, the choices for a faculty system seem less than ideal, and in the past two decades higher education—of which art colleges are a part—has come under criticism on two flanks: The conservatives have decried its "academic careerism," while liberals, who work inside the system, warn of an "education bubble" (as in stock market bubble).[16]

Everyone agrees that the cost of education has gotten out of control, and some say the culprit is tenure, a benefit system for aging faculty members. Once they have tenure, in other words, they will not retire, making colleges a giant pension system. Historically, tenure systems have been seen as highly political and contentious, since they are lifetime guarantees of employment and benefits. Many smaller schools, including MICA, say they have opted for a more egalitarian system, called "no rank, no tenure." This is a system of progressive contracts that, for good performance, provides "de facto tenure" for teachers whose contracts are regularly renewed over the years.

The contracts designate the amount of teaching, and it is here that most of American higher education is being taken to task by the general public, and sometimes by administrations. In most jobs, people work forty hours a week for eleven months of the year. The regime is quite different at colleges, and in teaching contracts, however.

At MICA, full-time faculty with full salaries typically work three days a week. They teach two to three courses a semester. They also have three months off in the summer. At MICA, as at other colleges, faculty members are given sabbaticals, or paid leave, and children of faculty get free college benefits. MICA is not unique, of course. This is the work schedule of all higher education, and in the debate over the cost of higher education, that light-looking workload is being scrutinized: In terms of hours, college faculty work half a year for a full year's pay. Lazarus, a businessman as well as an art-school leader, points this out, as do an increasing number of college presidents (who now use formulas to measure faculty hours and pay against faculty "productivity").

Naturally, the college teachers of the world protest this kind of analysis. They say quality is more important than quantity, and besides, teachers are preservers of a great cultural heritage; if they are not working on campus every day, every season, they are using their time conscientiously for "research," meetings, and professional development.

Nevertheless, reformers on the political left and right are calling for change in the top-heavy college and university world, with it aging cadre of tenured professors and growing corps of part-time "adjunct" teachers doing most of the instructional work.[17] At a school such as MICA this year, there's talk of reforming the departments, looking at teaching loads, adjusting budgets—ideas that can make art-school faculty nervous. "The metaphor of the building is not a bad one," says Lazarus. You can easily restructure a campus building for a new curriculum. "It's an inanimate object," he says. However, not so with "people's contracts, schedules, lives."[18]

[]

Over in the Department of Illustration, a new face shows up for the opening of the new semester—it's Jen Mussari, pretty well known already, of course. "I want you guys to welcome Jen Mussari to the department," says Whitney Sherman, chair of illustration. Claps and whoops come from her students, seated on stools around a large studio work table.

Today, Sherman's senior illustrators will summarize their plan for the weeks ahead. Each will give a presentation to the group and then have a one-on-one with Sherman. First there are some preliminaries. Sherman announces a few job opportunities: A new university journal is seeking illustrators, and the Baltimore City's bus system has fourteen poems by school children to be illustrated and made into placards to decorate buses, the annual "Words on Wheels" project. So far, all of this is unpaid or low-paid freelancing. It's where young illustrators start, however, testing their skills and building their resumés.

Now to the big picture. After sixteen years of education, Sherman says, "You want to have some plans in place. You are moving into the professional world." The last semester will go by more quickly than they imagine. "This is the big banana peel. And it's going to go faster." For the final senior project, she goes on, her students shouldn't bite off too much. In fact, she'll spend much of the day helping students narrow down their ambitions, during the one-on-ones.

Later in the day, one student spreads her sketches on the table, showing her ideas to Sherman. "So in all, it's about twenty illustrations," the student says.

"Why don't you focus on ten?" replies Sherman, persuasively. "Give those your best. The time will fly."

"Okay, that's probably better," the student says, relieved.

At around 1:20 p.m., it's Jen's turn to give her fifteen-minute talk to the group on what she plans to do on the banana peel express, the last semester. As with the other students, she talks about influences on her work, shows slides of previous projects, such as her "Bermuda bag," a DIY craft project. "I'd like to create an object that is useful from the outset," Jen says. However, her true love is hand-drawn letters and words. That is her identity

"I'm a letterer," she says.

She had once drawn images as her forte, but now she is moving toward decorative alphabets. Jen's is not the last presentation, so it's a long day in Illustration, with scores of students giving their forecasts. Vigilantly, Sherman prunes back their too-ambitious plans. As the day ends in twilight, they begin to bundle up for the winter outside. In less than two weeks, however, the coats, scarves, and caps will be little ammunition against what is coming. They've started the semester strong. However, even the mighty Illustration seniors soon will be thwarted: the largest snowstorm in Baltimore history is about to hit.

ART AND SOUL

SNOWMAGEDDON

A winter storm can be its own kind of art, and if dramatic enough, a Michelangelo of the Weather Channel. Such a masterpiece arrived in Baltimore in early February. For the art school, the storm was a source of awe, but also tribulation, two emotions not too alien to the lives of art students. However, after what seemed like two weeks of blizzards, the most common feeling for students will be that the spring semester, just begun, is starting all over again.

The storm system begins far away, over the Pacific Ocean. It washes over the Western states, then pummels Mexico with rain, heading back over Texas, where it meets another great system coming from the northern Rockies, down into the Midwest. They join forces, heading for the East Coast. On the afternoon of Friday, February 5, the storm reaches the Atlantic coast, burying Baltimore under two feet of snow. The president of the United States, just down the road, declares it to be Snowmageddon, and for the next two weeks—since a second storm follows—the snow and ice put human patience to the test.

As a native of California, Chris McCampbell is experiencing something truly new. "I think this would count as my first real winter," says Chris, stranded in his apartment north of the campus. "So far I'm impressed."

The change from having free movement to being utterly snow-bound is sudden. The two weeks of being forced inside, and another month of snow-piled roads in gridlock, will take a practical toll on everyone. It will also play on moods and emotions, depending on the person. If you're Meghann Harris, there's always a silver lining. To start the semester, her student government blog rang with cheerful greetings: "Hope you're all doing well after your first week of classes." That was at the end of January. By the time the worst had passed in mid-February, she is back at the keyboard, cheerful as ever. "Hope you guys are doing well and had fun in the Snowpocalypse."[1]

During the worst of it, Student Activities is working mightily to make sure students, especially freshmen, remain active, since most of their classes are canceled over the two-week period.

Making headway through Snowmageddon.

"I missed my painting class twice," says freshman Jonathan Levy. It's his favorite weekly class.[2]

Parents Weekend, a big event every year, and helpful to student morale, is canceled by the great blizzard as well. But students don't have to suffer cabin fever in this winter wonderland if they don't want to. They can go to the BBox Theater at the Gateway for Disaster Movie night, and elsewhere on campus for the Coffeehouse of Love! and the Raw Art Sale. Over at the Kramer House, the late afternoon soirees with visiting artists Lani Irwin and Alan Feltus continue. At one Sunday dinner, large numbers of students slog through snow banks to bring hot food for the gathering.

"A nostalgic period," says Feltus, much later, of course.

On the third floor of The Commons, however, a freshman named Kristoffer is not feeling like doing much.[3] A well-liked student, quiet and friendly, "Kris" is a pale young man from New England, tall, his blonde hair a mop. In his Critical Inquiry class, where Kris's essays were always interesting, he became know for a philosophical bent, and definitely modern philosophy. He quotes the existentialist philosopher Albert Camus, cites

the action painter Jackson Pollock (who said, "I am nature"), and speaks of the "death of the author" and deconstruction of life "into particles."

During the snow, Kris decides to double up on one of his art-school habits, a habit that preceded his arrival at MICA, and that is to drink. His favorite is dark or light rum. Kris is a student who makes art when he is intoxicated. It is something his friends marvel at, since that is something they can't do. Kris does drawings, collages, and assemblies, and is aiming for a major in Interdisciplinary Sculpture.

When Kris describes the ideas behind his art, he alludes to making maps in particular, but he also likes to talk about maps of disorder, randomness, and uncertainty. In an autobiographical class such as Critical Inquiry, all the students talk about their backgrounds, as did Kris on occasion, always with a bit of humor. As Kris jokes, he has Norwegian ancestry, a "people as cold as the country." To keep warm, especially during the disruptions of Snowmageddon, Kris is imbibing rum more than ever, doing it alone, which has been his pattern at art school anyway. Kris has a nice, if small, circle of friends. And yet, "No one *really* knew him, I think," says one roommate. As with many young artists, moreover, Kris is game to break from conventional routes. "I say ditch the path and create your own," he writes. It is a necessary choice, he says, since modern society is in a process of collapse.

By this week, Snowmageddon is past and students are returning to classes. For some reason, Kris is not interested in going to class. On Thursday night, his three roommates follow their regular routines. They chill out and get ready for Friday classes. Kris nurses his drink, and by last recollection, is watching a movie on his computer when everyone finally goes to sleep, night owls as so many freshmen are. The next morning, February 19, the bathroom door is locked. Kris is not in his room. One of the students picks the lock and enters the outer sink area of the bathroom, then steps into the shower area. Kris is there, eyes open. He has hanged himself with a cord from the shower bar.

The news spreads immediately, first by an administration e-mail. Later, as inquiries mount, a more precise statement reveals that Kris has taken his own life. As with any tragedy, everyone on the campus—about two thousand students and hundreds of faculty and staff—struggles with just how to feel about it, how to think. Someone looks up the statistics. The

most recent annual survey of U.S. colleges and universities suggests that one in three schools has had a suicide. Nearly all the cases are white male undergraduates, mostly driven by depression or relationship problems, and usually carried out by hanging.[4]

On campus, those who feel the most guilt are Kris's roommates and circle of friends, and also his teachers in the Foundation Year, the year when everyone hopes that art students will find themselves and make plans for a rich life ahead. Naturally, the leaders in student affairs, Foundation Year staff, and the administration move quickly, offering walk-in counseling for affected students, linking up anew with suicide prevention groups, and planning to add more counselors. Lesser known is that each year the MICA counseling department already helps a small number of students overcome their "suicide ideation," often by taking them to a hospital.[5]

In the face of tragedy, life goes on, as it certainly does this week at MICA. Some students and teachers are deeply shaken, others sad from afar, but everyone keeps the art-school wheels turning. As head counselor Patricia Farrell tells the campus staff, young people are remarkably resilient. At art school, "They have art therapy 24/7." Art will commemorate Kris as well. In the coming weeks, his close friends will collect his work for a show in his memory. The next school year, one of Kris's teachers will organize a memorial exhibit, an enclosed environment of hay bales in a small student gallery. The installation will hark back to Ireland's ancient cairns, memorial mounds made of stone. In the MICA gallery, these stacked bales will create a "Circle of Memory." The room invites students to sit and recollect. If they wish, they can write their name on a card and lodge it in the hay wall, to "commemorate and honor" Kris, but also all "lives ended too early."[6]

Two days after Kris's death, the school holds a memorial event in the courtyard of the Main Building. On this Sunday evening, a hundred students and faculty are gathered to recall the good things about Kris's life. They stand before an easel that bears one of his collage-like drawings, perhaps a map to Kris, a non-orderly semblance of faces, figures, squiggles, and shapes. A glass with white lilies is on the floor below.

Although Holden Brown did not know Kris, he is attending. Years earlier, Holden's best friend, an "art kid" at school, also hung himself. Back

in New Orleans, that situation was complicated, so Holden missed the funeral; he is still haunted by that fact. Now he is listening to Kris's memorial service, a public grieving of sorts, for a creative young person. For Holden, it is an emotional closure, and he'll build upon it later in the school year.

[]

It's presumed at art school that the young artists are finding themselves. This has a particular poignancy in the freshman year, when a young person leaves home. They often write about this in Critical Inquiry, especially in the final essay on a theme such as "My Critical Nature" or "Portrait of the Artist as an Intellectual."

Nora Truskey sums up her experiences by writing on her shyness, or what she calls "Hesitation," a pithy essay title.[7] "Making decisions has never come easily to me," Nora writes. However, hesitancy can have benefits as well. "I believe that my hesitancy has made me a much more cautious but understanding thinker." She traces the caution to her own particular personality, and also to her lifelong wrestling with being biracial in a society where races are well defined. "It's not my actual heritage that has affected me, but more of my own feelings towards my background. . . . I grew up between two different cultures — Chinese and western or American. Yet, as I got older I began to struggle more with identifying myself between the two. Am I Chinese or am I white? Can I really be both at the same time?"

To most people Nora looks Asian, but not completely. She is tall, with her black hair bobbed, an attractive young lady with almond eyes, but also with the spirit of a sprinter, since she ran track in high school. How can people know she is two races inside? This is always difficult for her to talk about with her peers, though she feels she must, somehow, some day. Although Nora is one of the better writers in her freshman class, she also believes that her hesitancy slows her literary prowess; it makes her writing less decisive. This is not all bad, she concludes. "By thinking so much about what I am about to say, I think it gives me time to really reflect on my own values and ideas. . . . I don't think I could have come to accept and love my multicultural heritage, as much as I do now, than if I didn't hesitate so much in talking with others. By spending so much time mulling over ideas I've grown as both a critical thinker and individual."

In Cory Ostermann's reflections on adulthood at an art school, she declares that after "deconstructing" her life she is more sure about her feminism, her newly declared atheism, and how she, so young, is already dealing with the question of death.[8] "At age seven, I had no idea what the word 'feminism' meant, but the light bulb had been turned on," Cory writes. "I knew that I would not allow myself to be seen as lesser, unequal. From thence on, the drive to push for equality in my life and in my work snowballed."

Cory had been reared in an evangelical household and at one time believed in the Bible and the values of her parents. By the end of high school, and now confirmed more deeply by her free academic discussions at art college, she believes that those past beliefs and values are childish, even uneducated. "Because I am a 'newly realized' atheist, I have only been dealing with the concept of death and the connected death of consciousness for a while now," she goes on. "Death has always been a reoccurring theme in my work. In my response to psychoanalytical theory [in Critical Inquiry], I wrote of the many fears that manifest because of this press of death."

The solution she's found so far is her long-held romantic idea about the artist, seeing the artist as someone who transcends death in the act of creating. "To be an artist is to be immortal, to be a creator, to mimic the 'higher calling,' and to beat death," Cory writes. "My father always called it 'making yourself god' and spoke negatively of it, something which I could not understand, because as a musician he was a creator, too." She's kept much of this in the closet, she says, although she has talked to her new boyfriend about it and to his mother as well. For her own mother, Cory has often offered only the discomfort of "my more subversive artwork." So for now, she writes, "I have my secretive atheistic works, my feminist art, to help sustain me."

Like just about every freshman writing for Critical Inquiry, Cameron Bailey also waxes autobiographical.[9] He found himself without purpose in high school, feeling youthful depression, and this at a time that his parents were divorcing. Also, a childhood friend suffered a crippling accident. "After much self-reflection, visits to doctors, and unnecessary medication, I realized what I wanted," he recalls in prose. He was intrigued about human perception, and wanted to study psychology; but then art became

a big part of his senior year. "My nervous depression seemed to slowly slide away." He was replacing it with the feeling of accomplishment, one artwork at a time. This produced positive thoughts, not negative ones. That positive outlook has become easier. "If I work hard enough, I can go wherever I want," he says.

Art is allowing Cameron to explore psychology, the unexpected connection between things: "I love finding patterns." During Critical Inquiry class, the two topics that interest him most are psychoanalysis and the reader-response approach to literature. One of his favorite books is Franz Kafka's short story *Metamorphosis* (in which a young man wakes up as a bug, and is treated that way by people). The reading assignments, or "artifacts" in his Critical Inquiry class, Cameron says, offered him similar literary puzzles to ponder. But this pondering also can go too far, so Cameron finally espouses a positive outlook above all. That is the best medicine. Pride in his artwork accomplishments are replacing shame about his anxieties. "As long as you continue to work towards finding happiness and comfort you will have a full life," the youthful wise man writes. "My anxiety hasn't disappeared, but now I can recognize unhealthy thoughts and behaviors."

Whatever thoughts a MICA student is having, and whichever year in school it may be, they do have someone to talk to at the academic advising department. In fact, this reminder goes out constantly, almost with the regularity of the church-tower bells on Bolton Hill.

Each month or so, a notice appears in student calendars, often backed by postings and e-mails. They typically say, "Sophomore Advising Begins" or "Junior Advising Begins." As a relatively small school, MICA has evolved an elaborate system to keep track of its two thousand or so students. The first level is the Foundation Year. Elements teachers stay with a group of about twenty freshmen all year, and in turn, are aided in guiding this group of twenty by their "linked" colleagues, teachers of the Art Matters and Critical Inquiry classes.

As freshman systems go, MICA's is remarkably comprehensive. Nonetheless, nobody can watch students around the clock. The City of Baltimore, with its many "scenes," sounds a siren call, and the drinking age of twenty-one is flouted openly. The head of Foundation academic advising, Richard Barber, gets notices from teachers when students are flunking

out of a class. Personal lives and habits are often off the radar screen, however, except to student peers, or to peer-aged dorm-floor supervisors. In the Admissions Department, the recruiters watch their students for grades, financial aid, and other matters. Under federal privacy laws, however, neither faculty nor academic advisors can talk with parents.[10] At the Bunting Building, around the corner from the popular coffee and snack canteen, student counselors are available daily. Everyone hopes the system works; they hope that young students are alert to each other's problems, although this peer-group alert system is probably the least reliable, since "friends" keep each other's secrets, cover for each other.

Eventually, freshmen become "rising sophomores," and by the end of their Foundation Year, they are assigned an academic advisor who will be their alter ego until graduation. There are four of these counselors, each with a group of sophomores, juniors, and seniors. To keep up, they meet several students every day. Parents are calling all the time, many unaware of the federal privacy laws. They are urged to contact their sons or daughters directly and ask how they're doing—that is the system.

When the student calendar states, "Advising Begins" for sophomore or juniors, it comes early in each semester. For the 350 or so sophomores, for example, this means each has a formal appointment with an academic advisor to go over their choice in majors, course requirements, and personal lives if the student cares to. The counselors try to offer two kinds of help, "holistic career" advice, but also "short-term problem" advice, according to Trudi Johnson, a longtime academic advisor for students beyond their freshman year (and an art history teacher).

Johnson believes that art students are tough souls, generally. "The Foundation Year is beautifully engineered," she says. "The ones who make it through have had good nurturing. It's not like throwing your kid in a big university system and then they fall through the cracks." As an advisor for upper-grade students, Johnson focuses each year on 330 students. She is fastidious in watching their progress. "I have a nineteen-year-old son; if somebody takes that kind of time with my kid, then life is good," she says. If she has the choice of mollycoddling or tough love, she usually prefers the latter. Art students are adults. They certainly claim the right to adult enjoyments. They offer cutting art commentary on "the system" of the elders. So they should learn to shoulder adult responsibilities,

at least in the tough-love school of advising. "Eat your Shakespeare and suck up your Nietzsche," Johnson tells her students, many of whom don't like academic requirements. She tells them further, "No one asked you to do this, but this is what you came here to do. So let's do it."[11]

[]

One afternoon after the snowy sidewalks are cleared, humanities professor Saul Myers walks over to the Studio Center, where the senior painters are back in their studios, defying the chill. Myers climbs to the second floor, where he meets Sean Donovan at his studio.[12] Faculty too make a difference to art students' happiness.

For Sean, Professor Myers is playing this role, as does one of the oldest painters on campus, Raoul F. Middleman, a painter whose work shows a love of color, surprising environments, and the grotesque. For two terms now, Sean has taken Middleman's Narrative Painting class. That Thursday evening course spends the first hour figure drawing. Then the class repairs to a back corner of the library, where students explore readings, some autobiographical, of great painters — Rembrandt, for example.

Sean has also taken two courses with Myers, a teacher he likes. First he took the course on The Enlightenment and now he is in Dream Workshop. As a painter, Sean dreams a lot. He feels that his paintings capture some of that experience, especially memories related to the death of his mother.

Sean shows up one day for the Dream class with a large painting. Myers is taken aback by the bold aesthetics as well as by the nightmarish quality of the image, a female grotesque cowering in a dark corner. "I knew from his work on his dreams something about his life," Myers says. "I didn't say anything to him, and he didn't have to say what the painting was about." Today at the Studio Center, where Myers is visiting, he sees Sean's work space for the first time. He's made the journey because he feels that the last two years of art school have given Sean stamina. "He's a very confident intellect now," Myers says. "It has a lot to do with his sense of himself as a painter."[13]

In Dream Workshop, the class studies the theories of Sigmund Freud as well as what modern neuroscience says about dreaming. They touch briefly on Carl Jung, who art students flock to, probably because of his

theory of archetypes, visual images, and stories easy to translate into art. The students also learn finer distinctions between dreams, delusions, hallucinations, and imaginings. This is a topic that Sean writes about, citing the philosopher Colin McGinn's analysis of mind-images in *Mindsight*. Then he carries these ideas over to a discussion of William Faulkner's modernist novel *The Sound and the Fury*. By warping the sense of time in the novel, Sean writes, "Faulkner makes us aware of the ways in which memories from the past can haunt us and impact who we are today."

Dreams fascinate a lot of painters. As a freshman, Calvin Blue has been interested in how the surrealist painters, such as Salvador Dalí, used dreams. He read an account of how the modern Spanish painter would capture dreams by dozing off in a chair, a brass key between his forefinger and thumb, a dish on the floor below. As Dalí says, "You will have merely to let yourself be progressively invaded by a serene afternoon sleep, like the spiritual drop of anisette of your soul rising in the cube of sugar of your body. The moment the key drops from your fingers, you may be sure that the noise of its fall on the upside-down plate will awaken you."[14] Then you can recall the dream.

It's something like keeping a dream journal—as Sean and other students do in Dream Workshop. Calvin tried the key and plate, but did not find it productive for images to paint. He has not given up on dreams, however.

More advanced on the topic, Sean does not have a personal theory about what dreams are, except that they come. He has produced a half-dozen large paintings so far in the year, all of them dreamlike. Their figures—men, women, goblin-type creatures—are somewhat identifiable, but then elusive. Sean tells people they come from his life experience. He won't name names; neither will he name dreams, if that is the source. As he'll say in his senior artist's statement, "the act of painting is about mortality." He visualizes the mysteries of life in thick oil paint, adding and subtracting, feeling that the layers are like life's struggle. "The painting is finished," he writes, when he has "created a raw, uncensored image of his struggle as he moves through life."

If art students sometimes sound despairing, it may come from learning about art's role in a despairing modern epoch. Art today, after all, is framed on one side by modernism, expressionism, and surrealism—all

reactions to bourgeois morality and world wars—and on the other by postmodernism: the idea that language is a game, and that nothing is as it really seems. Both are entirely secular, leaving out the legacies, or life-solutions, offered in religious thought. In Professor Robert Merrill's class, High Modernism, Sean and upper-grade art students are learning through philosophy and literature how the world got this way.

To that end, Merrill has them studying the philosophers Martin Heidegger and Maurice Merleau-Ponty, and reading the literary lights Virginia Woolf, Marcel Proust, William Faulkner, Thomas Mann, James Joyce, and T. S. Eliot. As Woolf famously said, "On or about December 1910 human character changed."[15] For Merrill's instructional purposes, this is a good date to use when talking about a convergence of modernist philosophy and modern literature—and hence modern art as well.

As to philosophy, Heidegger is essentially the founding father of the popular be-here-now existentialism. He espoused "being there" (*Dasein*), or "existing in the world," Merrill explains.[16] In this world, these philosophers said, there is no universal or individual essence, no eternal soul that comes from God. Life is a series of immediate experiences.

"Heidegger completes the turning of Western philosophy upside down," Merrill says. "I come to know myself by doing things."

This is more than mere existentialism now, for it is an expansion into the philosophy of "phenomenology"—you are the phenomenon you experience. To follow is Merleau-Ponty, a favorite French existentialist (and Marxist) among artists, and highly recommended by many of the art faculty at MICA. He is the rare phenomenologist who uses science to talk about artistic behavior.

"Merleau-Ponty is the philosopher of the body," Merrill says, keeping his class attentive on this particular afternoon.

The French philosopher argues that physical experiences of the body—sight, touch, the nervous system—make the mind what it is by shaping the brain. Merleau-Ponty was not a neuroscientist, but when artists want to connect neuroscience with art making, he is their favorite link, especially since he wrote about how the physical problems suffered by Paul Cézanne—bad eyes and poor nerves—probably influenced his postimpressionist painting.[17] Although Merleau-Ponty's phenomenology works from the premise of Marxist materialism, for artists, his work is poetic,

not ideological, and it does not turn artists into biological mechanisms, like Marx's laborers, Pavlov's dogs, or Skinner's rats.

Over the weeks, Merrill's class moves seamlessly between the high modernist philosophers and high modernist novelists and poets. They did not read each other, Merrill explains, but as Woolf said of 1910, the same ideas and feelings were in the air at that time in Europe and America.

As with the philosophers, for the novelists and poets, too, the objects of life are what count, not metaphysical systems. Woolf wrote about how food and forks on a table are more miraculous than all of theology. Proust wrote volumes not on memory of theories, but "memory of sensations," Merrill says. The same goes with Faulkner, who regales the reader with indelible impressions of sensation. James Joyce, the hardest to read of all (indeed, incomprehensible to most people), has his character, Stephen Dedalus, move around Dublin bumping into mundane things and calling them epiphanies (a theological term usually reserved for the appearance of divine things). For the modernist writers—including for Mann and Eliot—these epiphanies are simply things, sounds, impressions; these are the essence of life and the subject matter of art.

By this time in the High Modernism class, Sean and the other students understand the consequences of what was wrought on or around December 1910. As Merrill summarizes, "We've gotten through the major crisis of the first half of the twentieth century of questioning ontology and being." Existence has won out over essence, as a modern philosopher might say. By the 1960s, the philosophical problem will shift again, from ontology to the problem of language, what philosophers now call "the linguistic turn." That is the battle over whether language—as a "text" in flux and in play—can say anything truly certain about reality.

For this class, however, the students stop before the linguistic turn, tarrying in the modernist epoch; and now they must write a paper about art and literature in that time. Sean is attracted to the T. S. Eliot's poem, *The Wasteland*, a verse of 434 lines with voluminous footnotes. Given his own painting themes—despair, nightmares, and mortality—Sean will focus on the poem's opening lines, which fall under the section, "Burial of the Dead."

> April is the cruellest month, breeding
> Lilacs out of the dead land, mixing

Memory and desire, stirring
Dull roots with spring rain.
Winter kept us warm, covering
Earth in forgetful snow, feeding
A little life with dried tubers.

For Sean, an amateur art historian, the roots of modernist painting can be traced to Francisco Goya (1746–1828), whose thickly brushed realism about war and terror broke the spell of pretty paintings once and for all. For his paper in High Modernism, Sean ties Goya to Eliot. In both, creativity arises in times of trial. Goya is the painter (and etching maker) of nightmares and melancholy. He paints during a time of invasions, political upheavals, and dislocations. Similarly, Eliot is a poet after the First World War, and his impenetrable poetry, fraught with strange feeling, seems haunted by the chaos of that time. If Goya limns a literal period when France and Spain were at war, Eliot adds voluminous notations to *The Wasteland* to explain his sources and allusions. Sean feels influenced by both artists. In his own work, though, he is not going to extend any explanations. His paintings have neither notes nor context, just hidden autobiography, which Sean leaves to the viewer to interpret.

On the whole, young painters in art school today are not likely to extract any flowery optimism by looking at painters of the past. What optimism they generate is a product of *esprit de corps*, the camaraderie that painters generate among themselves, which is indeed an age-old tradition. Today they band together against the tide running strongly against them, toward conceptual art. While it is true that art journals are pointing to a revival of painting in the art world, a strong countervailing current still flows, and it goes under the old saying: "Painting is dead. It has all been done before." You will hear this phrase in some of MICA's departments, usually stated playfully, usually in departments where teachers work with digital and conceptual art, the world of new media.[18]

When this theme is sounded, however, it can embolden the young painters. "You get a hard-headedness about you, when you are a painter, especially a figurative painter," senior painter Philip Hinge says one day in his studio at MICA. "Figurative painting is supposed to be the most dead of anything, because people have been doing it so, so long. So you have

an attitude, 'I'll show you.'"[19] The previous summer, he had a painting residency at another major art school, and its painting department was mainly doing video.

MICA—in both its undergraduate program and at the Hoffberger School of Painting—probably focuses more on actual painting with paint on canvases than many other top schools. When parents visit MICA, the administrators say that MICA is diverse, that there is "no MICA look" in the arts. In painting, however, students will say somewhat the contrary: MICA does have a look, and in representational painting it tends to be chunky, colorful, short brush strokes, a style that students associate with Cézanne. Abstraction is also very strong at MICA, since the majority of its senior painting instructors are devoted to that style. Nevertheless, glimmers of realism appear in undergraduate painting, the nascent signs, for example, of a student who may become a successful portrait painter. One graduating senior, in her miniature portraits, evokes the quality of a Jan Vermeer, the seventeenth-century Dutch realist.

In the larger art world, a contentious debate continues between the two major approaches to painting, which the ordinary person might call realistic painting and abstract painting. The debate is not a big one at MICA, although it does arise. In one Artist at Noon talk, the Brooklyn painter Margaret Bowland, who this year won top honors in one of the Smithsonian National Portrait Gallery's contests, tells students about the "fascist" abstract painters who strongly rejected her attempt in art school to learn realistic painting, the approach of the old masters. "We don't do that here," those instructors told Bowland in the 1970s.[20] For her part, she stood before an abstract Mark Rothko painting, waiting to have the sublime revelations that art critics spoke about, but she felt absolutely nothing. Therefore she learned the classic techniques of under-painting and glazing on her own. After her noon talk, Bowland is a magnet for a small group of students who believe, like her, that realistic painting is, after all, the best painting.

On the second floor of the Studio Center, one small circle of senior painters has adopted the middle path, interested in figuration but producing paintings that are expressionist. For this group, the uniting factors are a work ethic—doing a lot of paintings—and a love of the painterly approach, applying paint thickly and colorfully to large canvases. Sean Don-

ovan is in this group, as are seniors Philip Hinge and Sam Green. They work expressively, but objects are identifiable in their work. They know all the labels but are not inclined to accept any. When it comes to labels, most artists dislike being pigeonholed. Yet the labels fly, fast and furious, in the art world.

According to one standard modern art textbook, abstract painting is painting "without literal subject matter, that does not take its form from the observed world."[21] In this framework, all non-abstract painting in some way plays off real things that the painter has seen at some time. The terms for this kind of painting are many and varied: figuration, representational, narrative, and realistic (still) being the most familiar terms.

Painters have their own preferences. For example, visiting painters Alan Feltus and Lani Irwin prefer the term "figuration," which to most people means human figures. However, figuration doesn't always mean painting by observation, for the figurative painter can work entirely from the imagination, as do Feltus, Philip Hinge, and even Sean Donovan (although their human figures come out *very* differently on their canvases). In contrast, other senior painters at MICA use the term "representational," suggesting that they observed an object while painting, even if the painting ends up being more abstract than realistic. The classic landscape artist or portrait painter, of course, is caught in these shifting terms. That is because those types of painters both observe *and* imagine, but in the end, come up with what an average person will call a very "realistic" painting. Realism has it synonyms, of course, and one used by some art experts is "illusionism," since recreating three-dimensional reality on a flat canvas requires the illusion of space, created by color, shape, and perspective.

In the view of some realistic painters, these illusionist skills have been squeezed out of most art colleges, now emphasized in only a select few, and being revived only in recently created academies, such as the one where Bowland teaches, the New York Academy of Art. This is the view of Mark Karnes, perhaps the most realistic painter on MICA's full-time faculty and a main instructor in portrait, landscape, and interior painting. Karnes recognizes the problem with terms, but says that "representational" is probably the broadest category for non-abstract work. "Representational might involve the idea of narrative or certain kinds of pop art," he says. (Indeed, pop art in the 1960s was unveiled as the "new

realism.") "Whereas figurative painting involves experiencing the thing in front of you," he suggests.[22]

During their years as painting majors at MICA, Sean, Philip, and Sam have by no means run in the same social circles, but in senior year, they have been brought together in a communion of common, paint-spattered experience. "Some days a painting's kicking your ass and you say, 'What am I doing here?' You start questioning. But then you know others are doing this. You're not the only one," says Sean, speaking of the camaraderie. Down the hall, Philip relies on a similar positive psychology. "The existential question comes up, 'Why am I sitting in my room by myself putting pigment on bed sheets, or whatever?'" he says. "You realize this is what you have to do. When it goes well, it makes your life fulfilled."

For their final year, all seniors must also deal with "the system," that is, the school program, and this unites them as well. For the painting seniors, this system fell into place in September when the head of the fine arts senior thesis program, Howie Lee Weiss, a Yale-trained artist who has taught at MICA for thirty years, called them all together. He told the fine arts seniors that if they'd never gone to the career counseling center, this is the year to begin.

"The first senior semester is a little scary to them," Weiss says later.

Then comes the second semester as a senior, and on February 1, all of them must attend a mandatory senior meeting—for *all* seniors. By this time, the more free-spirited seniors are chaffing a bit under the school bureaucracy, but they do what is right. So Monday afternoon, they all go down into Falvey Hall, the entire senior class of 388 students—45 of them painting majors—to begin a two-hour review of just about everything needed to prepare for leaving school with a bachelor's degree: the application forms, graduation requirements, the professional planning, and finally completion of a senior thesis and the Commencement Exhibition.

After this big meeting, the seniors go their own ways, by their departments. For Fine Arts seniors—painting, drawing, printmaking, and general fine arts—Weiss is the teacher to watch, for he will shepherd this group through to the end, a thirteen-week journey to graduation day. In the final semester, he says, senior awareness is heightened: "It gets kind of critical. 'Oh my gosh, I'm leaving school. What am I going to do?' A

kind of panic sets in." Weiss says it can be an exciting time for some, a rocky ride for others. "It's a whole big, big range of emotions."[23]

Assisting Weiss in this final send-off are a group of about ten fine arts instructors, among them Christine Neill and Dan Dudrow. Neill is Sean's senior teacher and Dudrow oversees painters such as Philip and Sam. Neill and Dudrow, painters themselves, have been doing this for years. They believe that the seniors usually can land on their feet—if they plan and remain confident. "Fine art majors tend to do okay when they get out," Dudrow says. "They know what to expect. They'll hit all kinds of crises when they get out. But they are resilient and resourceful."[24]

PAINT-SPATTERED WRETCH

In February, the oil paint dries slowly, thanks to the cold, moist weather. The mood of winter has also slowed down some of the painters, who are now back in their campus studios, stoking the fires of their creativity. At the Studio Center, Sam Green of Rhode Island, a senior painter, tapes a brush to his gloves to keep going on a particularly cold day when the heating system is down. This time of year, painters like Sam and Sean Donovan are highly motivated: They have a senior thesis to complete and then a year-end Commencement Exhibition.

"It's a huge thing to know you have to have a body of work when you finish here," says Sean, who works down the hall from Sam.[1] Sean has his eyes on the calendar for another reason. February 27 is the deadline for the annual contest in *New American Paintings*, a magazine-gallery that publishes the work of emerging painters.[2] This is not Sean's favorite kind of deadline because it involves taking photos of his paintings and turning those into computer jpegs (image files). In this process, painters face the fact that the exact colors can change, first in the digital photo and then when the jpegs are looked at on other people's computers. It's the high-tech cost of doing business. Eventually, Sean has sent his jpegs off by e-mail. He'd love to be in *New American Paintings*, but he knows one other reality about his own work.

"My paintings are *difficult*," he says, using the art euphemism. "They offer a vulgarness that is beautiful."

In other words, Sean paints grotesques, a distorted kind of human figure. The grotesque is a classic in art history, so Sean feels in the mainstream. He can look back on the gargoyles of cathedrals, or the Renaissance paintings of Grünewald and Bosch (he prefers the former). There's also the grotesque styles of modernists like Francis Bacon or Philip Guston. Similarly, Sean's body of work is made up of large canvases with sculpted, gnarly figures. Recently he is also working with very dark shadows, along the lines of what he's seen in Caravaggio, though hardly as successful.

"You go dark too quickly," Dan Dudrow, a painting instructor, tells Sean

The paint-spattered studio.

one day. "I assume your paintings are dark to express a dark vision. But Bacon's vision is dark too. So a dark vision doesn't necessarily have to be painted dark."[3]

As the semester moves on, the colors in Sean's painting begin to brighten, although they remain anchored in dark shadows. Sean's submissions to *New American Paintings* characterize his current figurative imagery, part sinister, part humorous. In one, the head of the figure is in the far distance, but the rugged bare feet are close up, while in the middle ground large hands hold a beer can and cigarette, its tip a bright orange spot against the dark. Another has a ghoulish face, its nose disfigured, sitting next to a lamp, again with cigarette; a large blue window and reddish ceiling make up the background. The third painting is among Sean's favorites. It is a large, darkly atmospheric painting of a human form under white cloth, only the gnarly feet exposed. The immediate impression is of a morgue.

For a change of mood, Sean alters the colors in his work space, Studio

242. Sometimes the walls are painted black, other times olive green, Florida pink, or dark red and light gray. The space has three tables, the largest his glass palette covered with paint. Tubes of paint are expensive. So for certain colors — such as Venetian Red — Sean orders powered pigment to mix his own paint by adding linseed oil. For a regular visitor to Sean's studio, the changes on a single canvas can be rapid and entirely unexpected. One week, a canvas has a large figure painted in, a clear narrative. The next week all that is gone — a main object gone, another figure added, the colors different. This is what Sean calls his layering, or a "mishmash." He also likes to "scumble" — drag a brush for a rough effect. As with so many times before, he eventually hits on an arrangement in the multi-layered surface of the painting that works for him. Then he's finished.

[]

Outside the Studio Center, the winter air is beginning to warm up. With the arrival of nice weather, it would seem that the Studio Center will fill up with vibrant artistic activity, especially since forty-five painting majors face graduation. However, there are not exactly forty-five studios going at full-tilt; most of them seem inactive.

"It's great to have this studio space," says Sam Green, who is in his several times a week. He must share his space with another painter. Hence, he says, "it can be frustrating when across the hall there are people who have a large studio space but never show up."[4]

The biggest turnout at the Studio Center is Sunday night, when juniors and seniors work on projects for Monday's crits. After that, the building's countless studios mostly are silent, except when class crits are held or it is the semester's "open studio" day, when even the public is invited to peek into the hundreds of work spaces. After four years at MICA, Sam has a theory about why the senior studios can seem so silent so much of the time.

"Many of the seniors end up saying, 'I do not want to be an artist,'" he concludes.

At art schools, one popular little book is *Art and Fear*, which, despite its title, is a manifesto of encouragement for artists.[5] The book's appeal is its no-nonsense message that artists are essentially on their own; nobody really cares about their art except themselves, and it's the fear of giving up that drives them forward day after day. Unfortunately, that battle

is futile for most artists, the *Art and Fear* authors—a successful photographer and painter—famously assert. They estimate that 95 percent of all people trained in the visual arts give up making art soon after they graduate from school.

Yet in painting hope springs eternal. Not many years ago, most seniors at MICA were painters. It was known as a painting school (and some still say that this continues to be its national reputation). In time, the old Painting Department lost space, shrank in comparison to other areas of growth. In recent years, however, the Fine Arts division—which includes painting, drawing, general fine arts, and printmaking—has staged a comeback. In their final semester, the seniors in the Fine Arts division show a particularly strong unity, unified by the rapid approach of graduation day. They are organized into "core groups," each with a faculty mentor who sees them through to the end.

"The seniors start the semester by coming and talking with the faculty, sharing their ideas about a final body of work," says instructor Howie Lee Weiss, who oversees the fine arts senior thesis program.[6] Seniors also must complete a "professional development" course, and then their final semester culminates with a Review Board, a crit session with three or four faculty. In the case of a painter, if a Review Board does not feel the work is up to par, that does not mean a bachelor's degree in painting will be denied. The credits needed to graduate are based on four years of a student transcript. Graduating in painting with a C or D grade average is rare, says Weiss, and it's rarer still for a fine arts senior to be held back.

"Most people who reach this point are pretty much going to graduate."

The great symbol of that graduation is the commencement show. As in past years, Weiss is coordinating that for fine arts seniors. As the different departments begin to organize this exhibition, which sets up across the entire campus, there's some competition for the best gallery space, but nobody is calling it a competition. The senior painters Sean, Sam, and Philip have their eyes on the large, well-lit studio off the Main Building courtyard. If they get it, it will become a venue dominated by a similar approach they all take to painting, which is large canvases, thick paint, and expressionist imagery.

The three of them came to painting by different routes. Sean started in sculpture, Sam with photography, and Philip in illustration. Over time,

they all came to admire the old-time "hard-core" painters at MICA, those who painted large, used loose brushwork, and generally tried to push the effects of paint to its limits. They also liked the way these painters created strange moods in their paintings, but also how they stayed away from tying to convey philosophical messages, overtly or covertly. Sean, Philip, and Sam believe that painting is deep, but does not have to be a vehicle for philosophy.

For Philip, it has been a good year in his painting. The previous semester he had a breakthrough. It came when he revisited the ideas of Renaissance composition. "It all goes back to the fifteenth century," he says.[7] Philip is speaking particularly about Piero della Francesca, an Italian artist who influenced so many modern painters with his tight, eerie compositions of figures and landscapes. As to subject matter, Philip paints from autobiography, not from observation. He's lived in sunny suburban homes in Seattle, Southern California, and now Madison, New Jersey. His very large paintings (done in acrylic) add what he calls "imaginary perversions" to these sunny suburban scenes: backyards in a bizarre drama of human and animal figures, rendered as grotesques, a lewd gesture here or there amid swimming pools, picnic tables, green lawns, bathing suits, and happy blue skies. The colors are bright, bold, the composition as well-fitted as a jigsaw puzzle.

Sam also feels he has had a good year in painting, and a turning point of sorts. During the first semester, by fluke and necessity, he hit upon a way to paint by observation in a relatively tight space (his studio) with a low budget (human models are expensive). He began to buy clutches of miniature plastic toy objects—airplanes, soldiers, cars, goldfish, penguins, dinosaurs—and then paint them in giant size. The tiny airplanes produced a striking canvas in muted blues, gray, yellows, and off-whites that was chosen for display in the President's Board Room.

"There wasn't a day when I said, 'Yeah, I'm going to paint tiny things big," says Sam, who today is heading off for his studio once again. He is tall with short, black hair and a few days of stubble. The morning is cold, so he's wrapped in a hooded sweatshirt and black coat. As Sam walks across the highway bridge, he's tall enough to look down, where he can see railroad tracks, a virtual train yard, and a ravine with a rushing Jones Falls Creek, snow still packed around its banks. This is the winter land-

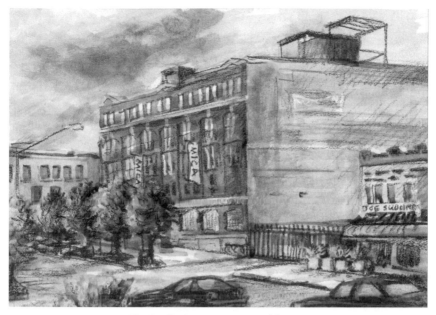

The Studio Center, a renovated factory.

scape of industrial Baltimore, all blacks, grays, browns, the dull orange of brick, and icy white. However, Sam does not paint landscapes. As he walks, he's thinking of goldfish and penguins.

Sam has climbed the stairs to the second floor of the Studio Center for a few years now, but when he's about to start a painting, he still feel anxious, even nervous. In his studio, he hangs his winter protection, takes a deep breath, and then turns to two blank white canvases that hang on the wall.

"There is no better feeling than having a painting underway," he's thinking.

First off, he indulges the well-known psychology of starting a new painting, and today he is going to start two of them. As quick as he can, he squeezes the oil paint onto his pallet, a piece of glass that is 4 x 3 feet. Like most painters, he squeezes his gobs of color in an arc from light to dark, yellows on one end, blues the other, reds in the middle. Black is over on the side. Sam keeps a fairly well-organized pallet for an expression-ist painter, usually known for their messiness. As he likes it, the Studio Center is quiet except for the thump of the heating system or creaking of floors.

The next step in the psychology is to attack the canvas without delay, filling it with a first draft, reaching a point of no return, no quitting. Before that, Sam examines his two models, the tiny, plastic goldfish and penguins. The first sits on a shelf between the canvases. The fish are mostly orange, but some are green, purple, and florescent yellow. Their beady white-and-black eyes stare back at Sam. This will be his large painting, roughly a 5-foot square canvas. For a smaller vertical canvas, the tiny penguins, black and white with yellow bills, sit in a jumble on the floor.

He decides to do the penguins first. After crouching once more to eye them, he reaches for his brush and the black paint, which he delivers rapidly to the white canvas, which looks strangely like a patch of the South Pole. The first strokes seem arbitrary. They are not penguin shapes. They are patterns he sees in the penguins, and patterns that emerge on the surface itself. (In a few weeks, the penguin painting will be done; a composition that strongly suggests the birds: shapes in blues, dark grays, whites, a pleasing picture, but not his best).

By lunchtime, his painter's blood is circulating. Sam is a physically active painter. He stands. He paces. His tiny models require that he step up close, then stride back. During the day of painting, he'll drop his brush and sit in a chair way back, flipping through an art book, looking at the canvases from afar.

"My weird dance," he says.

After some lunch, Sam turns to the goldfish, which sit in a brown wooden bowl and spill out on the shelf. He pokes them around, searching for a perfect "still life," or for a striking pattern. When he puts light blue paper behind them, the colors work better. With his brush, he collects blue and next red, both thinned by turpentine (to be fluid and to dry quickly). He starts putting down lines and shapes, the dominant one the bowl's ellipse. He tries the ellipse lower, then over to the side. The ellipse is turning out to be the initial problem in this composition, so he stops, steps back. Then he goes up to the wall and sketches a few tiny ellipses on the wall with charcoal. By now, he's painting in brown. Finally the ellipse seems about right.

Sam chose the fish because they have eyes. In his tiny-to-large mode of painting, he wants to try objects with creaturely personality. However, the eyes come later. Now he turns to the angles he sees in the tails of the

fish. They produce a maze of shapes and colors. He's looking for a pattern to focus on. In the meantime, he also finds a color contrast, produced by the yellow fish. Now the weird dance commences again: He steps up to the fish, takes a twisting step over to the palette, then strides to the canvas, soon stepping back to see it from afar. The painter's choreography can last for an hour or so.

By mid-afternoon, Sam is exhausted, but he has two full compositions. Both have ended up dark, relying on bold lines and shapes. The fish painting has an excess of brown at this point. In the end, however, it will be one of Sam's brightest paintings, popping off the wall with oranges, greens, and yellows. It will grow so bright that it becomes an experiment in color for him. "I tried not to go too far," he says. "You can overdo the color." As much as he enjoyed studying color theory as a freshman, he adds, "It was the last thing on my mind." The final painting features only a few of the fish eyes—but there they are, staring out. Many people will ask if it's lobsters or crabs. "Probably because we're in Chesapeake Bay country," says Sam.

Along with the airplane painting, the goldfish will be one of his best. It will hang in the Commencement Exhibition.

[]

Two floors above where Sam is painting, on the fourth floor, the Hoffberger School of Painting is a scene of regular activity, home to eight first-year graduate school painters, and six completing their second year, soon to graduate.

On most Thursdays, the Hoffberger painters hold crits, which include a monthly gathering in their lounge-library for Critical Studies Seminar. Today they have a different job to do. The interim director of Hoffberger, the abstract painter Timothy App, is employing them to help select applicants for the next entering class at the graduate painting school. For next year, Hoffberger will admit 8 new students, and that process has now begun. The school has received nearly 250 applications, so winnowing will be severe; the choice of the 8 will be tough. After reducing the 250 to 80, App will include his Hoffberger students in a portfolio review of those penultimate 80. From that point, he will select 30, who will be invited to Baltimore for an interview, one small piece of MICA's annual outreach.

Between January and April, the MICA recruitment machine is in high gear. The school is receiving applications for undergraduate and graduate programs, and deciding who will be admitted. By the time February has passed, all the applications must be in. For the graduate programs, it has been a bumper crop: about a thousand applications (for about a hundred slots). Over in freshman admissions, the arena is even larger. From a pool of applicants in the thousands, the school will admit about 1,200 students, 500 of whom, having been accepted, will decide to enroll (what colleges speak of as their final "yield" in the great flurry of each new school year).

Back at Hoffberger, App has lined up the 80 best candidates for the next stage of review.[8] Tall, solid, and favoring baseball caps, App has been painting and teaching for forty years. Now, at age sixty, he is among the veteran painters in the United States, his career overlapping with so much else that has happened in American painting. With that experience, choosing the 80 was relatively easy. It will get harder as he winnows down to the final 8. The goal will be quality, of course, but he also has the institution in mind, for MICA's painting department has a rich history, and each new class will perpetuate that. This year also, a MICA search committee will chose a permanent director for Hoffberger (which will turn out to be the New York abstract painter Joan Waltemath), a definite turning point for the art school.[9]

As a painting school, MICA has not had too many turning points in the recent past. From around 1940, its story has hinged on a very few personalities who took the lead in painting. The first was the French classical painter Jacques Maroger, who arrived on the eve of World War II and led painting for twenty years. Maroger was former director of the laboratory at the Louvre, an advocate of reviving the techniques of the old masters. The Maryland Institute had seen the occasional modernist rebellion against traditional painting in the early twentieth century. With Maroger's prestigious arrival, the school headed down a traditional track again. His traditional approaches spoke to the director of MICA, the classical sculptor Hans Schuler Sr., who led the Maryland Institute until his death in 1951.

Maroger retired in 1959. At that moment, some might say, the dead hand of the past had been lifted. More precisely, the disciples of Maroger left the Maryland Institute to continue his tradition. Maroger's assis-

tant, Ann Didusch Schuler (daughter-in-law of Schuler Sr.), founded the Schuler School of Fine Art just a few blocks from the Maryland Institute, a kind of banishment from the modern art school. As MICA went modernist, the Schuler School of Painting produced a national movement that was to be called the "Baltimore Realists," whose students continue to influence classical oil painting in the United States. After the age of Maroger and Schuler, however, traditional painting everywhere had lost its prestige. Art schools were now at the doorstep of 1960, a year when MICA itself was in crisis.

So the board of trustees cast about for an artist-leader, and they were lucky to find a full-fledged painter, the Yale-trained Eugene "Bud" Leake. He became president in 1961 and led the school for thirteen years. While Leake dabbled in abstraction, he returned to figuration, influenced by painters such as Fairfield Porter. Like Porter, Leake had a wealthy family background (by marriage), bringing an aristocratic touch to painting, treating it as a high art, a matter of skill and taste. To build up the painting departments at MICA, Leake hired young Yale graduates of a similar sentiment (skill and taste), hoping to turn the school around. Finally, he made an epochal decision about the graduate school of painting.

As it happened, one of the most famous abstract expressionist painters of New York's famous era had moved to Baltimore. She was Grace Hartigan, whom *Life Magazine* had called "the most celebrated of the young American women painters" in 1959. She and Leake began to talk. By 1964, Hartigan was head of graduate painting, infusing that school with a new identity. As Leake said to her, "I hired you for your name."[10] This was a time of growth for MICA in general. It received its first college accreditation from Middle States Association of Colleges and Schools and pulled off a successful funding campaign, which included a grant from the Hoffberger family—and thus the Hoffberger School of Painting gained its modern identity.

The Hoffberger painters had to organize their school wherever space was available, but after 2000, when MICA purchased the factory that became the Studio Building, Hoffberger was soon on its fourth floor. Over the years, Hartigan's approach to painting evolved. She began with abstract expressionism, moved to painterly pop art, and in her final years turned to a form of lyrical figuration, drawing on Renaissance and biblical

themes. Even family tragedy, alcoholism, and an attempted suicide did not break her hold on Hoffberger, or stop her from painting. Like Fred Lazarus's tenure as president of MICA (thirty years), Hartigan's may have held a record for head of a painting graduate school in America. She led Hoffberger for forty-four years, and when she died in 2008 at age eighty-six, she was still at the reins.

This year the post-Hartigan era is well under way. With App as interim director, a next new class of students is being chosen. He is assisted by the visiting critic Dominique Nahas, a curator in New York, who has been a key figure at the Hoffberger school for a decade. To get through the 80 applicants at this stage, App, Nahas, and the twelve Hoffberger students have to be all business, and that hard-nosed review begins one Thursday morning, February 4, with all due dispatch.[11] The scene is not one of painting studios, but the nondescript rooms of the graduate school offices on the third floor of the Bunting Building. With a secretary in attendance to record the results of the review, it barrels forward, a dark room with a giant slide screen, hundreds of works of art fleeting by, each artist getting as much attention as the group can muster, sincere attention to be sure, but all business.

One by one, the applicant painters are reviewed; the works flash on a screen. By late morning, everyone is in a good rhythm. Now a new artist is up. As his paintings fill the screen, App gives the general introduction: This is a male artist in his thirties working in Berkeley, California, in biological engineering. A scientist turned to art—this grabs everyone's attention, an oddity worth noting. A slight murmur arises. As the work of each artist is shown, one of the students reads something pertinent from the artist's submitted statement, and in this case, it is the turn of Virginia Wagner, a first-year Hoffberger painter who works in a realist style.

At this point, both an image and a text combine. The Berkeley artist has done a painting of a toothbrush, and as it appears on the screen, Virginia reads the opening line of his artist statement:

I lately decide that I really love the way the toothbrush feels in my hand.

Somehow the artist's genuine words and the subtle image, a toothbrush painted thickly, delicately in muted colors, stirs a feeling in every-

one, as the vote will soon reveal. Virginia can almost hear sighs and murmurs, even though the process is swift and quiet, with no discussion, no debate. For her part, Virginia is thinking that this painter has a kind of authenticity, especially in his choice of subjects: many simple household items. He is also a scientist. Virginia wants to ask him, Why did you take up painting? (Her Connecticut family is all scientists). As with the other applicants, the Berkeley artist's samples will bring to mind well-known painting styles already on the market (or in history), and for Virginia that will be the Belgian painter Luc Tuymans, who uses pastel colors and grays on blurred figurative images and objects.

All of this viewing process has been silent, for the most part, but what comes next reveals what everyone is thinking. The secretary asks for a vote, and down the line — a line of twelve students and App and Nahas — the votes are all fours and fives, the top scores. As Virginia recalls later, "Everyone at the same time was, 'Oh yeah.' We all got excited about this guy." (This candidate was invited to MICA for a final interview, but did not choose to attend Hoffberger, apparently).

For an entire day, the works of so many young artists flash before their eyes. For some of the first-year Hoffberger students, such as Virginia, judging the artwork of 80 of the best young painters in America is a novel experience, which is what she came to Hoffberger to obtain. She and some of the other first-year painters — such as Katie Miller (also a realist painter), Eli Walker, and Evan Boggess (who both lean toward the abstract) — are also working as Teaching Interns (TIS) to earn a credential that will allow them to teach at the college level. During the review session today, they are all fascinated by how contradictory many of the votes turned out: Some voting ones for a particular artist, others voting fives.

"Some were five across the board," Evan says later.

Evan, who hails from West Virginia, is particularly taken by seeing 80 samples of fussed-over portfolios. He is thinking how differently he would have done his portfolio if he knew what he saw now. The quality is impressive, even intimidating. The people are diverse. One applicant has been in construction work; another is a successful businessman. The toothbrush portfolio stood out so strongly because of the evocative statements by the artist, although such prose rarely seems a strong point in the portfolios. In fact, the written material from the artists suggests how confusing the

college application instructions can be. Everyone writes something different, some of the essays being unctuous, a lot of them ungrammatical.

"Some of them were awful," says Katie, originally a Californian.

Fortunately, the panel looks primarily at the art work. Katie saw trends in the work. A lot of painters mimic Kehinde Wiley, the black artist who puts brightly colored patterns behind figures in his highly realistic paintings. At other times, Katie was thinking, "Wow, this is really original. I've never seen anything like that before." As a hyper-realist, Katie knows painting skill when she sees it, but skill can also lack content; and some of that absence of content definitely happened on the screen. For Evan, glimmers of content are often good enough; everyone applying is young in the trade. He was looking for change in an artist, a willingness to experiment across the selection of works.

A lot of the paintings of the 80 don't work, but that is in the minority (since App already screened for quality). "So much of it is pretty good," says Virginia. "I didn't know what I would look for. But I felt free to advocate for who I wanted." In all, a native Texan like Eli felt it was an impressive line-up, though he knows his place in the process. "I didn't get the feeling that their fate was in my hands," Eli says of the applicants. Still, if he had his way in the final selection, "There'd be no two people alike."

For now, they have offered some votes, one element that Timothy App will take into consideration when he invites 30 of the applicants to MICA for twenty-minute interviews. Those 30 start arriving in Baltimore at the end of February, and by the second week of March, App is down to the wire. "At this point, it's a little bit less personal and more institutional," App says. "I want a diversity of styles or approaches to painting." He also wants a mix of interesting people, a chemistry that can help everyone in the Hoffberger School of Painting, and chart its future contributions. App has now made his "top 8" list, but knowing that not everyone will choose MICA (every school will want the obviously best candidates), he has lengthened the list with alternative candidates as well.

By Monday, March 15, the first round of official acceptance notices for all grades at MICA are printed and folded. The school's various admissions offices start sending them around the country. After this, the end-game commences. For undergraduates, MICA tells them they are accepted, but also what scholarship funding is offered. These students start comparing

MICA with what other art schools have offered them, and this can lend to a lot of hard bargaining. At the Hoffberger graduate school, the acceptance notice is straightforward. Hoffberger hopes to recruit its first choices, and usually gets most of them. There's no bargaining, however. At most, Hoffberger may offer a 20 percent scholarship. Whatever the offer may be, designed for that particular applicant, it is final.

[]

When it comes to financing MICA, the freshman recruitment is center stage. On March 10, as those freshman numbers are still being determined, the student government, or SVA, hosts a school budget information meeting. They gather today in the dark-wood President's Board Room, passing by the bronze bust as they enter. The students will hear a report from school president Fred Lazarus and from Doug Mann, vice president for finance.[12] The recession looms, and it seems to be hitting the college scene more this year than last. The evidence is this, so far: More freshmen applying at MICA are also applying at state or community colleges, where tuition is much lower. Parents are losing jobs, and retirement funds have lost value.

Lazarus has been doing business in this board room for thirty years, and outside, in the hallway, hangs a full-size portrait of him as a younger art college president, his hair curly but not yet so grey. After years of experience, he has a way with students, unflappable. He also can talk business without embarrassment. When the meeting is called to order, he begins to explain the sources of MICA's economic fuel.

"The majority of our revenue comes from tuition," Lazarus says.

So keeping enrollment up is important. But other sources are harder to control, such as state funding. This year, for example, the annual Maryland state grants to private colleges (the Sellinger Grant) has been cut. MICA will get about $1 million less than usual. MICA has an endowment, but the policy is to "draw" no more than 5 percent of its value each year. Finally, the trustees set an annual school budget and don't budge, Lazarus explains. "Once we set a budget, that's our Bible," he says. "We are fundamentalists. We don't deviate from that."

Therefore, the only option in a tight fiscal year is to try to boost enrollment, retain current students, and, at the same time, cut expenses.

"The first thing we're talking about is freezing all salaries," says Mann, head of finance. "Nobody is happy about this."

It's grim news in a year of formal salary talks with the faculty. The annual budget for MICA is about $60 million, and it's a tight-run operation, Lazarus explains. Even a mere $1,000 can be a big deal for a particular department. "If we were running the college well, any one of these cuts is going to hurt somebody," he says.

[]

The arrival of spring is having an upbeat effect on campus life. Today, Sean Donovan is back in his T-shirt and jeans, his senior painter attire. He has set out on his regular walk from Bolton Hill to the Studio Center, about a half mile, crossing the color-painted bridge, entering the edge of urban Baltimore. For four years, everywhere on campus, he has been going to critiques of his artwork. Today will be a little different. Every senior has a final critique, called the Review Board, and on this day in early April, his is scheduled for 3:30.

By now, Sean has digested the wisdom of the critique: It is the general observation that, in the end, *nobody* in art agrees on much. No advice seems to stand out over other advice. It is part of the art process, especially at art school, and students try to make the most of it. For the Review Board, the faculty strongly recommends that seniors bring a friend as a "scribe" to write down the Review Board comments as the dynamic situation unfolds. However, Sean goes it alone. He'll rely on his memory for any good advice he may receive. After all, he knows the teachers well enough, his senior core group teacher Neill, but also Dudrow, a senior painting teacher, and Ellen Burchenal, a painter who works with the Italy program.

In the great atrium on the second floor of the Studio Center, Sean has arrayed six large oil paintings, his body of work, some of it still wet. Word has come back to Sean that *New American Paintings* did not accept any of his pieces. Two of those are now on display in the atrium. His new works also feature scenes dominated by a single human figure, a man with a window, cat, and fish bowl; a man with an oxygen tank and statuary bust; a standing man with a white shirt and red tie, a globe to his right, books behind, and tennis rackets hanging on the wall. In Sean's free style, he

produces uneven surfaces. Some areas of the painting are glossy, others flat, which at the wrong angle, the wrong light, can obscure the painting's whole effect.

Neill knows Sean's work best, so she begins the review by pointing to one of his paintings that is not finished, a painting way down at the end, the one for which Sean bought a skinned raccoon for a model. The painting is called a failure, but it "was an important painting as a transition," Neill says, and Sean agrees.[13]

"I've had many failures," he says in his deep voice.

Their discussion becomes a flowing medley of comments, questions, and answers. They are covering a lot of ground. Which paintings are finished? Some look like they are open to more work. Sean has also provided a formal artist statement, and he summarizes some of its key points, especially *why* he paints. When he refers to "memories of certain people" that motivate his paintings, he stops short of answering the obvious question. Can you say which people? On this he declines, except to say that some characters recur in his mind. Others fade from his interest.

"Do you start with an idea, or do you just start scratching around, and as it starts turning into something, you take it somewhere?" asks Dudrow.

Sean says he begins by focusing his thoughts on a person, evoking what he can from his subconscious. Then he lets it emerge with spontaneity, letting the "truth to it" come out. In painting, this is a subtle distinction, one between beauty and truth, for they are really not the same.

"The palette has evolved," Neill says of Sean's colors. There is less black, more color. Still, Dudrow asks about the predominance of Venetian red, and Burchenal comments on the excessive darkness and scumbling, which tends to deteriorate the figures too much. True, Sean says, noting that Goya, too, is very loose in his figures.

Finally they come to how the viewer enters the paintings. Is the viewer looking at something like an Alfred Hitchcock movie, a scene of ordinary life that turns to horror? Or does the viewer feel complicity in the unsavory story of the painting, the dreamlike situation? Or can the viewer even enter, since sometimes a line, or rope, is painted across the scene? The Review Board—Neill, Dudrow, and Burchenal—also wonders if anything they have offered has been helpful to Sean. Regarding their comments or interpretations, "Does any of it feel right?"

"I don't think you can be wrong," Sean says. For Sean, that's simply how it is with crits and critics, and how it always will be. In this sense, the artist will always be alone, an island, left to make his own decisions. They ask Sean which paintings he will show in the Commencement Exhibition, but he's not certain yet. Neill has been impressed by Sean's productive streak this year, right up to commencement, and says: "He'll have a whole new set of paintings by then."

The Review Board is over, so now it's back to painting. "All right," Sean says, cheerfully. "Thank you very much."

CLIMBING THE GLASS CUBE

ate on a Thursday afternoon, March 11, Meghann Harris enters the glass Brown Center, making her way up two flights to her Typography II course, already with a few favorite styles in mind. She is climbing the glass cube. Outside, Chris McCampbell parks his car. He'll be on the campus late tonight, so best not to ride a bicycle home, despite the superb weather. As Chris makes his way up to the top of the glass cube, his mind is focused on how to build a scale-model exhibit of the history of neon signs.

For everyone in the Graphic Design department today, moods are bright. Spring break begins in twenty-four hours.

Just before six o'clock, the calm is broken. The stairways of the glass cube fill. Excited conversations echo off the glass walls as, it seems, the entire Graphic Design department (with 260 majors) streams down to the lobby, then down into Falvey Hall. Tonight's theme is "the design revolution." After a panel "debate" on design and social justice in Falvey, there will be a book party, an outdoor display, and a reception (with food). Today at least, the spirit of "design thinking" has completely taken over the Brown Center.

Design thinking is not exactly new in American art. Back in 1825, a year before the Maryland Institute was founded, the National Academy of Design opened in New York City as the premier art school, and before the Civil War, MICA ran its Night School of Design. So what is the design "revolution?" For a start, much is not in revolt. Design continues to mean communicating ideas (as in advertising and publishing), producing efficient kinds of products and environments, and following the rules of typeface and punctuation.

"I mean, who cares about quotation marks?" says Ellen Lupton, head of MICA's Graphic Design graduate department. "That's what *we* do."[1]

So the revolution is elsewhere, mainly on two other tracks: keeping up with the avant-garde for one, and for the other, making design for a "sustainable" world. This is design that is wise in its use of space and

resources and aims to relieve the particular mental stresses of today's environments. It is design that helps the poor and needy, as is evident in the panel discussion taking place in Falvey Hall. There, activists with Project H Design — an on-the-road group that is visiting MICA — are showing products that can "empower people and improve life." No mere "stuff making" here: Project H has designed wheelbarrows from disposable water jugs, a waterless washing machine, prosthetics for landmine victims, Braille Lego-style building blocks, and wheelchairs for rugged conditions. These kinds of designers are entrepreneurs. Outside, they've parked a 1972 Airstream trailer, which is traveling the country selling their book, *Design Revolution: 100 Products that Empower People.*

While Chris opted to stay in his class upstairs, Signs, Exhibits, and Spaces, to hear its guest speaker, Meghann Harris attends the panel, and finds the examples of helping the needy with design an inspiration. "The things they did are really admirable," she says, and she would like to do this in needy schools as an art teacher. She is intrigued also by how Web sites can join the design revolution. "Any kind of design can be beneficial," she says. "You don't have to actually be making objects. You can be making posters for fundraising. You can make a Web site. It doesn't have to be building houses."[2]

Now it's time to celebrate design books, and the book party tonight is for a MICA publication, *Exploring Materials: A Hands-On Guide to Product Design.* This book is produced by Lupton's students in cooperation with the Environmental Design Department at MICA. Unlike other art departments, graphic design can press books into service for the design revolution. Publishing and marketing are changing. Books must change too, becoming part of the DIY, or do-it-yourself, arts and crafts movement. That at least is the impression in the glass cube.

Based on her successful 2006 book, *D.I.Y.: Design It Yourself,* Lupton launched the Center for Design Thinking at MICA in 2007. It's mission is "to create opportunities for MICA students and faculty to author, design, produce, and contribute to publications, exhibitions, conferences, and other projects that participate in public discourse on design." The books just keep coming. For example: *Graphic Design: The New Basics*; *Indie Publishing: How to Design and Produce Your Own Book*; and *Graphic Design Theory: Readings from the Field.*[3]

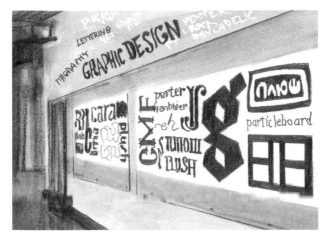

Fonts, typefaces, and lettering.

A native of Baltimore, Lupton is nationally known, a recipient of the design group AIGA's Gold Medal. She attended The Cooper Union and keeps that important New York connection as a curator for the city's Cooper-Hewitt, National Design Museum. Known as the Martha Stewart of Baltimore, she's also an advocate of "pragmatic" design, good-looking things that are useful. She's a leader in the DIY movement, which many MICA students, such as Meghann and Jen Mussari, are enthusiastic about. (Another book in this genre is Faythe Levine's *Handmade Nation: The Rise of DIY, Art, Craft, and Design*, and Jen, now in the Illustration Department, cherishes her dog-eared copy).

For an art school, however, the DIY movement raises interesting issues. For example, if you can do it yourself (using a book), why go to art school? Why hire professional designers? Of course, the answer is obvious: Art schools and design firms have experts, technology, resources, and commercial connections. The "design revolution" is also a bit utopian, so it believes that everyone can be a designer. There is always room for more design. The utopian spirit also extends to the belief among many designers, including Lupton, in the "open-source" use of design tools, such as typographical fonts. Usually, you have to pay for these, get licenses. But why not give them away free—then everyone can do design?

Like "do it yourself," the open-source, free-access ideas that often circulate at art schools can also raise dilemmas. If everything is free, how

can "commercial art" generate income for artists? How can artists protect against plagiarism and theft of "intellectual property?"

Over in Professor Ta'i Smith's Art Matters class, freshmen are learning about the legal side of intellectual property, which sometime arises in so-called "appropriation" art, a euphemism for plagiarized art.[4] For today, Smith has a handy example with which to discuss the legal side of art, a plagiarism lawsuit once filed against the artist Jeff Koons, MICA's most famous living alumnus. Years earlier, Koons had copied a postcard picture of a man and woman holding puppies to produce a sculpture, *String of Puppies*, for which he earned hundreds of thousand of dollars. The original photographer sued Koons for plagiarism. The lawyers for Koons said he had "free use" of the postcard for parody in his artwork, and could benefit financially from that free use. In 1992, the judge disagreed and Koons paid damages to the original photographer.

Now it's time for the student to take sides. Smith has assigned them to divided into pro and con sides on whether copyright law should be made stronger, more sweeping. They come to class prepared to debate.

"We feel that copyright law now has enough loopholes that it allows for creativity and still protects artists," says the young man who leads the con group. This group is by far the largest and most vociferous.

Then the counterposition. "Our argument is that copyright laws must be stronger to protect the artist," says a young woman.

No one seems totally against copyrights. By protecting an artist's work, argues someone on the pro side, copyrights help artists make a living and produce more work. Also, copyright law tells other artists they can't plagiarize, "so they have to create something original, not just copy someone else," and thus the world gains more creativity.

Before long, however, the anti-copyright side has mounted a spirited offensive, one that is strongly anti-corporate.

"Actually, monopolizing the marketplace in the hands of a few individuals [with copyrights] pushes down the amount of creativity," says a student on the anti-side. Looking at his notes, he states that 10 percent of copyright holders get 90 percent of copyright profits, and that elite tenth is corporations. "At that point, copyright law is just not that beneficial to artists," artists who can't make a living.

The students consider the fact that a billionaire such as Bill Gates owns

Corbis, a stock image company that controls the copyright to thousands of famous contemporary and historical images (in digital format). The same for music, says one student. Even the song "Happy Birthday" is copyrighted by Warner Bros. "It's become a commodity not owned by any artists, but by a corporation," he says.

At this point, the students are using mostly examples in popular culture, such as music and movies. In class today, few of them ardently favor copyrights; in other words, nobody seems to oppose people who "steal" or plagiarize music and art, since it's viewed as corporate spoils anyway. The anti-corporate side is taking over the class discussion. So Smith, the teacher, prods in the other direction: "I wonder if anyone who has not spoken is on the pro-copyright side?"

One student offers, "You get help distributing by using a company," a pro-corporate position. This comment shifts the classroom debate yet again, eventually to the Internet.

"Yeah, but the Internet is the new distribution system, isn't it?" one student says.

"Even there, an artist's work can be stolen."

A rejoinder is offered: An artist can decide to put only lower-quality, low-resolution digital work on the Internet. Still, someone notes, when you sell a high-resolution digital piece, that can be "shared" (a euphemism for stolen). In fact, Smith's students are part of a generation where high-density digital movies and music files are shared routinely—what the corporate owners call "theft," usually winning their argument in court. For many teenagers, however, they simply are engaged in friendly "file sharing." They are used to getting music and movies free, if they can. No one in class argues that this sharing is wrong, a violation of somebody's copyright.

Either way, Smith says, "The digital world transformed this debate to some degree."

In the Graphic Design department, copyright issues can arise over images, but mostly they arise over the use of licensed typography. Many of the world's favorite typefaces are copyrighted; you need to buy a license to print them. The alternative to paying to use a typeface, of course, is to make your own. That is what both Jen and Meghann like to do. In Typography II, Meghann is up to her eyeballs in new fonts. The class assignment

is to take three period fonts — such as art nouveau or pop art — as a spring-board to make something new. This requires drawing sixty sketches of the type faces. Eventually, when Meghann has invented her new style of type-face, she will sketch it out in an entire alphabet, then scan those sketches into a computer, touch them up to perfection, and save them for future use. Not a few students at MICA have created distinct fonts, named them, and hope to sell them. For the rest of the semester, fonts will be a big proj-ect for Meghann.

[]

On Tuesday mornings, Chris McCampbell used to walk down Mount Royal Avenue to a brick row house, home to MICA's Center for Design Practice. The center shows that design is also about generating income, especially by working with governments. When Chris participated briefly as a "fellow," he saw how the Center has been producing problem-solving designs: for health care education, green bike racks, and user-friendly re-cord keeping at hospitals. It also helped the Maryland Energy Commis-sion design public information billboards on green households.

During Chris's stint as a fellow, the billboard project became more am-bitious, trying to create a mobile and interactive exhibit where citizens can actually *see* how to revamp their homes to become more and more green.

"We call it 'The Box,'" Chris says.[5]

Once designed, these walk-in boxes can be taken to malls, sidewalks, or parking lots by government people in the energy conservation busi-ness. The public, passing by, can enter the box and play with hands-on household gadgets and learn how to save money.

During Chris's short stint at the Center, he got a taste of design as team collaboration, making proposals to funders, even governments. Educa-tionally, it was also part of what MICA's graphic design curriculum sees as a building-up process, a step-by-step learning. Chris is taking the steps. Early on he was asked to "brand" himself as an artist, and later to "brand" a project (a game book he designed). Then came an "information" project in which he produced a poster about Tibor Kahlman, a "bad boy" designer who had always fascinated Chris. The poster shows the cover of Kahl-man's book, *Perverse Optimist.*

For this era's "design revolution," designers such as Kahlman, who

came out of the 1970s, have been significant. He began designing interiors of book stores, then rock band album covers, later moving to Europe to edit the avant-garde magazine *Colors*, which used flamboyant imagery for edgy topics. Although Kahlman always made his money from corporate clients, he was part of a movement that styled itself as anti-establishment, following the 1964 designer manifesto, *First Things First*, which in effect condemned mass advertising (the main graphic design job). While the manifesto questioned the "high pitched scream of consumer selling," it did not call for an end to the marketplace, but rather "a reversal of priorities." It urged designers to helped society, preferably with progressive and counter-cultural messages.

That was the 1960s, and Chris still likes the idea of designers trying to promote good values while, by necessity, they make a living. (When the manifesto was issued again in 2000, Ellen Lupton was one of its thirty-three signers.) The next thing that comes Chris's way builds on his earlier classroom experiences. One day, his instructors bring in the San Francisco designer Martin Venesky to lead an intense three-day conceptual project, which is geared to showing how a designer can jump-start new ideas. Chris knows that problem well enough: "Sometimes you get a project and don't know where to begin." Venesky knows that dilemma as well, and his solution will be to start the designer off with a random "form," a shape that is come upon by chance.

So the three-day project begins with each student being given a text in a foreign language (and typically one they cannot decipher, since the typeface is entirely foreign). For example, Chris is given an Arabic text. All he knows is that the text has forms, based on its calligraphy, and Chris is taken by its "swooshes and punctuation dots." As the exercise intends, he takes those shapes out of their context and maps them on a flat surface. Then, using gray and black strips of paper pinned on a wall, he produces a variety of 3D looping effects that mimic the curves in the Arabic script. He photographs his work, creating several compositions of the loops and their shadows.

Eventually, Venesky spill the beans: He tells each student the origin of their script—Persian, Arabic, Chinese, Japanese, for example—and what it actually says. Chris has an Arabic poem, "The Pillow," a story of how both the pauper and the tyrant tell secrets to their pillows.

"Only I know the tyrant's quivering eyelash," the pillow says.

From this, Chris moves beyond form to some kind of idea in his design. From the poem he derives a "hide and reveal" theme. By now, the photos are in digital format and they are moving toward a poster design that Chris will print out in black, white, and gray. He starts adding the theme to the image by running some poem text (in English) along the looping black shapes. He's viewing the loops as the billowing of a pillow. He also manipulates the dark and light to hide and reveal things.

"You don't know what's shadow and what's material," he says, his pointing finger circling the final art work.

The finished poster is stunning, but in Chris's mind it is not really a serious statement on his part, like a design statement he might make in a piece of advertising or an entire exhibit. This was a worthwhile "formal exercise" — a study of graphic form. Chris will show the poster during a spring exhibit and, as it turns out, Lupton asks him to write a chapter on his process for her latest book project, *Graphic Design Thinking*, a "practical guide to creative strategies for graphic designers." Being able to write gives graphic designers an edge in the marketplace, of course, and for Chris, it also allows him to be a bit of the teacher as well. As he writes:

> How does a piece of paper wrap around an object? What happens when a length of string falls to the ground? Slowing down the design process and observing physical forms can help designers become attuned to nuances of space, light, and texture. . . . Venesky uses this method to make unexpected connections between form and content.[6]

Chris came to MICA in pursuit of his true ambition, to learn how to design environments (he had worked on school design in San Diego). On "design revolution" day, he misses the festivities to focus on Signs, Exhibits, and Spaces, a class on his favorite topic. On the fourth floor of the glass cube, in his studio, Chris shows his table-top model of a walk-in exhibit. It's an exhibit on the history of neon fast-food signage. "I want to show how it developed over the years," he says. In the miniature model he has built, the visitor walks in, sees signs from the 1950s, and by walking further moves to the present day. Artistically speaking, the older signs are better, says Chris. Today's signs are merely punched-out acrylic with

back-lighting, not full-color neon tubes. Either way, his miniature model shows "the development of a concept and how to lay out an exhibit space." This is the kind of model he would bring to a developer who would build it, with a million dollars. For *Graphic Design Thinking*, he also has written a chapter on this sort of problem.

"It's all about space," he says.

[]

Those might have been the very words of the MICA trustees when, around 2000, they approved a ten-year plan for the campus that included a brand new "signature" building—later called the Brown Center, the glass cube. Fred Lazarus took the project to Charles Brickbauer and his partners— Ziger/Snead Architects—giving them almost a blank check on the design.[7] It had to be a signature building and had to speak to the future. "I want people to talk about it," is about all that Lazarus said.

That left the rest in good hands. Brickbauer had built glass modernist skyscrapers as part of Baltimore's downtown renewal, and two glass buildings in the suburbs. Given their tastes in architecture, he and his partners were inclined to do a minimalist design, a design also to be of practical use for MICA. So they designed a "loft style" building, one that offers countless useful spaces and flexibility for future alterations. The building also had to provide the campus with a large auditorium (the future Falvey Hall), and that enclosure would define much about the building: To create a large basement space, the structure erected its columns on the outside, and "hung" the thick glass walls from them, a tried-and-true method in the field called "curtain wall" architecture. Hence the real challenge was the narrow, parallelogram-shaped plot of land that Brickbauer was given to work with.

Fortunately, the tight space allowed the glass cube to play off its crazy quilt neighborhood, in which none of the architectural styles matched: Renaissance marble, a Gothic church, brick row houses, factories, bridges, commercial buildings. "This building was going to be its own object," Brickbauer says. "It was not going to be related to any other buildings." Nevertheless, with its dull glass surface (with halftone Benday dots), the giant crystalline shape was enough of a mirror to reflect its environment, depending on where you stood. Two other goals were also achieved,

despite the object's independence. It tried to "gesture" to the other build-
ings and be visible from every approach on Mount Royal Avenue. This was
achieved by the glass building's "prow," a great angle that seems to lean
over the street. To *Architectural Record*'s thinking, it ended up "the finest
modern building erected in Baltimore or Washington since I.M. Pei's East
building of the National Gallery of Art in 1978."[8]

"It's a modernist building," Brickbauer says.

The architects also accept the term "minimalist," since the design is
based on a reduction of materials and principles to a minimum. By con-
trast, many would say that the Gateway building is postmodernist (or
deconstructionist), reflecting the postmodern belief in complex intersec-
tions, collisions, and accidents, true to the tensions of modern urban life.
The Brown Center uses a few materials and colors only. After opening day
in 2003, it became home to digital and applied arts, fating that students
in those majors would be climbing the glass cube.

During Baltimore City's Architectural Review Board hearings on the
new structure, there were no objections except for one.

"It's so angular," said one Board official. "Can you add some curves?"

"No," said Brickbauer's team.

There was nothing DIY about such a major architectural project, of
course, and the same would turn out to be true as MICA sought to brand
itself for the art-school market. It had new facilities, and it wanted to ex-
pand both its image and its enrollment. For this it turned to Pentagram,
the large international design firm. Conveniently, Lupton's husband,
J. Abbott Miller, was a partner in its Baltimore office.

For years, MICA had struggled with its name, which in the beginning
was wordy for sure: The Maryland Institute for the Promotion of the Me-
chanical Arts. Generally, the "Maryland Institute" stood in, at least until
it became an accredited college, and that word was added. So the goal, as
part of MICA's ten-year plan beginning in 2000, was to find a pithy em-
blematic identifier (other than "the 'Tute," a student slang invention). The
answer was "MICA" in a logo format. The school finally felt good about
using a resonant, geologic, even biblical-sounding, acronym as its "pri-
mary identifier."[9]

But in design thinking, there has to be more, as expressed in the three
lines between the letters: M|I|C/A. The two vertical lines stand for the old

and the new architecture at MICA. The third, a diagonal, stands for the prow, the glass cube's most compelling feature along Mount Royal Avenue. With its long history, MICA had every right to play with the old and the new: "The logo's rhythmic lines echo the juxtaposition of the classical Italianate structure (Main) and the linear geometry" of the Brown Center.

[]

In the last week of March, the prow is glinting in the spring sun, its mirror-like surface reflecting the white, flowering pear trees down the median of Mount Royal Avenue. The trees are in full bloom. Ideally, they burst open in early April when the campus holds its spring Open House for families considering enrolling their children at the art school. This year, however, the blossoms came too early.

Pretty as they are, the blossoming trees are a reminder to the fifty or more students putting on *A Midsummer Night's Dream* that opening night has arrived. Few of them have had much time for class work recently, and this applies especially to Amelia Beiderwell, a member of the costume team.[10] The costumes are falling into place. As might be expected, the directors want last-minute flourishes added to the garb of the characters. What worries Amelia most, logically, is the single most significant prop in the entire play—the donkey head. Under the crunch of time, the donkey head is not quite perfect. It will have to do for opening night.

In the warm April air on this Wednesday, the Gateway glows in the evening dark, and it soon becomes clear that there is a full-house audience. For any viewer, it's amazing that young actors can remember their lines, and they do. The stage set of wood, paper, and paint—the artistry part—is an impressive amalgam of giant spooky trees, ground mist, blue lights, and bright white Greek stone—and of course characters known by their costumes. This being a dark-woods story, however, throwing light on the faces of the actors proves to be a challenge (as the newspaper critics will say). The lighting is improved with each performance.

A better donkey head will also be constructed. Even on matters such as a donkey head, Amelia tends to perfectionism. After all, she says, that donkey head is a superlative turning point in the entire play, when Nick Bottom, a weaver in the "rude mechanicals" amateur performing group, turns

into an ass under fairy magic. "Unfortunately, the head only partly reads as a donkey," Amelia laments. "You couldn't see the face very well."

Amelia works in the back each night, helping with costume changes. She is watching with others what one of the staff calls a fact of life for the actors (and stage crew): "They were running into trees and stuff, because it was dark."[11] Practice makes perfect, though, and by the end of the ten public performances an exhausted cast is in top form. They are also ready for a catharsis. For Amelia, it comes on the last night, April 4, when she goes out front to watch the final act, when the rude mechanicals—in their endearing, wacky, threadbare costumes—act as theatrical fools before the wise-cracking royalty. "I was just howling with laughter, tears streaming," she says. The next two days were spent in tear down, and by the next week, you wouldn't know that the "play was the thing"—except in the worldly-wise, tired looks of the directors and players.

[]

On Friday night, March 26, as the play was picking up steam, Liam Dunaway heads to a reception for the annual campus show for his Environmental Design department. It is titled, "ENVentions: Inventions, Interventions, and Innovations," featuring work by forty-six students (overseen by their ten faculty). This is another world of design. Although its domain is the top floor of the Fox Building—a floor that looks like a giant, open architectural studio with a long-windowed view of east Baltimore—the department's spirit goes along with the glass cube. Liam's taste for minimalism (recall, he uses it in Drawing and Painting, to his teachers' dismay) is suitable for environmental design, whether modernist or postmodern (or expressionist, which breaks architectural rules).

Over the year, the number of freshmen interested in Environmental Design doubles to fourteen, and Liam is among those choosing the major. Clearly, drawing and painting are not his forte, but 3D work certainly is, as he is experiencing in Elements and in Sculptural Forms. On a whim, he also takes Introduction to Spatial Design, despite its cosmic description in the catalogue.

"Understanding space!" Liam says. "It sounded vague, but also sounded pretty neat."[12]

He was surprised at where this venture into space began, however. The

From idea to game to structure.

course started with origami, often considered a children's pastime. The students next studied how materials fold; this sounded more like it, Liam thought. Next they began drawing technical elevations of the origami— and then had to invent a story and make a game. Liam could see it was going somewhere, but he was not sure where.

For the game, Liam crafts a three-dimensional tic-tac-toe. He is beginning to understand what the teacher is getting at. That revelation comes with the big project: the students each will design a pavilion in which the game can be played. In turn, the pavilion (along with the game) must continue the story or theme. "When we started, some of this seemed way out there," Liam says. "After taking the whole class, it was really brilliant. Designing a building is a daunting task." Daunting even when it's done in balsa wood, cardboard, or other scale-model materials.

Many of these kinds of projects are on display tonight at the "ENVentions" reception. The projects emerged from classes on city planning, architecture, material fabrication, and designing user-friendly objects. Only now, these class projects are put all in one place, and on reception night, the students are orbiting around them, drawn to the white-clothed tables with snacks and sodas.

A convert to design, Liam has put behind any aspirations in fine art drawing. He is eager to learn another kind. That is the technical drawing of future courses. It is taking a while for him to understand the distinctions

between fine art and applied art, since they mix together on campus, and he's surrounded by that mixture. Even his three roommates at the residential Meyerhoff House, good guys who all get along, are all excellent in fine art drawing and painting. At first, his Foundation Year art courses seemed to him to be a flat rejection of design principles, but that worry has evaporated with time, "Now that I understand what fine art and design are." He is also learning the difference between industrial design and architecture: The first is about objects, the second about space. "Mine will be a design degree," he says.

And speaking of objects, there are plenty for him to see the next day (after the exhibit reception), when Liam travels to New York City to see the vaunted Whitney Biennial.[13]

Along with forty other students, Liam jumps on a charter bus Saturday morning out in front of the Main Building and, per an assignment for his Elements class, heads for Manhattan. The Whitney Biennial is North America's bellwether of what's truly "hot" and innovative in contemporary art. In recent years, a lot of this is video and installation, a kind of design. As Illustration instructor Warren Linn likes to say, the Whitney can be more like a "science fair" than an art exhibit.

When the MICA charter bus arrives, the Whitney is already bustling with visitors at its Upper East Side site, rising at Madison Avenue and Seventy-fifth. It's a five-story monolith of dark granite and concrete, appropriately called "the brut" style in architecture, a building with no windows (except one) and a cutting-edge design for optimal white gallery spaces. Soon enough, Liam and his classmates are buying tickets, checking backpacks, and gathering around a docent they will have for the day, a young artist in the Whitney program.

"So he took us to pieces that he had been studying," Liam says. Soon it becomes clear that much of the Whitney Biennial art is highly intellectualized art, typically offering lengthy expositions of its meaning, if you want the meaning.

Accordingly, Liam and the others spend a long time at one particular piece (out of many to see in just a few hours). The docent's talk is like a doctoral dissertation. He is trying to go deep, beyond a superficial look at this one work of art, a white limousine hearse with video projections inside and a long sound recording. By the end of the day, one MICA instruc-

tor asks Liam's class, "Do you think in the future we should just give you a short write-up on the pieces, and let you go on your own?"

"Yeah, do *that!*" everyone says.

The Whitney, exhibiting the work of fifty-five select artists on four floors, has its usual dominance of video, installation, and photographic work. This time it also has a surprising complement of paintings (many of them "ironically" traditional paintings — flowers, drapery, and house landscapes — or what MICA students called "punk rock" in their painterly irony).

The MICA faculty gives the show mixed reviews. For some it is the usual attempt to bombard the senses, usually with electronics. Many of the MICA faculty attended, part of a biennial ritual. Abstract painter Timothy App gave it a thumbs up, "the best Whitney in a long time." It includes more painting, he says, but it also "doesn't depend on sensationalism. And because it's a little quieter, it's going to be a little deeper." In contrast, MICA's new media artist Mina Cheon felt the Whitney was so quiet that it was almost asleep. It is still worth seeing this year, Cheon tells her EMAC class. She adds, however, that it's too conservative, even "schizophrenic" in its use of out-dated art objects. The selection of objects made the show more about form than about content.

"There weren't enough media pieces," says Cheon, a popular teacher in her classes. "I narrow it down to, 'Wow, that was really tame!' "[14]

As an art novice, Liam is surprised by three things. The presentation of many pieces of art is no better crafted than what he often sees in a classroom crit back at MICA. This is particularly the case with hung paintings and photos and installations. "You contrast it with student work, what's installed in an art-school gallery, and you'd expect something more," Liam says. The Whitney 2010 also had quite a bit of video (and in one case a Rube Goldberg-type film arrangement). The technology struck Liam as quite accessible, a lot of it like what he does on his computer all the time. Yet even the mechanical art could be obtusely intellectual. "Inaccessible on a conceptual level," Liam says. "You had to read a lengthy explanation to appreciate its point."

One final impression is how ironic, even cynical, the Whitney Biennial seems, as characterized by the docent's talk. The talk was mostly about the financial corruption of the art world, how practicing artists must be in

a perennial debt of about $150,000 to work in a big city. Although such artists loathe the "art world" system, they covet it as well, including the chance to be part of the Whitney Biennial. Even for a visitor, for the rest of your life you can say, "I was there."

Later in lower Manhattan, as the sun hangs low and the students gather in So-Ho to catch the bus back to Baltimore, Liam has mixed feelings about the great Whitney. "It's a little underwhelming," he says. "My idea of the Whitney Biennial is that this is the pinnacle of the contemporary art world." To be underwhelmed is also good, however. The students can see that even the vaunted art world is made up of stapled canvases and rough two-by-fours, and that "art" is praised as much for its political relevance as for its craftsmanship, and that it's good to have art world connections, and best of all, to have friends who are curators of important shows. Somewhere back at MICA, they probably will read the mid-century art critic Clement Greenberg, who calls the kind of objects seen at Whitney Biennials "novelty art." This art assaults the senses on first encounter, but the thrill does not last, the proverbial Chinese food of the art world, filling but not for long.

For Liam, the Whitney experience also helps clarify why conceptual art is not for him. "As a designer, I'm interested in problem solving," he says. "That's just the analytical mindset I lean toward."

[]

Two days later, on Monday, March 29, it is official: Meghann Harris announces to the Academic Affairs Council that she will not run for president again at next month's election (the last meeting of the council for the year). She encourages others to step forward, but you can never know for sure. Even young twenty-somethings can have a deeply conservative streak; they like to keep things as they are (with someone like Meghann taking responsibility).

Somehow, Meghann is feeling lighter, with a bit more spring in her step. She has helped with student government for three years. Now the future looks a bit freer. The hopeful energy she feels (in addition to feeling a little guilt) is propelling her forward. In the days after the SVA meeting, Meghann heads for the third floor of the glass cube. It's Tuesday and she is going to her course in Graphic Design IV, a favorite course

because it's also one of her favorite teachers, the graphic designer Zvez-dana Stojmirovic, who recommended Meghann as a student government leader.

In the final weeks of the school year, Graphic Design IV is embarked on two projects at once.[15] First, they are participating in an experiment called "LINKED," for which their class is working with a design class at Miami University in Ohio, and second, they are also designing promotional material for a nonprofit, City Blossoms, a program to help urban children develop gardens for recreation and learning. In these two projects, the importance of building human connections—a proverbial "old boy" or "old girl" network—at an art school becomes evident. In the first project, the "link" is with a Miami University teacher who graduated from MICA, now in the profession. In the second project, the tie with City Blossoms is similar: The program is based in Washington, D.C., and was founded by a MICA graduate who went into community arts, a low-paying but highly rewarding, art career, it is said. Meghann is contributing her part to both of these class projects, which are moving rapidly ahead.

For LINKED, each of the fifty-five students involved has developed a video image of one of the six letters—L I N K E D. Now, combined in six vertical frames, these letters are changing, part animation, part MTV-style flashing of images. It's called "motion graphics." Altogether, the Internet video created by the students is going through a flashing life cycle of seventeen seconds, then repeating. For the "I," Meghann has designed an image in blue yarn; it is her "module," added to all the others. Student editors at MICA and Miami University have knitted the student contributions together digitally, seeking the strongest visual effect.

By today, the final version is up on the Internet, essentially available for anyone in the public to view. "So are you guys tired of LINKED?" asks Stojmirovic, the instructor, on this particular Tuesday morning. "Or are you excited to see the final?" Either way, the lesson learned here about graphic design is that it works within deadlines and restrictions. "That often leads to better results," Stojmirovic says. The project is also about short attention spans in modern-day people, the reality (or curse) of the video age.

LINKED is possible because this is the age of "open-source" software, with generous geeks putting programs on the Internet for people to use

free. MICA and Miami University are conducting their project in just that way. "Students are exploring the concept of what it means to be linked; they see how collaboration works in graphic design," says Stojmirovic, a savvy designer trained at The Cooper Union and MICA, and an advocate of open-source tools on the Internet. She also knows the next question: Who in fact owns LINKED in this open-source world? Since it was made by fifty-five students, is it collectively owned by all the students, or by the teachers, or by their colleges? Can anyone take the video off the Internet—like Jeff Koons and the puppies—and sell it for profit? Stojmirovic says that all of these questions are up in the air, especially if you adopt the open-source worldview. Not that the seventeen-second piece of motion graphics is a new *Mona Lisa* that is likely to be bootlegged and sold for millions. Still, in principle, open source remains an open question.[16]

The other big project in Stojmirovic's Graphic Design IV class is more straightforward: The students are designing a public relations package for a nonprofit group, City Blossoms, which helps urban youth find recreation by planting gardens. The idea is to identify a "problem" in the group's public information set-up, and offer a solution. Meghann is way ahead on this one. She's focusing on an improved Web site, with a new slogan ("planting hope in inner city neighborhoods"), an attractive color scheme, and easy-to-use pages. On the last day of classes at MICA, on May 7, she'll also have an appointment with the City Blossom's founder (the MICA graduate). They will hire her to revamp the organization's Web site.

BEING IN FILM

O thers who climb the glass cube simply bypass graphic design, heading to the top floor, the dizzying realm of Video and Film Arts. For a month now, the vibrations of Hollywood success have resonated in the department. A few weeks earlier, *Music by Prudence* won the Oscar for short documentary. Three filmmakers at MICA worked on the video, shot in Zimbabwe, including the chair of video and film, Patrick Wright, who persuaded his school to give the first seed money for the project.[1]

For MICA's film instructors, there's hope that the Oscar success will bring attention to their young, small, but growing art-school department, which now has twenty-eight majors, including the freshman Holden Brown. The Oscar win confirms for Holden just how much can be done by young filmmakers today because of video, which is how *Music by Prudence* was shot. Using real film, 16-millimeter color film, is extremely expensive, an option only for the best-funded artists and studios. Not for nothing is the MICA department called "video" first.

As Holden begins his adventures in the video department, however, his first class is in full-fledged film, Film I, the foundation course for any serious filmmaker. Already, Holden has done a lot with video, and that is why, one recent Friday, it was something of a turning point for him in the editing room. At exactly 3:20, he spliced his first piece of 16mm film, just like they do in Hollywood.[2]

Holden's class is also known as Introduction to 16mm Film Production. Its primary weapon is the 16mm H16 Reflex Bolex camera, a few of which students can check out along with tripods and light meters. "The focus of this course is Technology," states the syllabus. Aesthetics, of course, is also relevant. Most relevant is the caliber of the teacher, Allen Moore, a Harvard-trained filmmaker who has been chief cinematographer for Ken Burns's many documentaries (popular on PBS). At a time when video—less expensive and easier to edit—is sweeping the field, Moore preaches roots, knowledge of vintage film techniques and tools. Holden has felt the

challenge, but enjoys it. As another student says, "Video is more about editing. Film is more about shooting."

Of all studio courses at MICA, filmmaking is perhaps the most academically technical. Over the term, students take an equipment test. They have three quizzes on *The Filmmaker's Handbook*, and must be reasonably conversant in the jargon, terms such as montage, split focus, cinéma vérité, noise floor, rough cuts, wild sound, dubbing—and screening. The screening—or showing the work in progress—will be each student's experience in about six cases, the final one a complete four-minute film. They all began with a few film exercises: plan, shoot, and have it developed (the film sent out to a professional laboratory). These small assignments are leading toward a *main* exercise, followed by a final project.

This main exercise is filming a single activity, shooting it from eight different angles, and then assembling it as a sequence; this is exactly what the great filmmakers do. Each week in class, Moore rolls out some examples for students to see, and none is a better example of simple editing than the Soviet filmmaker Sergie Eisenstein's classic *Battleship Potemkin*, which makes each scene a composition in itself, scenes that show the use of every kind of angle.

The 1925 film is an hour long. So Moore uses just the fourth of its five parts, a crowd scene on the Odessa steps, where the townsfolk face off with the czarist soldiers, a brief setback in their proletarian revolution. This is not pure art, but propaganda, Moore explains. Yet look at the technique: multiple angles on one scene, panning on others, and then close-ups, a moving camera, and the use of dramatic light and dark. "The film can be looked at like a story board," Moore tells his class. "Every frame has a really nice formal composition to it. There is a lot of inter-cutting and a lot of close-ups."[3]

By now, Moore's students are screening their eight angle shots, learning also about whether they have read the light and focus accurately (some are underexposed, some over). Nobody knows quite where Holden is going, but his angle shots are interesting. For lack of a cast budget, Holden has done his own acting, his girlfriend running the camera. In his angle shots, he styles himself a Charlie Chaplain–type figure, with hat and coat, a funny tie. In one shot, he stands at a door, his eyes darting around. Then there's a view through a key hole. In another, a block of brick row

The first splice — making a film.

houses is being snowed on, and then the block is on fire (in both, Holden's applied some special effects).

In the next weeks, Moore takes his Film I students to the editing room, where they use table-top machines for cutting and splicing (that is, taping pieces of film in a final order), and for adding sound to the visual film. Moore emphasizes the importance of doing it right, adding "leader" tape to the film and "double splicing" so there are no blips (most of the students will forget to do at least one of these).

Holden has a lot to remember when he finally gets to the editing stage. After going until two o'clock one morning, trying to get his clips in the right order, he's nearly there. He's thinking of old movies, hours-long movies, like *King Kong* and *Gone with the Wind*, "how much time they put into those," he says, doing the same thing he's doing for his three-minute assignment.

On screening day in class, it's roll 'em for Holden's first effort, a story that unfolds to the sound of the movie projector clicking along. The man comes out of his door. All of a sudden, the snow covers the block. He

looks surprised and steps back in. He looks through the keyhole, then he's out again. Everything on the street is burning, so he retreats. His expression grows more puzzled. Still, he comes out one more time, a fatal mistake: He dissolves into puddle of water, with his hat remaining. A woman comes by, dabs up the water, and is on her merry way.

The projector goes silent, the lights go on. "That was way more than the sequence, it was a narrative," says Moore. "Very interesting." No one says this, but it's also Kafkaesque—and that, along with special effects, interests Holden. He wants to make stories that are "timeless," whereas a Hollywood animation blockbuster like *Shrek* seems to crack jokes about today's headlines, which will be old tomorrow.

By now, Film I class has passed the mid-semester mark, and the students are on a downhill slope, struggling to finish the final project, a four-minute film. They began by writing a "treatment" for Moore. It's a couple-page synopsis of what the film is about, how its techniques will produce desired effects, and who the audience may be. The treatment is also a blow-by-blow list of what happens at each step: It becomes the filmmaker's rough guide for what needs to be shot. In other words, in film you have to think way ahead, create the movie before the camera rolls. (It saves money on film; a standard fiction film takes five times as much film as the final version, which is fairly economical. In documentary footage, the ratio is fifty to one).

At the end of this school year, Holden is nursing a particular theme in a few of his art projects, and it's the theme he'll also use in his final project for Film 1: the idea of embracing one's "inner demons," or difficulties in life. Holden does not think he has had more of these than most eighteen-year-olds. Still, he's had some. Unexpectedly, one of them is his top-scholarship to MICA and the pressures—the expectations—he feels. It was in late February, though, when he attended Kris's memorial at the Main Building, that a particular emotional breakthrough took place, which he would now use in film. During high school in New Orleans, Holden's best friend committed suicide. "He hung himself in his closet," Holden recalls. It was like Kris's case. "He was really young and artistic," Holden says of his friend. It was summertime. "I didn't find out until months later." Miscommunication followed. "So I missed my best friend's funeral."

Those memories rose in Holden as he attended the memorial for Kris, but at the same time, an emotional calm came over him. He felt a past sadness evaporate. "That was such a release for me," Holden says. "I felt like, by going to Kris's memorial, it was bringing closure to my friend's death as well. Fulfilling this need to show my respects." Finally, he has grieved publicly. He took the demons back inside of him, finally at peace.

It sounded like a good idea for a movie.

[]

Now it's five o'clock on a Thursday morning in late April. Holden is finishing up his academic papers, his studio projects, and posting the current version of his Film I final project, *Hair*, on the Internet. The film is done just in time.

On Saturday, he will set it up at Jordan Faye Contemporary, where forty-one MICA freshmen in two different Elements classes will present a week-long exhibit, a cornucopia of freshman art. On Friday, Holden heads over beyond the Inner Harbor, to Federal Hill, a nascent art district in Baltimore, but not quiet official yet. At the gallery there, he installs his computer-screen presentation (which he'll take down again in two days).

As a youth, Holden wanted to do Disney-type films. In recent months, his tastes have swung toward the European avant-garde. He finds in them the kind of dreamy, noire fantasy that he has dabbled with, which includes his *Starmaker* video that won the national Young Arts award (and a screening at the Smithsonian on the Mall in D.C.)

Small stuff, in his estimation, for he is recently watching such art films as *Wings of Desire*, a German-made stream-of-consciousness story based on poetry by Rainer Maria Rilke. It's the story of two angels watching modern Berliners, angels wishing to become mortal themselves, at which they succeed in the end. Rilke admired Russian writers, wrote innovative "thing poems," and was briefly secretary for the French sculptor Auguste Rodin. His poetry reflected the transition of his age, from traditional art to modernism; he is a favorite among the artists at MICA.

Holden has also become bewitched by *The Mirror* (1975), an autobiographical movie made by the Soviet-period filmmaker Andrei Tarkovsky. Never in the Kremlin's favor, Tarkovsky emigrated to the West, but even in Russia he was known for his beautiful, dreamlike sequences, often

using rain and fire, human figures gliding through complex frames as if the movie viewer is traveling through spaces to see the action. Sheer genius, says Holden. "It's one of the most visually stunning pieces of cinema I've ever seen."

Now he has a standard to measure himself by, a high one, perhaps an impossible one. He also has a lifetime to meet it. Like most of the freshmen, Holden is eager to get back home, to relax in New Orleans, catch up with friends. But one more thing for this film student: the screening of his final project in class.

[]

That day came on Monday morning, May 3. Holden had missed the previous class, but he is ready to go. As usual, he's in black T-shirt, cut-off blue jeans, flip-flops, a thickening beard. Moore is finding that most of his students have missed the deadline, and most of them forget details (leader, double splicing, punching where sound begins). Holden is on time, but lacks many of these particulars.

"We didn't know about that," someone in the class says.

"That's because you missed class," Moore says. "The syllabus says if you miss, you should ask fellow students." Holden's film is now in the projector.

"This is Holden's final project, titled *Hair*," Moore says. "How long is it?"

"Seven minutes."

They're still matching sound to picture, and have it now, so Moore says, "Three, two, one go."

The story is of a young woman who finds a fetus-like hairball in her sink, flushes it down the toilet, where it emerges as a small hairy creature with eyes and a quasi-human face. It comes to her, and she tries to get rid of it; first in the trash can out back then buried in a field. It emerges from the dirt and returns to her front door. The sound effects follow along, a high-pitched tone, a guitar string throbbing, a toilet flushing, sharp knocks on the door, dreamy chimes, like echoes, then the denouement: a squeaky door, an urgent pitch of sound, a gravelly foreboding. Finally, in a shadowy interior, the young woman confronts the creature in the basement, stabs it to death with a long knife. Then, she eats its bloody, furry, carcass.

The sound of the projector drones on, and then quiets.

Everyone claps.

"Wow," says Moore. Most of the footage was new. The ending was underexposed, too dark, however. "Was the ending mostly the way you wanted it?"

Holden had wanted a shadowy effect, but it became too dark. He would have shot it again but ran out of time. Moore encouraged him to finish it, complimenting the strong narrative, except "it feels like it's not ending." Holden explains that he actually has fixed the ending in his video version of the film (shown at Jordan Faye Contemporary and on the Internet).

"Well this being a film class, I'd love to see you finish it as a film piece," says Moore. Film is film (not video), as the filmmakers' credo must go. "The camera work is very strong. It's too bad it becomes too dark to be intelligible." The film reminds Moore of a Maya Deren film piece, *Meshes of the Afternoon*, about a crazed woman. Then he gave the final, obvious question, the question about the final action of the woman in Holden's *Hair*. Moore asks, "What was the reason for her eating it in the end?"

As Holden has written elsewhere, the little monster is a metaphor. Metaphor is big in art school. In this case, it's a metaphor for inner demons, bad memories that resurface in life. Inner demons are not all bad, just as the fluffy monster is kind of cute. Still, "the more you try to put them away or destroy them, they just come back and manifest themselves in bigger and more negative ways," Holden tells the class. "So in the end, the woman realizes the only way to get rid of the monster is by taking it back into herself." She eats it.

"Right," says Moore. "The symbolism though, from a strand of hair in the sink to that, it's a little hard to necessarily get that."

Point taken, but Holden has his reasons. "Well, I didn't think it was necessarily important to get that." For Holden, the opacity of "not getting it" is one of the virtues of art. It can have personal meaning the audience does not need to be privy to. The audience just needs to enjoy a strange yarn, walking out of the theater full of enigmatic questions.

Looking back on the project, Holden speaks of the real monster as being 16mm film, a medium that takes effort to master. Before now, he'd only done video. "With film I had to be more thoughtful with the cinematography and light," he says. "It forces you to think it out before hand." That includes everything from props to actors to lighting, and he can't

wait to do all of that a lot more in his sophomore year. Like a feast on the table, he's got Video II, Documentary Production, and Cinematography and Lighting. "Now I'll be able to focus fully on my film work," he says.

[]

Jordan Pemberton, the oil painter, has not put one foot into the upper reaches of the glass cube. Like Holden, she is wrestling with old-fashioned film technology, doing it on Fridays in the basement of the Main Building, home of the Photography Department. Before photo class on Friday, April 23, Jordan puts a letter in the mail, a signed lease on a house she and three roommates would rent for the sophomore year. "The rooms are so big," she says. These are the typical, high-ceilinged, brick row houses, a Baltimore staple. "I'm tired of living in a dorm." With four roommates, they can push their monthly rent down to $360 each.

Film technology in the Photography Department means developing and printing images. In fact, that's the final project in H. Thomas Baird's photography class, attended by Jordan. "The final goal is this," Baird tells his students. "Twelve mounted prints that amount to a body of works, either a series or a sequence; something that you are going to feel good about and I'm going to feel good about."[4]

Jordan has changed her feeling a few times already. Once she shot abandoned lots back in Michigan. Another time it was a fish market in Pittsburgh. At last she decides to compose a dozen still-life settings to photograph, images much like her paintings of objects in their environments.

One Friday, a short crit day, Jordan has ten images on the wall, still in process. She likes a vintage feel; she doesn't like computers. In any case, she has used an old box camera. It requires manual adjustments and uses larger film. The ten pictures include a birthday cake and balloon, a striped dress on a chair, a shipping box, a typewriter, a guitar, a panoply of butterflies. They all have an antique quality, a nostalgic mood.

"Why not make them diptychs," Baird says of her series. In particular, he points to matching up the birthday cake photo with the dress-on-the-chair photo, and then has an idea. "Keep up just those two," he says. "I want to try something."

There are many kinds of critiques, he told the class, and that goes for photography as well. You can comment on the craftsmanship, for ex-

ample. Or you can interpret the content of the photo, or the feeling that photo conveys. Now he points to the cake-dress diptych. "Interpret these images," he says. "One or both." Not verbally, but in writing, written on paper he's soon passing around. The students then exchange the papers. Each reads the few sentences of interpretations out loud.

One says the cake is about the past, a party now over; "the dress is about future promising times." The images are full of nostalgia, of memories gone by, a half-gone cake, a deflated party balloon, another says; it's an idea that many of the students offer. The dress looks like a girl has outgrown it, her childhood forever gone. "The girl who wore it has grown up and moved on." Another student says the cake is like the child, the dress the mother—it's a family connection. And another: "I think it's about time and memory."

Baird turns to Jordan. "So what do you think?"

"I didn't know people were getting all of that out of the pictures. So that's very helpful."

The Photography Department is under the fine arts curriculum, as it turns out, and indeed, the idea of teaching photo journalism has been tabled, since the news and magazine industry is on the decline (and cell phone cameras are conveying the news). That day in Jordan's class, it was clear that fine art photography still has its place alongside, say, abstract painting, where interpretation is important. By the next week, Jordan has rounded out the twelve photos, taking another few pictures, one of a hiking-boots-and map still life, inspired by talking to a friend about Iceland. The hot-press room is now a very busy scene in the basement, where the photos are cropped, backed with waxy paper, then heat-stuck onto exhibit board, as if pressing pants at a laundry. Jordan's twelve images come out crisp and clear. After so many attempts at subjects, a good deal of wet lab work, and now prints and reprints, Jordan's work suddenly snaps to a new level of elegance: twelve mounted prints, each a final piece of fine art ready for presentation.

On the next Wednesday afternoon, all of this lab work is behind Jordan. She is relaxing at a table in Cafe Doris, eating an ice cream cup, flipping through her sketchbook, a fat volume now filled with drawings, glued-in memories, and notes everywhere. She has just finished her last Elements class. The freshman anxiety is beginning to wane. "It feels really good to

have one thing done," she says.[5] Her sketchbook is like a year in review. At the start of the school year, she had attended the Friday night life-drawing class, until it was canceled. Her human figures are deftly drawn in black ink. Another drawing recounts her autumn field trip to the Hirshhorn Museum (the Smithsonian's contemporary art museum), where she sketched René Magritte's famous Russian doll-type female torso, *Delusions of Grandeur II*, in an exhibit called "Strange Bodies."

With these art skills at her beck and call, Jordan is still concerned about her pursuit of academic knowledge. She is at an art college, but she seems to want more of the *college* part. More of a campus would be nice, for example. She also would like something more in the academics, though she's not sure what. She reads books on her own, not as class assignments, and hears from a best friend who attends university. She found the Foundation academics—Critical Inquiry and Art Matters—either too therapeutic-oriented or too cursory, lacking in depth. She is also skeptical about writing papers on her personal experiences with art. Shouldn't an academic class stick to academics?

This is not too big of a debate at MICA, for it *is* a college, recognized by all the accrediting agencies as such, and considers itself academically sound. However, at a time when many art schools and college art departments want their graduates to look like "liberal arts college" graduates, the debate stays fresh. For Holden Brown's part, he has come to an art school to learn the art of filmmaking. "I'm not going to break my back on art history," he says. Not when there are art projects to be done. Over in senior painting, Howie Lee Weiss, the instructor, also doubts that MICA is a small liberal arts college. It's a small art institute that has grown large, he says: "My son goes to a liberal arts college, and this is not a liberal arts college," he says. "I just can't see it that way."[6]

Despite its long history, MICA gained its official status as a college in the 1960s, a time when all higher education was modernizing, and MICA has been upgrading its academic credentials every decade since. Famously, it removed a comma from its name to be more plainly than ever the "Maryland Institute College of Art."

In a few weeks, the school year draws to an end. It's a time when MICA's role in the collegiate world is being highlighted, since thousands of art educators—from public schools and colleges—are coming to Baltimore.

EDUCATION OF AN ARTIST

he change on campus is imperceptible. From mid-April onward, at least for a week, something is different around MICA. Calvin Blue, who is touching up white gallery walls for the Department of Exhibitions, picks up some clues. He notices that groups of adults are being escorted through the buildings. In the Art Education Department classes are canceled for the week, so busy are the staff. Cory Ostermann, rushing to write her final Critical Inquiry paper (and to make a giant slice of bread for Sculptural Forms), notices the extra activity as well.

At this time of year, of course, the change could simply be the weather. Classes are meeting outside on the patio. Fully clothed "life-drawing" models are in action on the lawn, students sketching. On the same lawn one evening, a MICA fashion show unfolds. Each year, the Maryland Institute Queer Alliance holds its "Gaypril," a month of activities about life and sex for GLBT culture, at midpoint holding a "Day of Silence"—with chalk drawings on the sidewalk in front of the Main Building—and then in the evening "Break the Silence," when a group of students bangs pots and pans in the spirit of coming out.

The mysterious difference *this* week, however, is being generated off campus, down in the sports and tourism district of Baltimore near the Inner Harbor. There, the National Art Education Association (NAEA) has drawn 4,200 art educators for their convention. All week, teachers are shuttle-busing up to MICA, the scene of ten workshops and events and where, up by the Gateway, a mural project is changing the face of a freeway embankment. "Practically everyone on the art education faculty is presenting" at the NAEA, says Karen Carroll, dean of the MICA department (and recent NAEA "National Art Educator of Year"). MICA faculty and alumni are playing roles in eighty of the academic sessions at the five-day gathering.

This week in particular, "art education" is taking on a double meaning. On one hand, students come to MICA to learn art, taking one-third academic courses, and two-thirds studio courses. This kind of curriculum

The alluring Inner Harbor.

turns an art academy into a *college*. On the other hand, MICA is also creating teachers of art. The job market willing, their certificates and degrees will obtain them work in public or private schools, kindergarten to twelfth grade (K–12). They also may become "community arts" organizers on the government payroll, or instruct in colleges (with the right certificate along with their master's degree). In all cases, they become part of the art education system. It's a power block in American education and a vehicle for a particular philosophical outlook on life.

At MICA this week, both kinds of education of the artist are taking place, revealing the school's soul as the college that it is trying to be.

[]

For their part, freshmen such as Calvin, Cory, Jonathan Levy, Cameron Bailey, and Nora Truskey have no doubt that they're in an art system. They've done art history. They've done lots of crits and gazed upon visiting artists, who have welcomed them into the fold. They are finding out what it means to learn art. For Jonathan, this ideally translates into teachers passing on their skills. "As much as I want to learn my own way, I want to be told of a technique that exists, and then go my own way after that,"

he says. "Math students don't have to figure out theorems, and how to do math, on their own."

That has been Cameron's taste in learning as well, though he is hardly the ideal apprentice when teachers tell him what to do. At least he has found his two favorite niches, one being figurative painting in studio art, the other being art history in academics. Today in his After Modernism art history class, instructor Ellen Cutler is lecturing on the rise of modernism in America. They are following the classic textbook *History of Modern Art*, and the twentieth century is going by like a bullet train: Picasso, the De Stijl movement, the Bauhaus, then wartime art and regionalism in U.S. painting and photography, and abstract expressionism in New York City, moving rapidly to pop art. Cameron used to shun modern art. Cutler has now changed his attitude. "Modern art is more than BS," Cameron concedes. "I understand it better. But I'm still partial to the figurative, which I feel like I could spend years studying."[1] (One of his oil portraits — "girl in a blue dress" — is displayed during Open House week).

Like his peers, Cameron has also begun to write about art, even expressing a personal stance. Slowly, he's feeling a part of the legacy of other painters. So in After Modernism, he chooses to write on those who paint portraits, beginning with the history of self-portraits. In olden days, the self-portrait was typically of the artist at work. With modernity, however, painters began to express "inner feelings and ideas" in their self-portraits. To illustrate this, Cameron compares two German expressionist painters from around 1912, Egon Schiele and Paula Modersohn-Becker. They both paint themselves as evocative individuals, Modersohn-Becker as a force of nature, bedecked with flowers.

"She creates the idea that she is more than just an artist," Cameron writes.

In another paper, he dissects how Baltusz Klossowski de Rola, known as the painter Balthus, paints portraits of other people. In general, Balthus's paintings have a "sense of unresolved mystery," rendered in a "dark restricted palette," Cameron explains. Perhaps most interesting, when Balthus portrays a family — a parent and child — the viewer can feel that there is a complex, tension-filled back story to the picture. As a young painter, Cameron would like to do the same some day.

After a year at art school, Nora is less focused on a niche than Cameron.

She is sampling the art styles widely. During a five-minute presentation in her Art Matters class, she'll reveal some of those personal tastes. Each student must speak on a work of modern art. Perhaps revealingly, she's chosen the most famous bronze sculpture of the surrealist Louise Bourgoise—the *Maman* sculpture, which depicts a giant "mother" spider with eggs at her midsection. For Bourgoise, Nora explains, the terrifying spider, an outdoor sculpture three times the size of a human, actually represents the loving care of her mother, who was a major influence in Bourgoise's work.

Over at the Brown Center, as NAEA events are heating up in Baltimore, the graduate students have gathered in a tiered lecture hall to imbibe what it means to gain an academic, liberal arts education at an art college. All the grad students, numbering about two hundred, are required to take a course titled Gateway Graduate Survey of Contemporary Art and Theory. Today the topic is "relational aesthetics," and Ta'i Smith is leading a lively discussion with her class about French theory. By now, most graduate students have taken sides. Some find "theory" fascinating while others find it somewhat ridiculous.

When it comes to relational aesthetics, Graphic Design grad student Chris McCampbell is on the fence. The founder of the idea, the French art critic Nicolas Bourriaud, describes relational aesthetics as an approach to art that covers "the whole of human relations and their social context."[2] To some students, this idea is provocative, while to others it is not profound at all, but rather a completely nebulous idea typical of French artspeak. "This kind of discussion, the relevance of these kinds of theories, has been going on the entire semester," says Chris. He says that many designers are averse to theory because it's art-talk, not design-talk. "There's a big debate on whether relational aesthetics, the term, actually means anything."[3]

The Hoffberger painters, who are fine artists, are taking to theory with mixed feelings as well, especially regarding the complex terminology, the hair splitting of concepts—and perhaps most of all, the time it takes away from their studio work. To be sure, it has its place for all of them, and some highly value the intellectual opportunity. "We are in a top grad school, and if we are not going to read this material now, we are never going to read it," says Virginia Wagner, a Hoffberger painter who earned her under-

graduate painting degree at Oberlin College, a liberal arts school.[4] A class
like the Survey of Contemporary Art and Theory, some students acknowl-
edge, makes them true insiders, exposing them to how key journal arti-
cles, gallery events, and personalities shaped the contemporary art world
discussion.

[]

Despite some mixed reactions to studying contemporary art "theory" at
an art college, it is part of the modern humanities curriculum everywhere.
It has gradually sunk its roots at MICA as well, and a bit of history tells
how this came to be.

In 1966, a little-known French professor named Jacques Derrida passed
through Baltimore, presenting a paper, "Structure, Sign, and Play in the
Discourse of the Human Sciences," at a Johns Hopkins University confer-
ence. The paper was the start of Derrida's rise as a world-class philoso-
pher. His idea of "deconstructing" not only language, but all past beliefs
and value systems, was what the 1960s wanted to hear. The ideas were
further catapulted into the modern imagination by the Europe-wide stu-
dent strikes of 1968, which some art historians mark as the beginning of
a new kind of art—indeed, "postmodern" art. In literary studies, and thus
in the humanities, the American universities had to know this material to
be up to date. So the new European ideas were imported through French
studies and comparative literature departments at top U.S. universities. In
the 1980s, artists, too, began to read the postmodern theorists, borrowing
those ideas to explain their works of art. By the 1990s, art-school curricula
had to include "theory" or be left behind.

At MICA, John Peacock knows the story as well as anyone. In the mid-
1980s, Peacock (with a PhD in comparative literature from Columbia Uni-
versity) was hired as part of MICA's effort to meet accreditation standards
with more teachers holding doctorates. At the time, the head of graduate
studies was Leslie King Hammond, a noted African-American art histo-
rian (and later president of the College Art Association). Hammond asked
Peacock to develop an upper-level "theory" course. The new French the-
ory had not quite penetrated art schools yet. So he designed a course that
focused on existentialism. "That was the philosophy art students tended
to gravitate toward," Peacock says.[5] Eventually this evolved into separate

"theory" and "intellectual history" courses. (Today, every MICA under-graduate must take one theory course and two in intellectual history.)

By the mid-1990s, contemporary French philosophy was knocking hard on the door of art schools, especially the graduate programs. In fall of 1995 at MICA, painting instructor Christine Neill organized a one-year post-baccalaureate degree program and asked Peacock to lead a seminar on critical theory for artists. The idea caught on. Soon, the Peacock seminar spread to the master's in digital arts, and then, in 2005, to the Rinehart School of Sculpture. For years, the former head of the Hoffberger School of Painting, Grace Hartigan, had rejected theory. After her death, the sem-inar was invited into Hoffberger as well. In a short decade, "theory," once unheard of, became a core requirement for MICA students.

And, as many students will testify, this is not easy material.[6] The back-drop of modern theory, at least, can start out fairly simple: It has three main ingredients. It begins with modern-day adaptations of Marxism, with its argument that humanity has a "false consciousness" foisted on it by late-stage capitalism. The second basic ingredient is the adaptation of Freudianism, which presents human beings as at war with their culture (because society cannot allow every sexual desire to be fulfilled). The third and latest element is modern linguistics, which argues that human "re-ality" is created by systems of language (not by the objective material or spiritual "realities" that are pointed to by science or religion).

These three ideas—Marxist, Freudian, and linguistic—developed mostly in France, with additions from feminist studies. As they perco-lated, theory became tantamount to criticizing and opposing both past tradition *and* the present ruling order, since both are false illusions and therefore malevolent. In this view, actually, there is also no "natural" order to human existence, because everything is "constructed" by the flux of language, desires, and images. Only one thing seems sure: It is usually a ruling patriarchy of unworthy tyrants who are controlling the language, desires, and images that make up the constructed reality.

The hardest part of theory, at least for Americans, is remembering the names of all the European theorists (who are mostly French). Two of the crucial names appear before the Second World War. They are the Swiss structural linguist Ferdinand de Saussure; and the "Frankfurt School," a Marxian institute that invented the term "critical theory." Saussure was a

pioneer in exploring how languages have a "structure" — with signs, symbols, and signifiers — and how these can change. This was called "structuralism." Meanwhile, the Frankfurt school, which influenced art critics and art historians, said that all "cultural production" is driven by ideological interests, typically capitalist.

After the 1960s, the French thinkers carried this discussion forward. For example, the Derrida lecture in Baltimore in 1966, "Structure, Sign, and Play . . ." represented a rejection of structure in language. Derrida said that language is fluid, always in "play," its hierarchy of words always at war. Derrida's "post-structuralism" soon swept through the humanities. Other ideas followed. The French historian Michel Foucault said that power in society is determined by the "discourse" of experts and professional groups, giving them control. The French cultural critic Roland Barthes declared the "death of the author," since all authorship is really borrowing from other texts, and because authors were not really themselves, but instead products of the social discourse. Freudians such as Jacques Lacan, another Frenchman, offered that human sexual identities are "imaginary" linguistic constructions to cope with desire, and the Marxist thinker Louis Althusser (also French) explained how "ideology," or any belief system for that matter, is an imaginary way to cope with reality.

In such a world, said the French theorist Jean Baudrillard, just about everything we say or do is an illusion or facade, a *simulacra*, rather than reality. In 1979, as if summarizing the overall worldview, the French philosopher Jean-François Lyotard declared that we live in the "postmodern condition." There is no longer any "master narrative" that people can believe. Faced with this postmodern world, a person must adopt a kind of skepticism to life — a skepticism that can be either pessimistic or playful, depending on the person.

Skepticism is hardly new in the history of human thought (it has been both a secular *and* religious argument). In postmodernism, however, the skeptical feeling is often one of paranoia, a sense of being a victim in the world. The world is a conspiracy of "dominant ideologies" and "privileged narratives" against the individual, who must question these on every front. For many visual artists of the 1970s and after, this was the basic concept behind their art. Postmodern art ranged from a row of "minimalist" bricks on the floor to a cut-up collage of advertising photographs — all of them

"calling into question" tradition and the mass media world, in which images create a fantasy land. Often enough, postmodern works claim to "radically question," "address," "engage," or "interrogate" this false reality, but they also stop short of explaining what *that* really means.

At MICA, the humanities professors concede that you have to know postmodernism to teach at a modern college. "It washed into the art world because it washed into the whole world," says literature professor Robert Merrill. An art historian like Kerr Houston is not a partisan in how theory may affect art history. However, he readily points out that modern theory has produced a tidal wave of incomprehensible, inaccessible writing. "My main pedagogical goal, and my goal in writing, is level-headed accessibility," Houston says. "I grow pretty tired, pretty quickly, with abstruse academic discourse."[7] Each year at the College Art Association (CAA) convention, a new crop of young art intelligentsia delivers papers that, yet again, plow through Derrida, Foucault, Baudrillard, and Lyotard. They are young art scholars with recent doctorates, climbing the ladder of professorships, seeking the nirvana of tenure.

In MICA's graduate program, Ta'i Smith and John Peacock do their enthusiastic best to present the academic material of modern art theory. Smith is not a theorist. As a historian, though, her grasp of the art trends is impressive. She tells her reluctant students, "Let it wash over you." They can decide what's useful. Peacock, who is not a convert to theory, nevertheless knows the difference between modernism and postmodernism in literature. The analogy between literature and visual art is the one he'll often use in his theory seminars.

He might begin with the linguist Saussure, for example. Saussure said that words can have two meanings. The word "lamp" refers to the thing, but it also says the thing is not a "chair." In other words, language is built on relations to other things. "There's an equivalent idea in the art world," Peacock says.[8] A painting, on one hand, can refer to the thing it portrays. On the other, shapes inside the painting relate only to each other. "If it's modernist art, the shapes may not refer to anything in the outside world." Another postmodern literary idea is "intertextuality." Here, every work of literature is a reuse of other literature, and so all human texts are in constant relationship. The same can be said of art. "Works of art have this [intertextual] relationship, regardless of what they refer to in the outside

world." All of these ideas, Peacock says, began in literature. They were next applied in popular culture and media, and finally to the fine arts.

Literary theorists are much more rigorous in this kind of analysis, he estimates, whereas artists take a more seat-of-the pants approach. Nevertheless, artists must "talk the talk to walk the walk," and he goes back to Andy Warhol to explain why. The reception of Warhol's Brillo box as art proved that the context of an object, not skills or the materials it is made of, defines whether it is art or not. Artists today must know how to navigate the contexts of the art world to succeed. "You need to be able to articulate where you are if you are making art," Peacock says, "This contextualization, whether in the art world or not, is an intellectual problem. That's why there's all this theory, and why people need to have more than a technical education." Theory is like a poker game. Everyone holds their argument close to the vest. However, if you dismiss theory, and all its French forebears, you can't get to the table to play.

[]

There have been happier times in Falvey Hall. Today the auditorium is a place of institutional business, a hard-nosed discussion among the faculty. A happier time will come again in a few weeks, when Falvey Hall will host the Maryland Film Festival. A packed audience will watch the East Coast debut showing of the Oscar-winning *Music by Prudence*. As the credits at the end of the film are still rolling, the packed audience will gasp, even cheer and weep as, suddenly, Prudence Mabhena, the lead singer of the Zimbabwean band, moves onto the stage in person. She rides her wheelchair, performs two live songs, and then takes questions from the audience.

But that is a few weeks off. Today is April 7, and Falvey Hall is the scene of this year's penultimate Faculty Assembly meeting. A hundred or so faculty members are attending, taking chairs mostly down front, mostly stage left. The late afternoon event is moderated by Nancy Roeder, chair of the Faculty Executive Committee. Witty and wise, she opens with: "They say there's not enough joy at Faculty Assembly."[9]

The year is almost over, and some faculty believe there is much still to be resolved with the administration. MICA is going through the normal pangs of higher education, pains that are inflicted by accreditation

standards, financial strains, and relatively poor communication between administration and faculty, who, in the end, are two very different interest groups under the same roof. More than a year earlier, in February, the visiting accreditation review team of Middle States was on the campus doing its report for the once-per-decade review that every college and university undergoes. Back in the 1960s, thanks to Middle States, MICA was given its accreditation as a full-fledged college (not just an art academy), and it has been asked to live up to that in all respects every ten years. As it was plain to see, MICA was hardly going to lose its accreditation, but every Middle States review finds some area that needs improvement at a college, and at MICA it has come to be called "shared governance," or a sharing of decision-making powers—especially over the use of money—between the administration and the faculty.

This issue has coincided with the review this year of faculty salaries, something done at MICA every five years. It's no secret—even to Middle States—that the faculty wants better pay and benefits, and the faculty also wants to know all the internal details about MICA's finances, which fall under the purview, strictly speaking, of the board of trustees. Throughout this year, Dennis Farber, an art instructor, led what his faculty camp calls the "negotiations" with the administration. Today in Falvey Hall, he has good news to report.

Farber has a new list of offers from the administration for the Faculty Assembly to vote on. "We've made a fair amount of progress," and with no notable compromise, he says, speaking from the front of Falvey.[10] The recession is affecting everything, so the cash pay-out is minimal: a pool of about $150,000 to be shared among faculty salaries. Otherwise, the cost of living adjustment, or COLA, is frozen, as it is for all employees. However, the faculty sabbaticals, currently a half-year of paid leave, are increased to two-thirds of a year paid. Hope still springs eternal for better pay; the agreement includes a three-year hiatus—called a "review"—but then a return to hard bargaining.

As much as MICA's full-time teachers might like to unionize, that can be hard for artists. A closed-shop teacher's union would be contrary to the spirit of freedom. If they formed a union, they also would have to pay union fees and endure union politics. Even so, the urge to organize is palpable. The MICA faculty has some exemplars in the art-school world.

After a brutal battle in 1978, the Rhode Island School of Art and Design faculty unionized, later shutting down the school on strike, and today its faculty reportedly have the best salaries and benefits in the art field. On the other hand, the San Francisco Art Institute, hit by "financial exigencies," laid off a quarter of its tenured faculty (prompting an intense internal row and resignation of its president of six years).[11]

Such institutional rows are not ideal, but some MICA faculty want more teeth in the negotiations. "Next time, we need a professional [labor negotiator]," says Richard Lipscher, who is retiring from MICA after thirty-five years. "You cannot have the faculty doing this any longer."

"I agree," says Farber, who once taught at a university. A union is "something else we are looking into."

The faculty is hardly united in these sentiments, however. In the debate over faculty perks and resources, the graduate and undergraduate teachers don't share the same interests. On days like this, they eye each other warily. So at the end of the Faculty Assembly, the graduate division unanimously votes against the resolution (a project of the undergraduate leaders). As moderator of today's gathering, Roeder has one more challenge for the teachers, most of whom work on campus just three days a week, nine months a year: They have to put in more time on faculty committees. "You no longer have the ability to say, 'I cannot serve,' " she says. This year some faculty are pressed into service. Others, as usual, step forward as volunteers.

Over in student government, faculty relations is also an occasional topic.[12] As an SVA president, Meghann Harris has visited Faculty Assembly meetings before, hoping to convey student concerns. Students will always find a few faculty members they admire, turn to as confidants and friends, but in the end, students and faculty are two different classes of people at art colleges. Faculty must give grades, even to slackers. Here and there, feelings can become chilly. At one SVA meeting, a freshman asks, "Do teacher evaluations ever get teachers fired?" The discussion is about the teacher reviews that students write at semester's end; reviews that are confidentially sealed and delivered to department chairs. Expelling a teacher is virtually unknown, however. As someone at MICA once said, "You'd have to be caught raping a student on the Main Building steps to be fired."

This world of student-faculty relations is happily being left behind by Meghann, who presides over the election of new leaders of the Academic Affairs Council of the Student Voice Association (SVA) on April 19 (the last of the year). Today, another service-minded student, a senior, puts his name in the ring to be president. He is elected by acclamation, and the duties now fall on his shoulders (along with a vice-president and the secretary). As student government closes for the year, the list of academic concerns — hours, space, costs, department status on campus — continue to be the same. The next year, the SVA will offer "Studio Workshops" to help students master art-making materials and technology on campus. They also have a project in the works, a "Red Book" to help students navigate academic life.

Meghann offers a smooth transition to her successors. "I'm happy to meet with you a few times to pass everything on," she says. "You'll get to see all the things I do, and what's up ahead next year." She is not disappearing by any means. Next year she will be a senior, also well into her Master of Arts in Teaching (MAT) program. "I'm going to be on the Council next year for MAT," she says, and adds: "I just want to say thanks for an awesome year, and an awesome last three years that you guys have been here. I think we made some strides."[13]

[]

To overgeneralize, the teaching of art in America's public schools has followed national agendas, first to train people with "useful knowledge" to advance industry, and later to cultivate taste, teach morals, encourage expression, and even design national propaganda during war time. In contemporary times, however, the role of government in teaching art has receded and professional art teachers associations — such as the National Art Education Association — and powerful funding sources (such as the Getty Foundation and its Research Institute) have shaped art curriculum.

MICA joined the modern curriculum movement in 1987 when it offered it first master's degree in "teaching," which certifies its graduates to teach from kindergarten to twelfth grade (K-12). Three years later, it revised this to be a five-year Master of Arts in Teaching, which has now become the most popular degree program for art students who want to instruct in public schools. For better or worse, however, this kind of instruction in art

teaching has begun to drift away from studio practice, often putting more emphasis on a new field called "visual culture." Or this is what worries some art educators, such as Karen Carroll at MICA, who is ready to articulate that concern at the NAEA meeting this week.

Many teachers in MICA's Art Education Department have felt the emotional rush of the NAEA coming to Baltimore, including Joan Gaither, a veteran instructor. Even so, the week before, Gaither has kept her classes on track, including her Critical Response to Art, PreK–12 course, which Meghann Harris attends for her MAT degree. Despite the excitement, Gaither's Thursday class is keeping up a tight schedule of student presentations on books, "instructional resources" that pre-kindergarten-to-twelfth-grade art teachers can use.

Today the book is Kerry Freedman's *Teaching Visual Culture: Curriculum, Aesthetics, and the Social Life of Art*, a standard text on a cutting-edge trend: visual culture. "It's really a big topic, especially for where the field is going," says Gaither, a gracious African American art teacher whose own medium is quilt-making, indeed "quilting for social justice." But today is visual culture. "Much of this is very, very new, and it's having a great influence on how you are being formed as artists."[14]

Then a student asks, "What's the difference between fine art and visual culture?"

"That's tough one," Meghann offers.[15] She suggests that visual culture has a lot to do with "branding," the way symbols evoke messages or feelings. "You have connotations with colors or with patterns." You can associate red and blue with the American flag or with Pepsi-Cola. As Meghann knows well, the experts say that visual culture has "collapsed" fine arts and pop art together. The arts are all mixed now. It's all advertising. As usual for this class, the discussion spreads. Enthusiasm is contagious.

"All right, ladies, ladies!" says Gaither, since her class is all women. Time for the book presentation by two of the students.

According to Freedman's book, contemporary culture *is* visual, so citizens need guidance on how images affect identifies, choices, and values. The things that make up visual culture are legion: movie theaters, art museums, billboards, computers, shopping malls, mass media, amusement parks, sculpture gardens, the Internet, cartoons, fashion, furniture, and so on. Unfortunately, people "can be manipulated through images that

Decoding visual culture.

are often antithetical to their individual natures," Freedman says.[16] But by knowing how images assert this control, individuals can fight back, defending democracy and multicultural equality.

In the first pages of her book, Freedman rests her authority on a host of postmodern philosophers: Lacan, Baudrillard, Foucault, and Lyotard, for example. When it comes to visual culture, however, another benchmark has been the British Marxist art historian John Berger. His 1972 television series and book (in reaction to Kenneth Clark's 1969 traditionalist *Civilization* television show and book about art), titled *Ways of Seeing*, criticized the way that museums, corporations, and advertising sell art as products, often turning women into sex objects. After Berger, this anti-marketplace critique of art was expanded by feminist art critics and then racial minorities.

With the addition of the French theorists, visual culture became the art of "decoding" the true message behind all the false and imaginary messages created by images, typically controlled by the upper classes or the business class. The oppressed could use images as well, however. That is the role of countercultural art. This is "cultural critique," Freedman says, which has become "powerful through the use of visual forms." For example, wearing monkey masks, the Guerilla Girls protested for several years outside museums, using images to question male sexism. Finally, museums did include more female artists. This being a postmodern age, how-

ever, some analysts now argue that there is really no "right or wrong" in visual culture, it's just a miasma of competing viewpoints, all of it an illusion to some extent.

In class today, there is no time to probe this kind of topic in detail. The two students making the presentation mainly focus on how visual culture helps teach K-12 art classes. This is a positive role. For instance, school children should learn about many types of images. "Kids have a much smaller visual database than we [adults] do," one presenter says. If children know images early in life, they can discern stereotypes as they get older. They can see through manipulative advertising. Furthermore, the presenter is quick to add, "visual culture can make older stuff more interesting." For example, children can learn about Renaissance paintings on video games.

In the discussion period, it's noted how companies use images to sell products. They place items on shelves in food markets according to the relative height of men and women, prodding them to buy. On magazine racks in the big bookstores, they place covers with "beautiful" people out front, but put minority races in the back.

"That's visual culture at work," says Gaither.

"I mean, it's evil, but it's clever," Meghann says.

Gaither says, "We should be teaching visual culture for kids to decode this all the time." Knowledge of visual culture can help future generations interpret old masters in the museum and filter the cultural signals of the mall, movies, and television advertising.

Downtown at the Baltimore Convention Center, the thirty-two sessions on "visual culture" being held by the National Art Education Association (NAEA) might make it seem a central theme this year. In wider perspective, however, it is only one topic of many in the nine hundred such academic sessions, plus a hundred more social events, awards, and tours of the art scene between Baltimore and Washington, D.C. The NAEA is also a kind of teacher's union, a public education lobby in Washington. The official theme this year is "Social Justice," replete with a raised-fist symbol (with paintbrushes in the fist).[17]

In NAEA circles, learning art is viewed as a basic human right, but a right unequally distributed in American society. "The disadvantaged don't get much art in the school," says MICA's Karen Carroll, who has a doctorate

in art education. "But the privileged build themselves facilities and have massive programs in the arts."[18] If art education is spread equally, it can help rebalance society. Art gives the underprivileged a tool to take action, even for economic goals. "It's about empowering others to gain the confidence they need to speak on their own behalf," Carroll says. That is the agenda behind the Community Arts movement, for which MICA is expanding its degree program.

On Friday evening, Carroll will help lead an NAEA session on organizing a Community Arts Interest Group, an opportunity for networking among art educators. The "community arts" topic will also get a boost at the NAEA from a big ceremony highlighting social-activist artist Mel Chin's "Fundred Project," aided by MICA students, to send millions of hand-drawn dollar bills to Congress to urge that they pass legislation to clean up the lead poisoning that contaminates urban soil. At the NAEA this year, twenty-three sessions are dedicated to "community arts," a growing number, but still small compared to other concerns (classroom art technology has twice as many sessions, for example).

In any case, says Carroll, MICA aims to train more community artists, part of an Art Education Department that she describes as "holistic," operating under the motto "learner-centered, studio-based, and context-sensitive." The quality of the art teacher today is more important than ever, she says. Art teachers are not known for staying in the profession as a lifelong career, or even at length. Now, in a recession, public school districts are cutting back art and music budgets.

"The signs are not good," Carroll says.

Still, the Master of Arts in Teaching (MAT) program at MICA, now twenty years old, is always full. New instructors are also being recruited at MICA because veterans, such as Gaither, are retiring. MICA also plans to offer a doctorate in art education.

Down at the NAEA conference, at a Friday morning session on "How Well Prepared are Art Teachers," Carroll is addressing another of her concerns: the way that art teachers today get academic breadth, but not studio depth. In the ordinary bachelor's degree program for art teaching, students experience only "introduction to" studio courses. "No further studio work is required," Carroll says. "Think about that." A future art teacher is not required to focus on one particular skill, such as painting or pho-

tography, a skill that usually helps the teacher feel like a real artist. Then that individual tries to teach art in public schools. "Most of our teachers coming out of undergraduate programs are functioning on breadth, not depth," Carroll says.[19] She is well aware of the challenges that art teachers face, such as the debate on whether art really helps students succeed in the modern economy, or whether it's just creative recreation, a way to form creative personalities in young people.

Either way, Carroll believes that more skill training can only help the art teacher profession, especially since, as a national voice, it is promising to do miracles in public schools, if only art teachers got the money and status of teachers in science, reading, and social studies. Eventually, she will publish an article on this topic in an art journal. The title is, "What If They Believed Us: How Well Are Art Educators Prepared to Deliver on the Promises of Art Education?" The NAEA issues long lists of the tangible benefits to children and society of art education.[20] The article will ask, "Can teachers really do this?"

At the NAEA convention this year, the throngs have no doubt that they can accomplish very much in society with art education, and they have come to Baltimore to find out better ways to teach, better ways to organize as art teachers.[21] Participants represent a balance of university art educators and teachers in primary and secondary schools. In the latter case, most serve in public schools east of the Mississippi River, and predominantly on the eastern seaboard, where art is more common in school district curriculums. Going west, fewer school districts include art instruction. In all states, however, the profession is predominantly female. On Saturday, an afternoon session is posted, titled, "Where Have All the Men Gone?" The audience turnout is reasonable, but the organizers did not show (it was a last-minute session).

Like all large membership groups, the NAEA is trying to hold together. A growing number of interest groups are trying to live under its roof. Three of the largest, called caucuses, are social theory, women, and GLBT. Forty other specialized groups hold business meetings as well. This year, there is some talk of ways to reorganize NAEA so that interest groups have a stronger voice. Revolution is always part of the art scene, of course, but at the NAEA, this session for change is delicately called "(re)shaping" the NAEA, not overthrowing its structures. Along with the College

Art Association, the NAEA is a national hub for art educators. The NAEA annual conventions are also a place where groups in the business of art can exhibit their art resources and accessories. The convention this year draws 188 purveyors of art supplies, books, services, and educational opportunities. Fifteen of them are college art schools or departments, and a few more offer Internet degrees in art, or offer classes and a certificate in the mode of the well-known art institutes, a for-profit degree program.

Near the NAEA registration area, where a "poster session" of academic projects is displayed, the most prominent among them displays a "visual culture" (or semiotics) analysis of two Hollywood films portraying art teachers, the best known being *Art School Confidential* (which is based on a satirical graphic novel by a disgruntled art student who attended Pratt Art Institute in Brooklyn). According to this visual culture analysis of Hollywood fare, the art teachers portrayed in the movie are "coded characters," lending to "the stereotype of the art teacher." Some of those stereotypes are actually fine: The teacher is creative, passionate, into the art. Mostly, though, the image is of an eccentric teacher, disconnected from the students, engaged in flimsy do-what-you-like art instruction. The study also asked focus groups to watch the two movies and comment on the Hollywood portrayals; to the groups, art education looked very informal indeed. Fortunately, perhaps, *Art School Confidential* was a box-office flop—nevertheless, you can bet that everyone working at American art schools knows the film.[22]

[]

The image of the art educator is something that MICA instructor Stacey McKenna has grappled with for years, being an artist herself, heading a high school art program, and now teaching at MICA (and completing a PhD at Columbia University). She teaches a graduate seminar for students who want to teach art in college, a class on the "philosophy and pedagogy" of art teaching.

Whichever course McKenna is teaching, the theme these days is "strategies" for teaching. As always, the new pedagogies have a history. In the past, art educators put a lot of focus on the "stages" of human development when it comes to art. This followed the general field of psychology. The Swiss psychologist Jean Piaget offered stages of cognitive development,

while later, psychologist Lawrence Kohlberg identified stages of moral development. Inevitably, the "stages" of artistic development in human beings was also studied, and some of those findings are still considered valid and useful. From ages two to adolescence, for example, children either draw what they *see* (a table with four legs) or draw what they *know* (mommy with four limbs)—it's not clear which is always the case. Still, children begin drawing for the pleasure of motor movement. They learn to make complete shapes. Then they connect shapes with lines. The young mind focuses on objects as local things, only later learning to think about the broader relationships of things, or things in their environments

At some point in early adolescence, the child values literalism and realism over the early childhood expressionism. In late adolescence, a preference for expressiveness may return. Indeed, it has been argued that adult expressionist painters, unlike other jaded adults, recapture the genius of childhood, prompting the hackneyed skeptical outburst, "My five-year-old could paint that!" (The rejoinder to these adult parents is, "But can you paint that?")

As helpful as the idea of "stages" has been to art educators, the idea is being questioned seriously now, as evidenced by one session this week at the NAEA. The topic is the work of art psychologist Michael Parsons, who in the 1980s presented a case for stages of aesthetic development in his influential book, *How We Understand Art: A Cognitive Developmental Account of Aesthetic Experience.*[23] While Parsons's developmental stages once were considered a breakthrough, they are now being dismantled, viewed not as inevitable steps in human development, but simply "viewpoints" or "strategies" that people take in as they approach an art activity or art appreciation.

For example, Parsons had argued that human beings go through five aesthetic stages of response to art from infancy onward: 1) intuitive delight; 2) noticing beauty and realism; 3) enjoying expressiveness; 4) appreciating style and form as elements of tradition; and 5) finally choosing autonomy, or individual judgment. Today, art educators question whether such stages are really rooted in biology or culture, since individuals can adopt any of these "viewpoints" toward art at any age. This rearranging of stages is especially true now that art education looks more closely at children with "special" needs, psychological "gifts," or the new distinctions

between "right brain" (intuitive) and "left brain" (technical) learners. As a result, "developmental" theory is no longer king in art education. The pluralistic outlook on students now demands a pragmatic approach, which leads to "strategies." The art educator is looking for strategies to teach *each* kind of student—or each kind of combination of students in a given classroom.

This is the heart of Stacey McKenna's Strategies for Teaching Art, PreK–12 class every Friday, a class that Meghann Harris is attending.[24] During the NAEA week, McKenna is presenting at a session. Her students who are seeking the MAT degree are required to attend one of the NAEA events, getting a feel for the profession in assembly. Some of her students return to class with sky-blue T-shirts, bearing in black letters NAEA and MICA. Now that the big NAEA week is over, McKenna's twenty students are heading toward a kind of D-Day, a day when each student presents a full package of art education tools—a Unit Lesson. A Unit can cover two classes or ten classes. Whatever the case, it is a kind of strategy, or bag of strategies. It includes an array of visual objects to conduct the lessons in K–12. (In this final project, each student can pick the grade that the lesson is best for, but it should also be a lesson that can work in all grades.)

In these final days of class, the students display all the elements of their Unit. Each of them has an entire table to present their project. On this, they erect a large backdrop display, show some of their own work, and array the pieces of the Unit Lesson in binders, objects, and handouts. They will also speak on their Unit Lesson for four minutes. The audience will be different, too. This time, art supervisors from the local Howard County, Maryland, public school district will be there to hear the presentations and offer comments.

At the heart of such Unit Lessons, guided by strategies, is the "elegant problem." This is the simple exercise that K–12 students can engage in to learn a particular aspect of art, whether sculpture or visual culture. Every elegant problem, in turn, must have visual objects for students to learn from. These are called the "manipulables," things that young hands and minds can manipulate (also called "art supplies" in school budgets).

At this point in the school year, Meghann is ready to consolidate everything she's worked on as a junior, pouring its essence into her Unit Lesson; the lesson has an "elegant problem," but will also include theory,

design, and contemporary culture. Her lesson aims at older students in high school, so it employs the kind of acronyms they use in text messaging, codes such as ILU (I love you), BRB (be right back), SUP (what's up), and ROFL (rolling on the floor laughing). When using her elegant problem in a high school classroom, Meghann would ask students to take a "popular text message" and use its meaning, or a comic spin-off of its meaning (by taking it out of context), to design a product with an advertising logo. Although this is a project for older students, she says, the teaching principles can apply at any age: creative thinking, subject matter, media technology, visual concepts, styles of typeface, and finally a product with packaging.

More than just packaging, this is also a lesson in art theory. It asks students to understand "recontextualizing," a key idea in contemporary art theory. The key idea is that a message gains its meaning by the context it is placed in, and when you change that context, you change the meaning—and also create humor. In today's presentation, Meghann shows examples of how artists have recontextualized words and images in their artwork; the artwork is known to have generated surprise and amusement in viewers. Meghann has also put on display her own artistic creations: She has taken original typefaces she designed, stitched them onto fabric in shiny thread, and framed them ornately. As befits her own high-tech generation, Meghann has used text messages and code words to spell out romantic lines, elegantly stitched—*ilvu* being one, *hugz* another.

[]

"Hey Cory, I saw your picture in the newspaper!"

The holler comes on a Monday morning from a faculty member who rolls down his car window, hailing Cory Ostermann. Indeed, there Cory is, animated in a large photo in the *Baltimore Sun*, her long hair flowing. She had attended the official opening of her Finding Baltimore class's second mural, finally put up at Penn Station after months of delay. "The whole idea of the artist as a recluse who doesn't get involved in the community is outdated and needs to be revised," she told the *Sun* reporter. "I come from a place where people constantly try to do community art, but are unsuccessful. That's not the case here. Baltimore is so different from any other city where I've ever been." [25]

Clearly, Cory is finding her voice and identity, and her newspaper debut is only one of the turning points. In Critical Inquiry, the class's debate on the feminism chapter in their textbook, *Critical Theory Today*, assures her that the cause of feminism is just, but must be renewed, made new for the next generation of women. Since the news article, Cory has cut her hair— now a pixie cut—her first haircut in memory. She also has made a significant decision: Although her mother loves her unique name, Corynne, she hereafter will sign her artwork with "Cory." "It's going to break my mother's heart," she says. "But I feel like if the common viewer doesn't know I'm female, then I won't be read that way." Women artists face obstacles, she says. So why add to that with a feminine name?

Not that she's against rallying for the female. Her final painting for Elements—on "personal mythology"—is an attempt to combine what she has learned recently about myths that she can take personally. For this class, for example, she borrows ideas from the best-selling 1992 book, *Women Who Run With Wolves*, with its "myths and stories of the wild woman archetype"; she also draws upon ancient Dutch tales of "*witte wieven*," female healers, shamans, and tricksters from pagan days. As if this was not enough literary richness, Cory also taps the Dutch tale of the "The Nettle Spinner" (now a feminist icon), who, being oppressed by a rapacious lord, tricks him into a slow death by putting thorns in his coat (and in the end, marrying the humble hunter she loves). That is the nettle spinner's only mistake, Cory suggests: "Excluding her marriage to the hunter, I thought she was a very strong woman."

Hence, her oil painting is of a strong woman in white gown, traditional-looking, but pregnant with all Cory's literary meanings. Unfortunately, her teacher says, if you have to explain all that lore and mythology to a viewer of the painting, then the painting is not really a success, for it should speak for itself.

The next assigned project comes straight out of postmodern and feminist theory. Cory and her classmates are asked to make an artwork about "the other," the act of "othering," which means to build one's identity on the denigration of another (as men are said to "other" women, or how whites "other" non-whites). Cory feels that the way the Chinese communists treat the Tibetans is a clear case of othering, but again, the teacher— who tends to like sculptural art—says her initial piece, an arrangement of

small flags, does not work. So it's back to the drawing board for Cory. But she returns triumphant, wielding a charcoal drawing of an interrogation cell, small lightbulb dangling, an eerie drawing to go with the flags. "The Chinese are 'othering' the Tibetans by interrogating them about things that don't really matter, or by torturing them," Cory explains.

That hurdle crossed, Cory is almost done as a freshman. After summer, she is headed into her sophomore year. She'll have a chance to study and paint more, even learn about the economics and business of art, which interests her. She's already thinking about how to make it in the art world — not as Corynne, but as Cory.

[]

On the second floor of the Main Building, Calvin Blue is enjoying the snacks with his fellow students in Drawing II, a class he has enjoyed.[26] All the students are thinking back on their thirty weeks of drawing. Calvin has had more ambitious projects this year, such as his series of large paintings of people in African scenes, attempted for his Storytelling and Mythmaking class, where he tried to merge a past era with modern people (he shows his friends in high-top tennis shoes hunting on the green plains of Africa, like ancient Zulu warriors). It is a major project, a big painting that involves modulating difficult green colors in the landscape, and it's something Calvin will not quite finish this year.

Today Calvin is feeling much more closure about his Drawing class than he feels about his many unfinished painting projects. Everyone's drawings are on display, a kind of gallery show, music playing, a spread of salty snacks, sweets, and sodas on a table. All year, this room has been Calvin's Monday evening hangout, his very first class of the week as a MICA freshman. The final project is a set of twelve renderings. The teacher is Michael Downs, an accomplished black artist and role model for Calvin. Downs likes the idea of taking one theme and working on it a long time, or producing many versions of a single topic. In one of Downs's past assignments, his students had to draw an object at the size of 2 x 2 inches, but then do six more drawings of the same thing, enlarging the paper each step, finally reaching 60 x 60 inches, a project that tried Calvin's patience. "That's when I got bored," he says.

The final project for Calvin's Drawing II is to turn words into pictures.

For the past month or more, Downs has given the class twelve words as the basis for twelve drawings, words like Neptune, lust, nightmare, religion, justice, object, two animals, portrait, and more. During this time, Downs introduced Calvin to the image style of the famous black artist Kara Walker, who cuts out black silhouettes to tell whimsical, edgy tales about antebellum slavery in the South. So Calvin tries his hand at silhouettes. In his final result — twelve silhouettes lined up on the wall — Calvin reveals his ken for literal imagery, rather than metaphors. For his exhibit today, you see the word-object as literal emblems.

After all, at a young age, Calvin already knows what he likes. For many teachers, this is not the ideal kind of freshman student, but it is a common type: the student who stays with a particular skill or strength, aiming to make it better, uninterested in trying other things. Nibbling a snack, Calvin points to one group of drawings on display today, a group of very realistically rendered drawings of the twelve words. He says they are the best final drawings in his class. After a year at MICA, and long after seeing his first hyper-realistic painting by Salvador Dalí, realism is what he's after. He knows it will take some work to be as good as Salvador Dalí, or as good as the black painter Kehinde Wiley, another hyper-realist. Calvin has other challenges as well, not least earning money to continue paying for his tuition and housing. For the summer, at least, he has a nearly fulltime job in Baltimore. He'll work the information desk at The Commons. Come what may, he'll try to finish his Africa series of oil paintings.

Down the hallway on the same second floor of the Main Building, Jonathan Levy is wrapping up his final critique in Phil Koch's Drawing class.[27] Like Calvin, Jonathan has reported to this room for the past nine months, and he has seen his drawing skill improve. What he has learned most, he believes, is that he should take time on a piece, not always rush. Already, teachers are complimenting his ability with composition. His drawing is still scratchy, but entire pictures hold together. This is particularly evident in Jonathan's biggest painting project of the year (as a nascent painting major). It is no less than a triptych, his response to a Robert Frost poem, "On Going Unnoticed," about a person going through a forest, its trees with rugged bark, a "coral root flower" being plucked "as the trophy of the hour."

In the triptych, Jonathan has portrayed a grotesque, a homely figure,

a narrative of this man's venture in the woods to gain the pink flower, as beautiful as the creature is ugly. In this, Jonathan feels like a painter. At the invitation of Koch, he includes the paintings in his final Drawing crit. "If the room was on fire, and I had to chose between the drawings and paintings, I think I'd run out with the paintings," says Koch, offer encouragement overall. "There are flawed masterpieces here."

"And yet, still masterpieces," says Jonathan, laughing, but confident.

Given Jonathan's style, Koch suggests that he study the works and compositions of Thomas Hart Benson, a stylistic realist who was "reviled" by the abstractionists. Jonathan can relate to that. This summer he'll be arts-and-crafts director at a youth summer camp in the Midwest, but says that this job in no way suggests that he's viewing his art career as child's play.

"What are they going to call you?" Koch asks.

"They are probably going to call me sir."

[]

Today, Nora Truskey arrives at her Elements class with a string of green Mardi Gras beads around her neck.[28] Soon it is clear why. In her Elements class with Dennis Farber, each student has produced a brief video. They have done straight shots, collage, or animation—which is what Nora has chosen. She is up first. Her animated story projects on a screen as fellow students watch. The scene is the top of a desk, where a wooden Chinese doll and several animal figures appear, one at a time, moving across the desk, where a sinister set of Mardi Gras beads, like a snake, comes out of a jar and pulls them in—to their apparent doom. Easy-listening rock throbs in the background. It took Nora hours to do this stop-action work, but it's easy enough nowadays with a digital camera and the iMovie software, which everyone has on their Mac computers.

Surely, Nora has gained confidence and identity during the year, but she is eager to be home for the summer as well. For all her exposure to the crazy and experimental aesthetics of her freshman year, and for all the urgings from faculty and students to do *difficult* art (that disturbs), Nora's personal aesthetic remains a pleasant one. When asked about her video, she says, "I didn't really know what to do. So I picked things that I liked." She decided to work with a narrative. "It was fun."

The class's videos are soon over, and their Foundation Year is over as well.

"We've come full circle," says Farber, their instructor for the year. "I can't say I'm sorry school is ending. But I can say I will miss you all. See you as sophomores."

ART WALK

On the balmy Wednesday afternoon of May 5, two days before the end of the school year, Jen Mussari bursts from the glass doors of the Fox Building. She is heading for the printmaking building, about three blocks down the hill. Jen is carrying three large portfolios, filled with a semester's worth of silkscreen posters, a final body of work as a senior in the Illustration Department.

The series of prints is titled "Very Important Posters." As this wordplay on VIP suggests, Jen's fine art posters are doing more than announcing events. With their clever phrasing, colorful shapes, and elegant hand lettering, the posters invite viewers to draw their own conclusions, Jen explains. "By denying the aggressive nature of advertising, these posters are more kind in welcoming the viewer."

As the artist, she has her own interpretation as well (and has drawn some influence from the writings of the avant-garde designer Stefan Sagmeister, who will soon visit MICA). So for example, Jen's poster *Don't Say Don't Say* is supposed to invoke nostalgia for childhood. The poster *You're Next* suggests the "duality of communication," since it could indicate a benefit or a threat. Others continue in this vein: *Lost Gen* points to "the bizarre culture that my generation has grown into," and *Get Real* suggests that although irony rules in modern art and humor, "it's much more powerful to be sincere."[1]

These posters are the heart of Jen's portfolio as she goes on the job market, and they will be showcased in the Commencement Exhibition. For now, she is headed for her Wednesday night Screenprinting class, ready for her final crit. She's confident about the portfolio art, but worried about the fast-ending week. The printing building closes Friday afternoon, and that means she may not find space—it's crowded until midnight in finals week—to screen print more of her five-color "promotional" business cards, which she hand crafted.

At this time in her life, Jen has chosen her forte as an artist: designing letters in the alphabet, drawing them by hand, transferring them to

At the last minute in printmaking class.

a silkscreen, printing the letters with other kinds of images, creating fine art posters or other kinds of information pieces (cards, book covers, advertisements, etc.). With the printmaking crit over, the next day she heads to her illustration Senior Seminar, where she will publicly explain her artistic direction (all seventy of the Illustration seniors are giving a presentation like this). The most important person in that simulated public today is their instructor, Allan Comport, a former professional art agent who has managed hundreds of top illustrators, placed lots of imagery in children's books (and also cooked up advertising for the Florida Lottery and the American Egg Board).[2] Before his career in the art world, Comport worked as a trained therapist. Naturally, he can tell when his Illustration class is stressed-out, especially on this, the last day.

"Okay, Uncle Al's psychotherapy for just one second," he says. "The stress levels are a little elevated around here."

For two weeks now, the Senior Seminar students have been fulfilling their assignment to present a portfolio in slides, explain a "business plan," and take questions, with Comport asking the kind of things employers might ask. These are going well. The illustration students are also thinking about their final thesis exhibit, which they must install, and about getting a job—any job. On this, Comport offers more sage advice. They shouldn't expect to get hired at the *New Yorker* their first day out (or

first decade out). "Your life is a marathon," he says. "The first thing [job] you do is not what you are going to do for the rest of your life."

At the last session, Jen is up first. She has put her large, shiny aluminum portfolio on the table at the front of the theater-like classroom. Its pages bristle with a concise history of her best artwork. Now at the podium, she clicks, and her Powerpoint projects her Web site on a big screen. Thanks to her boyfriend, Jonnie, her presentation is animated, her main pieces of art spinning, flying around, and then falling into order. There also is a pencil-drawn picture of Jen — more precisely, Jen's face on a cat — and then her illustrations of animals, product labels, and people, followed by a sampling of the "Very Important Posters."

Some of her illustrations have gone "viral," passed around the Internet, such as a humorous one that shows party girls wearing Indian headdresses. The heart of her work is the VIP prints, all done on 15 x 22-inch sheets of paper. The slides flash by.

"This is another piece for my thesis," Jen says. "I really like the way the lettering works with the flat shapes in the poster series."

Then she shows the five-color business cards with her hex sign, a pencil, and the words, "Allow Me To Letter That For You." Keeping a tight schedule, she finished printing the business cards just the night before, with not a minute to spare.

"Oh really, just last night?" Comport asks (in mock surprise, since this is typical in art assignments). "Are those fake piles, or is that a real pile." (You can also manipulate digital photos.) The class laughs, but Jen's are real. The Illustration class, as a whole, is perhaps the most joyous, or giddy, of any on campus. Comport goes on. "Give us a thought about what your professional goals are and how you are moving into that."

"I'm definitely into the freelancing scene," Jen says. She's headed to San Francisco to do that. "There is a lot of opportunity there for fine art and illustration that is interconnected." In other words, in California, even commercial posters are viewed as gallery art. "I do a lot of lettering, so I also would like to do headlines." That's for magazines, such as the *New York Times* magazine. "And book covers would also be really great." Jen says that her particular hand-made aesthetic — "Americana and vintage styles" — also matches the tastes of Chronicle Books, based in San Francisco. Then her cat picture comes twirling onto the screen.

"Bye, bye," Jen says (for the cat).

A few days later, the chair of the Illustration Department, Whitney Sherman, is setting up a small social event at the Society of Illustrators headquarters building in New York City. She has invited artists and art directors to come by, have a snack, and speak—via the teleconference computer screen of Skype—to students at MICA, flipping through their portfolio, offering advice for fifteen minutes. Elsewhere, other art directors in New York City will also connect from their offices, as will other professionals, anchored at computer screens in California, Ohio, Florida, Maine, New Jersey, Texas, Utah, and Washington state. All of this is the networking genius of Sherman, who is well connected in the illustration industry.

Early on this Thursday morning, the day-long series of interview hook-ups has begun. On the MICA end of the hook-up, the Illustration Department is bustling, its students coming and going, lingering around piles of hot pizza and snacks; this is their home territory, the third floor of the Fox Building. As Sherman holds down the fort in New York City, Comport and other instructors shepherd the students through the day, the big moment coming when, finally, they sit down before a computer screen and start talking to a far-off professional artist. Scheduling is not easy today. At a first opening, Jen takes an interview with a top freelancer. Later in the day, her request to talk with someone at Chronicle Books comes through, so she's on Skype again.[3]

The Chronicle art director has Jen's Web site open. As a treat, he turns his computer camera so Jen can see the office, including its view of San Francisco Bay. Her hand lettering catches his attention. He advises that she build upon that handcraft feel, making a mailer that stands out (since art directors get scores of job-seeking art postcards everyday). At the end, he says that the standard procedure at Chronicle Books is to submit promising portfolios to the monthly portfolio review meeting among staff.

"This looks good," he says. "Would you like me to submit this?"

"Yes, definitely," Jen says.

After it's over, one thought stays with her. The art director said that young artists should think five years ahead, envisioning the kind of work that will be in their portfolio on that future date. Will it be book covers, CD music covers, and typeface patterns? Whatever it might be, and if that future is clear, a young artist should try to accomplish it now. This is part of

the branding process, thinking far ahead. Jen is thinking about what she'd like to do five years down the road. It comes up fairly clearly.

"Well, yeah," Jen says. "I can do that now."

But not exactly now, because she still has to graduate, reorientate her life, and then move three thousand miles to northern California. Her art-school education is over.

[]

Over at the Kramer House, Lani Irwin and Alan Feltus are stacking rolled painting canvases against the wall, feeling a bit nostalgic about their nine months at MICA.[4] Their painting exhibit, "Personal Interiors," had been planned long before the MICA invitation, beginning in Tulsa, Oklahoma, showing at university galleries in Washington, D.C., and northern Virginia, and now traveling to two more venues as they depart for Italy. A few days before they leave, Feltus's New York City show has opened.

While living in Baltimore, they finished six new paintings between them, and taught two studio courses each. Over thirty weeks, they saw the attendance at their Kramer House gatherings rise and fall, given life by a core group, often hosting entire classes, once being a haven during Snowmageddon. They saw many teas of ten. Dinners of twenty were not uncommon, for Irwin loves to cook and host. As seasoned art teachers, Irwin and Feltus love the young people, but they notice how young people are changing, with technology being a major factor. "They see things in a different way," she says, comparing generations. "They are going their own direction." The reliance on computers is fine, except perhaps when it "becomes *too* easy" to do art.

The art-school visit has been invigorating, and Feltus has had a chance to visit other, smaller art schools or art departments in the United States, comparing what he saw of this new generation of painters. "I think the range of work is similar at every school," Feltus says. At MICA, the number of really good painters exceeds smaller schools, but that is a matter of numbers and recruitment. "There are good students and good teachers here; it's an exciting environment." Irwin and Feltus taught all levels of students this year, and they saw the perennial struggles of young artists. Some start slowly but then excel; others are slackers. Many don't take advantage of learning opportunities. Still others have a work ethic

that bespeaks success. The "gift" and the work ethic — that's what a student needs, says Irwin: "What I say a lot is, 'Even if your direction does not make sense to me, if it makes sense to you, then that's fine. But you have to keep doing it. Because it's not enough to get the idea and just stop in the middle.'"

Now it's back to Italy, where in future summers they are likely to meet up again with visiting American art teachers, many from MICA. The International School of Art at Montecastello di Vibio, Umbria, is just an hour from their home. There's nothing formal about this artist network, formed in the land of the Renaissance.

"We're all just friends," Irwin says.

[]

By now, some of the open questions in MICA's future have been settled, and many of them at the eleventh hour. The board of trustees meeting came on April 30, and various faculty committees have also met in the past two weeks to give their votes on various proposals or candidates. During one week, a model of the new Studio Center — to be renovated as a modern Graduate Center — was on display in the Main Building. The project will take three years to complete, but it will house the growing graduate department, with its ten schools, and solve a problem stated by Lazarus: "Right now, if you wander around here, you would never know we have a graduate program."[5]

Another future question remains unanswered, however: Will three hundred graduate students, circulating in the Station North Arts District, turn the depressed neighborhood around? MICA and the City of Baltimore hope so. One reason that MICA needs to renovate the Studio Center is that the school's graduate programs are expanding. Already next year, the graduate program of Graphic Design and the Hoffberger School of Painting will expand their enrollment (and Hoffberger will hire its new permanent director, Joan Waltemath). Soon after, MICA will also launch programs just approved by its boards and committees: a master's degree in Illustration Practice (led by Whitney Sherman), an expanded master of fine arts in Community Arts, and a master's degree in Curatorial Practice and Social Design. It will also offer an online business degree, a master of Professional Studies (in the business of art and design).

At the undergraduate level, as the summer passes, good news is coming in. Despite the recession, MICA has recruited an ample freshman class for the next year, and retention in other classes is on par. Next year also, the school will offer a new major, a bachelor of fine arts in Humanistic Studies/Studio Discipline, an art degree with a more comprehensive liberal arts requirement. Best of all for the teachers, they may be getting more elbow room, since the EMAC classes — long held in the Bunting Building — will be relocated to a new building dedicated to computer workspace. Now, Bunting can offer more office space, becoming all library, lecture rooms, staff offices, department hubs, and counseling center.

On the second floor of Bunting, the dean of students, J. Davidson "Dusty" Porter, waxes philosophical as school draws to a close. "Every year is its own year," he says. Porter has worked with students at regular colleges. While art colleges are different, at least this is the same: "I can't say there's a good year or a bad year. Each year has its own narrative, with high points and low points."[6] The goal is to increase the number of high ones, which is always an unpredictable task.

In the basement of the Fox Building, Gerald Ross, head of exhibitions, has let the monster Commencement Exhibition take control of the campus. For the past few weeks, the campus maintenance crews have been installing hundreds of temporary white walls in every building to provide a "white cube" gallery atmosphere to show the works of the nearly four hundred graduating seniors. This is the final senior exhibit, mainly for parents and students, but also featuring a one-day "Art Walk," a festive campus event in which MICA, its publicity machine at full-throttle, invites the Baltimore public to see what may be a few miles of artwork, have some refreshments under a big, white, party tent on the campus green, and hopefully buy some of the students artwork as well.

The artwork is like a map of the campus. The Station Building is all sculpture, from installations to conceptual objects. At the Fox, the two premier galleries offer a cornucopia from all the departments. Upstairs in the Fox 2 Gallery, Jen has an entire wall, her eight posters up, her artist's statement there to be read.

Over in the Main Building, the Art Walk passes through a good deal of work by the fine arts departments, with some ceramics as well. Sean Donovan and his senior painter friends have gained control of the first-floor

A rainy commencement parade to Meyerhoff Symphony Hall.

main studio, their giant expressionist paintings lining the walls, with natural light streaming in the tall windows. Guests are milling about, some sitting on wooden benches at the center of the room, with its polished black floors. It feels a lot like an opening day at a major contemporary art museum. That is the intention: the final emotional satisfaction of four years at art college. Now the show. Then, into the real world.

But not before the pomp and circumstance of the graduation ceremony, which ends the three days of the Commencement Exhibition.[7] It's a drizzling day, and between the main campus and the Station Building parking lot, clumps of students are on the go, their black gowns fluttering under umbrellas. Before long, the students are standing for a class photo, the clock tower behind them, ready for a block-long procession to the Meyerhoff Symphony Hall, where parents await and the pride of each department swells as its graduates file in, carrying a department banner. Everyone has a gown, except a few, as expected. They've dressed in evening wear, or put on a green cape with electric lights, or worn a Viking helmet with horns. Some of the faculty members, especially in the Fiber Department, break custom, too, wearing bobbles on their academic gowns, funny hats, a full Indian headdress, even an Islamic burqa.

As Lazarus, the president, began the school year, he now ends it—with encouraging words. "You have helped us make MICA the college it is today," he tells the graduates, promising to put their suggestions into practice as much as possible. To follow, Ray Allen, the provost, jokes about deciding not say something "heavy" about graduates facing a tough world, the likes of which their parents had never known.

"Nah," Allen says.

"This is the world you've got, the world you've been given," he says. "Have the confidence to believe that you have everything necessary to take the next step." The quality of the Commencement Exhibition he says, is proof that they have what it takes. They have been trained to ask the right questions and so, as the poet Rainer Maria Rilke advised young artists, "The point is to live everything. Live the questions now." The answers will come.

Next come a few more encouraging words from an artist who's asked those questions, this year's guest speaker, the internationally known graphic designer Stefan Sagmeister (who followed in Tibor Kahlman's reputation as a leading "bad boy" of design, but is now a commercially successful design icon). In 1997, Sagmeister secured his position in the upper ranks of the avant-garde by having his assistant carve on his torso with a utility knife, a bloody script displaying a poster advertisement for his own guest lecture at art school, in cooperation with the American Institute of Graphic Arts, or AIGA. Today at MICA, the tall and imposing Austrian is in gown and cap, ready to receive an honorary doctorate.

Twenty-five years earlier, during his own time of youthful uncertainty, Sagmeister had dared to approach an older woman he saw on a Viennese subway, drawn by her black attire and red roses in her hat, to say, "You are incredibly good looking!" She liked it of course. Once he had crossed that shyness barrier, Sagmeister tells the students, he began to conquer the artist's fear.

"Having guts always works out for me," he says. "Every time I overcame my fear, it turned out well."

If the students want an analogy, Sagmeister offers a psychological one: The conscious artist is like a tiny rider on an elephant, which is the unconscious controlling most of a person's life. The elephant is the fear. The art-school graduate is the rider, who can learn to tame the wild beast. "I

did train the elephant, a little bit," he concludes. (Later, a small group of students get a chance to meet Sagmeister, take a memento photo, and the enterprising Jen is one of them).

If Sagmeister is looking back over his career, taking a rearview glance from his pinnacle of success, the final word for MICA's graduates comes from their own ranks, graduating students who are looking into the unknown. Fortunately, these two speakers are captivating enough, beginning with Graham Matthew Coreil-Allen of the Mount Royal School of Art, one of MICA's graduate schools. His talk is in the grand manner. He offers a survey of the world situation, a fairly grim picture, a view from a privileged art academy, students seeing the world fall to pieces: recession, war, poverty, death, ecological disaster—and student debt. Generally, the cause of this is the "organized crimes of capitalism," he says, leading to a final question. "Does an MFA seem all that important?" Graham asks in a peroration, his audience on the edge of its seats.

"My answer is a stern, Yes."

The students (and presumably their parents, too) laugh with relief.

Going to art school is not economically sensible, he goes on. Nevertheless, they *had* to go. More laughter. "We had no other choice. The creative force is undeniable. We make because we must." Although "cultural producers" must accept this kind of risky financial life, they also have financial hope, and that is because history proves that "the most powerful creative forces emerged outside of the institutions and outside of the market." So to the ramparts, Graham urges, by building new DIY spaces, decentralized media, and networks that move across art disciplines.

"Success will be written by us."

The undergraduate speaker, while no more optimistic than Graham, offers a good deal of comic relief. That is because he is a stand-up comedian, the head of MICA's Improv League. He is Samuel Downs Thurman, a graduating senior in the Interaction Design and Art Department. Samuel's theme is Baltimore as a city of contradictions, a scary urban place, but if explored, a treasure store as well. You can find art galleries squeezed between welfare hotels and empty lots, he says in his survey of life as an art student. In Baltimore, if you come upon a city warehouse with cool-dressed people outside, it could be either "a crack den or a hipster art collective." As an art school, MICA's strength is that it exists in the middle of

this kind of city, Samuel says, and despite Baltimore's TV image on *The Wire*, the HBO crime drama, the city has its own kind of greatness.

"The ugly side of Baltimore can be our impetus to make beautiful things," he concludes, predicting that a strong case of nostalgia will descend on graduates very soon.

There are no big surprises this year as the students, each of their names called by department major, walks across the stage of the Symphony Hall, cheers and clapping showering down from the tiers of seating. Well after three o'clock, Sean Patrick Donovan is striding across the stage in black robes and mortar board, not a drop of paint anywhere on his clothes. At 4:03 comes Jennifer L. Mussari, *cum laude*, who pauses to hug two of the academic officials in the commencement line. There are challenges ahead, but that is part of being young, loving art, and deciding it's the "world they've been given," the world they will try to navigate.

The head of admissions, Theresa Bedoya, speaks for the vast majority when she says during the ceremony: "Leading a creative life is the best way to live."

[]

In reality, the end of the school year is never as beautifully done as the commencement ceremony. As the seniors linger for graduation, the freshmen, pushing red hampers on wheels, their parents' SUV's creating traffic jams outside The Commons and Meyerhoff House, are trying to consolidate a year's worth of art-school products—and detritus. In the classrooms, hundreds of unclaimed canvases are being piled up by the janitorial staff. In their dorms, students are figuring out what to do with giant-sized sculptures (with paintings, they can de-frame a canvas, and roll it up).

In this week of freshman departure, a teacher like Ellen Cutler bends a few rules to help her students, adorable young slackers such as Cameron Bailey, who took her art history class. To be sure, Cameron has learned to draw and paint. Still, his life-management skills need some honing. Eagerly, he bought his airplane ticket home for Saturday, even after Cutler clearly announced that the final exam is on Monday. Ever patient with her wards, Cutler has come in on her Friday off to give Cameron the test.

"Oh, their attention spans," Cutler sighs.

This does not solve all of Cameron's problems, however. Dropping out

of one freshman class (EMAC) has hurt his grade average; students must maintain at least a 3.0 to keep any scholarships they are awarded. To boot, Cameron has still not turned in proof of his medical shots, required to re-register. In a few weeks, in fact, he will be back in rural Washington state, working at a bank to earn money to return to MICA. He's going to have to take a semester off. Cameron still has a lot to organize.

As Cameron catches his flight, the dust is still settling at The Commons, one of the busiest crossroads in the last two days of school. Holden Brown is the last one out of his ground-floor dormroom, unit 3109, which is nearly as clean as when he arrived (and where Jonathan Levy also had lived). Unit 3109 is probably a happy exception. For the next month, MICA's housing staff will be sending bills to freshman for damages, the most common being "excessive cleaning" ($30–$300); most rooms sport thick layers of black charcoal on the walls, where students did lots of drawings. Oil paint is also splattered around. In some cases, smashed dry wall needs replacing or drains clogged with paint need clearing.

On a busy moving-out day, Kyle Davis, director of housing, sits in his small office at The Commons entrance, waiting for the calm. "Sometimes I wonder how, over the course of nine months, a room can get so dirty," he says. "We walk through all the rooms. I will have to go home and shower." Clearly, most eighteen-year-olds have not mastered hygiene yet, neither boys nor girls. "The illusion of girls being cleaner than guys melted away for me a long time ago," he says.[8] The school hosts summer programs, so the schedule is tight. The repainting must run apace.

Tidy students such Holden are just as happy to bolt Baltimore as his messy peers. He's driving back to New Orleans. With so many friends back home, he was not necessarily looking for new ones at art school, though he found a small circle, a circle that was serious about art and life. "Most people here are dedicated to their work," Holden says. "It's not a party school." In this final week, he has had one more chance to confirm his dedication to filmmaking. He catches the Maryland Film Festival, some of it held at Falvey Hall, and sees *Music by Prudence*, the Oscar-winning documentary in which one of his teachers played a role.

"It was so powerful," he says. "You see how much film can make an impact."

After a year in Baltimore, Chris McCampbell, a California native, sees

himself as an East Coaster. He was quickly acclimated by Snowmageddon, his "first real winter." His wife, a social worker, has found work in the city. It has been nine months since the hot August day when Chris sat on the outdoor porch of the Gateway, his first day at MICA, and a lot has changed. This summer he'll spend his weekdays at a Pentagram design studio in a private home in Roland Park, a mile north of the campus, doing an internship with the large design firm. Chris cannot afford to be lulled into summer doldrums; he also has to develop the idea for his master's thesis. It must be an idea so good that he can turn it into a career, a re-launch, at age thirty-three, into the competitive design industry.

If you pick up the *Washington Post* this summer, you will see a picture of Sean Donovan who, like Pablo Picasso, is wearing only short pants, painting in a hot, cinderblock studio. In Baltimore, the *Post* says, the art scene "has taken off," although it's still characterized by what Sean's doing.[9] He's a young artist in a cheap-rent space trying to get started, all against the odds, but also knowing that the veteran gurus of career painting warn against the "mad rush to market."[10] By now, the advice of Sean's painting instructor, Christine Neill, spoken to his senior painting group, has probably faded in his mind, but her point has sunken in. When you graduate, Neill said that day in class, you lose a campus studio. ("You also lose your audience," said one graduating painter). Either way, Neill said, get a new studio going as soon as possible, wherever: a warehouse corner, back of the kitchen, your parents' basement.

Sean's off-campus studio is at Open Space, a hive of studios carved out in a vast building once dedicated to the Baltimore Body Shop. Two stories tall and made of brick, the building is more than a mile north of MICA, an old neighborhood, halfway to the Baltimore Museum of Art. Like the other industrial buildings in the neighborhood, the Open Space facade occupies a "desolate, weed-filled corner," the *Post* says. Still, a Subway sandwich shop is across the street. The young artists there have day jobs, as does Sean; for the summer, he's working as studio assistant to one of the MICA faculty's old-timers, the painter Raoul Middleman.

While Sean has his eyes on the next painting, Jen Mussari has fixed her gaze on San Francisco.[11] Her boyfriend Jonnie has a pre-paid airplane ticket, paid for by his company, Adobe, if he travels by mid-July. So that is their goal. They had dreams of finding a home in SoMa, an artsy section of

San Francisco, but the alternative is turning out just fine (by August, they are moved into a high-rise apartment near the San Francisco Civic Center and City Hall, also near Hayes Valley, called a little So-Ho for its shops, cafes, and galleries).

In the days before they depart, Jen grows nostalgic. She visits the Baltimore Museum of Art once more to see her favorite paintings and prints. In a few weeks, they will be three thousand miles away. Avant-garde as Jen may be, it's Andrew Wyeth paintings in general that pull her heart strings at this moment; the Wyeth landscapes are of her own region in Pennsylvania, a landscape that "pretty much embodies home for me," Jen tells her friends. Now she's leaving the Wyeth side of the country.

Every art student, and college student for that matter, decides how much they want to entwine their life in the school at which they've spent four years. Jonnie separated early, a bit alienated from "school" by his job and self-taught interests in computer programming. However, Jen, like a vine, has woven herself into MICA's fabric. In this they differ, but thanks to MICA, they met. About this time, Jonnie is celebrating (on his blog) their being together for three years. Jen has "been my source of inspiration," Jonnie announces. "I simply can't wait to see where the next three years take us." As is appropriate for the world of art, Jen is Jonnie's muse, but yet another muse gone from MICA.

New students are coming. Graduates are soon to be forgotten, though not lost, for they are all on the Internet, the new art world geography. Interested parties can find Jen at her cyber-site, "There's Water Here." Here, she continues to reflect about art and life, her freelance dream of making and selling "custom, handmade, totally unique goods," especially handmade prints. Jen spent her senior year developing an identity, a brand. In art, as in life, however, creativity is fluid. The ideas never stop coming. Who will she be in another year? Every day she sees the latest work of other artists flying up on the Web, filling up art world cyberspace, and it keeps her thinking about what she can do better.

"Only a few months out of school," Jen says, "and I'm already itching to redesign my identity."

THE MARYLAND INSTITUTE COLLEGE OF ART
AND ITS NEIGHBORHOOD

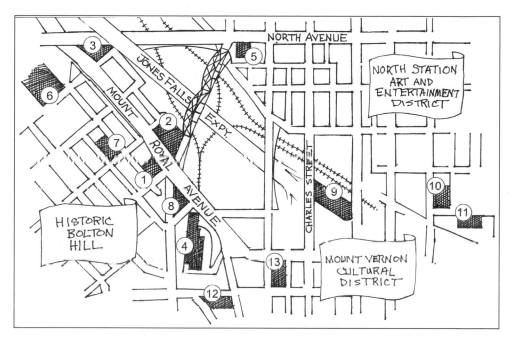

1. Main Building
2. Brown Center, Fox and Bunting Bldgs.
3. Gateway
4. Mount Royal Station
5. Studio Center
6. The Commons
7. Meyerhoff House

8. Bookstore and Printmaking Bldg.
9. Pennsylvania Station
10. Copy Cat Bldg.
11. Area 405
12. Meyerhoff Symphony Hall
13. University of Baltimore

This project would not have been possible without the generous welcome of the MICA administration, faculty, and students. My particular thanks to President Fred Lazarus, Provost Ray Allen, and Undergraduate Dean Jan Stinchcomb for approving my request to participate in the eight months of a school year, and for the chairs and directors of various departments for rolling out the red carpet to an unknown journalist. Most of all, I thank the students who allowed me to inquire closely into their art-school lives.

For this project, I was at the campus for about 100 days of a 150-school-day academic year. This was the 2009–1010 school year, beginning on August 31, 2009, and ending on May 7, 2010. In my first semester on campus, I focused on a particular set of classes and took in the larger picture of the art school and the Baltimore art scene. In the second semester, I followed specific students. During the entire year, I was able to attend, briefly or consistently, fifty different studio classes, touching on all fourteen undergraduate departments (and most of the ten graduate schools), and to sample fifteen liberal arts courses. The number of lectures, exhibits, staff meetings, ceremonial programs, and orientation events I attended add up to another forty or fifty occasions (not including travel to art events related to the school in Miami, New York, Pittsburgh, and Chicago).

Naturally, then, much in these pages has been selective and simplified, and there's been a certain amount of mixing-up of time frames to organize the narrative. Most of what I recount is based on eyewitness participation. Other parts are reconstructed from interviews, videos, audiotapes, Web sites, or documents. I conducted sixty recorded interviews with staff and faculty members, thirty-six recorded interviews with students, and perhaps another fifty interviews taking notes; I also took down voluminous class notes and countless observations. To gain access to school life, I followed the honor code of letting subjects know how I use their remarks; some asked for changes and some comments are kept anonymous. In all cases, the chief concern has been factual accuracy.

Any book on higher education begs for a good deal of institutional,

financial, and sociological analysis. However, in this text I have avoided that kind of number-crunching; the endnotes offer some of those facts and figures and pointers to Web sites that offer data on art schools. By the same token, some readers may approach this book as a "how-to" guide on shopping for art colleges. I hope that this book reveals something universal about the life of every art school, and thus has general application. However, in choosing an art college, the wise shopper must do the research and make the comparisons. Each art school has a Web site and handbook full of facts, from courses to costs, history to housing.

When I graduated from the art department of San Jose State University in California in 1974, I had a pretty good grasp of the art-making process, especially drawing and painting in a more realistic vein. I followed another career, however, but never dropped art as a hobby, or art as something to apply to my work with nonprofit groups, newspapers, magazines, and books. For this book, I have ventured a series of illustrations. They are all black-and-white hand drawings based on my photographs and my imagination, the sizes ranging from 5 x 7 to 6 x 9 inches, done on paper in pencil, charcoal, Conté, and watercolor.

My completion of this book was greatly aided by MICA historian Doug Frost's remarkable time line of the school's 184-year history, and by Rachael Cohen's superb editing. Thanks are finally due to my agent, Laurie Abkemeier, and my editor at University Press of New England, Stephen P. Hull.

[NOTES]

INTRODUCTION: *Portfolio Day*

1. Daniel Grant, "High Schools of the Arts," *American Artist*, February 2010, 74. See the Advanced Placement information on studio art at www.collegeboard .com/student/testing/ap/sub_studioart.html.

2. These are three of the fifteen institutional concerns of private art colleges listed in Bill Barrett's "15 Concerns" (Association of Independent Colleges of Art and Design, March 25, 2008). Four of the concerns focus on the U.S. economy, four on AICAD schools' ability to compete with other educational options, four with government efforts to regulate higher education—and finally, one concern focuses on how art schools can grab attention in a busy, media-saturated society.

3. Private art colleges have a range of prices, but generally charge more for tuition than state universities or community colleges (with art departments that offer the same degrees in art). Among the top tier of art colleges—which includes MICA—the cost of a freshman year (tuition, room, and board) is on par with the top private liberal arts colleges and some Ivy League schools: around $45,000 a year in 2009. (This is typically broken out as a mid-$30,000 figure for tuition and $10,000 to 12,000 for room and board). The Web sites of forty-one private art colleges in North America listing their tuitions and statistics can be reached through the Association of Independent Colleges of Art and Design directory at www.aicad.org.

As with all private colleges, MICA boasts that most students receive some financial aid. A similar pattern is seen at all expensive private schools: On one hand, a large percentage of the students pay the full amount, and on the other, schools offer merit or "need" scholarships to the rest. A typical merit scholarship at MICA covers 50 percent of tuition. Students whose parents can't pay in cash take out federal loans; every college relies heavily on this federal money. (Taking that money has required virtually every American campus to hold a "Constitution Day" event, for which MICA featured the famous radical Angela Davis at its 2009 event, which was on the topic of the Constitution and women's rights; the next year it was gay marriage and the Constitution.)

4. The typical portfolio is a cardboard folder with ten to twenty samples of art works—either the "best" or most representative of the artist—presented for easy review, often with a simple document explaining the artist's interests

and works. However, in the real world, portfolios can range from CDs to fancy aluminum cases. One standard description for a high school portfolio is given by the College Board in its Advance Placement review guidelines for Studio Art (see www.collegeboard.com/student/testing/ap/sub_studioart.html). Foremost, the art handbooks say that the portfolio presentation depends on who it is being submitted to, and on the guidelines that organizations provide for what they want to see. Exemplary how-to books include Heather Darcy Bhandari and Jonathan Melber's *Art/Work: Everything You Need to Know (and Do) As You Pursue Your Art Career* (New York: Free Press, 2009); Jackie Battenfield's *The Artist's Guide: How to Make a Living Doing What You Love* (Philadelphia: Da Capo Press, 2009); and Margaret Lazzari's *The Practical Handbook for the Emerging Artist*, second ed. (Boston: Wadsworth, 2010).

5. I borrow this three-part history from Thierry de Duve, "When Form Has Become Attitude — and Beyond," in *The Artist and the Academy: Issues in Fine Art Education and the Wider Cultural Context*, eds. Stephen Foster and Nicholas deVile (Southampton, UK: John Hansard Gallery, 1994), 23–40. As to art "attitude," while its contemporary form blossomed in the 1960s, its true modern roots go back to the European bohemians, especially in Paris after the late 1800s, where the art attitude became robust and bizzare. See Roger Shattuck, *The Banquet Years: The Origins of the Avant-Garde in France, 1885 to World War I* (New York: Vintage, 1968).

6. Interview with Raymond Allen, August 23, 2009.

7. Maryland, like many states, has a rich history of accomplished and "highbrow" native sons and daughters in the visual artist. However, Baltimore seems best known for its two lowbrow native sons, the filmmaker John Waters (locally called the "sultan of sleeze" for his repertoire of vulgar films and latter-day photo art), and the musician Frank Zappa, who pioneered gonzo rock music. Meanwhile, *Rolling Stone* magazine has designated Baltimore as a leading alternative music scene (but does not mention its visual arts).

8. Artscape 2009 took place July 17–19. It reportedly drew 350,000 people, nearly half from outside Baltimore. The total business impact was $25.97 million for the city, and $9.2 million for vendors ($3.35 million of that "in art from exhibitors"). See "Audience Research and Economic Impact Study of Artscape 2009," Forward Analytics, Inc., Pittsburgh, 2009.

9. Quoted at www.mica.edu/news/7th_annual_transmodern_festival.html.

10. Richard Florida, *The Rise of the Creative Class: And How It's Transforming Work, Leisure, Community and Everyday Life* (New York: Basic Books, 2002).

11. Daniel H. Pink, *A Whole New Mind: Why Right-Brainers Will Rule the Future* (New York: Riverhead Books, 2006), 54. For a more futuristic vision of art education, see two recent collections of essays: Steven Henry Madoff, ed., *Art*

School (Propositions for the 21st Century) (Cambridge, Mass.: MIT Press, 2009), and Brad Buckley and John Conomos, eds., *Rethinking the Contemporary Art School: The Artist, the PhD, and the Academy* (Halifax, Nova Scotia: The Press of the Nova Scotia College of Art and Design, 2009).

12. Interviews with Fred Lazarus, October 22, 2009, and May 7, 2010.

13. See Elliot W. Eisner, *The Arts and the Creation of Mind* (New Haven: Yale University Press, 2002). Eisner's book offers two classic lists of how the arts benefit human beings: first, a list of eight "Visions and Versions of Arts Education" (chapter 2, 25-43), and second, a ten-part list of "What the Arts Teach and How It Shows" (chapter 4, 70-92). In addition, a "benefit" not mentioned by Eisner is the use of art for political protest and countercultural dissent.

14. For Eugene Leake's story see, Craig Hankin, *Maryland Landscapes of Eugene Leake* (Baltimore, Md.: Johns Hopkins University Press, 1986), 1-21.

15. Dana Gioia, "Executive Summary," *Artists in the Workforce 1990-2005,* National Endowment for the Arts Research Report #48. Washington, D.C., May 2008, 2.

CHAPTER 1. *"Very Gifted People"*

1. The term "postmodern" was used first in architecture, referring to postmodern buildings that rejected the "modern" style of collective housing and city planning, a style that revealed its dreary urban effects by the 1960s. In its heyday, "modern" architecture was viewed as an extension of the Enlightenment project, a world of progress that is rational, scientific, and utopian in approach. Postmodern architecture broke from that rational vision. Thereafter, the term "postmodern" migrated easily to art: Postmodern art rejects progress through science, reason, and expertise; instead, it endorses plural viewpoints and questions the "modern" project.

2. Dana Gioia, "Executive Summary," *Artists in the Workforce 1990-2005,* National Endowment for the Arts Research Report #48. Washington, D.C., May 2008, 1.

3. The psychological profile of a young person who is artistically inclined is much debated, as are summaries of the "art student type." One consensus seems to be that, because an artist must spend time alone to produce significant work, the "loner" youth may characterize the art student in high school and college. In turn, loners may be more introverted, or less socially adept, and this could be for psychological or family reasons (on one extreme a degree of autism, or on another a broken family). However, many "art kids" have a parent or relative who is an artist, so role models could be more significant than psychological factors. Today's art students are in the cohort called "millennials."

According to one major survey, this group is more pro-government welfare, so-cially liberal, and less religious than other generations, and it may be that art students are even more liberal in some areas, such as creativity, nonconformity, or sexual morals. At the same time, surveys find that millennials go to college mainly for a job with good income (70 percent say that is most important), a "conservative" factor that is likely among art students as well. For an overview on millennials, see Pew Research Center, *Millennials: A Portrait of Generation Next—Confident, Connected, Open to Change*. Washington, D.C., February 2010, at www.pewresearch.org/millennials.

4. Keeping students is important for independent art schools because they operate almost entirely on tuitions and fees. Many of the schools have limited financial endowments. At MICA, the endowment is stated to be around $60 million (not counting dips during the stock market decline and recovery). This may seem low for an institution that is nearly 190 years old, but it is the fate of many small schools. Other art schools have large endowments, The Cooper Union reporting $600 million and the Rhode Island School of Design $374 million (both before the 2008–2009 stock market dip and recovery). Such large endowments are specific to the founding of art schools and, later, the wealth of alumni. Some schools are attached to large universities (Rhode Island to Brown University, for example), or institutions (the Chicago Art Institute, for example, houses its art college and a world-class art museum, a repository of the art wealth of the Midwest). MICA did not have a single wealthy founder and, apparently, few extremely wealthy graduates over the years, compounded by the relative poverty of a city such as Baltimore (although Maryland has the highest median household income of any state). Art schools are small operations: In 2009, MICA had an operation budget of about $60 million, whereas nearby Johns Hopkins University (with an endowment of $2.5 billion in 2008) had a $3.7 billion operation budget in 2009.

5. Patricia Farrell's comments were made at the Foundation faculty meeting before the school year, August 25, 2009. The number of students at any college who take psychiatric medication is confidential. However, the annual National Survey of Counseling Center Directors reports that in 2009, 25 percent of all students who go to college counseling centers are on psychiatric medication, up from 9 percent in 1994 (see www.collegecounseling.org/2009directorsurvey). Medications typically are taken for Attention Deficit Disorder, anxiety, or depression. While more college students report mental illness problems than a decade ago, that is because treatments now allow them to cope with going to college. On this, see "College Students Exhibiting More Severe Mental Illness," American Psychological Association, 118th annual convention, August 13, 2010, *Science-Daily*, at www.sciencedaily.com/releases/2010/08/100812111053.htm (retrieved

November 10, 2010). The report says: "Students with severe emotional stress are getting better education, outreach and support during childhood that makes them more likely to attend college than in the past." As with every college, the MICA syllabus for each class includes an "ADA Compliance Statement" (Americans with Disabilities Act), which encourages the student to talk with the instructor about "accommodation based on the impact of a disability," and about referral to school counselors or learning centers.

6. Interview with Richard Barber, February 3, 2010.

7. Annual Report of the President, Maryland Institute College of Art, 2008–2009, 47.

8. The freshman enrollment this year (2009-2010) consists of 25 percent from private high schools, 19 percent from public art magnet high schools, and 56 percent from public high schools. This year, private and magnet school recruitment rose 13 percent over the previous year.

9. Maria Falzone, "Sex Rules," August 28, 2009, Falvey Hall, Baltimore. Author's notes.

10. A standard book on the critique is Kendall Buster and Paula Crawford, *The Critique Handbook: A Sourcebook and Survival Guide* (Upper Saddle River, N.J.: Prentice Hall, 2007). At this writing, MICA plans to publish its own book on the critique. Also, its faculty received a foundation grant to formulate an ideal eight-step "liberatory model" for the critique. For this see, Ken Krafchek, "The Liberatory Critique," Community Arts Network/Art in the Public Interest, December 2009, at www.communityarts.net/readingroom/archivefiles/2009/12/the_liberatory.php.

11. Interview with Jen Mussari, January 11, 2010. All comments from Mussari in this chapter are from interviews and from the "Art of the Critique," August 30, 2009, including those by Nancy Roeder. Author's notes.

12. Interview with Cameron Bailey, February 24, 2010.

13. Pablo Picasso famously said this and it is repeated in these words by Francis Bacon in Michael Kimmelman, *Portraits: Talking with Artists at the Met, The Modern, The Louvre and Elsewhere* (New York: Random House, 1998), 37.

14. Typically, art schools do not have departments on "conceptual art," since it is an artistic outlook that crosses many disciplines. In short, it means that the idea behind the art work is more important than the object. At MICA, conceptual artists are most likely to be majors in General Fine Arts or Interdisciplinary Sculpture, but few faculty or students adopt this specific label for their art discipline. It seems to be a more common term in art textbooks and gallery shows. As art critic Roberta Smith has aptly said, probably more conceptual art "pieces" have been made worldwide than any other kind of work of art, but despite their dizzying number, they are so ephemeral and temporary that none

last in memory or have an impact on art history, except perhaps the very first "conceptual art" projects that are now in textbooks. See Roberta Smith, "Conceptual Art," in *Concepts of Modern Art*, third ed., ed. Nikos Stango (New York: Thames and Hudson, 1994), 256–70.

15. Annual Report of the President, 47.

16. Interview with Theresa Bedoya, November 10, 2009. Comment by Kerry Freedman, "Visualizing Masculinities: The Place of the Visual Arts in the Education of Boys," session at the National Arts Education Association conference, April 16, 2010, Baltimore. Author's notes.

17. On the rise of homosexual art, which has strongly influenced art schools, see Gavin Butt, "How New York Queered the Idea of Modern Art," in *Varieties of Modernism*, ed. Paul Woods (New Haven: Yale University Press, 2004), 315–38; David Hopkins, "Duchamp Legacy: The Rauschenberg-Johns Axis," in *After Modern Art, 1945–2000* (New York: Oxford University Press, 2000), 37–64; Christopher Reed, "Postmodernism and the Art of Identity," in *Concepts of Modern Art*, 271–93.

18. Interview with Jonnie Hallman, January 11, 2010.

19. Annual Report of the President, 47.

CHAPTER 2. *Visiting Artist*

1. Interview with Sean Donovan, February 24, 2010.

2. Artist talk, August 31, 2009. Author's notes.

3. Interview with Gerald Ross, October 8, 2009.

4. "The Sabbatical, Foundation, and Faculty Exhibitions," *Juxtapositions*, August–September 2009, 5. (This is MICA's bimonthly events publication.)

5. In talking with art teachers, I could not find a consensus on how to best stock an ideal art school with faculty. Some faculty members say that hiring too many of a school's own graduates creates an "inbred" style, which does not allow other currents or talents from the art world to stimulate the campus or curriculum. On the other hand, hiring local graduates (especially as adjuncts) is efficient, both in terms of the cost and the art school culture. Some faculty have said a school such as MICA should pay whatever it takes to get more "art stars" from outside, raising the school's reputation and exposing students to famous artists. Contrary to that, other faculty members say that art "stars" are notoriously eccentric, self-enamored, and make bad teachers. Either way, a saying around campus reveals how a Baltimore art school can feel compared to the "New York art scene": "Teachers who come down from New York are considered the thoroughbreds, and those who live in Baltimore are considered the draft horses."

6. Chardin, quoted in Denis Diderot, "The Salon of 1765," in *Diderot on Art, Volume 1: The Salon of 1765 and Notes on Painting*, trans. John Goodman (New Haven, Conn.: Yale University Press, 2009), 4-5.

7. On Duchamp's escapade, see Calvin Tomkins, *Duchamp: A Biography* (New York: Henry Holt, 1996), 170-89.

8. Jeff Koons spoke at the Station Building about his 1989 series, "Made in Heaven," on April 12, 1993. He was interviewed beforehand in John Dorsey, "Artist Jeff Koons Paints a Portrait of Sincerity and Self-Promotion," *Baltimore Sun*, April 12, 1993, D1. The sexual explicitness of Koon's public talk was recounted for me in an interview with Abby Sangiamo, March 19, 2010.

9. See the chapter on Jeff Koons in Calvin Tomkins, *Lives of the Artists* (New York: Henry Holt, 2008), 189-213.

10. This account is based on an e-mail interview with Meghann Harris, February 15, 2010, a telephone interview, March 14, 2010, and attendance at her classes.

11. Comments by Brockett Horne, November 31, 2009.

12. Comments by Christine Neill, September 14, 2009.

13. See "Professional Development and Core Skills and Objectives," Professional Development and Programming in the Academic Curriculum, MICA, January 2010.

14. Warren Seelig, "Materiality and Meaning," Artist at Noon talk, September 14, 2009. Author's notes.

15. Interview with Jonathan Levy, February 17, 2010.

CHAPTER 3. *Tattoos and the Foundation Year*

1. This account of Dennis Farber's Elements class is based on intermittent attendance throughout the school year, on Farber's notes for the first day introductory lecture, and on an interview, February 3, 2010.

2. This account of Nora Truskey is based on the author's attendance in her class, on an interview, February 26, 2010, and on one of her Critical Inquiry papers, "Hesitation," December 7, 2009.

3. Interview with Nora Truskey, February 26, 2010.

4. "Kitsch" is said to derive variously from the German noun for "trash" or from the verb for "to make cheap," *verkitschen*. It was introduced into contemporary art debate in 1939, when the art critic Clement Greenberg compared kitsch (he cited advertising, jazz, illustration, B movies, and other formulaic, mass-produced art forms) unfavorably to a superior "avant-garde" art, which Greenberg saw in the rise of abstract expressionism. In 1964, the writer Susan Sontag said that viewing kitsch ironically, taking it as something cool and hip,

was the new art attitude of "camp." In the 1970s, artists began to take traditional kitsch objects and, calling it ironic art, presented them as pop-art or fine art that could be displayed in galleries and sold to collectors.

5. Compared to the anti-establishment bent of 1960s and 1970s art students, Farber says today's students are more "conservative," closer to their parents, willing to conform, and mostly interested in getting a job. The vast majority of all college students today (70 percent) go to school for a job and income. However, they are more socially liberal and secular on morals, government welfare, and religion than any modern generation. In every generation, art students are probably more liberal than others in their age cohort. As to anti-establishment messages in their art, that remains to be seen in the next decade or two.

6. Randall Lavender, "The Subordination of Aesthetic Fundamentals in College Art Instruction," *Journal of Aesthetic Education* 37 (Fall 2003): 43–46. Lavender also outlines three different approaches that Foundation years tend to take, ranging from trade-school-like basics to a purely expressionist classroom. MICA's Nancy Roeder, former chair of the Foundation Year, says that it's hard to find teachers who enjoy teaching a class, like Elements, that must lay down the basics: "We can find a million people to teach Drawing I or Painting I, because that is akin to their studio practice." Interview with Nancy Roeder, March 23, 2010.

7. Rudolf Arheim's most popular work is *Visual Thinking* (Berkeley: University of California Press, 1969). See also, Arnheim, *Art and Visual Perception: A Psychology of the Creative Eye* (Berkeley: University of California Press, 1954), and *New Essays on the Psychology of Art* (Berkeley: University of California Press, 1986). "Gestalt" means "wholeness" of perception in German. The earliest use of the idea was in the psychology of perception (by Goethe, Kant, and others), and elaborated by art psychologists such as Arnheim. Using the same term, a school of psychiatry also arose, presenting Gestalt Therapy as a therapist-client approach, developed by Fritz Perls in the 1940s.

8. On theater, see Herbert Bayer, Walter Gropius, and Ise Gropius, eds., *Bauhaus, 1919–1928* (New York: Museum of Modern Art, 1938), 29.

9. This chapter's account of Amelia Beiderwell is based on the author's attendance in her classes and on interviews on March 1, March 8, and April 8, 2010.

10. This chapter's account of Catherine Behrent's Elements class is based on the author's participation for the four-week assignment.

CHAPTER 4. *Seeing Red*

1. The account of Michelle La Perrière's Elements class is based on the author's attendance during three weeks of the color exercises and on her class handouts.

2. The Josef Albers quotations in this chapter are from Josef Albers, *Interaction of Color*, rev. edition (New Haven, Conn.: Yale University Press, 2006), 3 (red), 82 (preferences), 23 (fools), 69 (engineering), 88 (rid), 120 (constant), 65 (exciting), and 88 (courageous).

3. Video shown December 10, 2009. See PBS, *Art 21: Season 5* (2009); Mary Heilmann in episode 2, "Fantasy."

4. Dennis Farber's comments in this chapter are from an interview, February 3, 2010.

5. Calvin Blue comment in class, December 17, 2009. Other quotations are from interviews, February 28 and March 17, 2010.

6. Interview with Chris McCampbell, October 8, 2009.

7. Richard Dyer, *White: Essays on Race and Culture* (London: Routledge, 1997), 2.

8. In a mild retreat from his disagreement with Ittan on the relativity of color, Albers acknowledges that color can be associated with moods, listing "lucid," "serious," "mighty," "serene," and "melancholic" as examples.

9. David Batchelor, *Chromophobia* (London: Reaktion Books, 2000), 22.

10. Diane Ackerman, *A Natural History of the Senses* (New York: Random House, 1990), 255.

CHAPTER 5. *Lines and Marks*

1. This chapter's account of Barry Nemett's Drawing II class is based on the author's participation during the first semester and on the author's notes.

2. Comments by Warren Linn, August 25, 2009.

3. This chapter's account of Cameron Bailey is based on the author's attendance in his Drawing class, on informal conversations, and on interviews, February 24 and May 6, 2010.

4. The author attended this meeting August 25, 2009.

5. Interview with Abby Sangiamo, March 19, 2010. Sangiamo had been head of MICA's drawing and fine arts requirements for several decades.

6. Stuart MacDonald, *The History and Philosophy of Art Education* (New York: American Elsevier Pub. Co., 1970), 259. For a history of American drawing in the 1800s, see Mary Ann Stankiewicz, Patricia M. Amburgy, and Paul E. Bolin, "Questioning the Past: Contexts, Functions, and Stakeholders in 19th-Century Art Education," in *Handbook of Research and Policy in Art Education*, ed. Elliot W. Eisner and Michael D. Day (Mahwah, N.J.: Lawrence Erlbaum Associates, 2004).

7. Isaac Edwards Clarke, *Art and Industry: Industrial Drawing Applied to the Industrial and Fine Arts* (Washington, D.C.: Government Printing Office, 1897),

181–82. See also Otto Fuchs, *Handbook on Linear Perspective, Shadows, and Reflections* (Boston and London: Ginn & Company, 1902).

8. Quoted in Craig Hankin, *Maryland Landscapes of Eugene Leake* (Baltimore: Johns Hopkins University Press, 1986), 13.

9. David C. Levy, "Art Expert: The Problem with School Art Programs Are Teachers Who 'Can Barely Draw,'" *Washington Post*, online edition, October 13, 2009, at http://voices.washingtonpost.com/answer-sheet/guest-bloggers/david-levy-the-problem-with-sc.html.

10. Interview with Karen Carroll, March 9, 2010.

11. This account of Phil Koch's Drawing I and II class is based on the author's attendance in the first and second semesters, on class handouts, and on an interview, March 3, 2010.

12. Interviews with Cory Ostermann, March 3, April 12, and April 28, 2010, and attendance at many of her classes.

13. This account is based on attending Liam's Drawing class and on interviews, February 28, April 1, and May 5, 2010.

14. *David Hockney's Secret Knowledge*, British Broadcasting Corporation, 73-minute video, 2002. The television program was based on David Hockney, *Secret Knowledge: Rediscovering the Lost Techniques of the Old Masters* (New York: Viking Studio, 2001).

15. Comment by Tony Shore, instructor in Drawing from the Tablet, spring 2010.

CHAPTER 6. *Dead Authors Can't Define Art*

1. Eisner borrows this phrase from the title essay in Lydia Davis, *Samuel Johnson Is Indignant* (New York: Picador, 2002).

2. Interview with Amy Eisner, February 18, 2010. This chapter is based on the author's attendance at Eisner's Critical Inquiry class through most of the first semester.

3. At MICA, the main liberal arts department for years was called Literature, Language, and Culture, but in 2010 it was renamed the Department of Humanistic Studies. A smaller wing of liberal arts is the Department of Art History, Theory, and Criticism.

4. Lois Tyson, *Critical Theory Today: A User-Friendly Guide*, second ed. (New York: Routledge, 2006), 1–2.

5. Galway Kinnell, "The Deconstruction of Emily Dickinson," in *Imperfect Thirst* (New York: Houghton Mifflin, 1994), 23–25.

6. Tyson, *Critical Theory Today*, 455.

7. The donkey's name was Aliboron. See Dan Franck, *Bohemian Paris: Pi-*

casso, Modigliani, Matisse, and the Birth of Modern Art (New York: Grove Press, 2001), 143–45.

8. Calvin Tomkins, *Duchamp: A Biography* (New York: Henry Holt, 1996), 53.

9. The Winslow Homer story is told in Roger Kimball, *The Rape of the Masters: How Political Correctness Sabotages Art* (New York: Encounter Books, 2004), 115.

10. Interview with John Peacock, April 20, 2010.

11. See Susan D. Blum, *My Word!: Plagiarism and College Culture* (Ithaca, N.Y.: Cornell University Press, 2009). Similarly, art students are constantly faced with debates over copyrights, intellectual property, and "appropriating" other people's art without permission. The standard plagiarism statement in MICA classes is strict: "MICA will not tolerate plagiarism, which is defined as claiming authorship of, or using someone else's ideas or work without proper acknowledgment. Without proper attribution, a student may NOT replicate another's work, paraphrase another's ideas, or appropriate images in a manner that violates the specific rules against plagiarism in the student's department. In addition, students may not submit the same work for credit in more than one course without the explicit approval of all of the instructors of the courses involved." To an observer, it is clear that students occasionally use one art project for two classes, whether informally or with teacher permission. Cases of plagiarism are confidential, although many art classes have a debate about "appropriation" of art and copyrights in art.

12. Interview with Christopher Shipley, March 1, 2010.

13. These events are recounted from Kerr Houston's Art Matters class, September 4, 2009, from the class syllabus, and from interviews with Cory Ostermann, March 3, April 12, and April 28, 2010, and with Adam Dirks, February 17 and March 24, 2010.

14. Interview with Joseph Basile, March 25, 2010. In class, Basile notes that classic art history was often written in the nationalistic spirit of its German and English authors. Also, the term "fine art" did not even exist in the ancient world, since it was invented by the French in the 1700s, showing up in English dictionaries only in the next century. Still, most elective art history courses at MICA remain chronological. After taking two required courses—Art Matters and After Modernism—students can chose three other electives of any kind. Hence, some teachers lament that MICA students can earn a bachelor of fine arts without ever taking a course in the Renaissance if they prefer studying modern art history only.

15. Remarks by Sam Hope and Robert Milnes, General Session of the National Association of Schools of Art and Design, October 16, 2009, Pittsburgh, Pennsylvania, from author's notes. As to setting art standards, public school

art educators have tried to assure lawmakers with their own standards. In 1994, for example, artists provided the U.S. Department of Education with a set of kindergarten through twelfth grade National Standards for Arts Education (an obvious influence on colleges as well). See the National Standards for Art Education at www.arteducators.org/store/NAEA_Natl_Visual_Standards1 .pdf. The National Association of Schools of Art and Design also has the current *NASAD Handbook 2009-10*, which broadly defines curriculum standards (see http://nasad.arts-accredit.org/index.jsp?page=Books).

16. The latest discussion on requiring colleges to show student employment can be found in, "Part II, Department of Education, Program Integrity: Gainful Employment; Proposed Rule," *Federal Register* 75 (July 26, 2010): 43616. The "proposed rule" is to amend Title IV of the (1965) Higher Education Act (see at http://frwebgate.access.gpo.govCgi-bin/get++doc.cgi?dbname=2010_register &docid=2010-17845-filed). The rule aims to "establish measures for determining whether certain postsecondary educational programs [using federal student assistance] lead to gainful employment in recognized occupations."

17. Sessions at the NASAD program also covered national economics, arts advocacy, writing and public speaking for art students, liberal arts, graduate programs, the PhD in studio art, multimedia, technology, design curriculum, and local metropolitan art scenes.

18. Ray Allen, "Report by the President," 2006 annual meeting, National Association of Schools of Art and Design; interview with Ray Allen, August 23, 2009.

19. Kerr Houston spoke on, "The Limits of Words: Description and Art Criticism in the 1960s," at the College Art Association session, "Can Description Help Images Speak?" Chicago, February 13, 2010. Conference tape.

20. For the survey, see Richard Barber and Cheryl Garner, "MICA Class of 2011 Freshman Year Focus Group," Part II, May 12, 2008, 4. The student comments are from their teacher reviews.

21. In Eisner's format, the three essay topics for the semester are: (1) a meaningful disagreement they've had about an artifact; (2) a comment on how others responded to an artifact; and (3) a case where they have changed their minds about an artifact.

CHAPTER 7. *Urban Legends*

1. The best book on the Cone sisters was written by a graduate of MICA: Mary Gabriel, *The Art of Acquiring: A Portrait of Etta and Claribel Cone* (Baltimore: Bancroft Press, 2002). For the Matisse visit, see the Prologue, xv–xix.

2. Quoted in William R. Johnston, *William and Henry Walters, The Reticent Collectors* (Baltimore: Johns Hopkins University Press, 1999), 127.

3. The story was recounted to me by Jen Mussari in an interview, March 26, 2010, and by a Web site at http://artdatabase.wordpress.com/2009/12/10/works-from-expatriate-artists-in-the-george-a-lucas-collection-bma-baltimore/.

4. Editorial, "It's Baltimore's Art Forever," *Baltimore Sun*, June 7, 1996, A18.

5. Interview with Terry DeBoise, November 3, 2009. This account is based on the author's attendance at the Finding Baltimore class and its off-campus activities in October and November 2009.

6. Ken Krafchek, "The Liberatory Critique," Community Arts Network/Art in the Public Interest, December 2009, at www.communityarts.net/readingroom/archivefiles/2009/12/the_liberatory.php.

7. Richard Florida, *The Rise of the Creative Class: and How It's Transforming Work, Leisure, Community and Everyday Life* (New York: Basic Books, 2002), xvii.

8. Susan Lowe, "How I Met Leo Murphy and Other Scary Scenes," *Link: A Critical Journal on the Arts in Baltimore and the World*, no. 2 (Summer 1997): 160.

9. Quoted in John Wetenhall, "A Brief History of Percent-for-Art in America," *Public Art Review* (Fall/Winter 1993), 4–7.

10. Much of my perspective on the "art district" movement came from talks given by city officials in the Art, Artists, and the City course, which I frequented in spring of 2010. A very helpful talk was by Ben Stone, an artist and urban planner with the city's Baltimore Development Corporation, February 4, 2010.

11. Quoted in Jamie Stiehm, "Art as Economic Development," *Baltimore Sun*, February 15, 2003, B1.

12. Blake Gopnik, "Expansive Lofts Inspire Expanding Minds," *Washington Post*, July 11, 2010, E3.

13. Quoted in *The Rooms Play* posters at "Group Production: A Show about Working in Collaboration with Others," Main Gallery, MICA, April 27, 2010.

14. The event was recounted in an interview with Daniel D'Oca, July 19, 2010, and on the event Web site at www.skyspaceproject.com/.

CHAPTER 8. *Exhibitmania*

1. Interview with Cornell Rubino, April 29, 2010.

2. This account is based on viewing of the Fox 2 gallery and on an interview with Jordan Pemberton, March 3, 2010.

3. The MICA 2009–2010 year offered fifteen different photography courses each semester, with two focusing on digital photography and two on analog. The rest were on specific techniques and approaches to photography, and students usually used digital photography in these courses.

4. I have reconstructed the life of the SVA meetings through attendance at three of them, from interviews, and by reading the minutes for the six Academic Affairs Council business meetings during the school year and Meghann Harris's SVA blog.

5. Interview with Gerald Ross, October 8, 2009.

6. The naming of the Fox building has a long history. One graduate in 1885 was Charles James Fox, and his wife Hazel Fox had a grandson, Alonzo G. Decker Jr., who became chairman of the Black and Decker Company. Fox and Decker wealth has been a boon to the school. Another major donor has been the Brown family, headed by a successful black businessman with T. Rowe Price in Baltimore. In 2000, Eddie and Sylvia Brown gave the school $6 million, which allowed it to embark on what became the Brown Center. It was the largest donation by a black family to an American college.

7. "Top Ten: The Year in Visual Art," *Baltimore City Paper*, December 9, 2009, 32.

8. Comments by Kerr Houston in his Introduction to Art Criticism course, November 23, 2009.

9. There are some exceptions to this overall pattern, of course. The art magazine writers Clement Greenberg and Lawrence Alloway were prominent enough in their day to curate shows in New York and Los Angeles, even at the Guggenheim Museum. Also, museum shows have on occasion named movements: The architecture show at the Museum of Modern Art in 1932 coined the term "international style."

10. Quoted in Alessandro Martini and Gareth Harris, "Shock Appointment of Anti-Modernist to Venice Biennale," *Art Newspaper*, issue 311 (March 2010): 1.

11. Interview with Michelle Gomez, April 29, 2010, during the year-end Fine Arts Department exhibition.

CHAPTER 9. *Digital Tsunami*

1. Interview with Jason Sloan, December 17, 2009. This account of his class is based on the author's attendance for several sessions in the fall of 2009.

2. Interviews with Liam Dunaway, April 1 and May 5, 2010.

3. Interviews with Holden Brown, February 20 and May 10, 2010.

4. Scientists led the way in the first computer art. The first art exhibits using a computer came in 1965, held in New York and Stuttgart, West Germany, done

by laboratory scientists and still considered gimmicks by most fine artists and graphic artists. This changed when the science research produced useful studio tools in the early 1980s, software such as Images I, Paintbox, and Easel.

5. Interview with Tom Hyatt, October 28, 2009. All quotations from Hyatt are from this interview.

6. Interview with Richard Lipscher, March 11 and March 28, 2010. All quotations from Lipscher are from these interviews.

7. Before the 1997 meeting, the campus already had begun to run wiring for computer and Internet connections. After the meeting, every department prepared to go online. Faculty members were urged to learn to use computers, with not a little resistance. New teachers were hired who had experience with computers, photography, and video. In regard to technology, the turning point came in 2000, when a $6 million gift by Eddie and Sylvia Brown allowed the school to start building the Brown Center, a $20 million project that included a massive purchase of computers and digital equipment.

8. Richard Barber and Cheryl Garner, "MICA Class of 2011 Freshman Year Focus Group," Part II, May 12, 2008, 5.

9. The typical EMAC syllabus lists the following hardware and software for class use: scanners, black-and-white and color printers, CD burners, USB flash drives, digital cameras, video cameras, microphones, PowerPoint, Keynote (for MAC), Photoshop, Illustrator, Dreamweaver, Image Ready, Audacity, Final Cut Express, Screen Grab, Image Grab, Zooming Screen, Photoshop Action, and Illustrator Trace. MICA's Division of Technology emphasizes that the campus has an Art/Tech Center and a 3D printer, laser cutters, CNC milling machines, wide-format fabric printers, 3D scanners, a haptic sculpting arm, a large archival 2D printing studio, "smart" classrooms, wireless connectivity, and hundreds of online subscriptions and software tools.

10. Comments by Meghann Harris, Flexible Design Studio I class, March 30, 2010.

11. Interviews with Jonnie Hallman, January 11 and March 16, 2010; see Hallman's blogs at http://destroytoday.com/blog/2009/11/; http://destroytoday.com/blog/2009/10/.

12. Interview with Jamy Sheridan, December 17, 2009.

13. This is the four-member Commission on Multidisciplinary Multimedia, organized in 2008 by the Council of Arts Accrediting Associations to assist the arts sectors (art and design, dance, theater, and music) of higher education. Its draft report, "Basic Organizational Concepts: Multidisciplinary Multimedia in Higher Education," aims to help schools in multimedia decision-making. The draft appeared for comment in March 2011 at http://www.arts-accredit.org/index.jsp?page=CAAA+Multidisciplinary/Multimedia+Working+Group.

14. Kaprow is quoted in H. H. Arnason, *History of Modern Art*, fifth ed. (Upper Saddle River, N.J.: Prentice Hall, 2004), 489.

15. Quoted in *MICA Presents A Midsummer Night's Dream*, 4, the play's program. It ran from March 24 to April 4, 2010.

16. Interviews with Amelia Beiderwell, March 1, March 8, and April 8, 2010.

CHAPTER 10. *Art Market Monster*

1. Author interviews in the Miami art district. The author attended Art Basel Miami Beach and the satellite fairs from December 3 to 5.

2. Interviews with Calder Brannock, February 23 and April 19, 2010. This account is also based on the Camper Contemporary's Web site and Brannock's artist talk, April 27, 2010.

3. Figures in Don Thompson, *The $12 Million Stuffed Shark: The Curious Economics of Contemporary Art* (New York: Palgrave/Macmillan, 2008), 57.

4. Duveen is quoted in Thompson, *The $12 Million Stuffed Shark*, 31.

5. On the sociology of art, which is also its economics, see Howard S. Becker, *Art Worlds* (Berkeley: University of California Press, 1982); and Victoria D. Alexander, *Sociology of the Arts: Exploring Fine and Popular Forms* (Malden, Mass.: Blackwell, 2003).

6. On the Scull auction, see Anthony Haden-Guest, *True Colors: The Real Life of the Art World* (New York: Atlantic Monthly Press, 1996), 1–20.

7. Elizabeth Currid, *The Warhol Economy: How Fashion, Art, and Music Drive New York City* (Princeton: Princeton University Press, 2007).

8. Author's notes from observations in the exhibit area at Art Basel Miami Beach, December 3–5, 2009

9. "Brighter Mood As Blue-Chip Art Finds Buyers at Miami Beach," *Art Newspaper*, December 3, 2009, 1.

10. Douglas Hanks, "Sales Rebound Paints Pretty Picture at Art Basel," *Miami Herald*, December 7, 2009, online edition at www.miamiherald.com/2009/12/07/1369211/sales-rebound-paints-pretty-picture.html.

11. Author's notes from observations in the exhibit area at Art Basel Miami Beach, December 3–5, 2009

12. Quoted in David Smiley, "Surprise! Marshals Seize 4 Paintings," *Miami Herald*, December 4, 2009, C1.

13. "The Going Is Tough: But Stronger Sales at all Levels than Last Year," *Art Newspaper*, December 5–6, 2009, 1.

14. The 40 percent estimate was made by Don Thompson in a telephone interview, August 5, 2009. Karen Rosenberg, "Miami Fair: Big Pieces, Smaller Prices and Relief," *New York Times*, December 5, 2009, C1.

15. Quoted in Thompson, *The $12 Million Stuffed Shark*, 175.

16. The delegations included Museo de Arte de Lima; Brooklyn Museum; Museum of Fine Arts, Boston; MOCA Los Angeles; Guggenheim Museum New York; Museu de Arte Moderna Sao Paulo; Dallas Museum of Art; MCA Denver; Birmingham Museum of Art; Detroit Institute of Arts; Hirshhorn Museum and Sculpture Garden, Washington; Art Institute of Chicago; Walker Art Center, Minneapolis; Institute of Contemporary Art, Boston; Los Angeles County Museum of Art; Palais de Tokyo, Paris; Whitney Museum of American Art, New York; New Museum, New York.

17. Author's notes from observations in the exhibit area at Art Basel Miami Beach, December 3–5, 2009

18. Thompson, *The $12 Million Stuffed Shark*, 16.

19. The prize figure is in Thompson, *The $12 Million Stuffed Shark*, 183. For the number of art fairs, see 169–76.

20. Interviews with Chris McCampbell, October 8, 2009 and April 18, 2010. The author attended the "Instant Messages" reception, December 10, 2009.

21. For his final thesis on Camper Contemporary, Brannock also developed "Moped Modern," a fold-up gallery display that can be toted around on a steel bracket installed on a motor scooter. He also evolved some "curatorial techniques" for Camper Contemporary, taking student artists on an "adventure," then having them make art in response, art that will be displayed in the camper gallery under an exhibit theme. The first adventure was to explore a breakwater of old sunken boats in the Chesapeake Bay just south of Baltimore.

22. Interviews with Jen Mussari, January 11, March 26, and May 6, 2010; interview with Whitney Sherman, February 23, 2010. The author browsed the Art Market on several occasions.

23. Interviews with Adam Dirks, February 17 and March 24, 2010.

CHAPTER 11. *The End of Sculpture (as We Know It)*

1. Interview with Tylden Streett, January 27, 2010.

2. "Interdisciplinary Sculpture," *Academic Bulletin, 2009–2011* (Baltimore: Maryland Institute College of Art, 2009), 37.

3. Interviews with Liam Dunaway, February 28, April 1, and May 5, 2010.

4. Interviews with Holden Brown, February 20 and May 10, 2010.

5. Interviews with Amelia Beiderwell, March 1, March 8, and April 8, 2010.

6. Baltimore also has a performance art tradition dating from the 1960s. See Megan Hamilton, "Stenciled on Marble Steps, Woven into Rows: Assembling a Baltimore Historian," *Link: A Critical Journal on the Arts in Baltimore and the World*, no. 2 (Summer 1997): 11–31; Peter Walsh, "A Brief and Biased

History of Performance Art in Baltimore, Maryland," *P-Form* magazine (Spring 1998).

7. Tracey Warr, ed., *The Artist's Body* (London: Phaidon, 2000); Barry Gewen, "State of the Art, *New York Times Book Review*, December 11, 2005, 28; Rose Lee Goldberg, *Performance Art from Futurism to the Present* (New York: Harry N. Abrams, 1988). For context, modest self-mutilation (or use of human and animal blood) has long been part of tribal rituals and religious practice, as has been self-denial (such as fasting). In art, the surrealists made the Marquis de Sade (source of the term *sadism*) their patron saint, and today a subculture of permanent "body modification" exists outside of the art world. By contrast, body artists perform as public spectacle. When the physical stress is extreme, the genre has been called variously "actionism," "endurance performance," or "ordealism."

8. "New Department Policy," February 28, 2010. The undergraduate sculpture department argues that, despite the salience of performance art, the department is mostly craft-based, offering forty-eight different courses in "sculpture." See "Interdisciplinary Sculpture," *Academic Bulletin, 2009–2011* (Baltimore: Maryland Institute College of Art, 2009), 134–47.

9. For this period, see Irving Sandler, *The New York School: The Painters and Sculptors of the Fifties* (New York: Harper and Row, 1978), especially chapter 14, "Circa 1960: A Change in Sensibility."

10. The Maciunas manifesto is quoted in Adrian Henri, *Total Art: Environments, Happenings, and Performance* (New York: Praeger Publishers, 1974), 159.

11. See Randall Lavender, "Teaching and Supporting an Authentic 3-D Design Curriculum," *FATE in Review: Foundations in Art Theory and Education* (2000–2001): 17.

12. Interview with Maren Hassinger, February 23, 2010.

13. Interviews with Adam Dirks, February 17 and March 24, 2010. Adam's comments to his classes were made on April 30 and May 4, 2010, during the author's attendance.

14. Interview with Christopher Shipley, March 1, 2010. At the start of this school year (2009–2010), a consensus view of the administration-faculty relationship was summarized as follows: "All have agreed that the existing problems are due, in part, to the rapid growth of the College and its concomitant increases and changes in academic programs, faculty, staff, resources, and facilities." All parties agreed that "shared governance was a priority for AY10 [Academic Year 2010]." See Annual Report of the President, Maryland Institute College of Art, 2008–2009, 24, 25.

15. Nancy Roeder comments at the Faculty Assembly, April 7, 2010.

16. At this writing, the most critical books are Andrew Hacker and Claudia

C. Dreifus, *Higher Education? How Colleges Are Wasting Our Money and Failing Our Kids—And What We Can Do About It* (New York: Times Books, 2010); Mark C. Taylor, *Crisis on Campus: A Bold Plan for Reforming Our Colleges and Universities* (New York: Knopf, 2010).

17. Every college has its financial story, either with a growing number of aging faculty who will not retire or too many adjuncts. At MICA, for example, the famous abstract expressionist painter Grace Hartigan, head of the Hoffberger School of Painting, died at the helm of her department at age eighty-six. The longtime faculty and the trustees of MICA disagree on who really needs the financial help, whether the growing number of adjuncts or the many teachers with "de facto tenure." Meanwhile, tenure has become much harder to achieve at any school. See Christopher Shea, "The End of Tenure?" *New York Times Book Review*, September 5, 2010, 27; Stephanie Simon and Stephanie Banchero, "Putting a Price on Professors," *Wall Street Journal*, October 22, 2010, C1. See also Robin Wilson, "Tenure, RIP: What the Vanishing Status Means for the Future of Education," *Chronicle of Higher Education*, July 4, 2010, daily online edition at http://Chronicle.com/article/Tenure-RIP/66114/. In this account, the Department of Education reports that just 31 percent of today's college instructors have tenure, compared to 57 percent in 1975. If graduate teaching assistants are counted as "instructors," then the tenured group falls to 25 percent. MICA, like many colleges, relies on a large majority of adjunct, or parttime, teachers.

18. Interview with Fred Lazarus, May 7, 2010.

CHAPTER 12. *Snowmageddon*

1. SVA blogs by Meghann Harris, January 25 and February 20, 2010.

2. Interview with Jonathan Levy, February 17, 2010.

3. This account of Kris is based on the author's interactions with him over a semester in his Critical Inquiry class, interviews with some of his roommates and classmates, his art projects, and his essays written in Critical Inquiry. The essays were titled, "Critical Inquiry: Arguing over the Unknown and the Myth of Sisyphus," September 6, 2009; "How I'm Supposed to Think," September 27, 2009; "I'm in a Balloon Castle," October 10, 2009; and his final essay, in part read aloud in class, December 15, 2009.

4. See the National Survey of Counseling Center Directors at www.college counseling.org/2009directorsurvey. The annual survey canvasses a sample of 302 counseling centers at colleges and universities, which in 2009 reported 103 student suicides in the past year. Given that there are about 4,900 U.S. colleges and universities, there may be a total of about 1,600 student suicides each year. The Center for Disease Control reports 34,598 deaths by suicide in 2007,

with 9.7 percent of them among people aged 15 to 24. See National Vital Statistics Reports, 58, May 20, 2010, Table 11, at www.cdc.gov/nchs/fastats/suicide .htm. Furthermore, a survey of 3,256 college students who went to college counseling between 1997 and 2009 found that at the beginning of the period about a quarter of the counseled students thought about suicide, but it dropped to 11 percent, probably because colleges have expanded suicide prevention programs and outreach, according to the report, "College Students Exhibiting More Severe Mental Illness," American Psychological Association, 118th annual convention, August 13, 2010, *ScienceDaily*, at www.sciencedaily.com/ releases/2010/08/100812111053.htm (retrieved November 10, 2010).

5. At MICA in 2008, fourteen students were taken to the hospital with suicidal "ideation"; in 2009, it dropped to six. "Anxiety and depression" are the most common student reports. See Annual Report of the President, Maryland Institute College of Art, 2008–2009, 37.

6. The idea of the cairn memorial was based on an art work done by Eleanor Coppola, who conceived the idea of constructing a "Circle of Memory" after her twenty-two-year-old son died in an accident in the Chesapeake Bay in 1986. The MICA memorial used Coppola's inscription: "For those people who haven't had a personal experience with the loss of a child this installation provides a place to reflect and commemorate the loss of young life we learn about daily— the death of children by illness, accidents, violence, famine, and war."

7. Nora Truskey, "Hesitation," December 7, 2009, final essay for Critical Inquiry class.

8. Cory Ostermann, "My Critical Nature," April 23, 2010, final essay for Critical Inquiry class.

9. Cameron Bailey, "Critical Nature Essay," April 2010, final essay for Critical Inquiry class.

10. The 1974 Family Educational Rights and Privacy Act (FERPA) forbids college administrators, faculty, or counselors to disclose, verbally or in writing, any "private" information about a student without the student's written consent. The parties most affected tend to be parents, who are advised to speak directly to the child about personal or academic issues. By the same token, during college entrance, student are also responsible for their medical records, such as proof of shots, which they often overlook.

11. Interview with Trudi Ludwig Johnson, October 26, 2009.

12. This chapter's account of Sean Donovan is based on an interview, February 24, 2010, several conversations, Donovan's "artist statement," April 12, 2010, and three academic papers: "Mindsight and Memories," November 18, 2009, and two that were untitled as of spring 2010, one on *The Sound and the Fury*, and another comparing T. S. Eliot and Francisco Goya.

13. Interview with Saul Myers, April 1, 2010.

14. Salvadore Dalí, *50 Secrets of Magic Craftsmanship*, trans. Haakon M. Chevalier (Mineola, N.Y.: Dover Publications, 1992), 36–37.

15. Virginia Woolf uses this phrase in the 1924 essay, "Mr. Bennett and Mrs. Brown." See Virginia Woolf, *The Virginia Woolf Reader* (New York: Harcourt, 1950), 194.

16. Comments by Robert Merrill in High Modernism, which the author attended three times, February–March, 2010.

17. See the essay on Cézanne in Maurice Merleau-Ponty, *Sense and Non-Sense*, trans. H. L. and T. A. Dreyfus (Evanston, Ill.: Northwestern University Press, 1964). See also Maurice Merleau-Ponty, *Phenomenology of Perception*, trans. Colin Smith (London: Routledge, 1962).

18. On painting *not* being dead, see Roberta Smith, "It's Not Dry Yet," *New York Times*, March 28, 2010, AR1; I thank MICA photography instructor Nate Larson for his playful comment that "painting *is* dead," interview, December 1, 2009.

19. Interview with Philip Hinge, April 5, 2010.

20. Artist at Noon talk by Margaret Bowland, March 1, 2010. Author's notes.

21. H. H. Arnason, *History of Modern Art*, fifth ed. (Upper Saddle River, N.J.: Prentice Hall, 2004), 135.

22. Interview with Mark Karnes, October 8, 2009.

23. Interview with Howie Lee Weiss, February 3, 2010.

24. Interview with Dan Dudrow, December 14, 2009.

CHAPTER 13. *Paint-Spattered Wretch*

1. This chapter's account of Sean Donovan is based on an interview, February 24, 2010, several conversations, and attendance at his Review Board, April 12, 2010. The author spent several days of the school year visiting the second floor of the Studio Center, where the senior painters work.

2. See *New American Paintings* contests at www.newamericanpaintings .com/.

3. Comment by Dan Dudrow, April 12, 2010.

4. Interview with Sam Green, March 7, 2010.

5. David Bayles and Ted Orland, *Art and Fear: Observations on the Perils (and Rewards) of Artmaking* (Santa Barbara, Calif.: Capra, 1993).

6. Interview with Howie Lee Weiss, February 3, 2010.

7. Interview with Philip Hinge, April 5, 2010.

8. This account of the year at Hoffberger and the selection process for new

students is based on an interview with Timothy App, April 15, 2010; an interview with Chris Harring, Office of Graduate Admissions, March 2, 2010; and conversations with Hoffberger students and visits to that department over the school year.

9. On May 13, 2010, the administration announced that it had chosen the New York abstract painter Joan Waltemath as the second director of the Hoffberger School of Painting, meaning that the school had passed over two other candidates, one being Timothy App, the interim director. In this selection process, the search committee votes, but the provost ultimately decides. A resident of New York, Waltemath would commute to head the school three days a week. She was known for abstract geometrical paintings on narrow canvasses, employing mathematical ideas, and experimenting with different metals in the pigments. She also wrote for online art magazines and had teaching stints at The Cooper Union and Princeton University.

10. Hartigan's recollection of Leake's comment is recounted in her obituary, Jacques Kelly, "Grace Hartigan Dies at Age 86," *Baltimore Sun*, November 16, 2008, A23.

11. This account of the winnowing session is based on a group interview with four Hoffberger students, April 3, 2010, a follow-up interview with Virginia Wager, and an interview with Timothy App, April 15, 2010.

12. Comments from Fred Lazarus and Doug Mann at the Budget Meeting, March 10, 2010. Author's notes.

13. Comments by Christine Neill, Sean Donovan, Dan Dudrow, and Ellen Burchenal at the Review Board, April 12, 2010. Author's notes.

CHAPTER 14. *Climbing the Glass Cube*

1. Ellen Lupton comments made at "ESAD Personal Views 35," Superior School of Art and Design (ESAD) conference, Portugal, May 28, 2007 at http://vimeo.com/6141401.

2. Interview with Meghann Harris, March 14, 2010.

3. Ellen Lupton and Jennifer Cole Phillips, *Graphic Design: The New Basics* (New York: Princeton Architectural Press, 2008); Ellen Lupton, ed., *Indie Publishing: How to Design and Produce Your Own Book* (New York: Princeton Architectural Press, 2009); Helen Armstrong, ed., *Graphic Design Theory: Readings from the Field* (New York: Princeton Architectural Press, 2009).

4. Author's notes at Art Matters, April 20, 2010.

5. This chapter's treatment of Chris McCampbell is based on interviews, October 8, 2009 and April 18, 2010, visiting his studio, and exhibits of his work.

6. This text is from an early draft of the book, *Graphic Design Thinking*, exhibited during the school year covered.

7. Interview with Charles Brickbauer and Steve Ziger, September 1, 2009.

8. Deborah Snoonian, "The Razor-Sharp Modernism of Ziger/Snead and Charles Brickbauer Befits a New Program for the 21st Century at the Brown Center of the Maryland Institute College of Art," *Architectural Record* (July 2004): 127.

9. Laura Vozzell, "Brand-New Logo, $75,000; MICA's Explanation, Priceless," *Baltimore Sun*, April 1, 2007, B2. The quotations are from a MICA press release.

10. This account is based on interviews with Amelia Beiderwell, March 1, March 8, and April 8, 2010. The author attended the class once, visited set-up sessions, and watched the play on opening night.

11. Interview with Paul Slupski, April 8, 2010. A film and video major, Slupski videotaped the play.

12. Interviews with Liam Dunaway, February 28, April 1, and May 5, 2010.

13. This account is based on the author's visit to the Whitney Biennial on the student bus, and on interviews with Liam Dunaway, February 28, April 1, and May 5, 2010.

14. Interview with Timothy App, April 15, 2010; comments by Mina Cheon in her EMAC class, April 12, 2010.

15. This account is based on the author's attendance at three of the Graphic Design IV classes, and on an interview with Zvezdana Stojmirovic, April 13, 2010.

16. To address this question, Zvezdana Stojmirovic has co-authored *Designing for Participatory Culture* (New York: Princeton Architectural Press, 2011), with Helen Armstrong, which she says "considers the role of graphic design in the networked culture occasioned by the Internet."

CHAPTER 15. *Being in Film*

1. *Music by Prudence* is a 28-minute video film about a music group in Zimbabwe made up of young people born with physical handicaps. Its lead singer is twenty-one-year-old Prudence Mabhena. For the project, MICA provide $4,000 as the first seed money to the film's two producers, Roger Ross Williams and Ellen Burkett, with MICA's Patrick Wright as a co-producer. Wright made the five-minute trailers to seek further funding. The project was finally taken on by HBO, who submitted it for the Academy Awards on December 1, 2009. Two MICA students also played a role: Recent graduate Errol Webber did the video filming in Zimbabwe and current student Matt Davies helped Wright with the editing.

2. This account of Film I is based on the author's attendance of five classes, beginning in early March, and viewing student work in the editing room. Interviews with Holden Brown, February 20 and May 10, 2010.

3. Comments by Allen Moore in Film I, March 8, 2010. All of Moore's comments are from author's notes in several classes.

4. Thomas Baird's comments are from the Intermediate Photography class in the spring term, which the author attended. The student comments also come from the class.

5. Jordan Pemberton's comments are from the Intermediate Photography class in the spring term, which the author attended, and on interviews with Pemberton, March 3, 2010.

6. Interview with Howie Lee Weiss, February 3, 2010.

CHAPTER 16. *Education of an Artist*

1. Interview with Cameron Bailey, February 24 and May 6, 2010. He is quoted from his untitled After Modernism paper.

2. Nicolas Bourriaud, *Relational Aesthetics* (Dijon, France: Presses Du Reìel, 1998). 113.

3. Interview with Chris McCampbell, April 18, 2010; the author attended a session of the survey course as well.

4. Interview with Virginia Wagner and other Hoffberger Painting School students, April 3, 2010.

5. Interview with John Peacock, April 20, 2010.

6. My brief account of postmodern theory is based on Christopher Butler, *Post-Modernism: A Very Short Introduction* (New York: Oxford University Press, 2002); Charles Harrison and Paul J. Wood, eds., *Art in Theory 1900–2000: An Anthology of Changing Ideas*, new ed. (Malden, Mass.: Wiley-Blackwell, 2003; Simon Malpas, *The Postmodern*, new ed. (New York: Routledge, 2005), Steven Best and Douglas Kellner, *Postmodern Theory* (New York: Guilford Press, 1991); Lois Tyson, *Critical Theory Today: A User-Friendly Guide*, second ed. (New York: Routledge, 2006).

7. Interview with Robert Merrill, December 16, 2009; interview with Kerr Houston, January 7, 2010.

8. Interview with John Peacock, April 20, 2010.

9. Comments by Nancy Roeder, Faculty Assembly, April 7, 2010.

10. Comments by Dennis Farber, Faculty Assembly, April 7, 2010. Other faculty comments are from this event.

11. Joe Eskenazi, "But Is It Art? SFAI Students, Riled by School's Move to Drop Nine Tenured Faculty, to Blockade Building," *San Francisco Weekly*, April

3, 2009, at http://blogs.sfweekly.com/thesnitch/2009/04/but_is_it_art_sfai_ students_ri.php. The RISD faculty unionized in 1978 and four years later went on strike. The school now has five unions, which continue to be embattled by the recession and administrative changes. See Jennifer D. Jordan, "Economy, Friction, Dissent Test RISD President in His First Year," *Providence Journal*, August 23, 2009, A1; Bill Van Siclen, "At RISD, the End of An Era," *Providence Journal*, April 27, 2008, A1.

12. Student views on faculty were observed during attendance at SVA meetings and interviews.

13. Meghann Harris comments at the last SVA meeting, April 19, 2010.

14. Comments by Joan Gaither in Critical Response to Art class, April 8, 2010.

15. Comments by Meghann Harris in Critical Response to Art class, April 8, 2010.

16. Kerry Freedman, *Teaching Visual Culture: Curriculum, Aesthetics, and the Social Life of Art* (New York: Teachers College Press, 2003), 3, 4.

17. The NAEA may be the least political of the arts organizations, although it does act as an education lobby and its caucuses support social and political issues. The main political group is Americans for the Arts, which lobbies for federal and state funding and rallies the "art vote" in elections. For a summary of NAEA political activism in the arts related to the annual Arts Advocacy Day in Washington, D.C., see Leonard Jacobs, "Arts Advocates Get New Script, Bigger Role Citing Economic Impact of the Arts, They Gain Clout and Money," *Backstage Magazine*, April 15, 2009, at www.backstage.com/bso/news _reviews/nyc/article_display.jsp?vnu_content_id=1003962409. For a criticism of art politics, see George Will, "Artists in Harness," *Washington Post*, September 17, 2009, A25. To build support for the White House health care initiative, the National Endowment for the Arts held an August 10, 2009, teleconference with many of the arts groups it funds to ask them to mobilize favorable public opinion.

18. Interview with Karen Carroll, March 9, 2010. Carroll was selected "National Art Educator of the Year" at the NAEA's spring 2009 meeting in Minneapolis.

19. Karen Carroll, "How Well Prepared Are Art Teachers to Deliver on the Promises of Art Education?" Higher education session, National Art Education Association, April 16, 2010, Baltimore.

20. The NAEA Web site posts "10 Lessons the Arts Teach." They are extracted from Elliot W. Eisner, *The Arts and the Creation of Mind* (New Haven: Yale University Press, 2002), 70–92. See chapter 4, "What the Arts Teach and How It Shows."

21. This summary of the NAEA is based on the author's attendance, April 14–18, 2010, and the program schedule.

22. Alexandra Overby, "A Semiotic Study of Stereotypical Images of Art Teachers in Genre School Films," Arizona State University, poster session at NAEA, Baltimore, April 14–18, 2010. The two movies studied were *Art School Confidential* (2006), about a college teacher, and *Ghost World* (2001), about a high school art teacher.

23. "How/Does Development Matter: The Continuing Legacy of *How We Understand Art*." Higher education session, National Art Education Association, April 15, 2010, Baltimore.

24. This account of Stacey McKenna's Strategies for Teaching Art class is based on the author's attendance on occasions in the spring term and interviews with students.

25. Mary Carole McCauley, "'Baltimore': True Inspiration," *Baltimore Sun*, March 7, 2010, E3. This account is based on attendance at Cory Ostermann's classes, and interviews March 3, April 12, April 28, 2010.

26. This account is based on attendance at Calvin Blue's final Drawing II class, May 3, 2010, and interviews.

27. This account is based on attendance at Jonathan Levy's final Drawing II class, May 5, 2010, and interviews.

28. This account is based on attendance at Nora Truskey's final Elements class, May 4, 2010, with instructor Dennis Farber.

CHAPTER 17. *Art Walk*

1. Jen Mussari, "Very Important Posters," artist's statement, Commencement Exhibition, May 13, 2010.

2. This account is based on attendance at Allan Comport's Senior Seminar for the Illustration Department in the final weeks of the spring semester. Jen Mussari gave her final presentation on April 29, 2010.

3. The Skype interview day was May 6, 2010, which the author observed; interview with Jen Mussari, May 6, 2010.

4. This account is based on interviews with Lani Irwin and Alan Feltus, April 27, 2010.

5. Interview with Fred Lazarus, May 7, 2010.

6. Interview with J. Davidson "Dusty" Porter, April 2, 2010.

7. This account of the MICA graduation commencement day and ceremony, May 17, 2010, is based on the author's attendance. All comments are from the ceremony.

8. Interview with Kyle Davis, May 6, 2010.

9. Robert Storr, "Haste Makes Waste," *Frieze Magazine* 101 (September 2006). Storr says: "Art schools are not like those in other disciplines, where one acquires a set of skills during a three-to-seven-year training period and then proceeds directly to apply them to practical and agreed-upon ends."

10. Blake Gopnik, "Expansive Lofts Inspire Expanding Minds," *Washington Post*, July 11, 2010, E3.

11. See Jen and Jonnie's comments at http://destroytoday.com/blog/2010/04/page/2/; http://thereswaterhere.blogspot.com/2010/06/wyeth.html; http://thereswaterhere.blogspot.com/2010/08/stitch.html.